THIS
IS
MARS

ALFRED S. McEWEN
FRANCIS ROCARD
XAVIER BARRAL

COLLABORATIONS BY
SÉBASTIEN GIRARD AND
NICOLAS MANGOLD

aperture

TABLE
OF CONTENTS

PREFACE

THE IMAGES SENT by the probes *Mars Global Surveyor, Mars Pathfinder,* and *Mars Express,* as well as those delivered by the Martian rovers, have satisfied our curiosity. The observations made since 2006 by the camera HiRISE have challenged our understanding of Mars and have revealed the contours of a very ancient landscape at an unprecedented level of resolution. I have approached and scrutinized the lava plains of the North, the ergs of the dunes, the craters covered with volcanic dust, the abyssal canyons, and the collapsed poles; and, as a stroller-in-place among the tens of thousands of images, I have chosen to maintain a uniform vantage point: each photograph covers six kilometers (3.7 miles) in breadth.

At the end of this voyage, I have gathered here the most endemic landscapes. They send us back to Earth, to the genesis of geological forms, and, at the same time, they upend our reference points: dunes that are made of black sand, ice that sublimates. According to Victor Hugo, a landscape is a kind of writing, at the origin of the alphabet as well as of images: every letter was at first a sign, and each sign was at first an image. These places and reliefs can be read as a series of hieroglyphs that take us back to our origins. *Valles Marineris, Noachis Terra, Olympus Mons, Iani Chaos, Meridiani Planum, Gemina Lingula, Athabasca Valles*—these are among the many new places that work their evocative power on us and on our imagination. **X. B.**

PLATES

EDITED BY
XAVIER BARRAL AND
SÉBASTIEN GIRARD

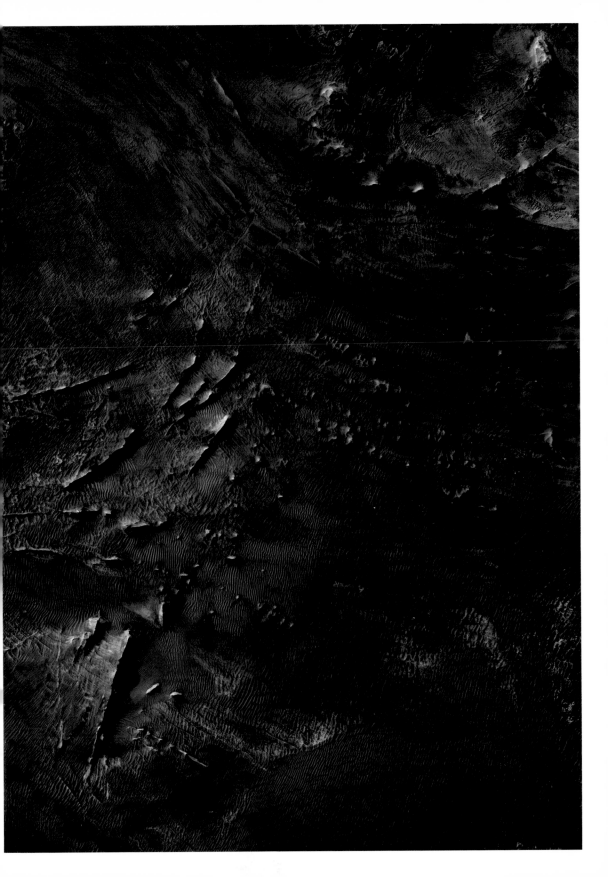

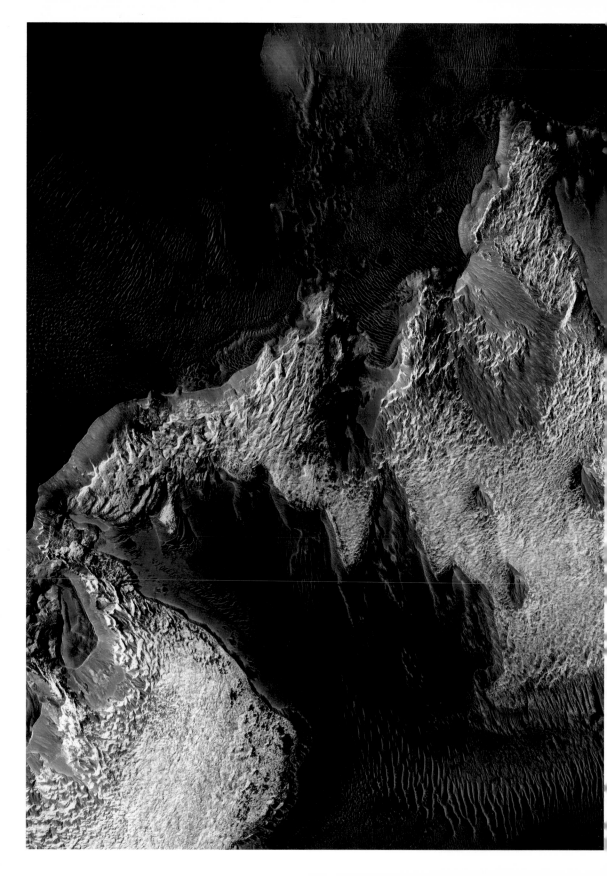

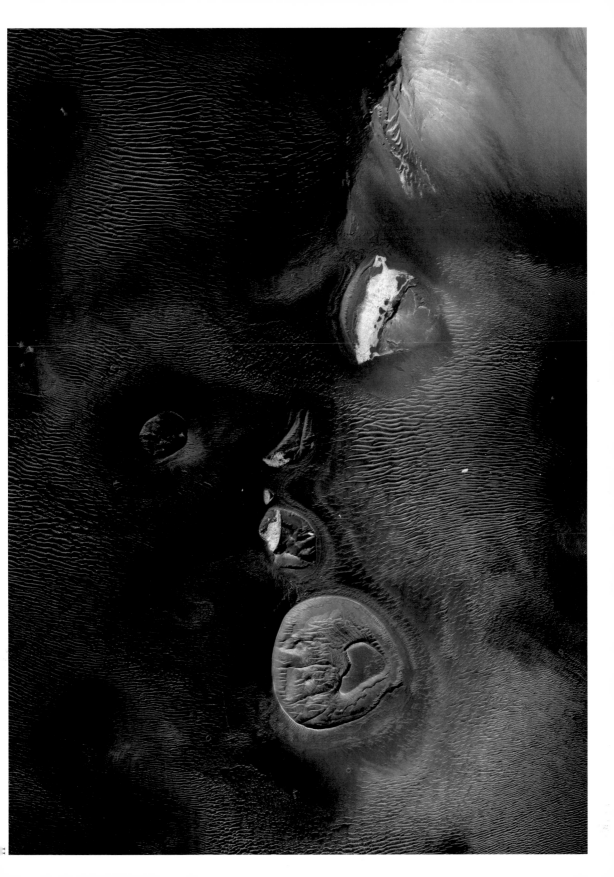

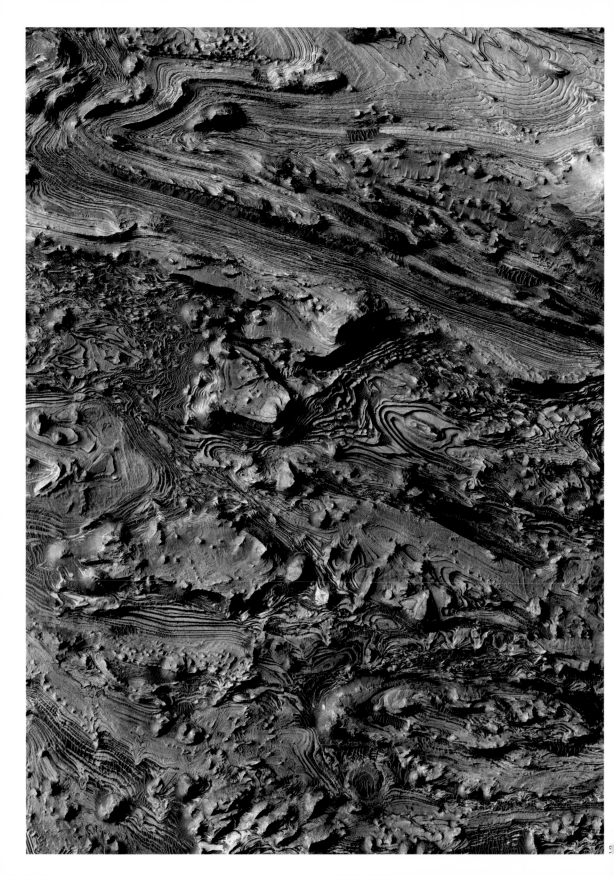

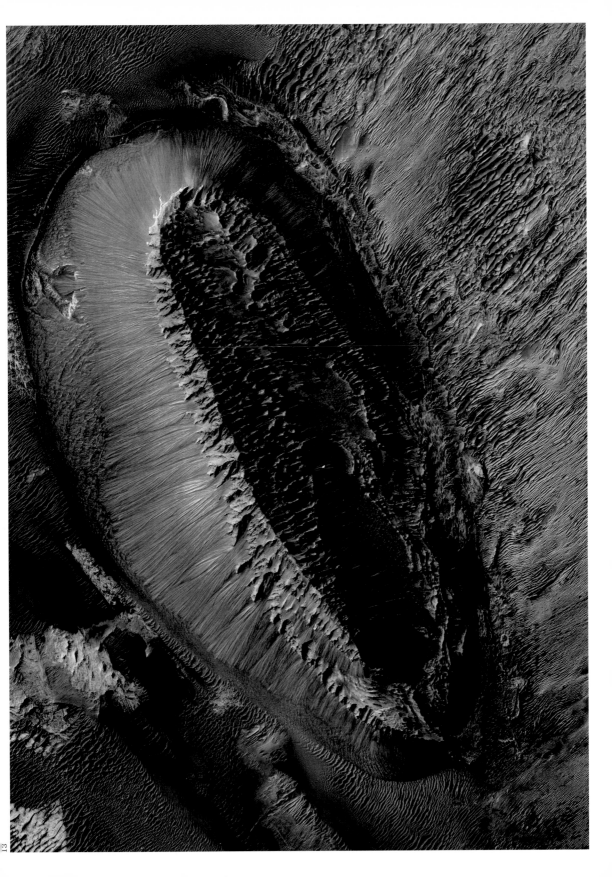

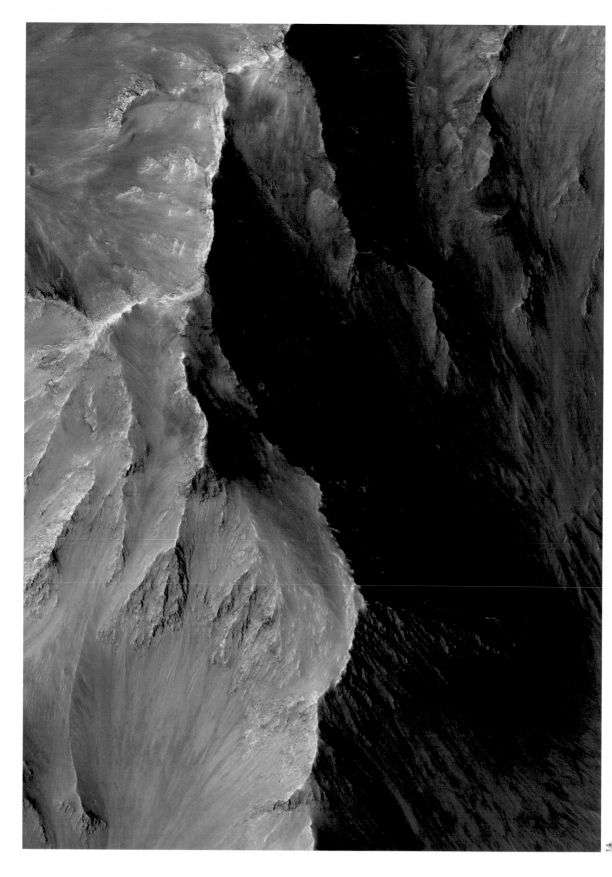

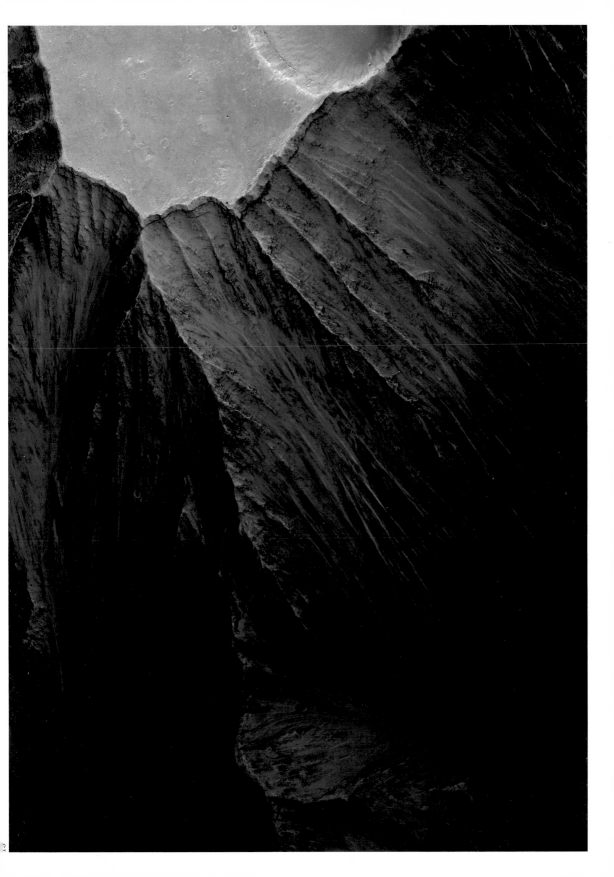

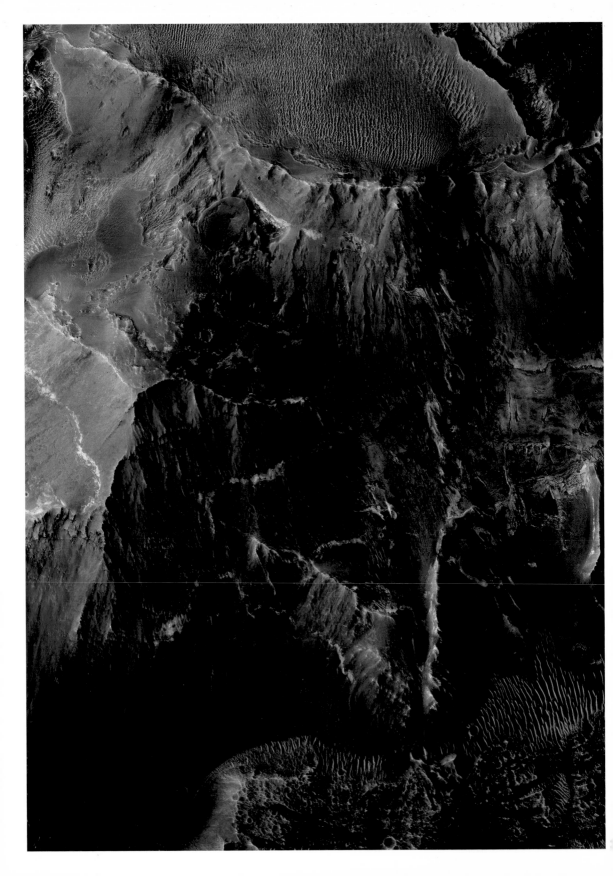

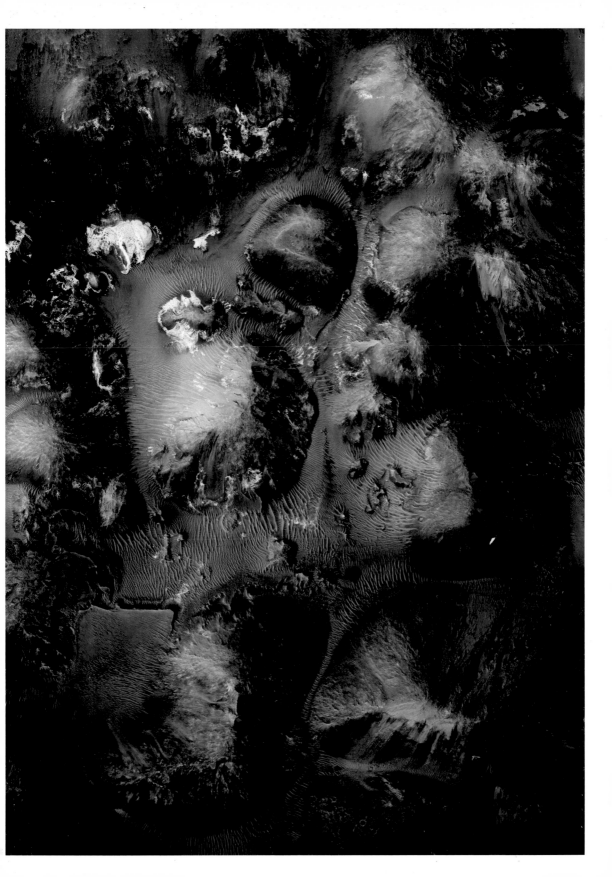

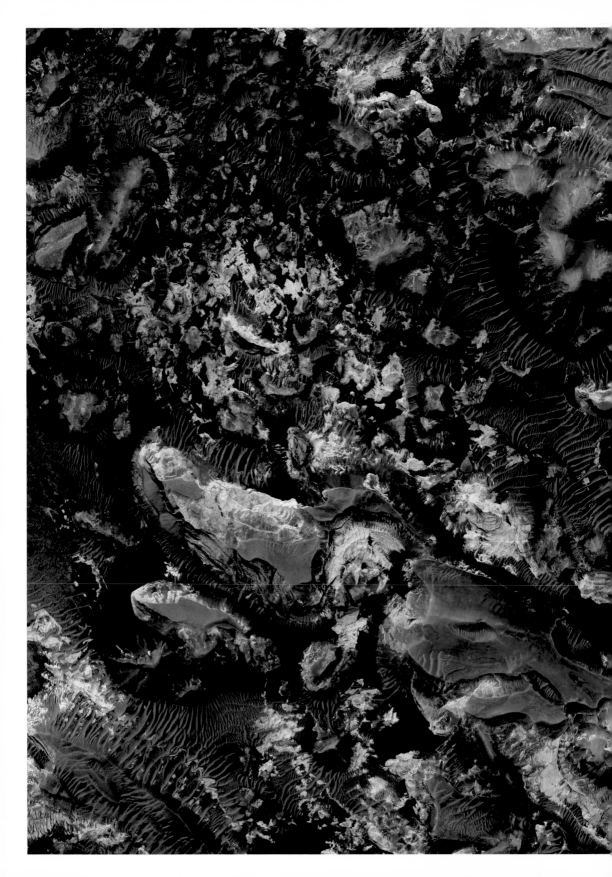

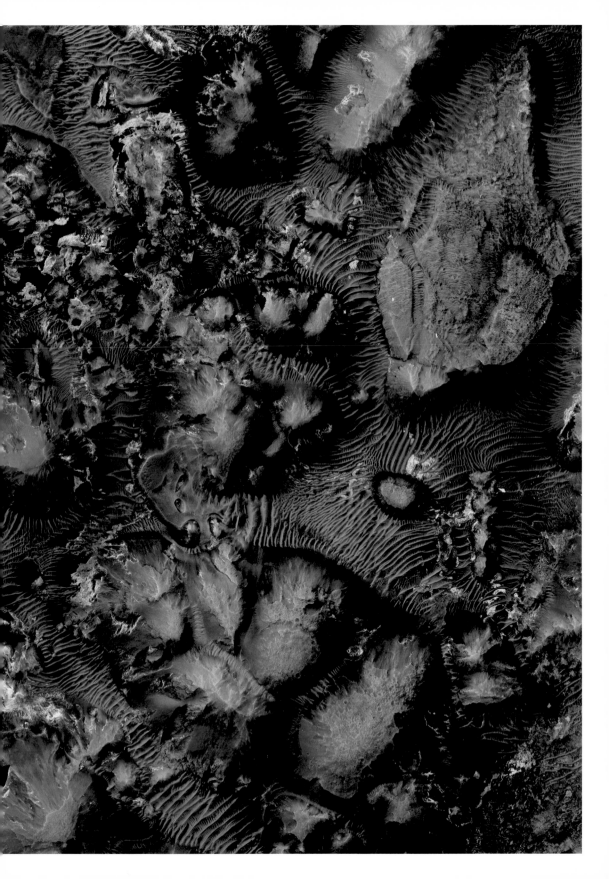

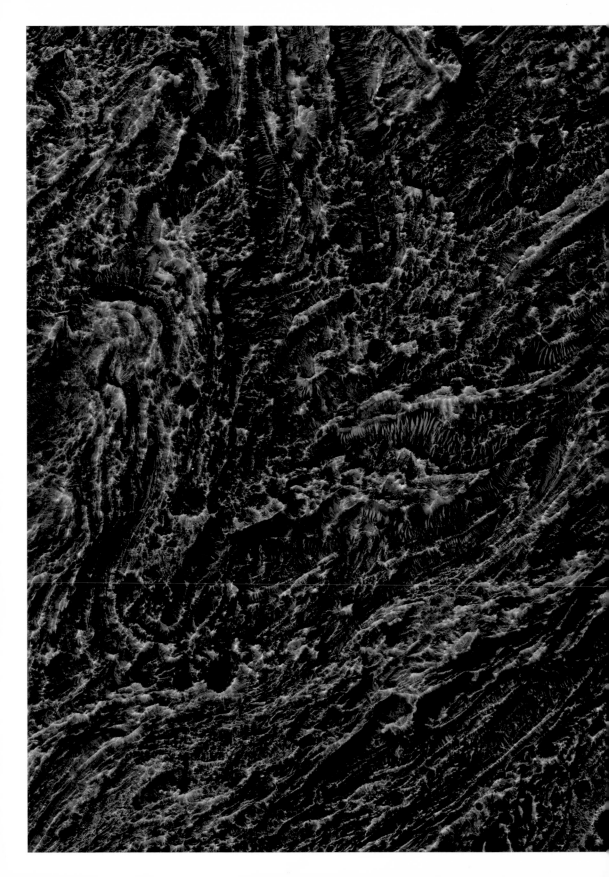

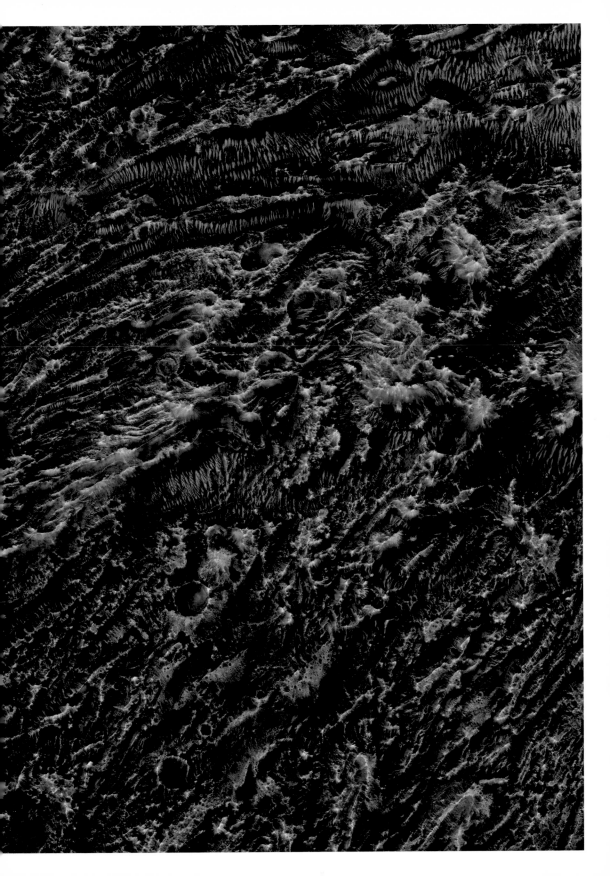

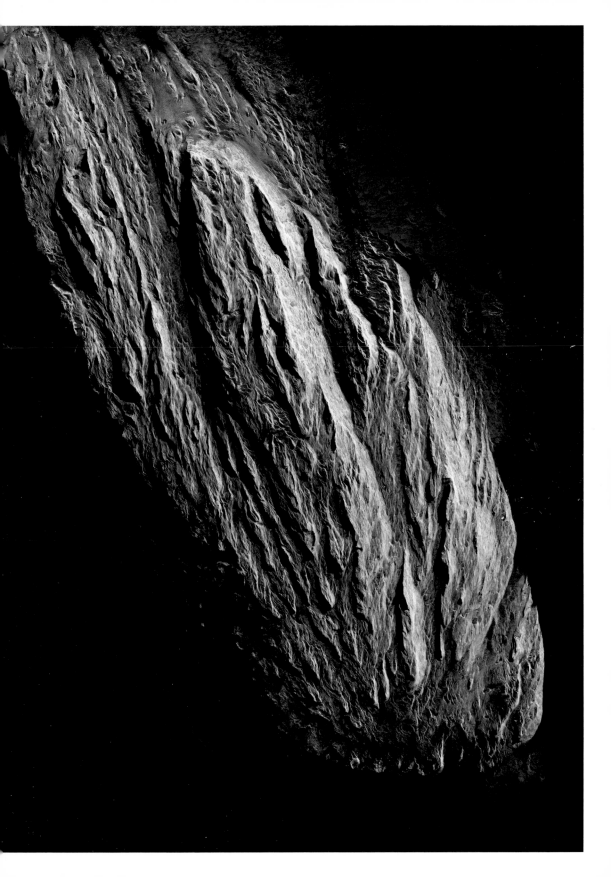

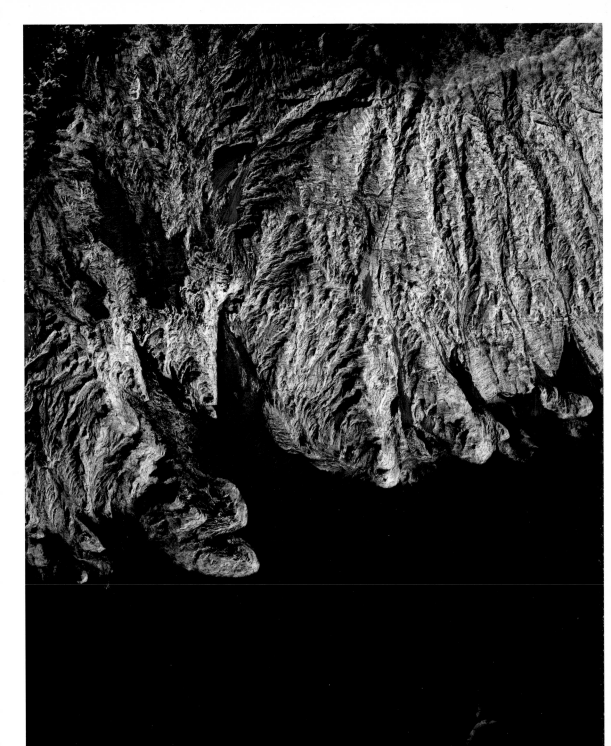

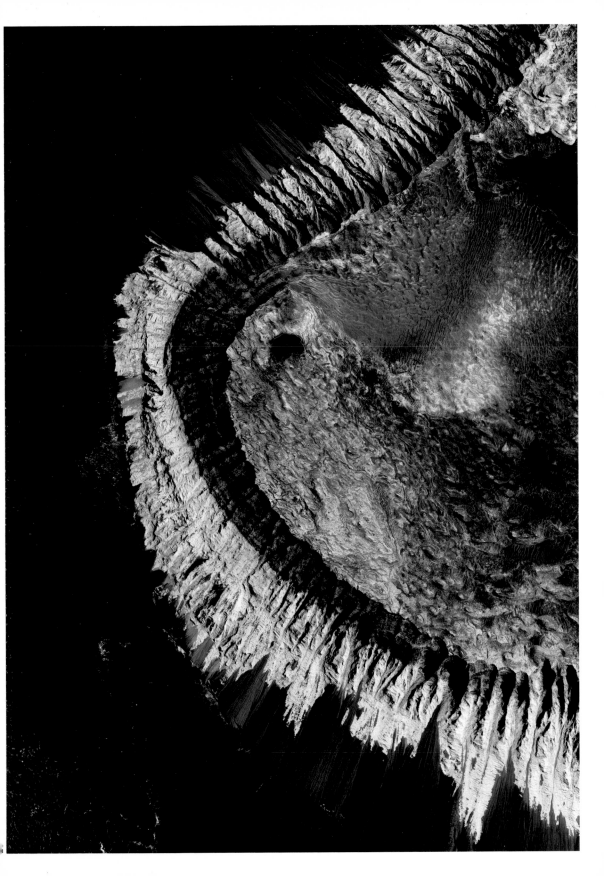

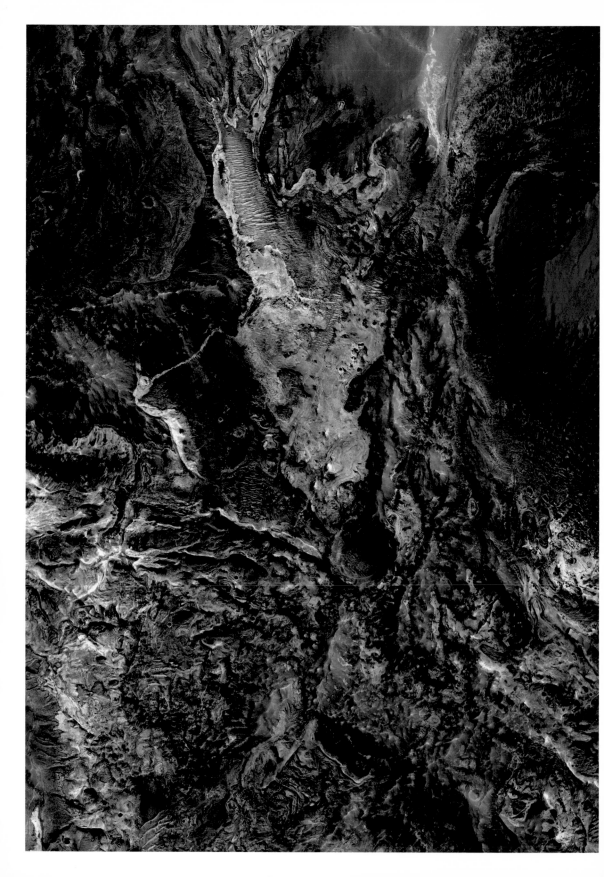

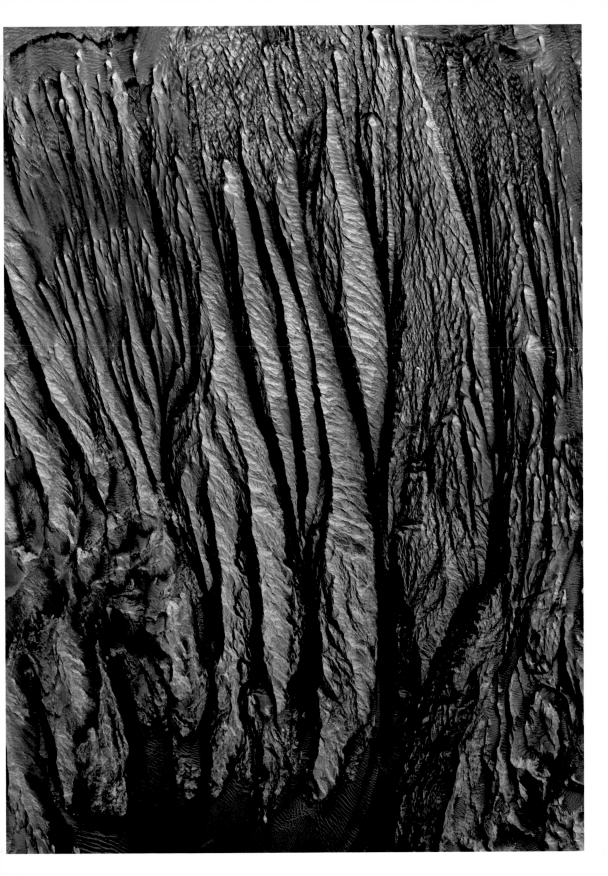

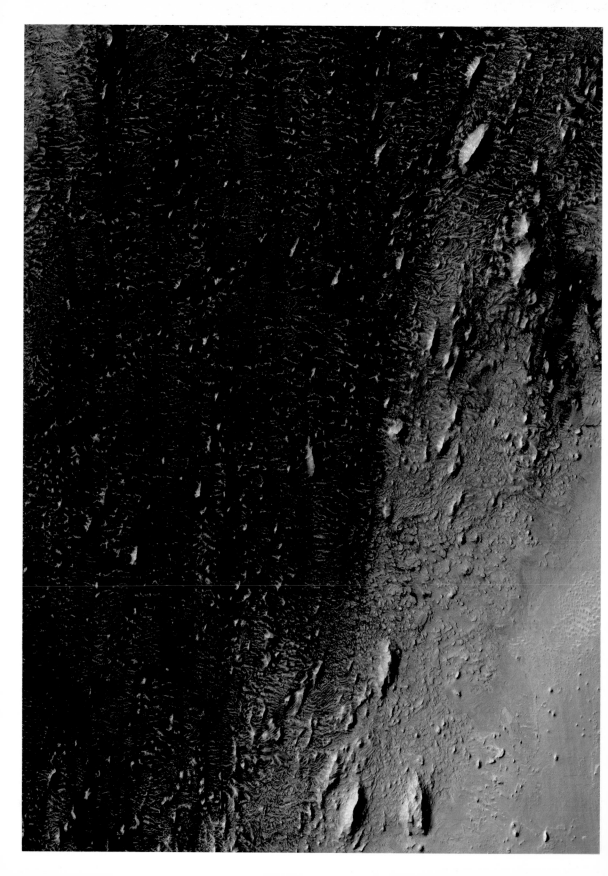

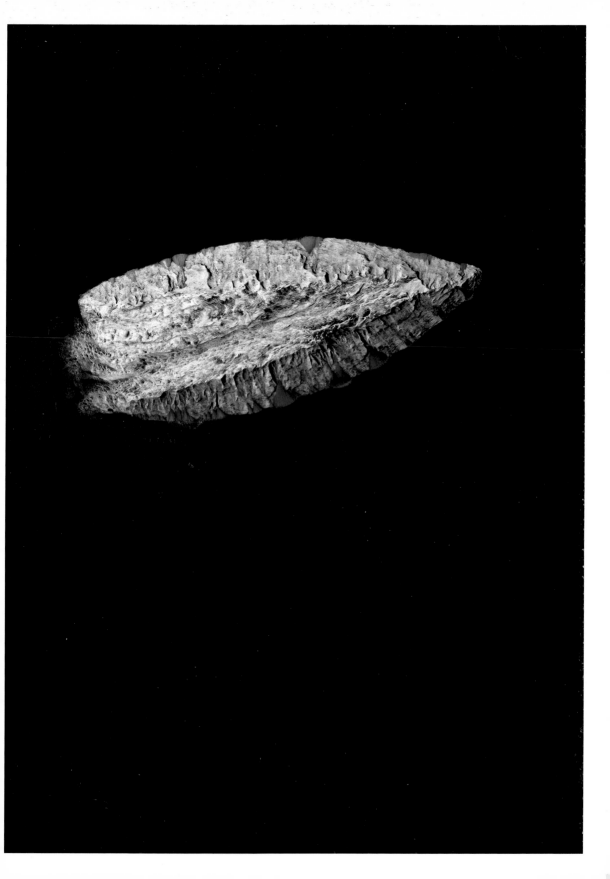

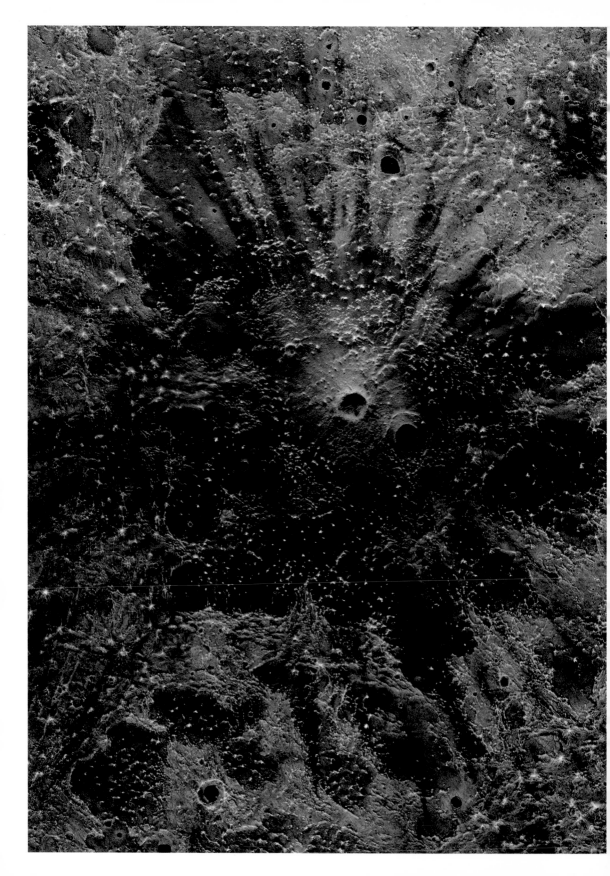

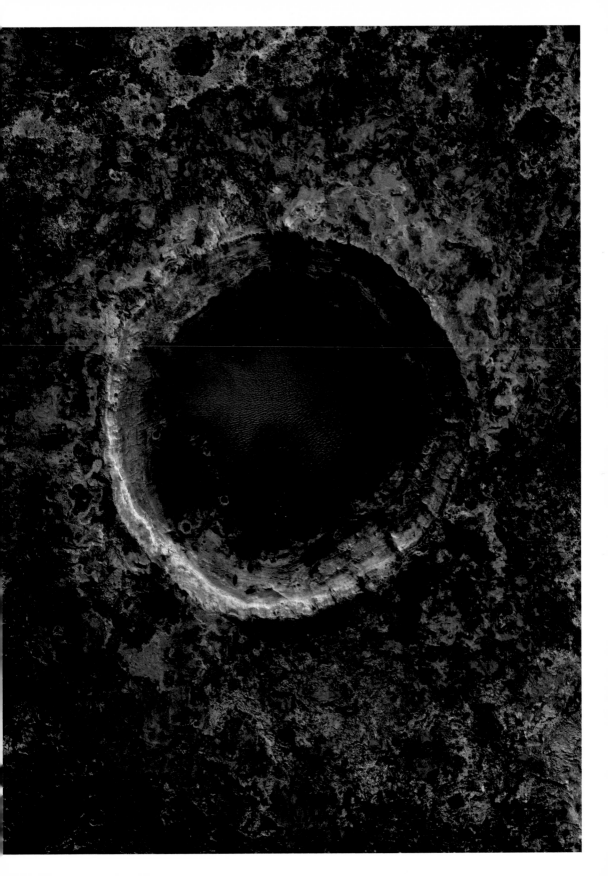

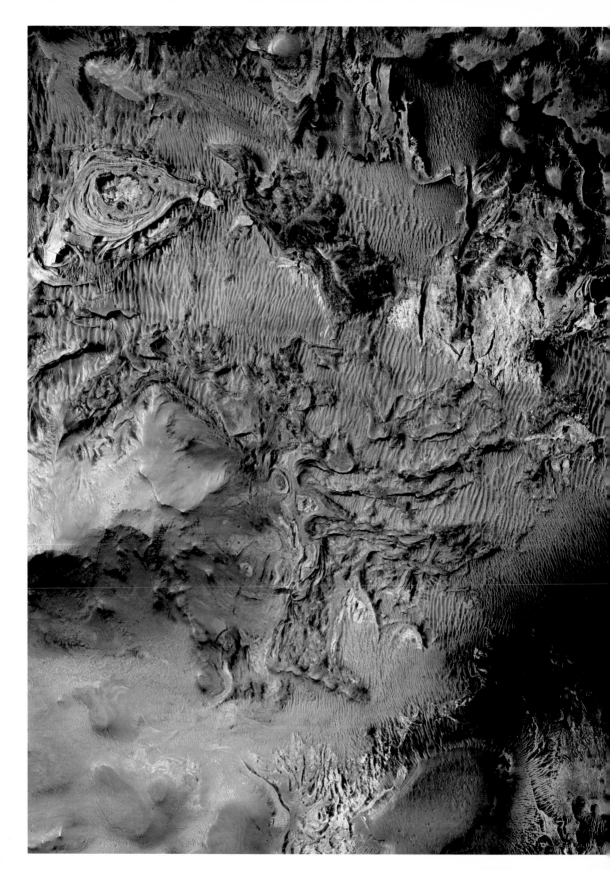

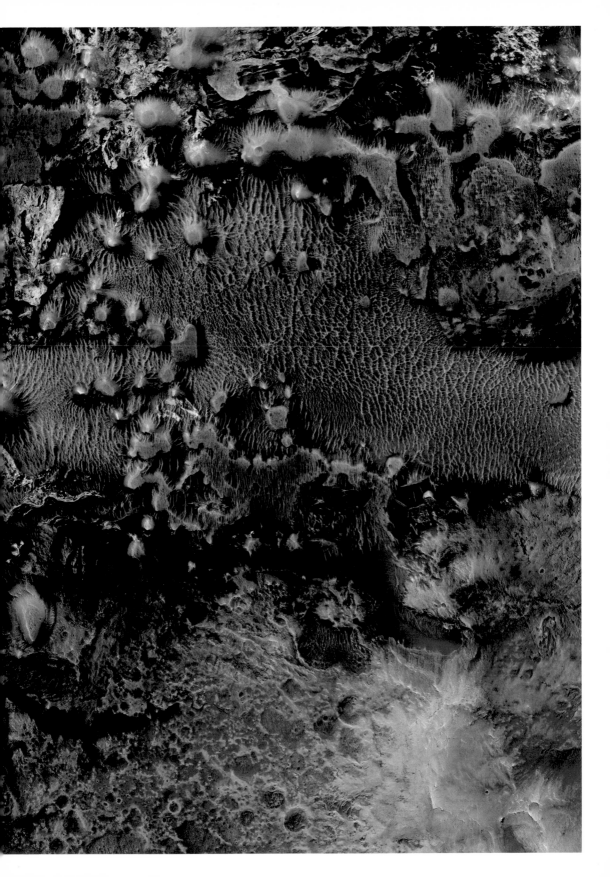

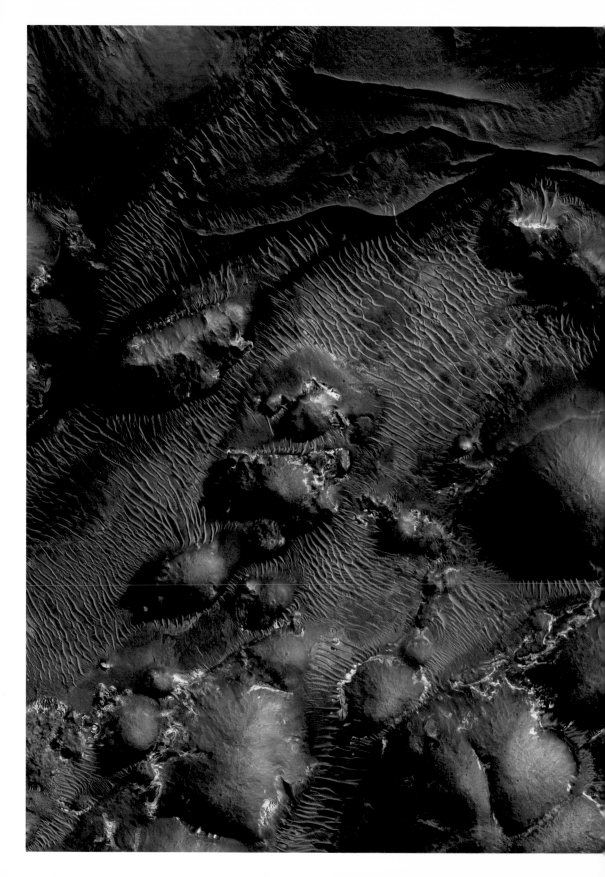

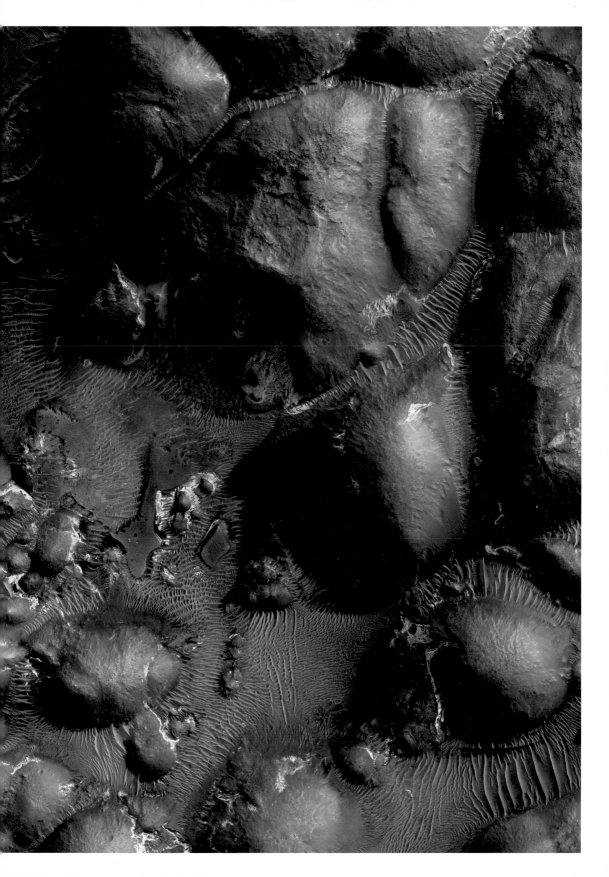

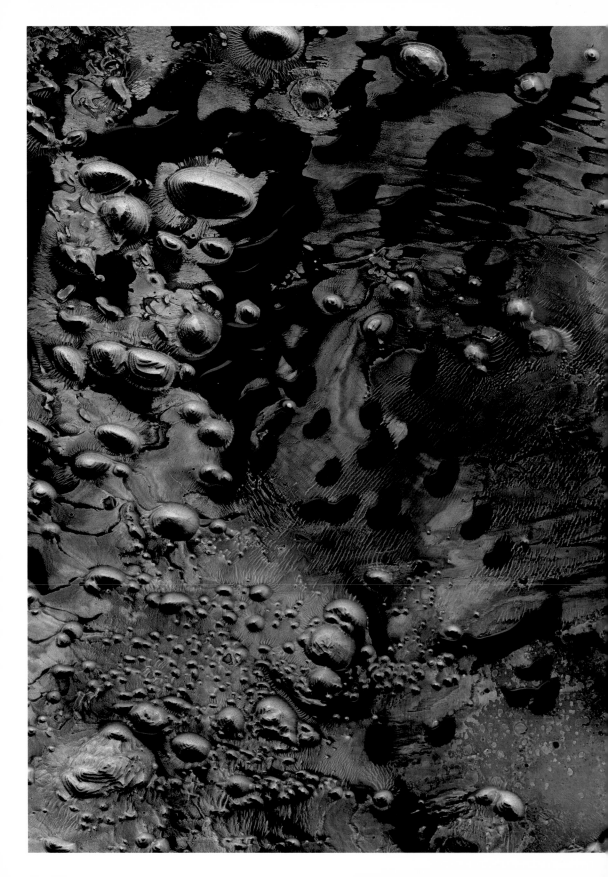

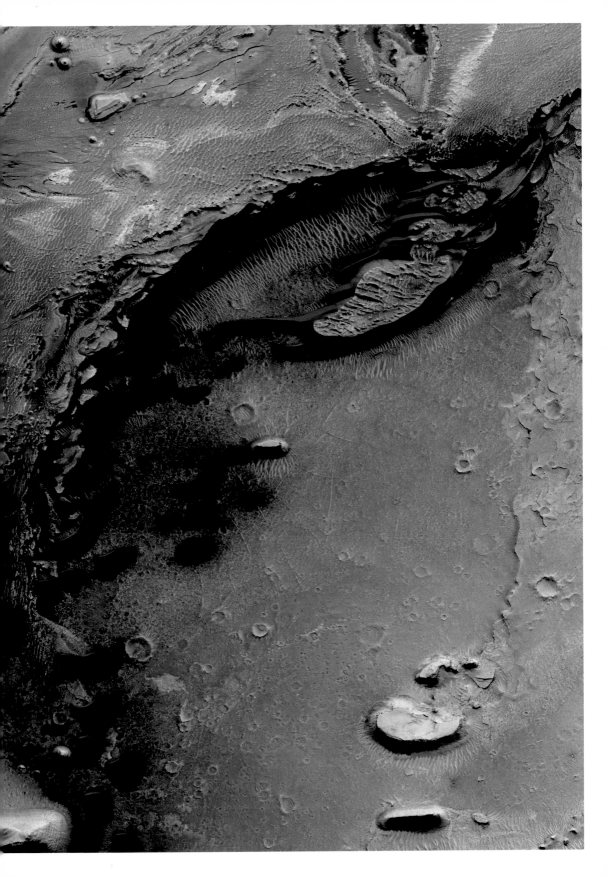

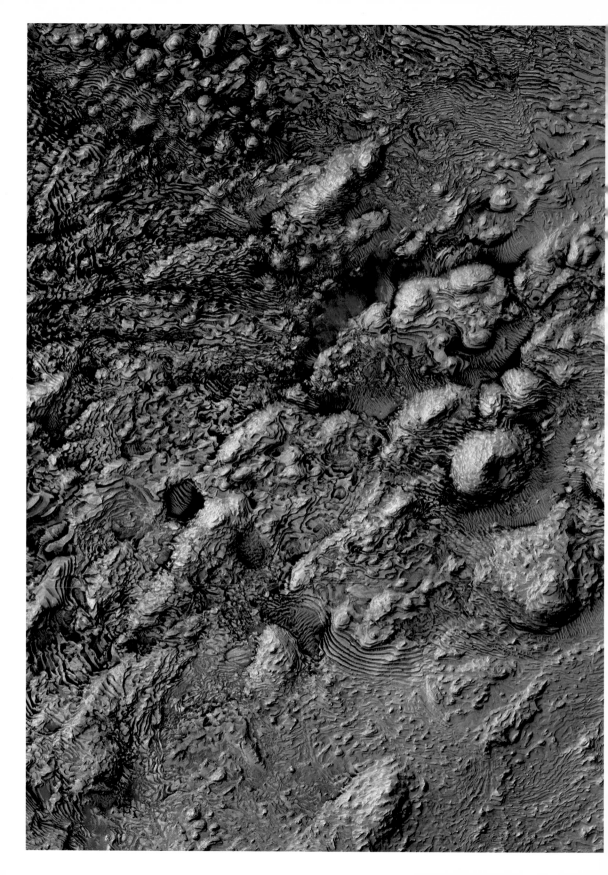

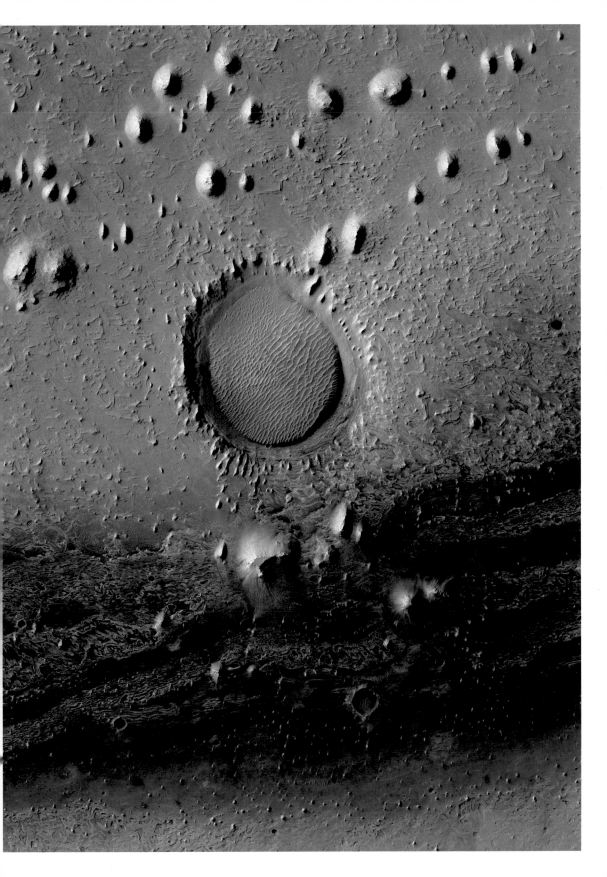

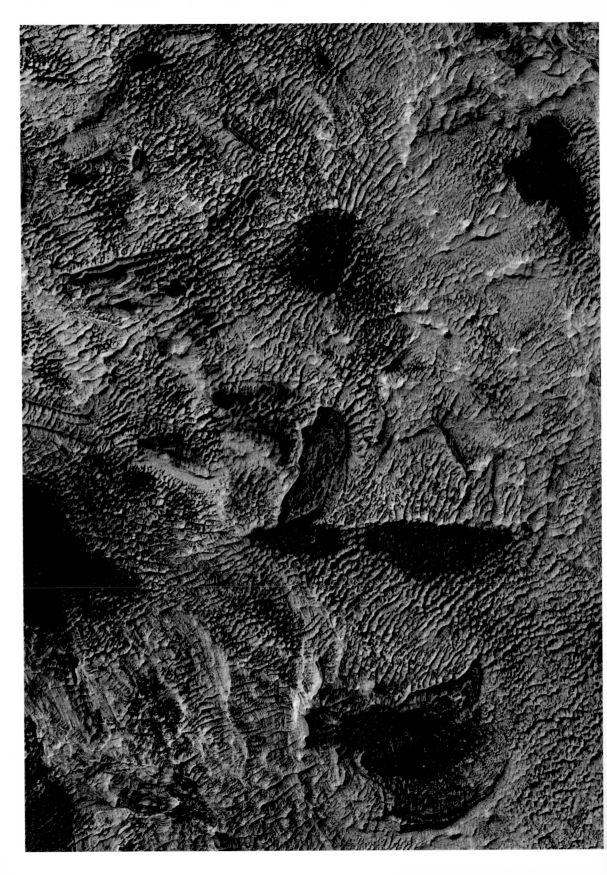

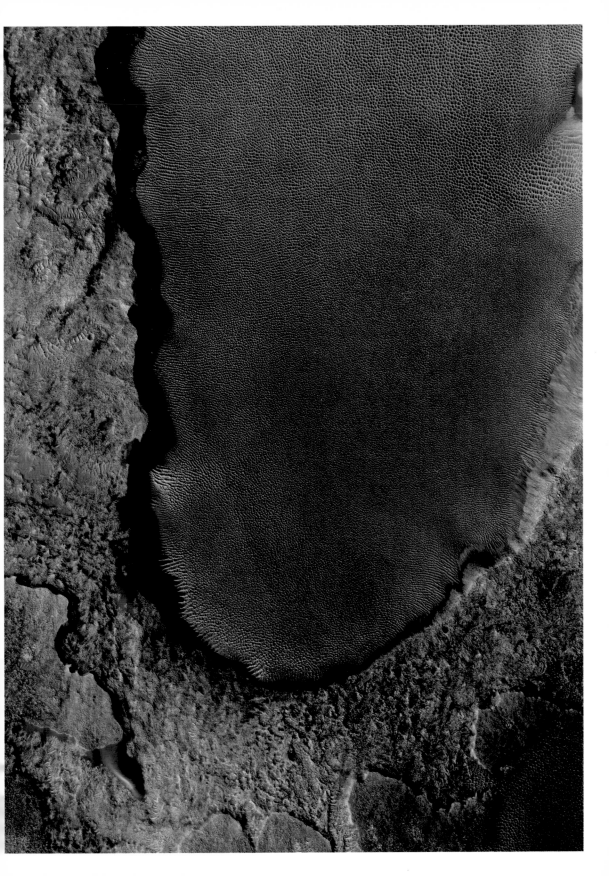

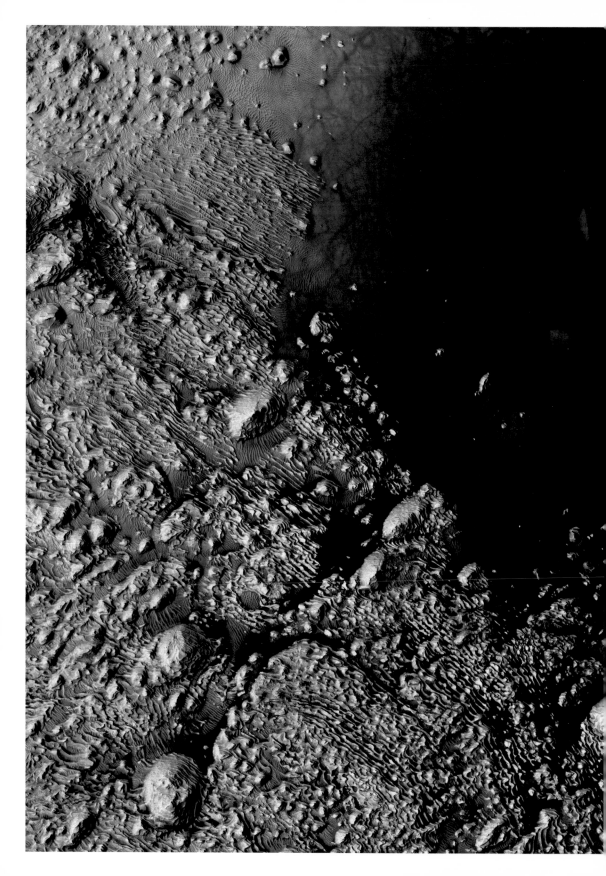

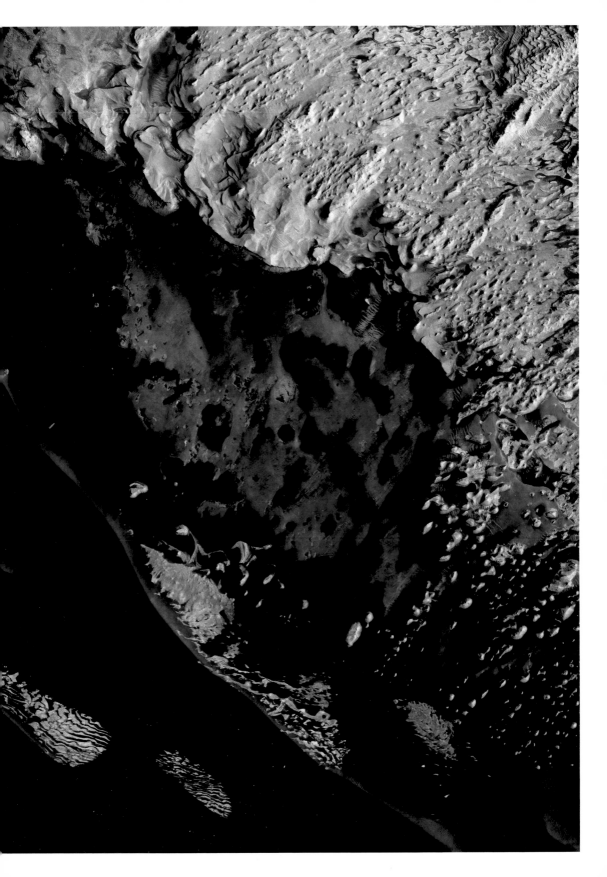

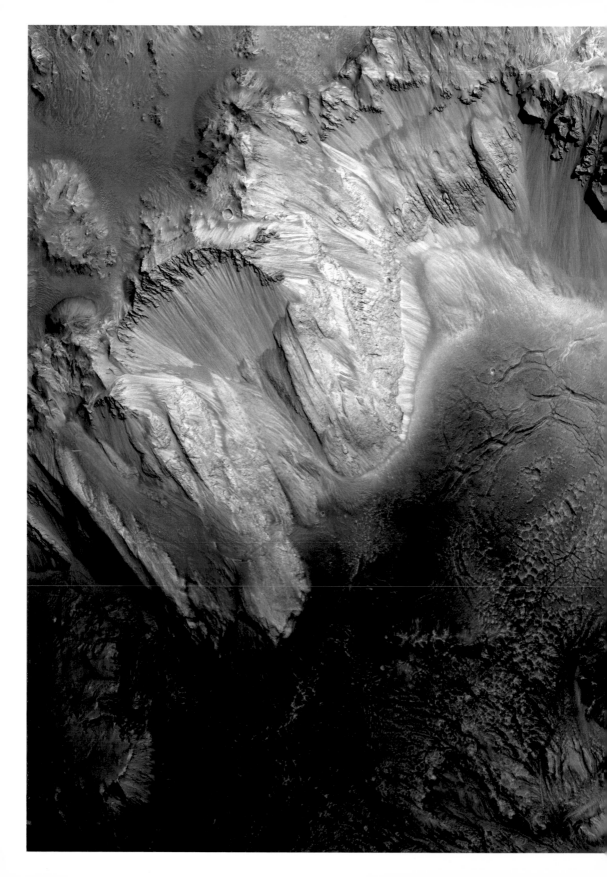

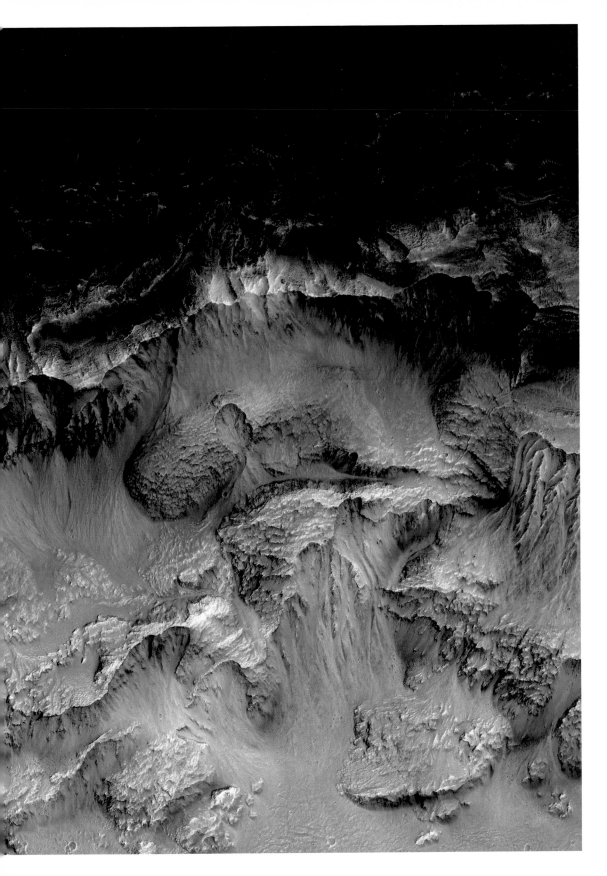

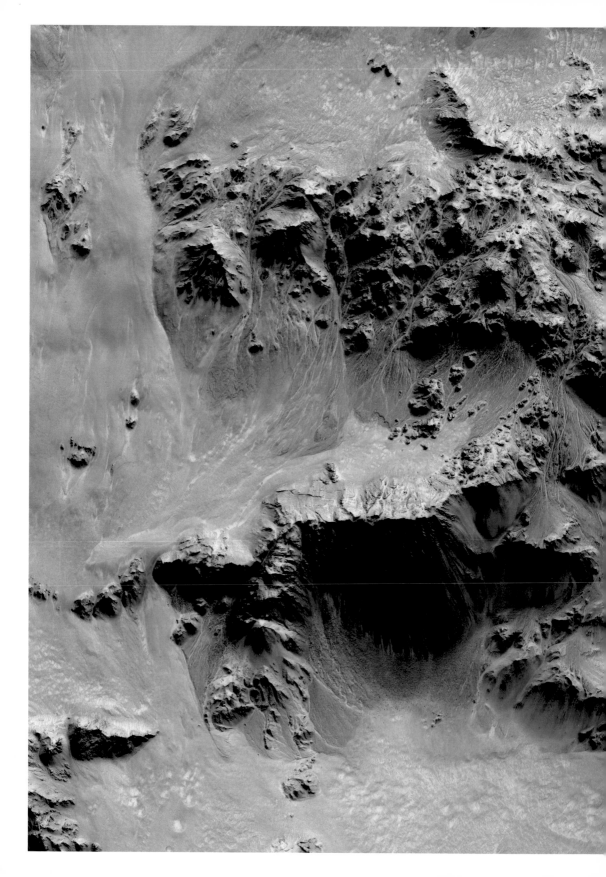

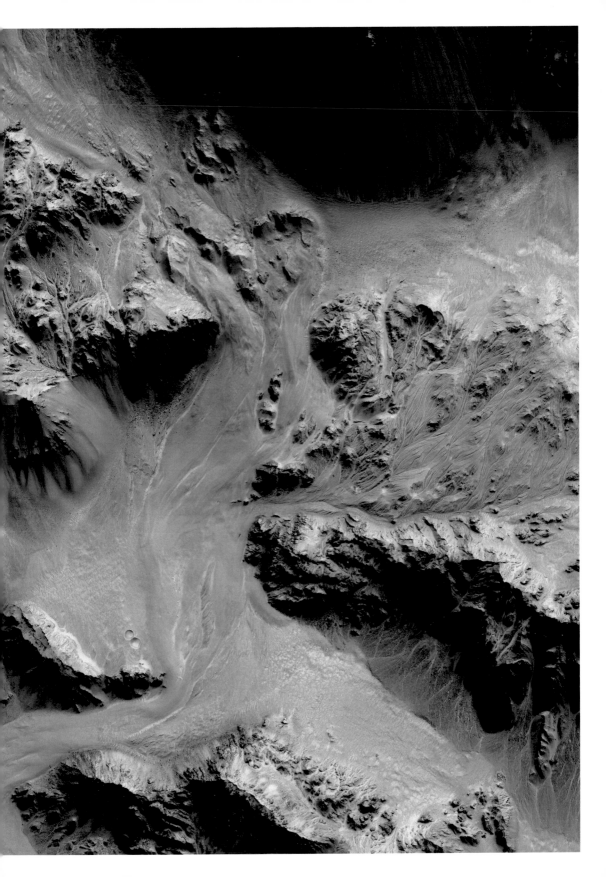

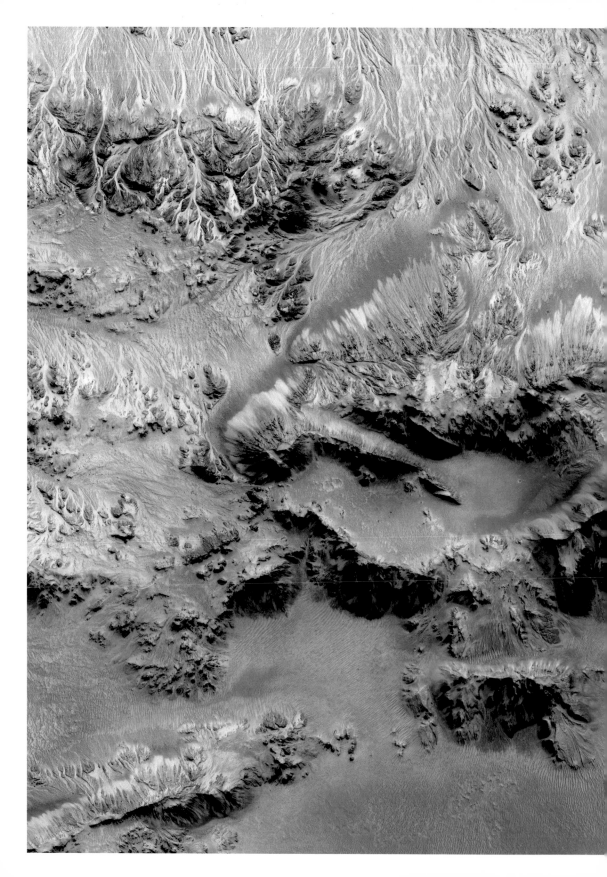

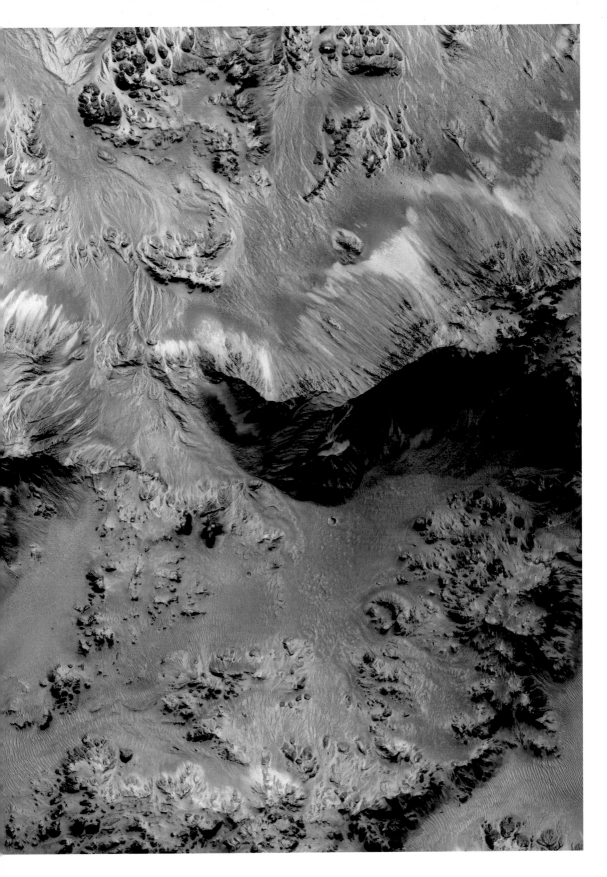

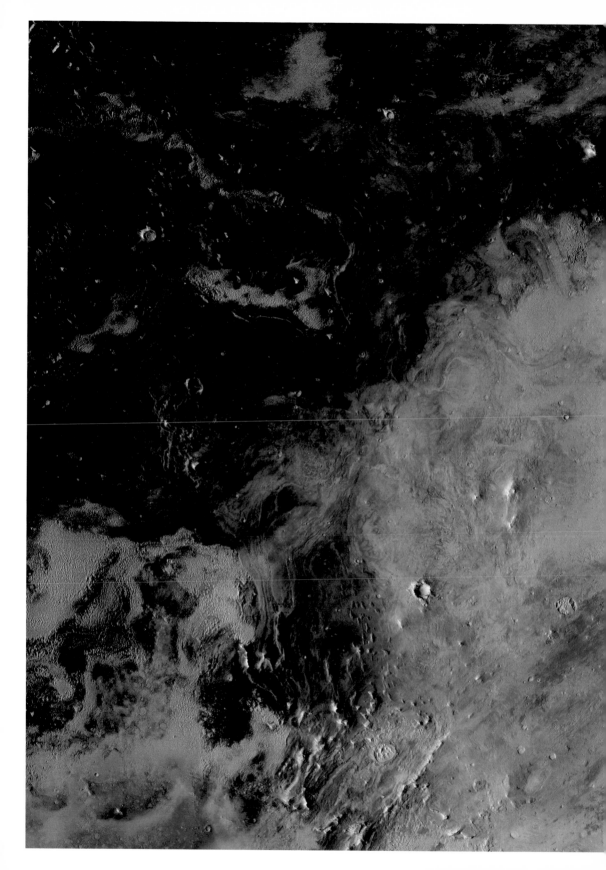

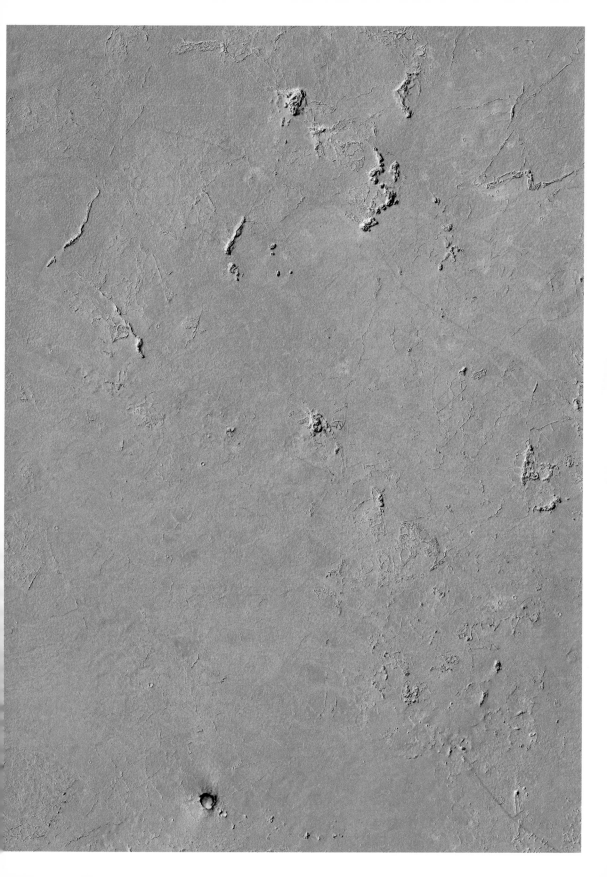

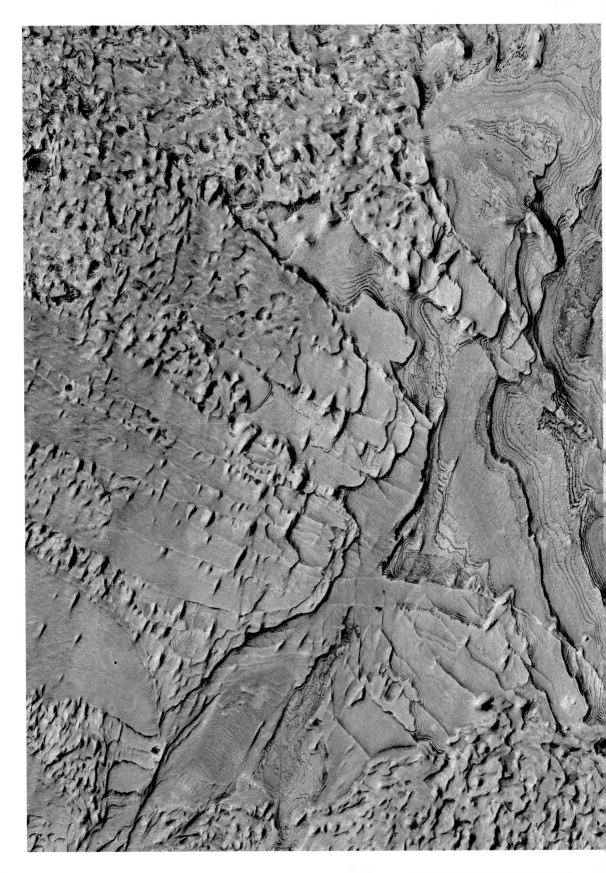

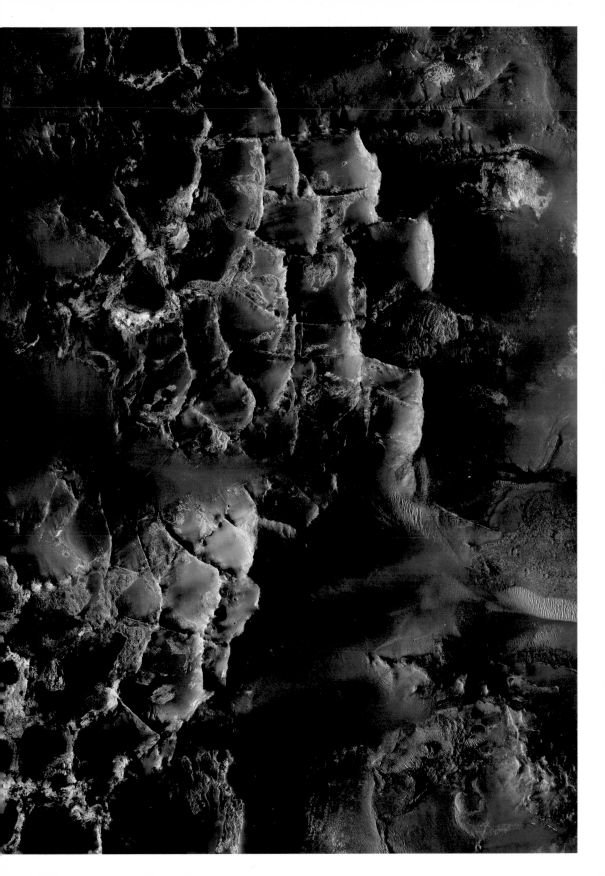

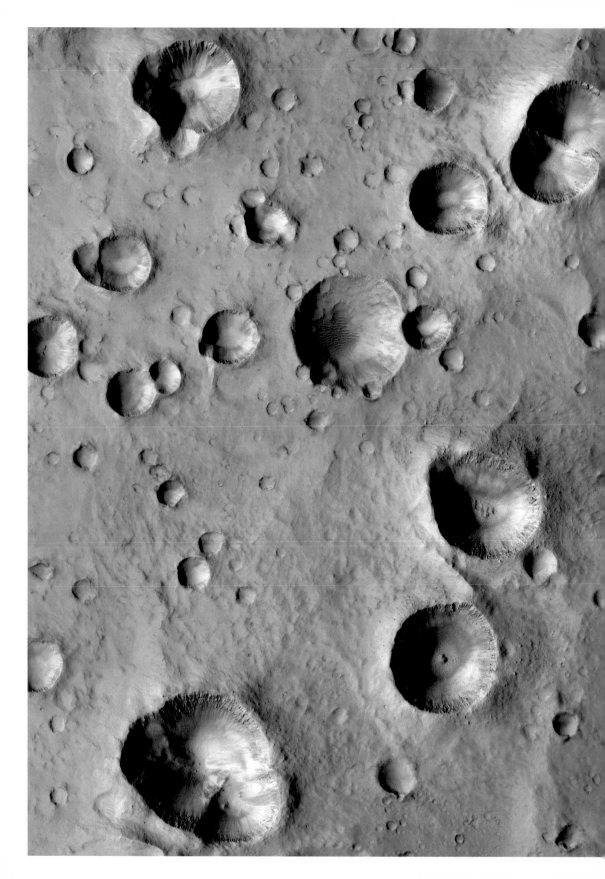

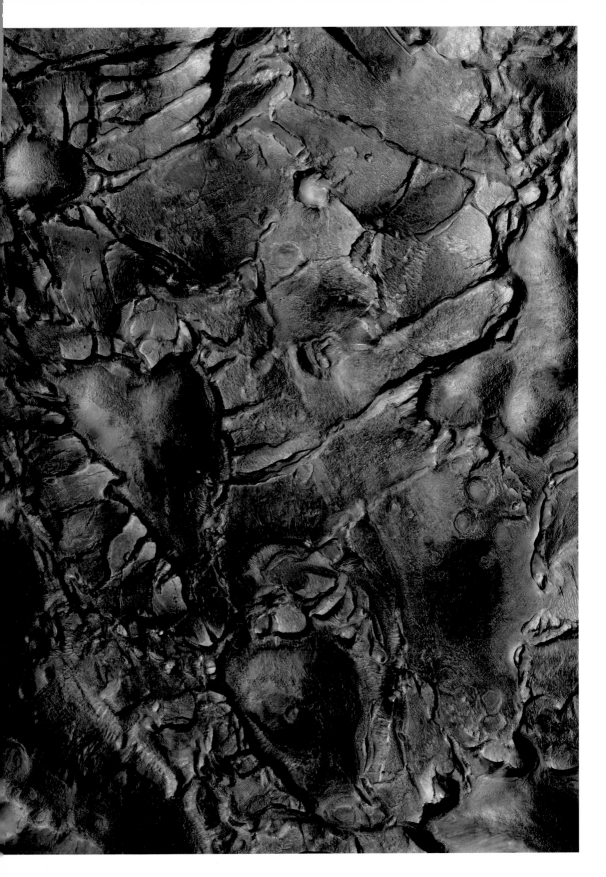

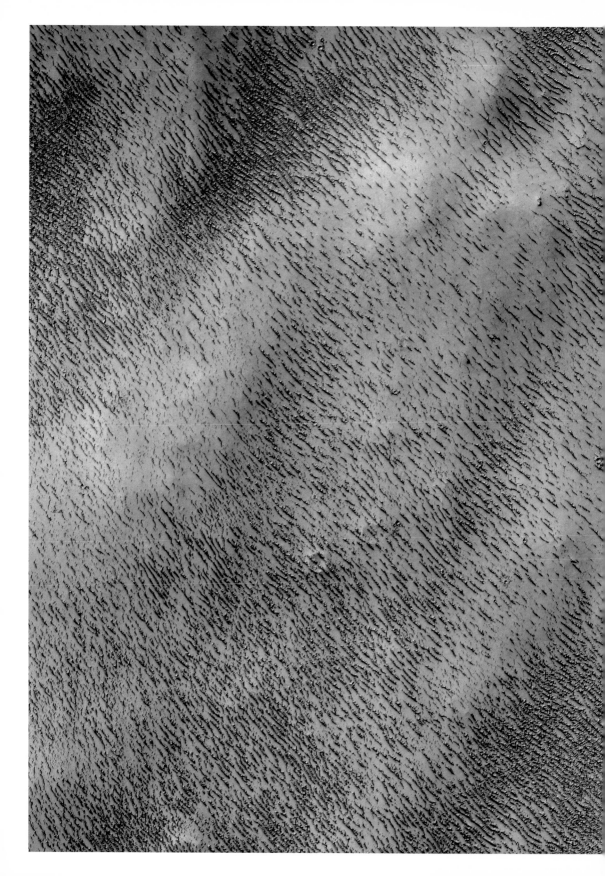

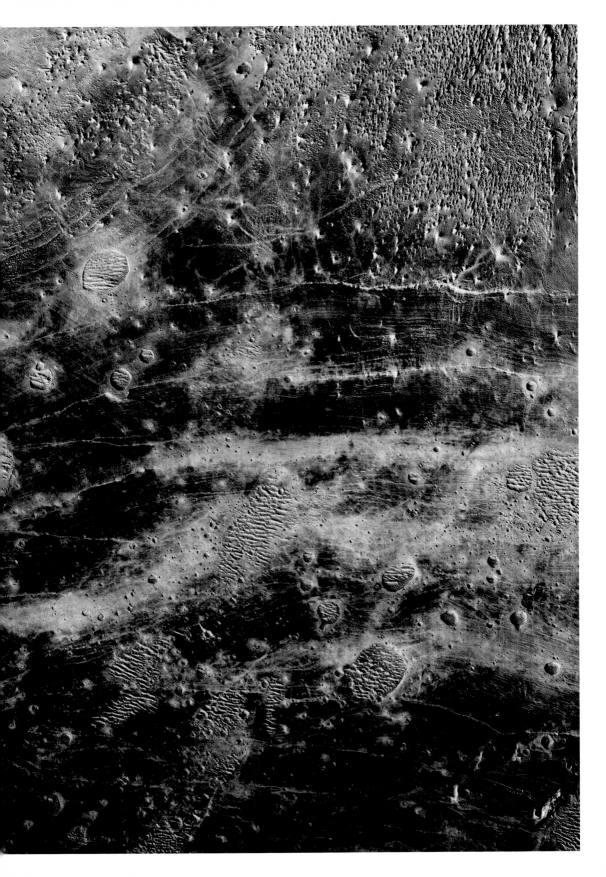

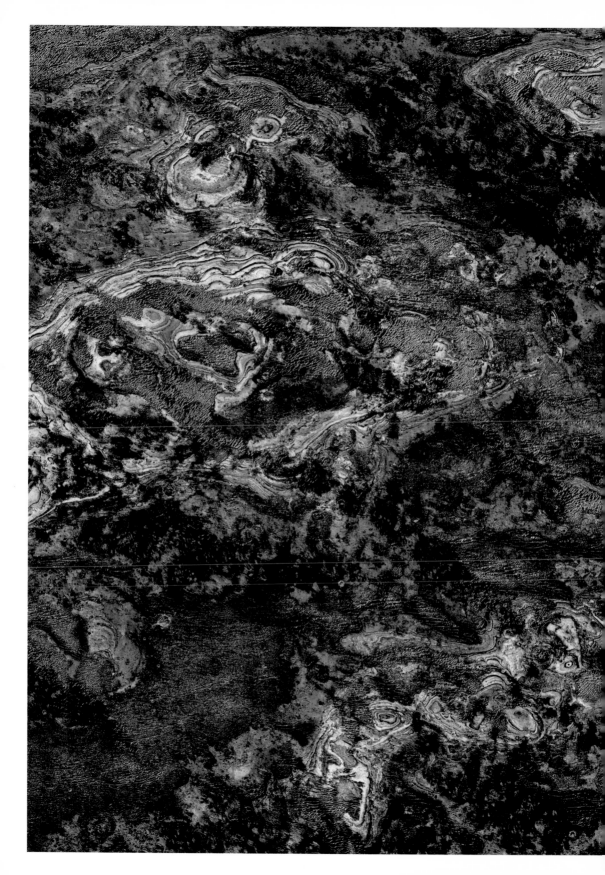

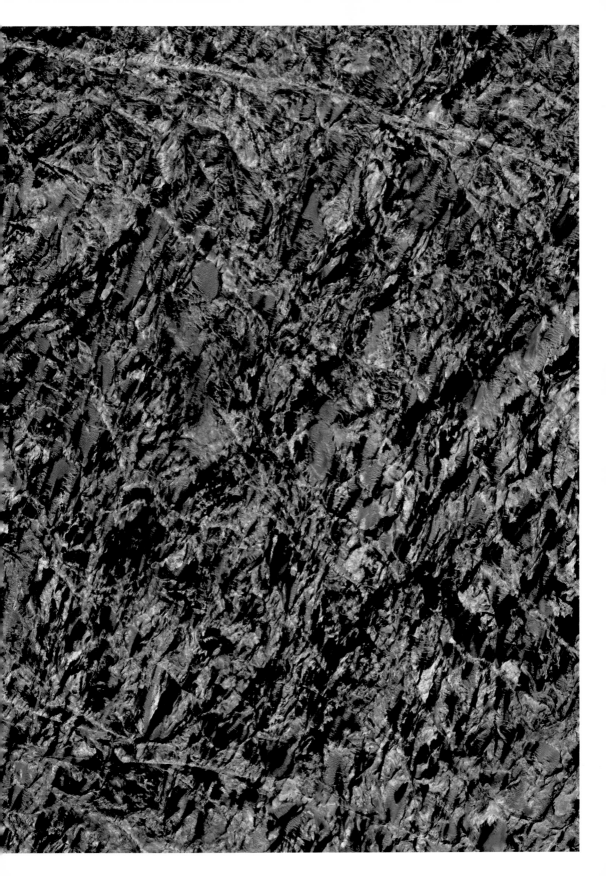

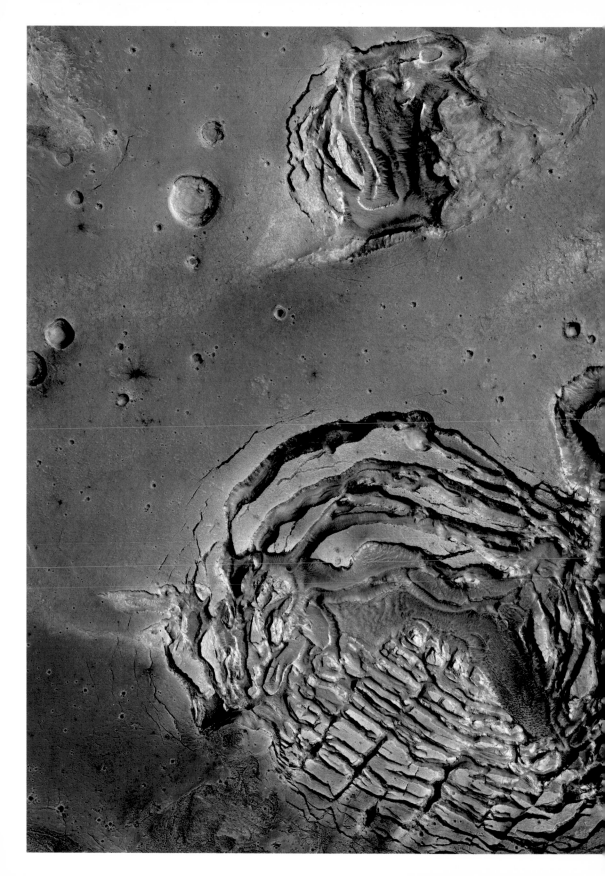

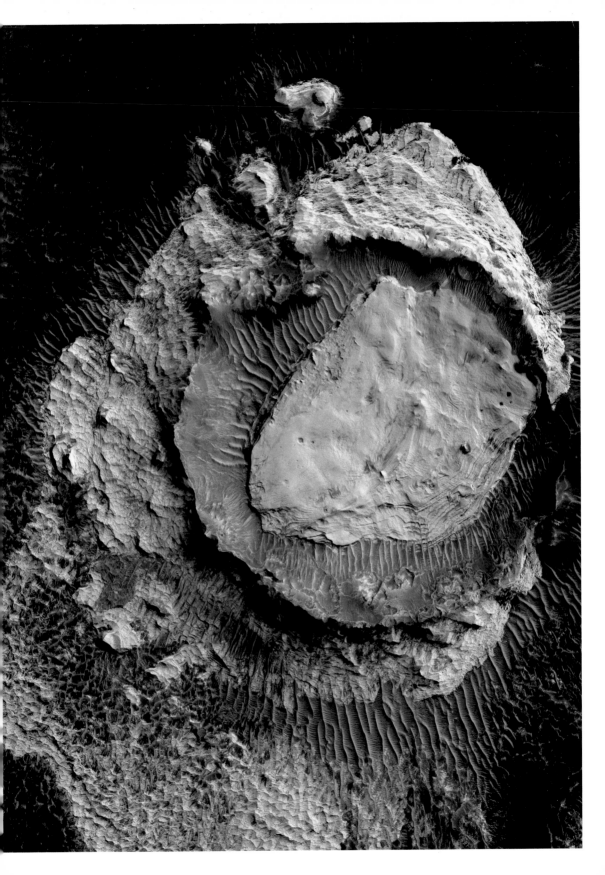

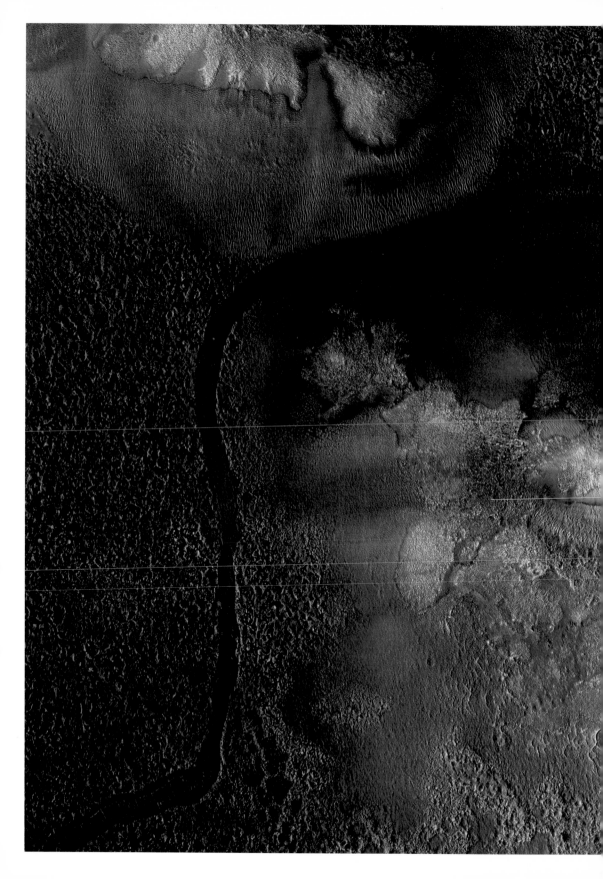

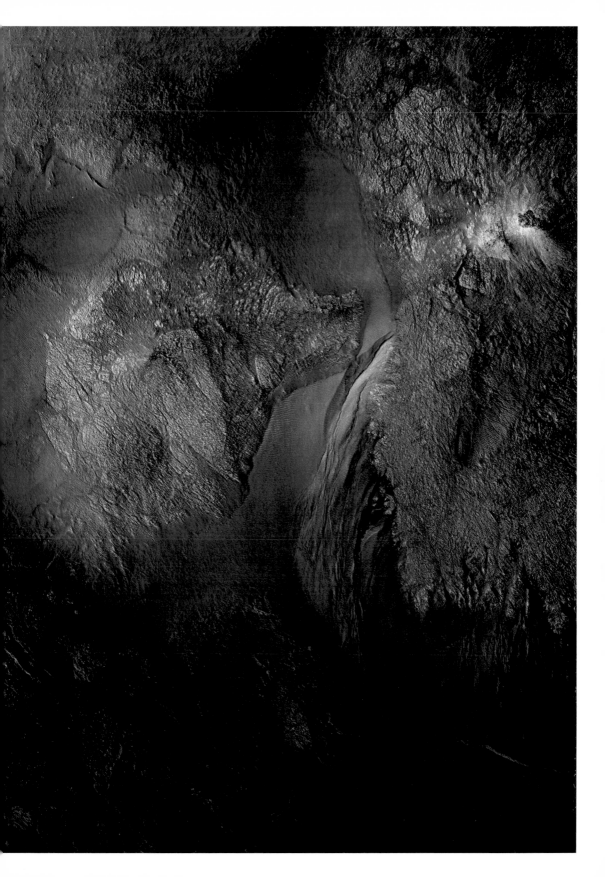

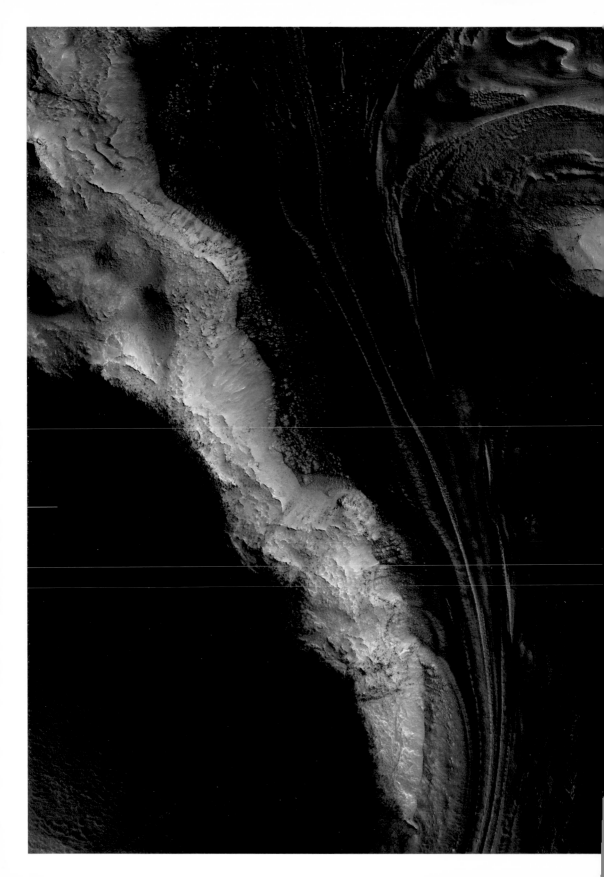

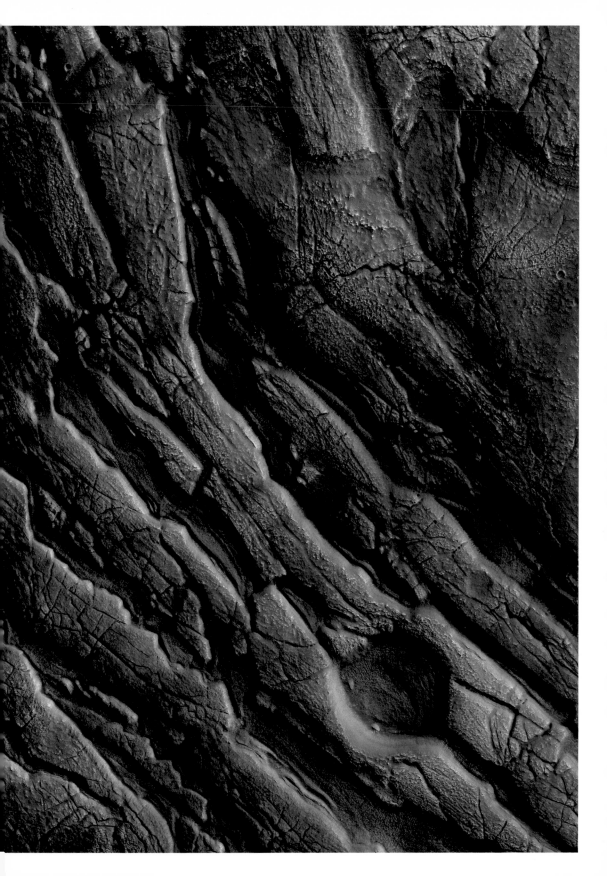

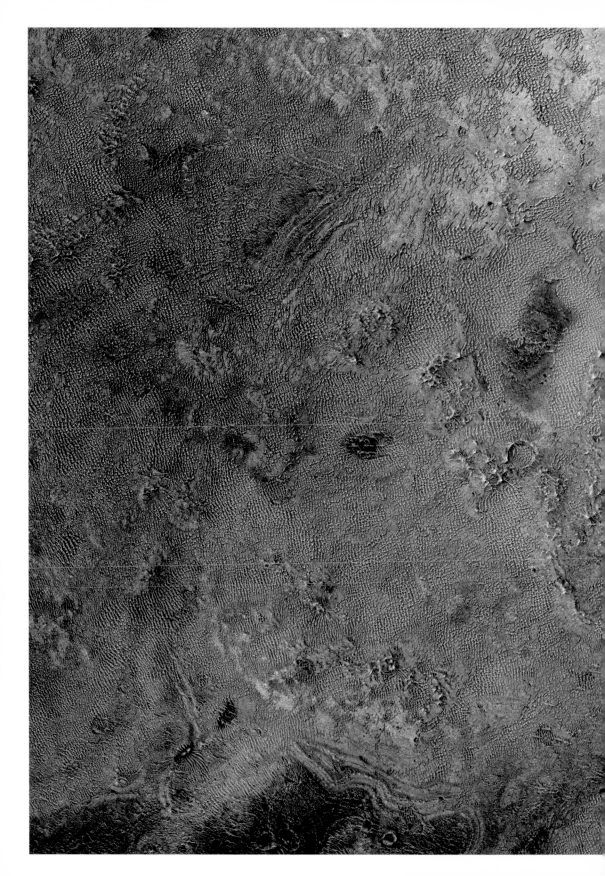

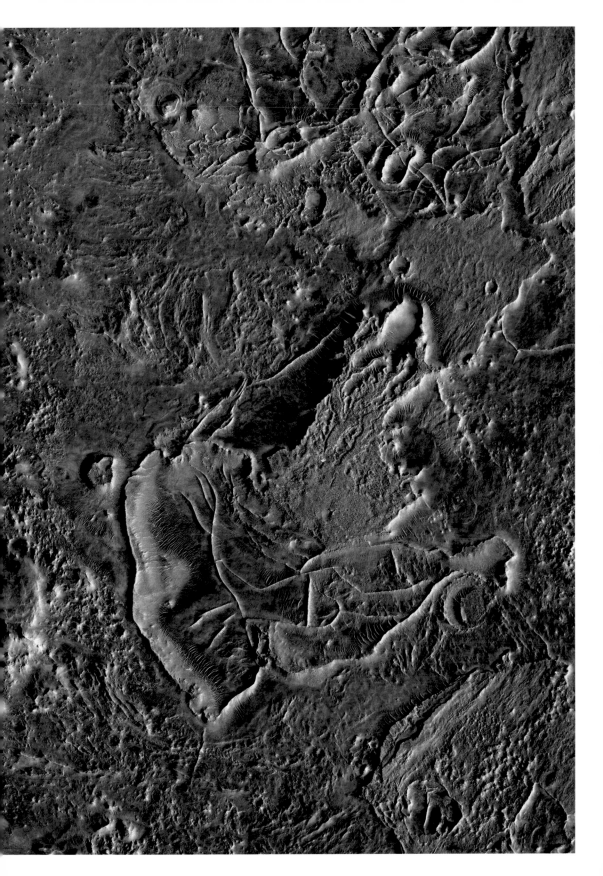

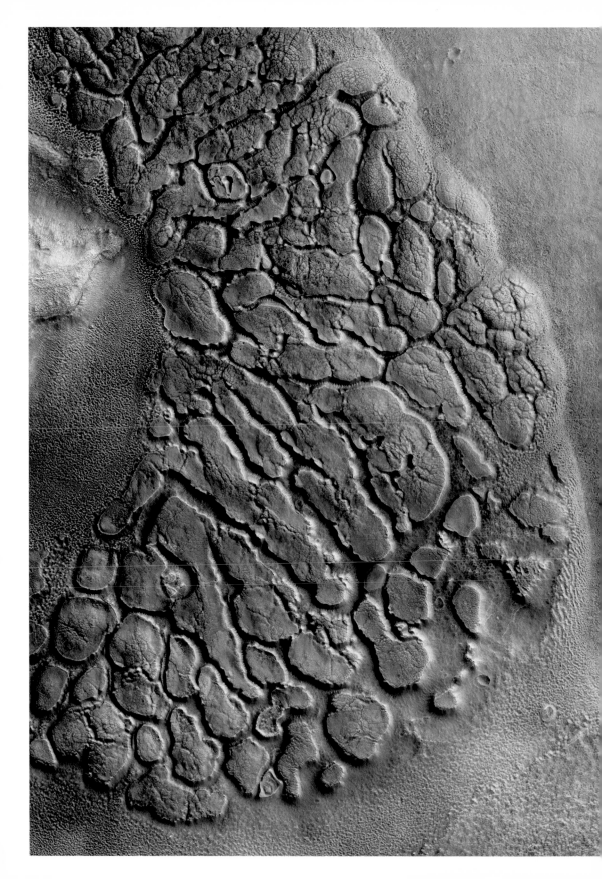

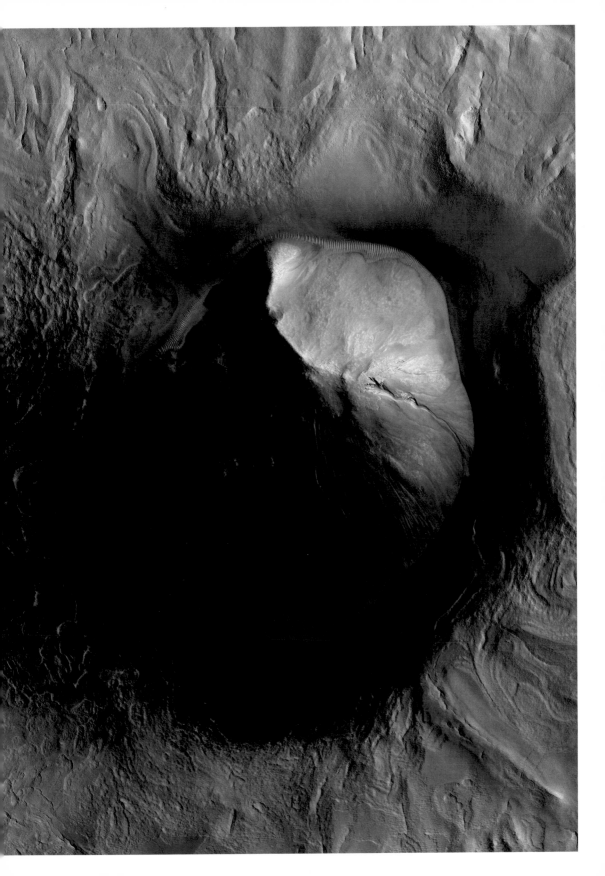

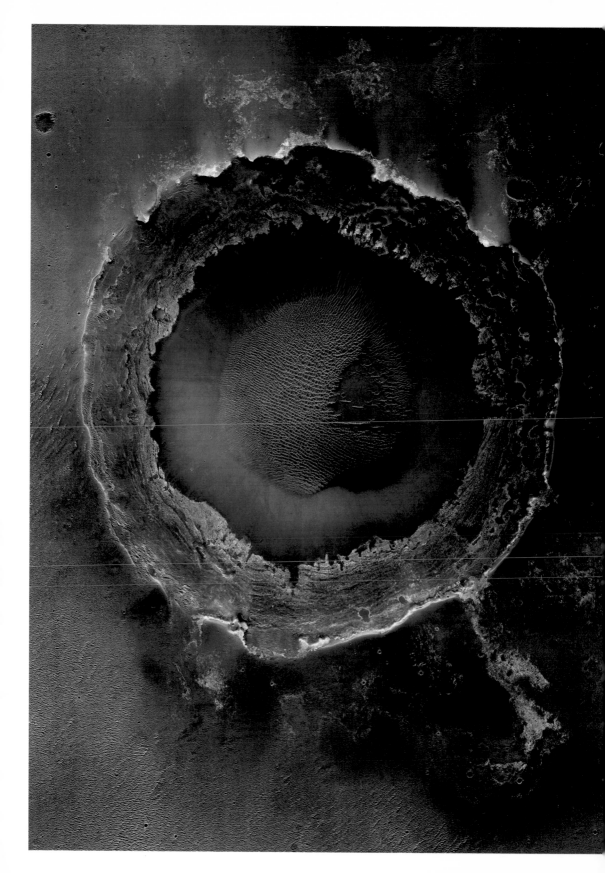

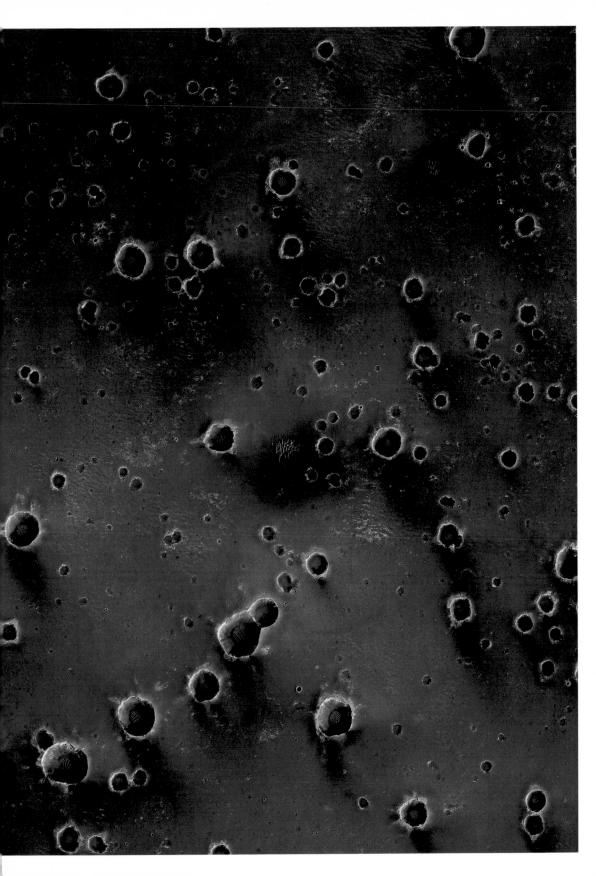

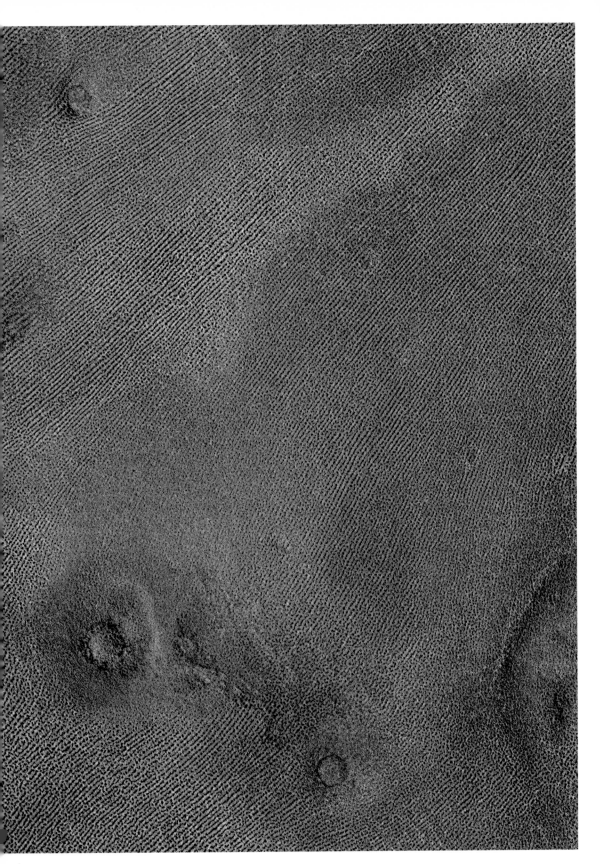

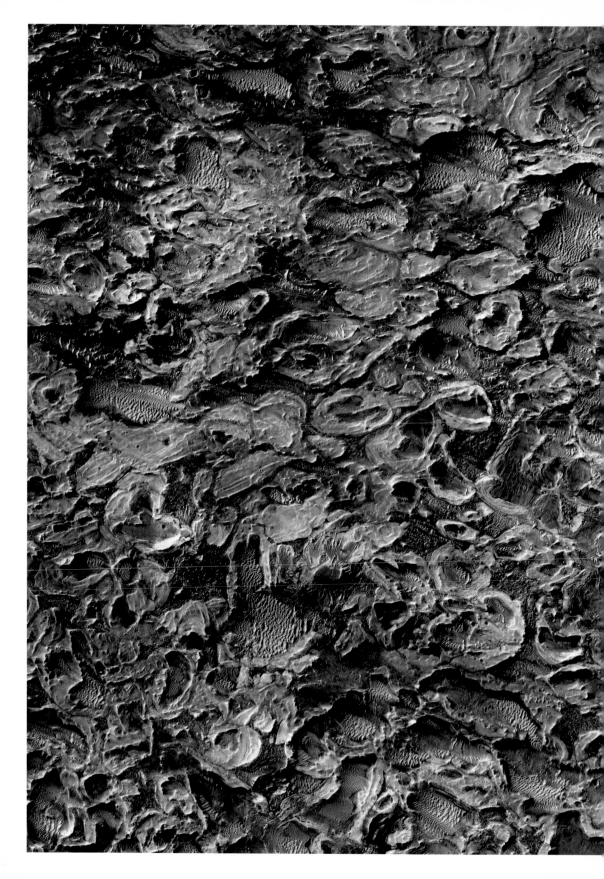

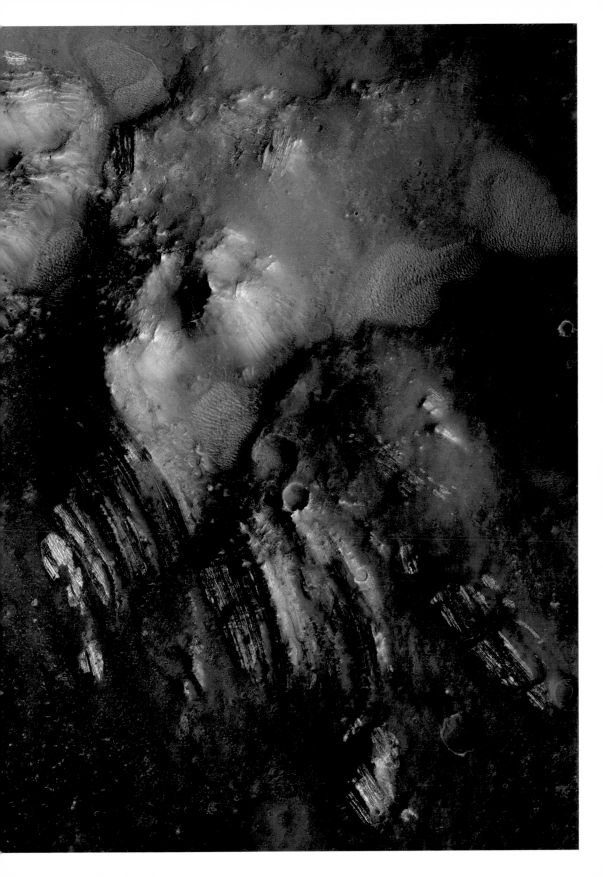

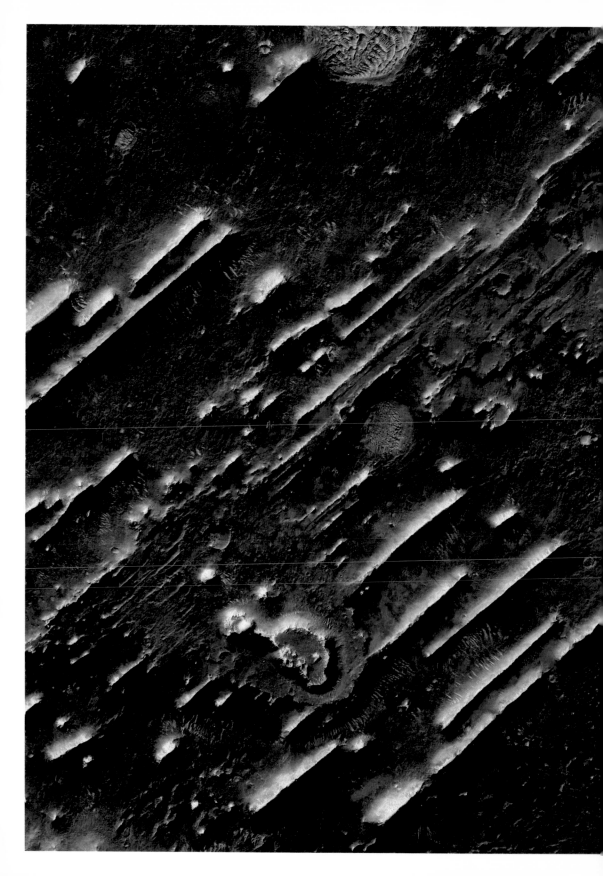

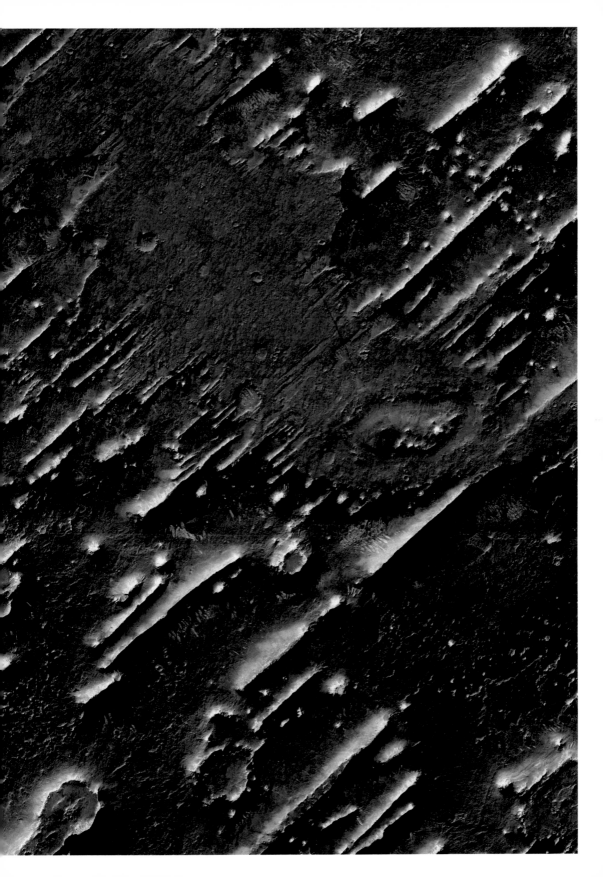

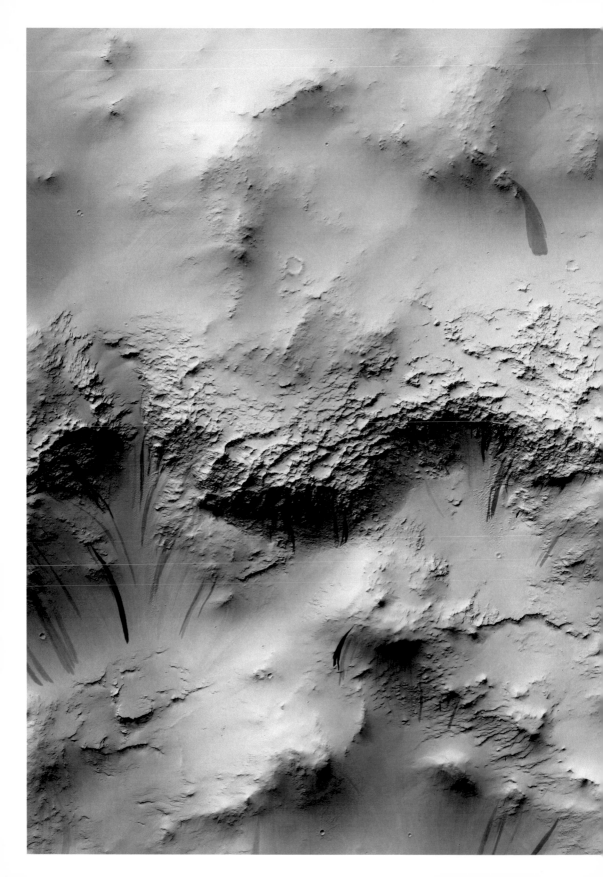

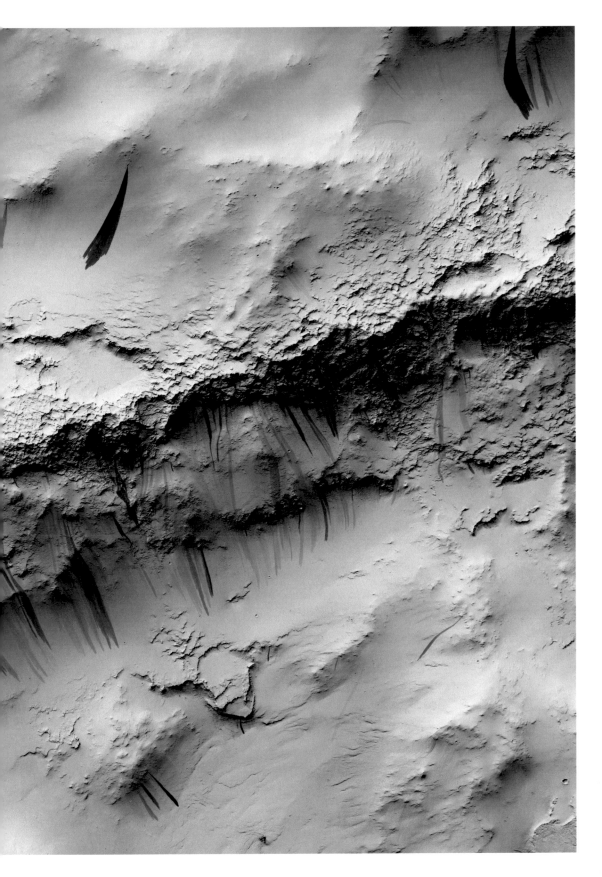

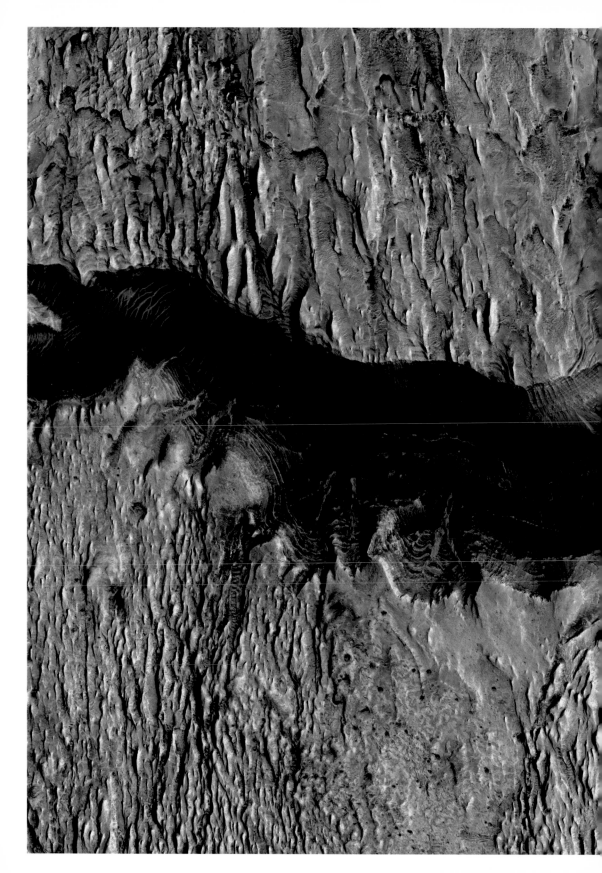

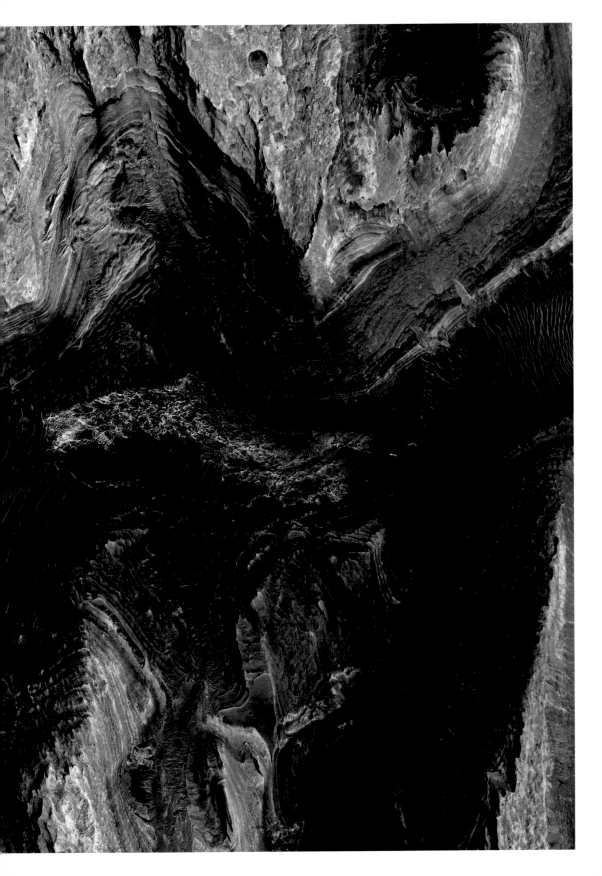

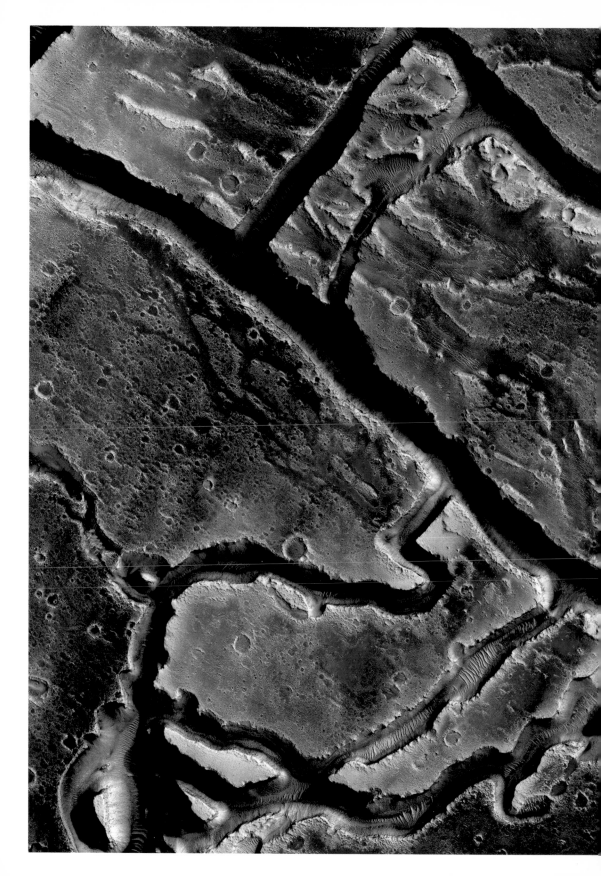

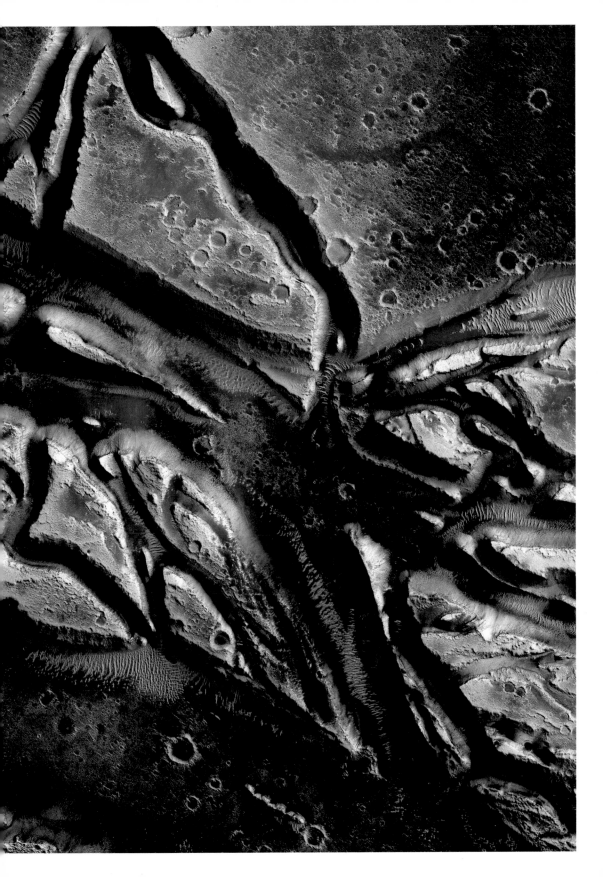

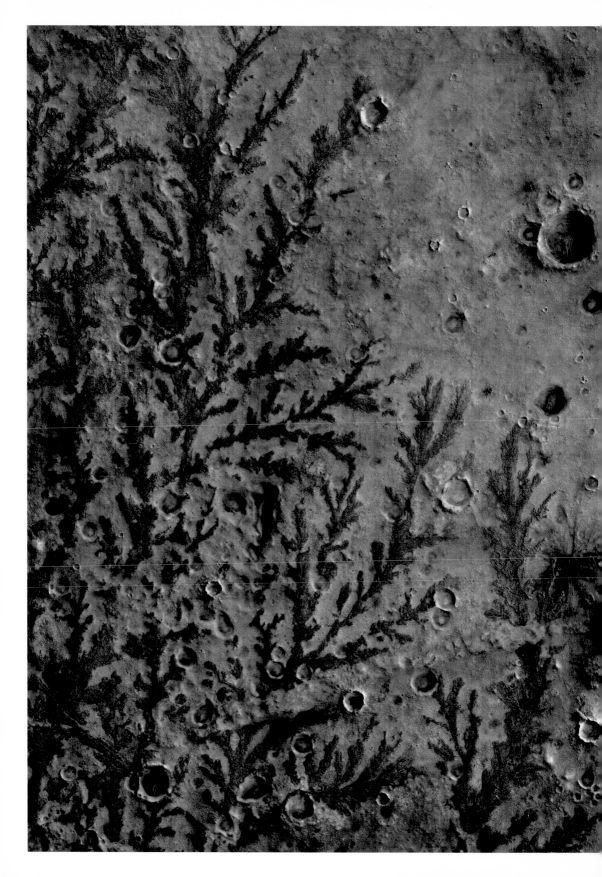

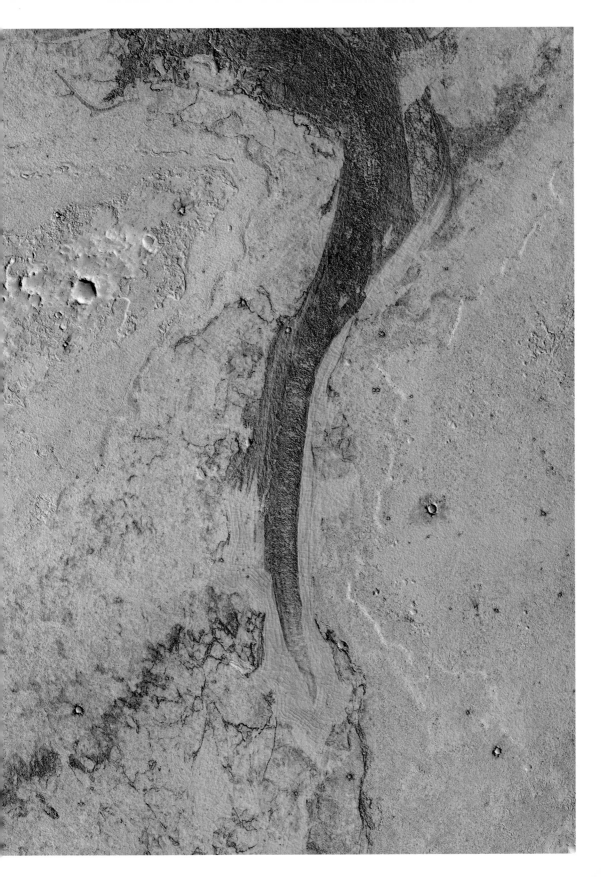

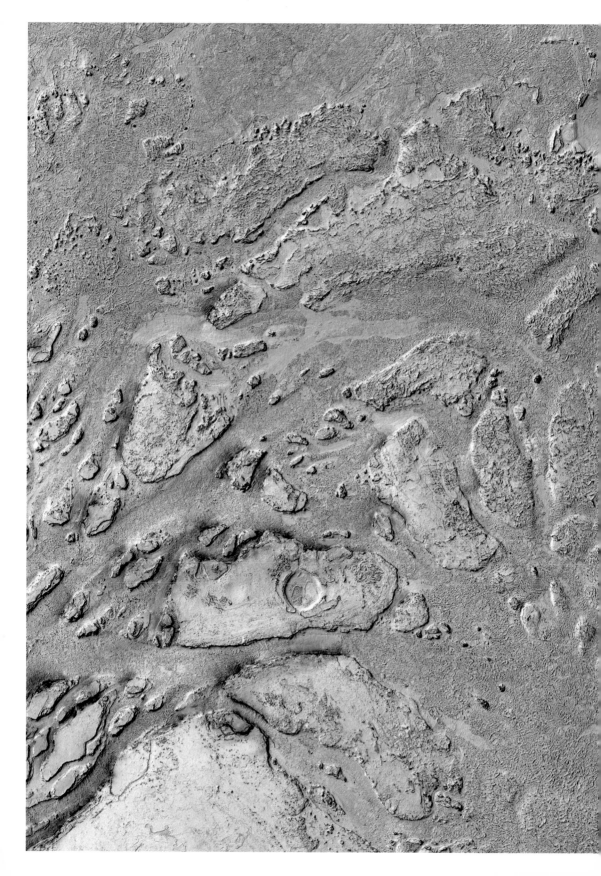

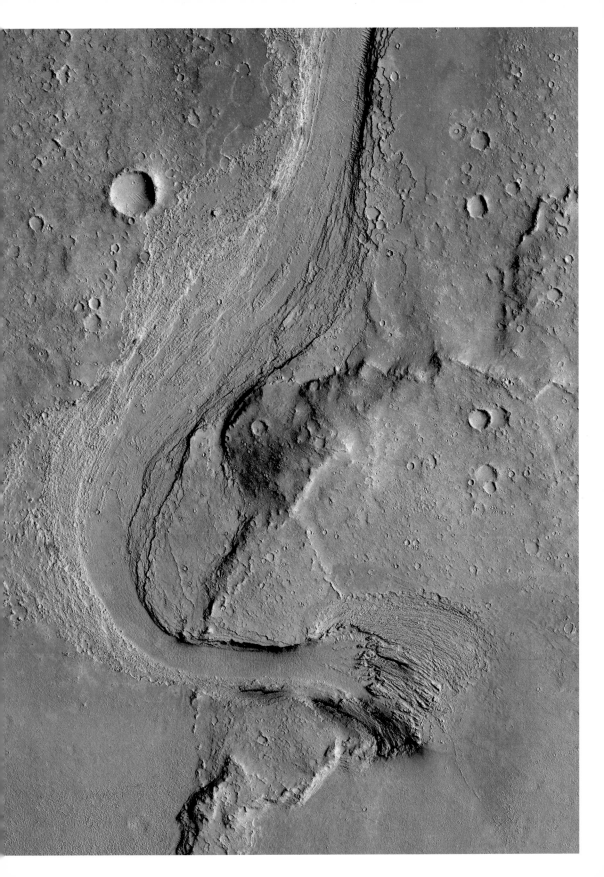

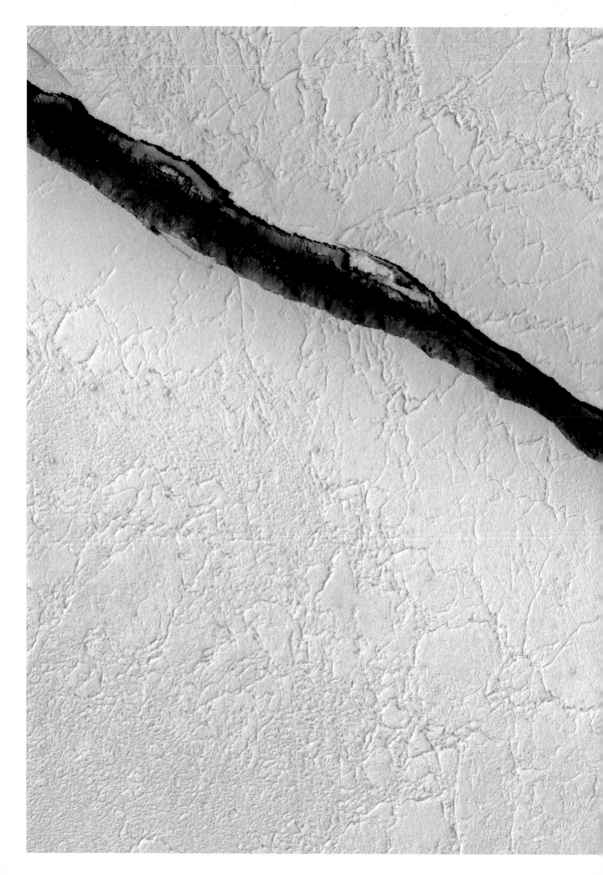

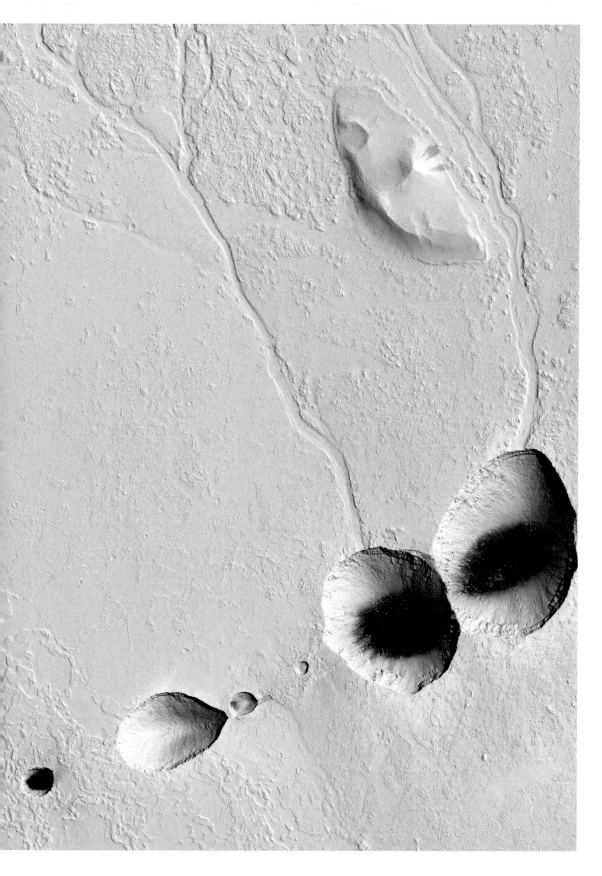

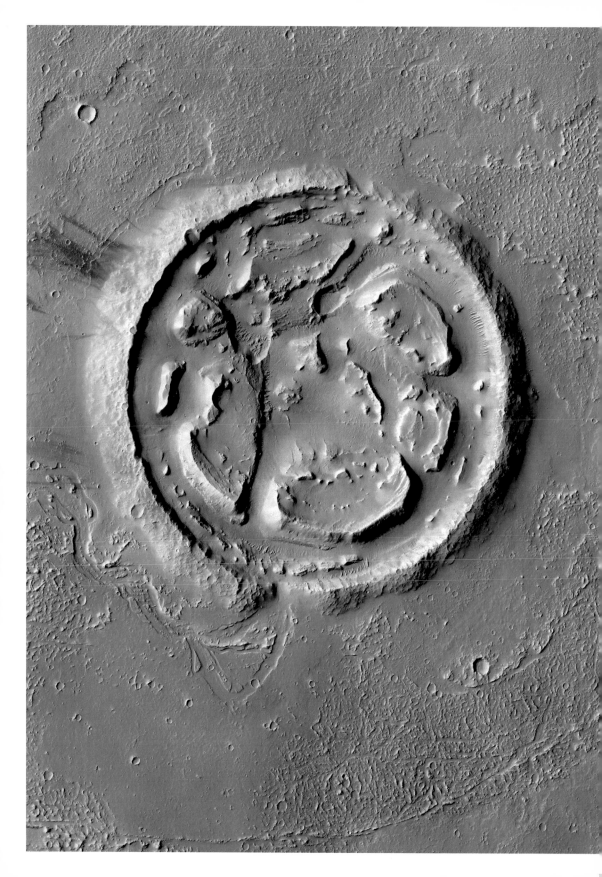

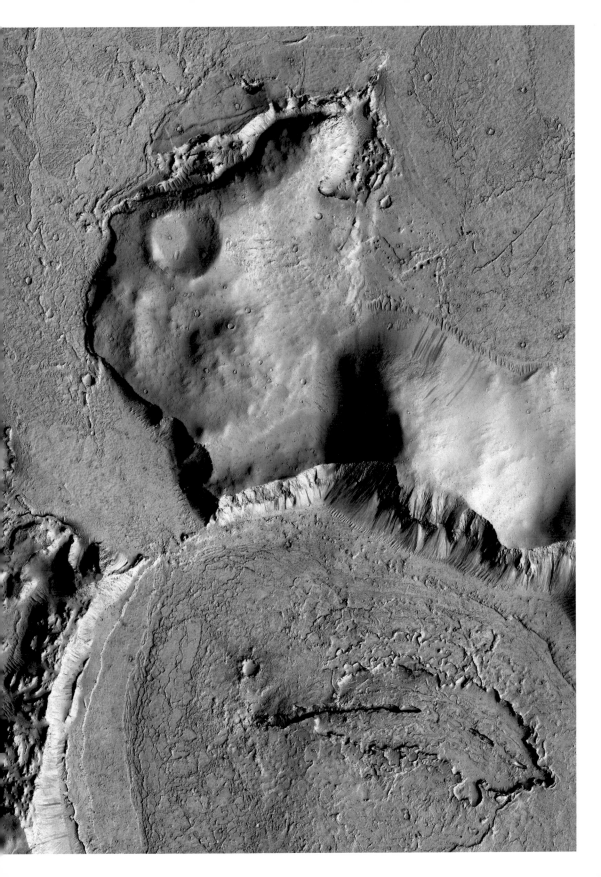

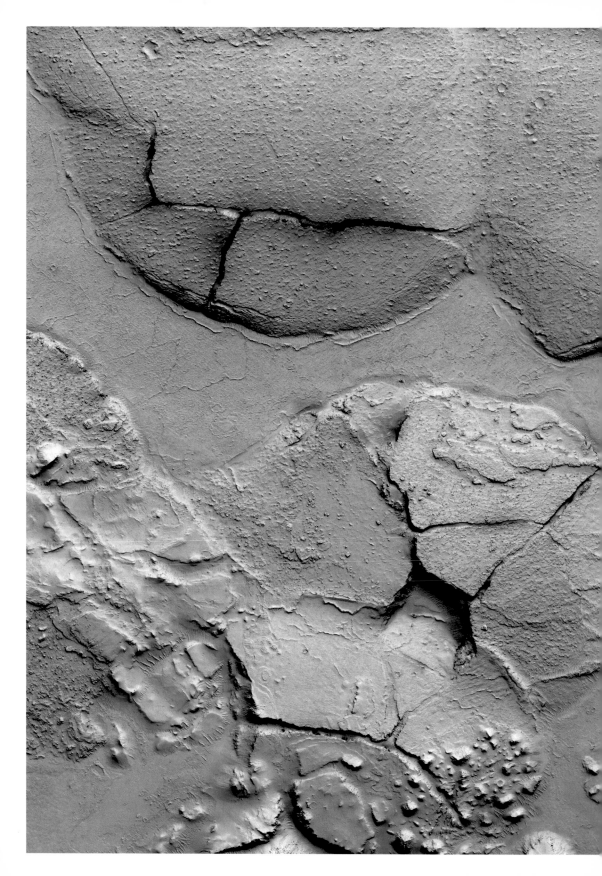

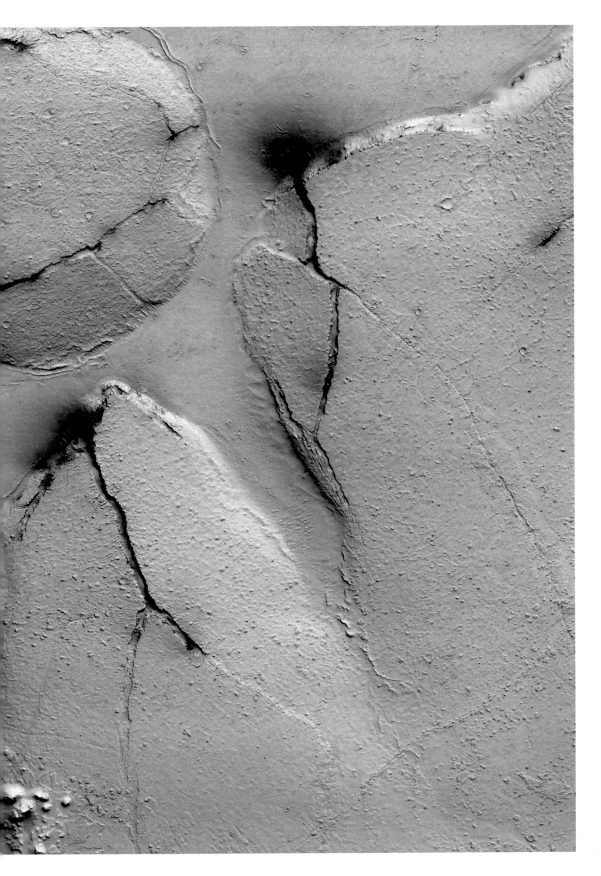

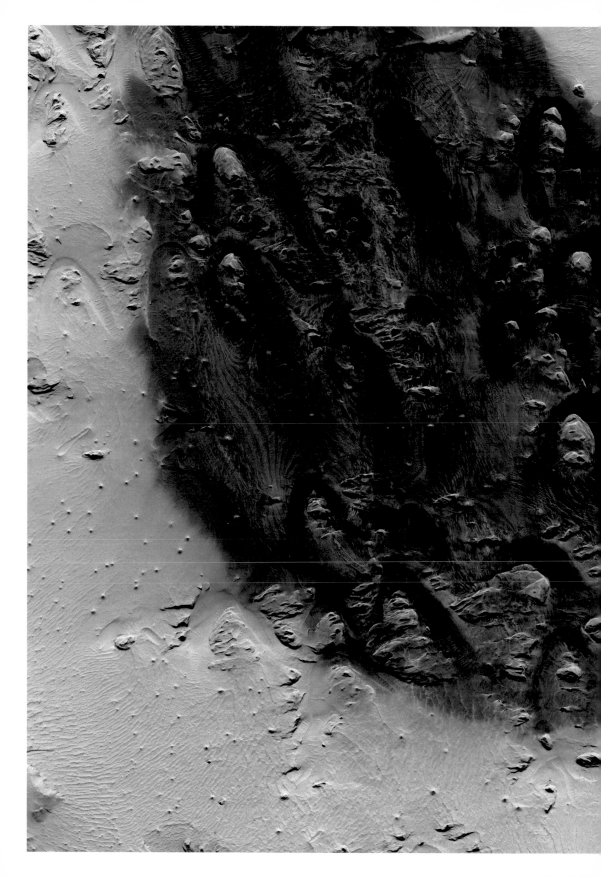

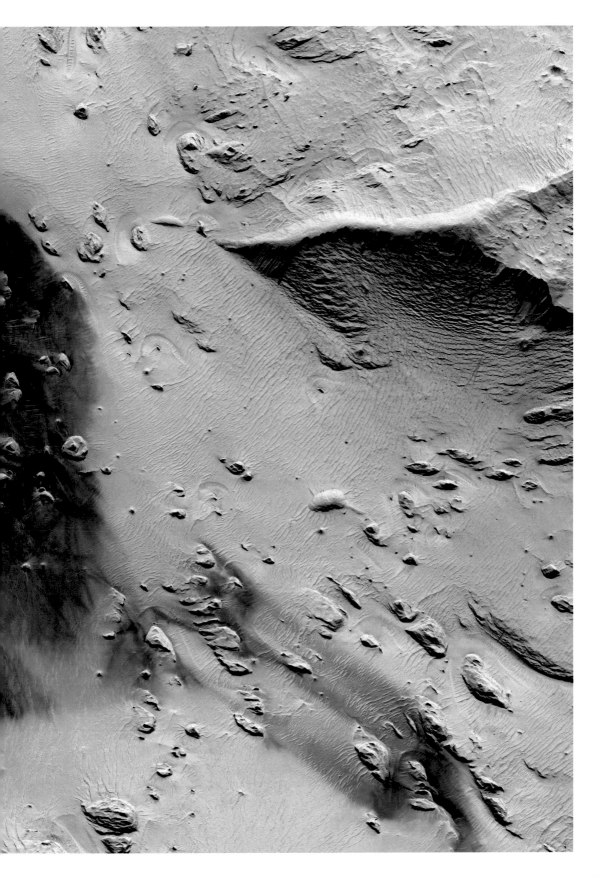

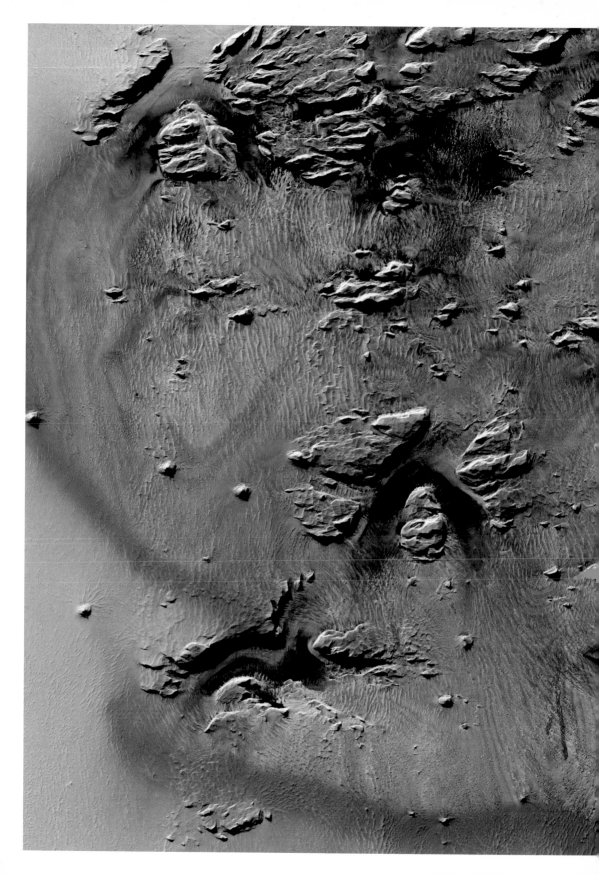

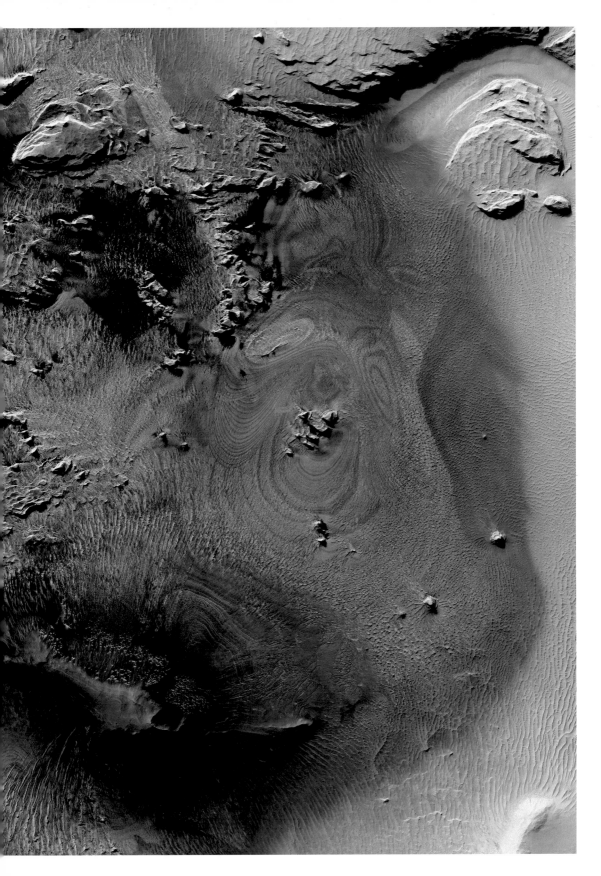

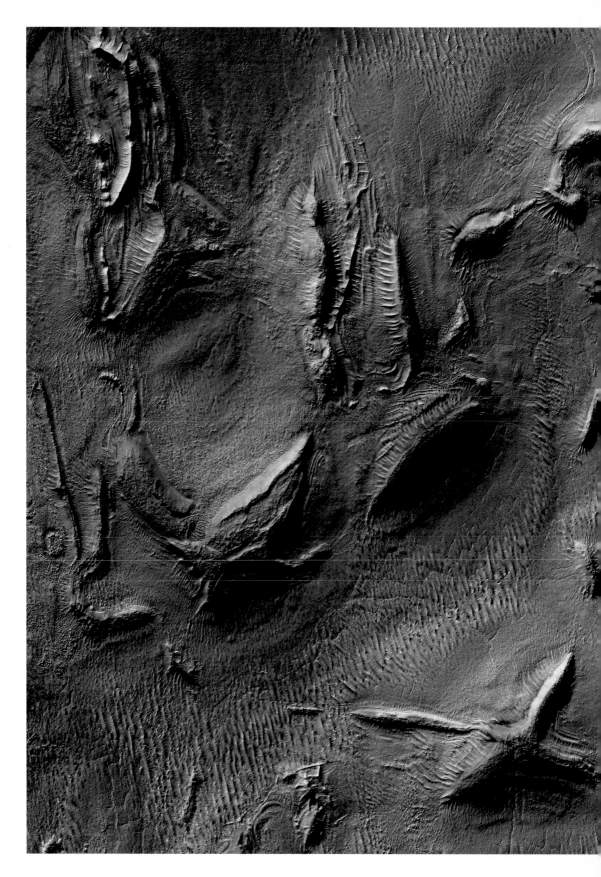

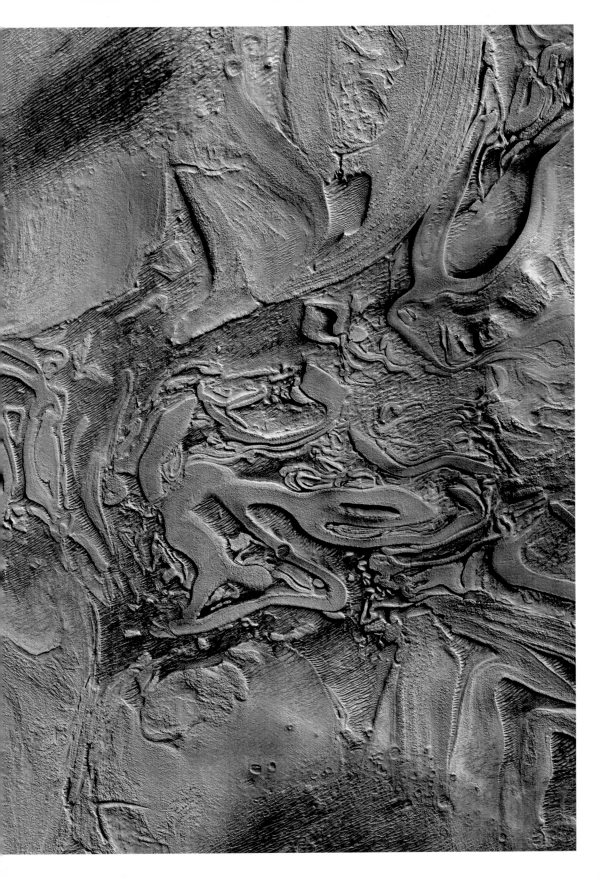

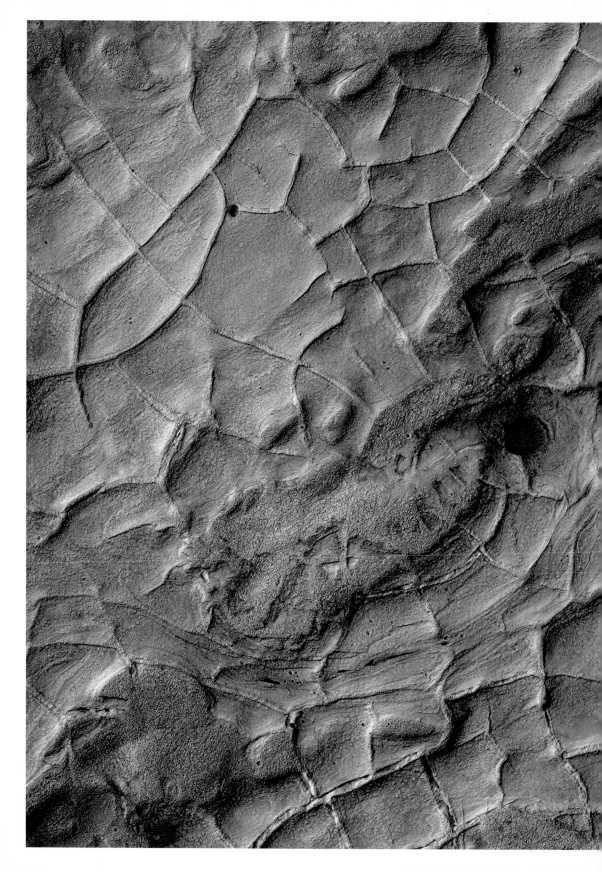

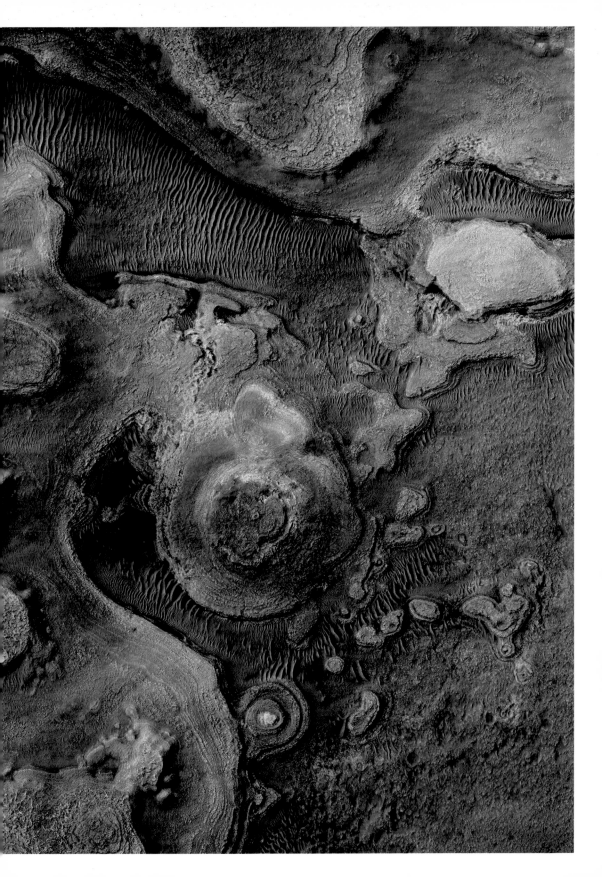

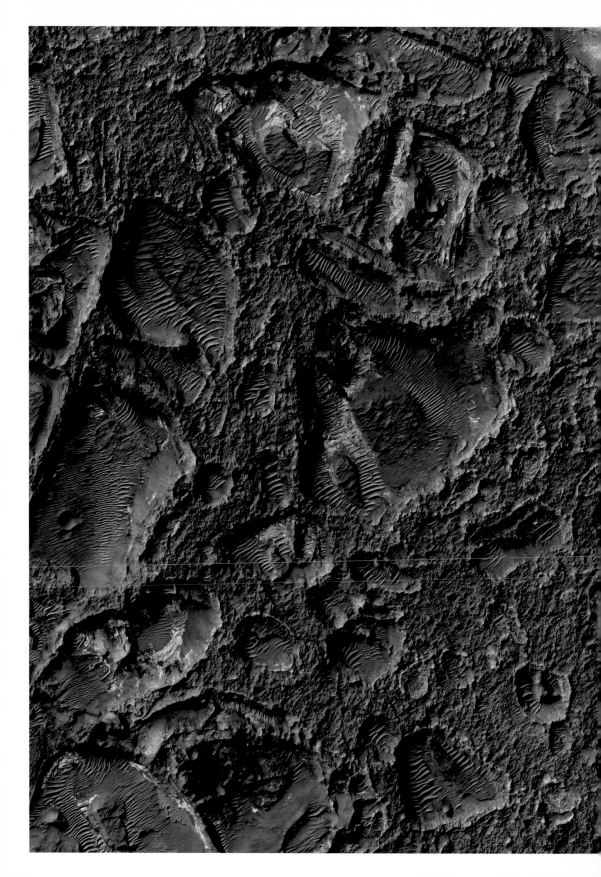

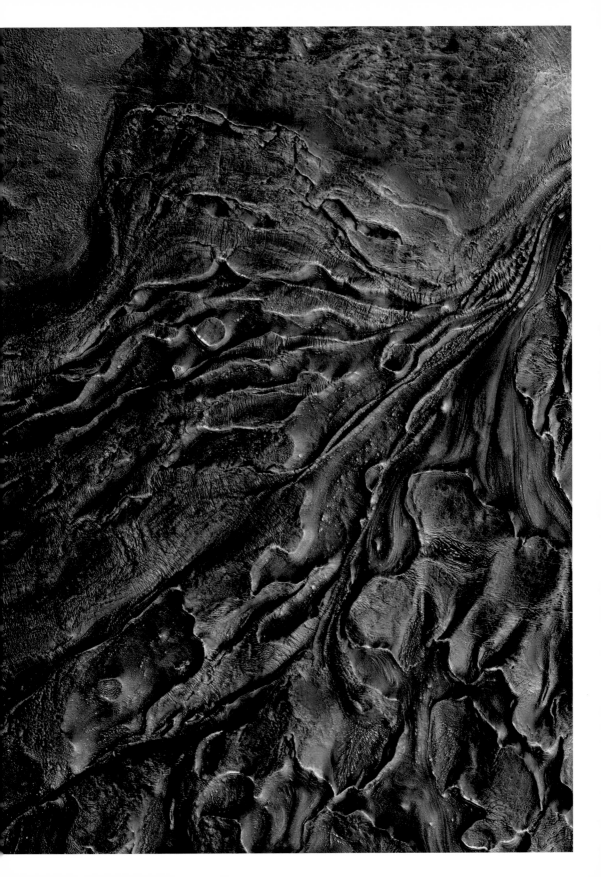

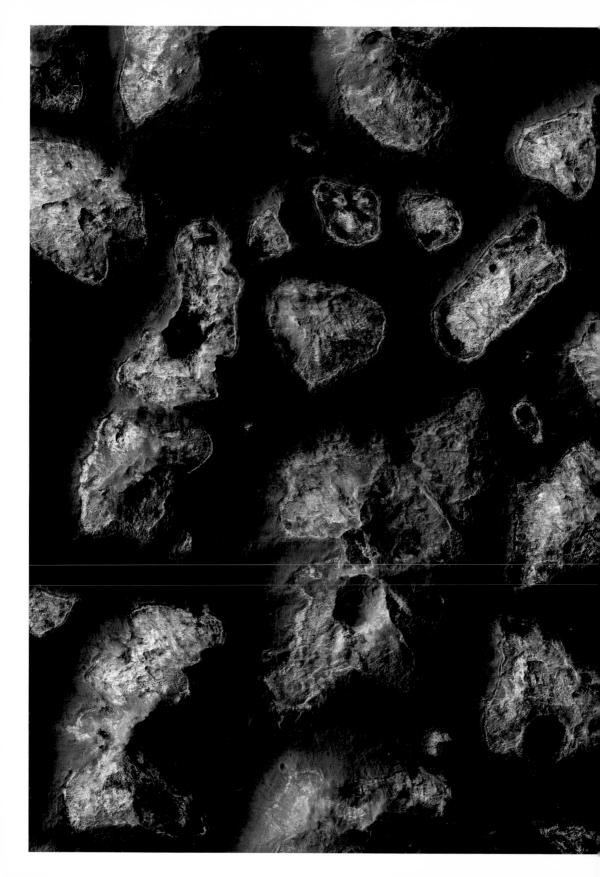

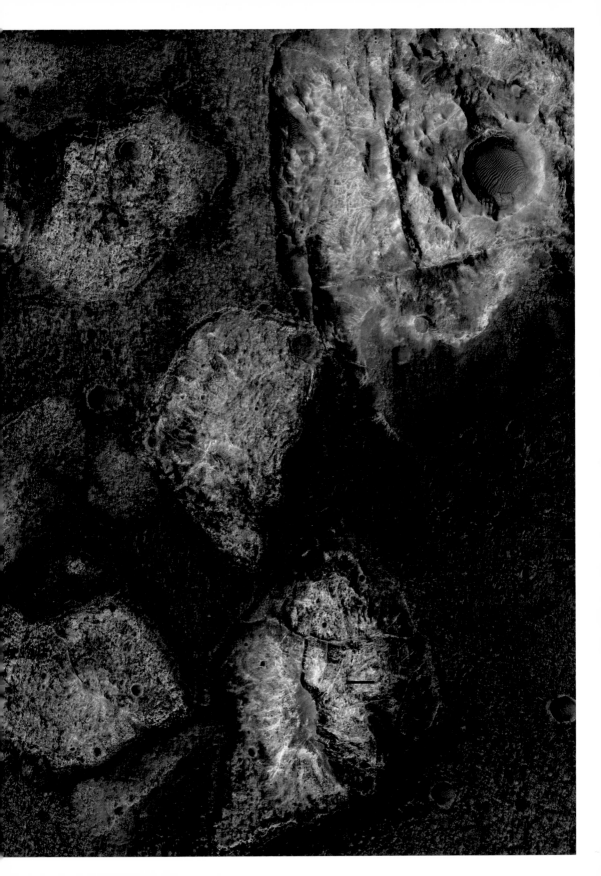

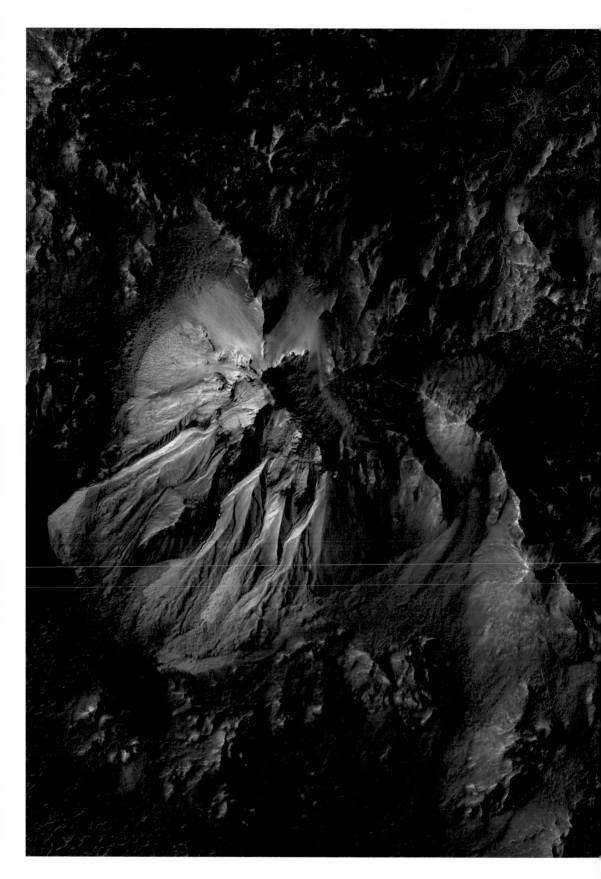

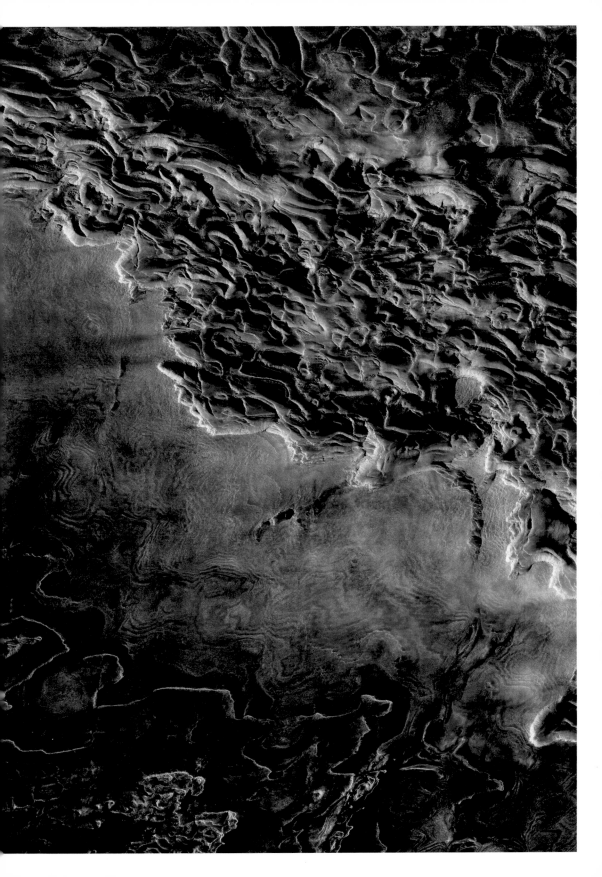

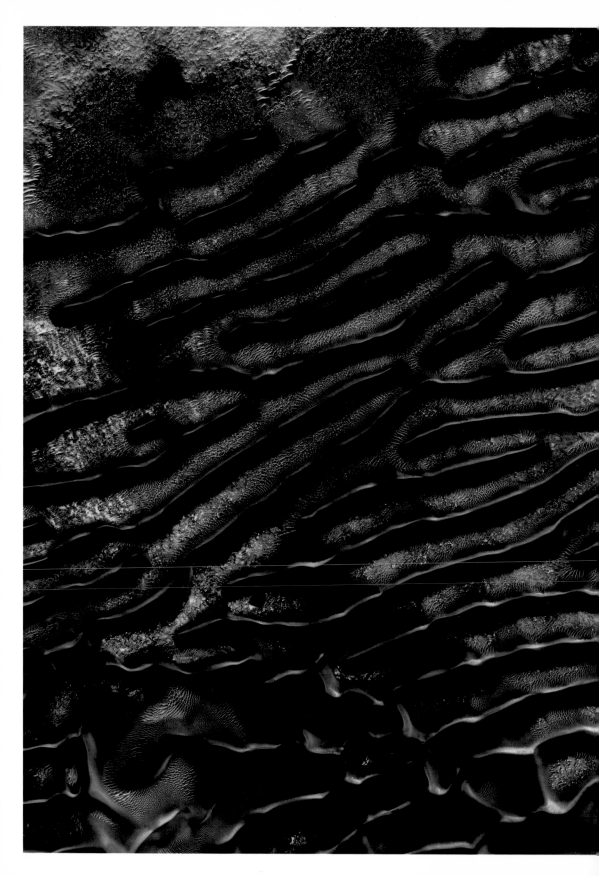

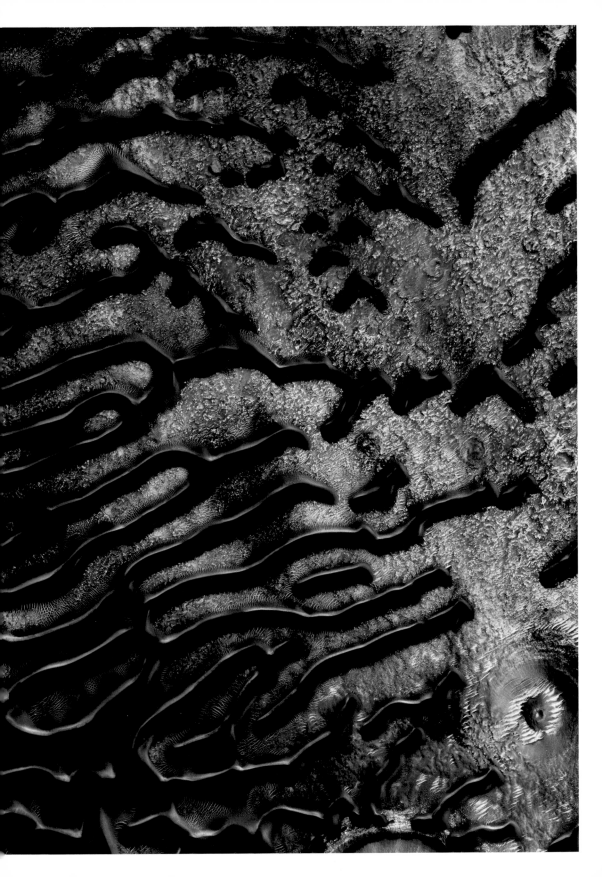

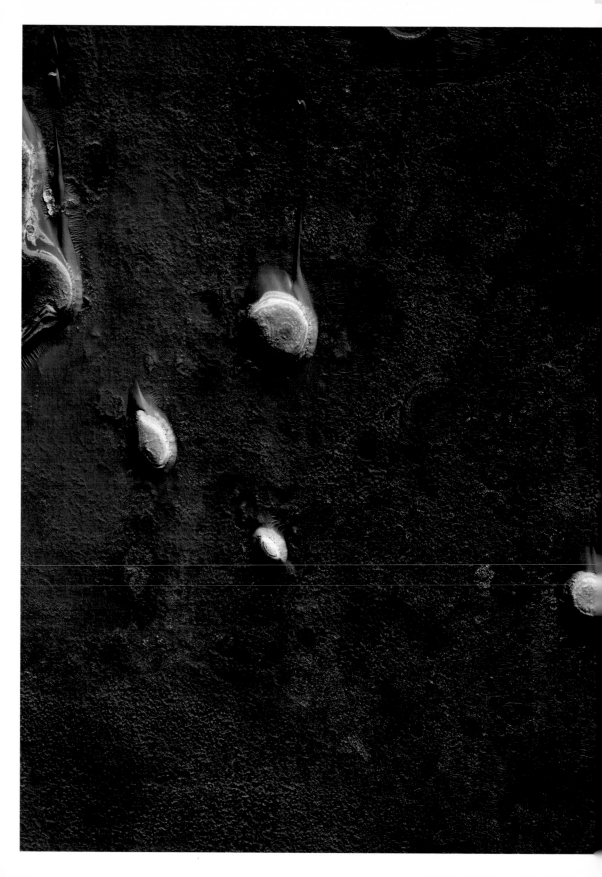

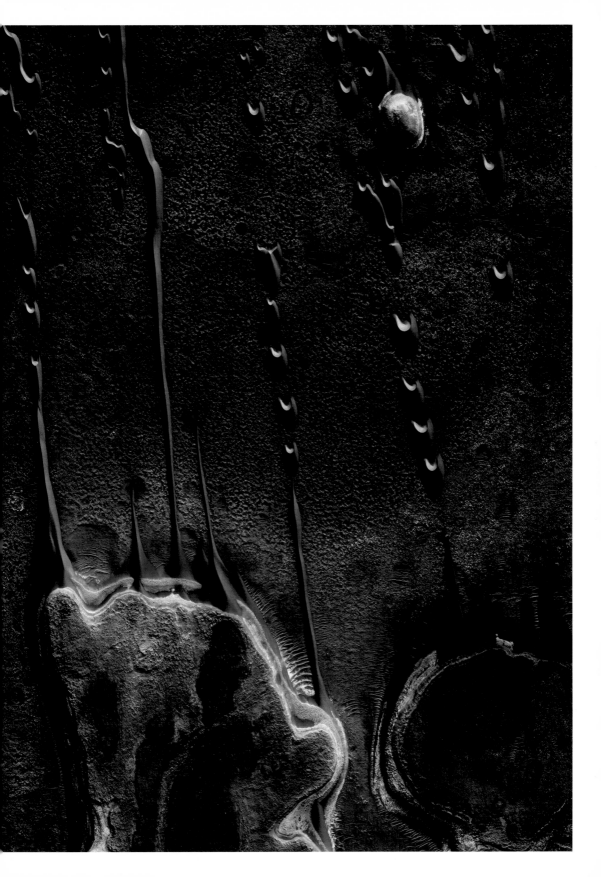

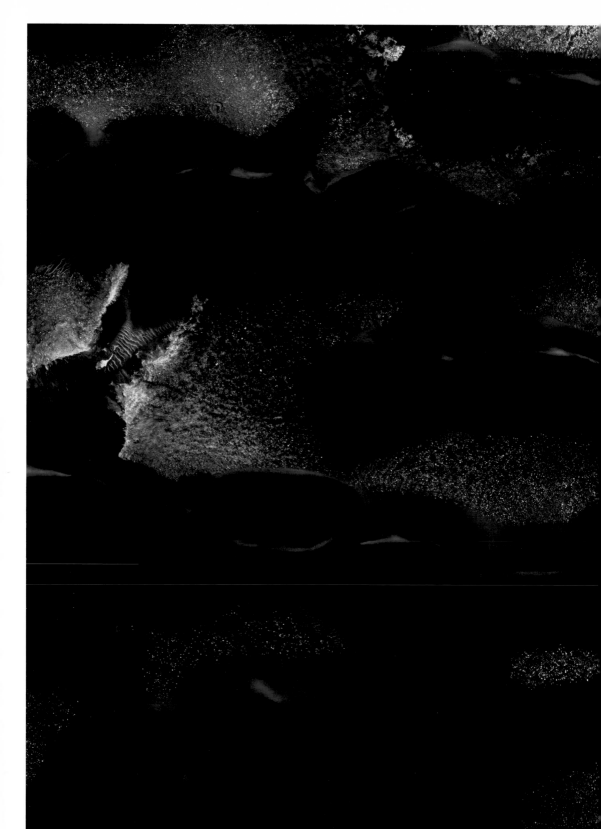

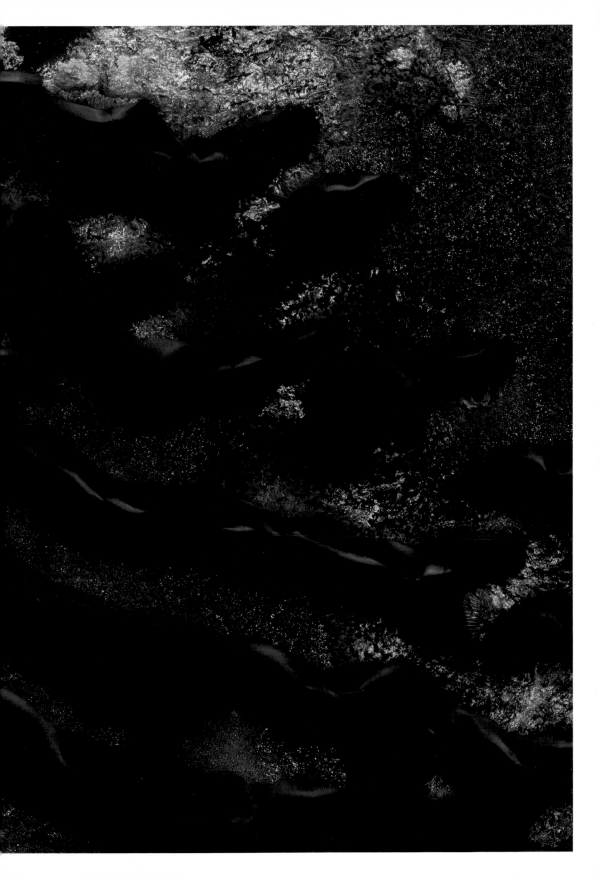

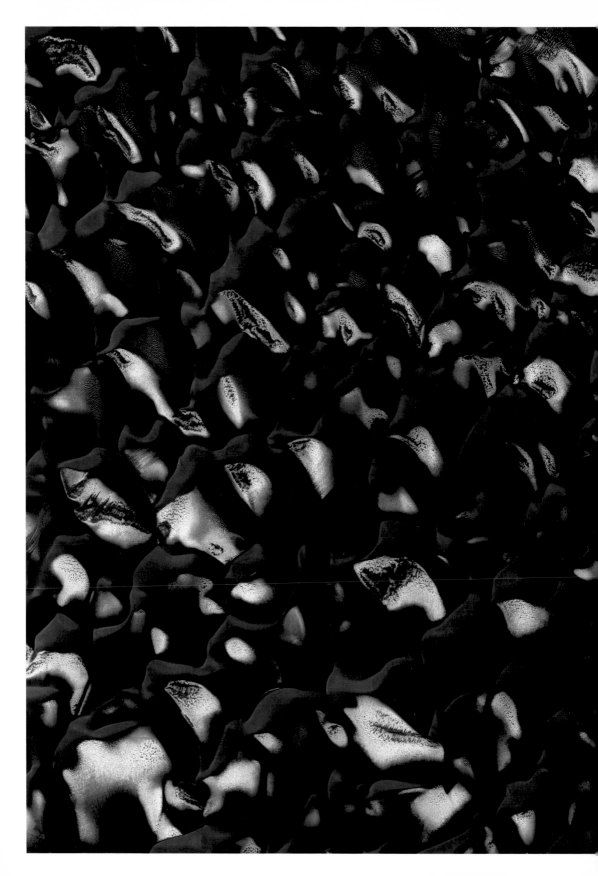

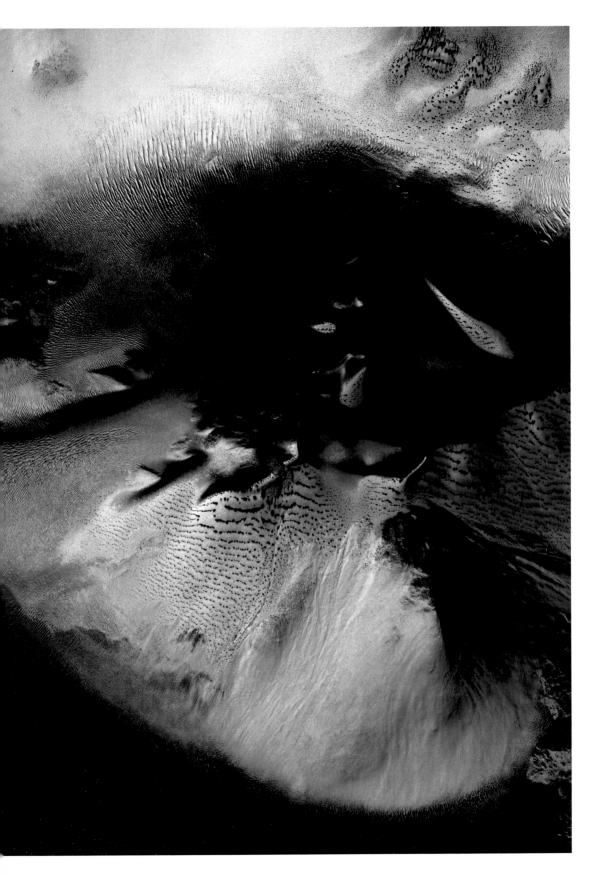

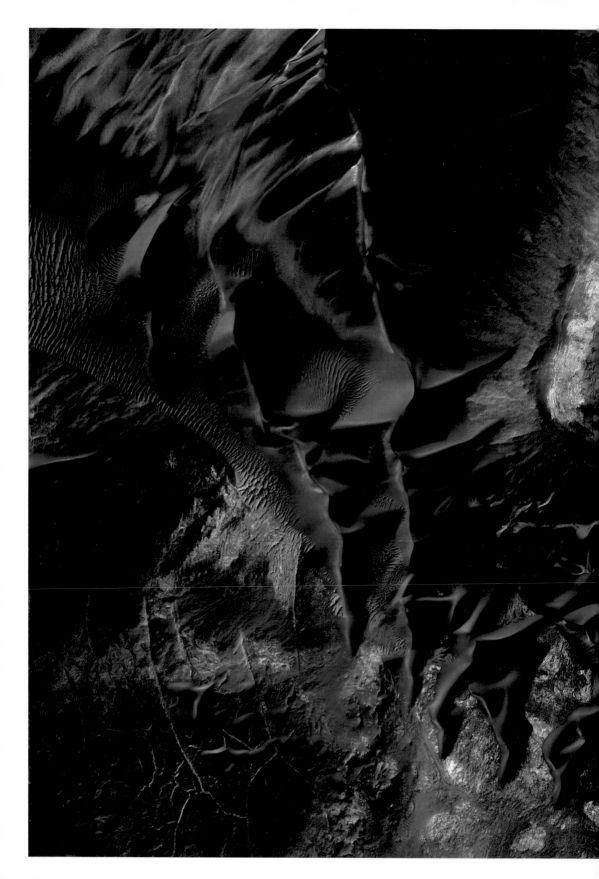

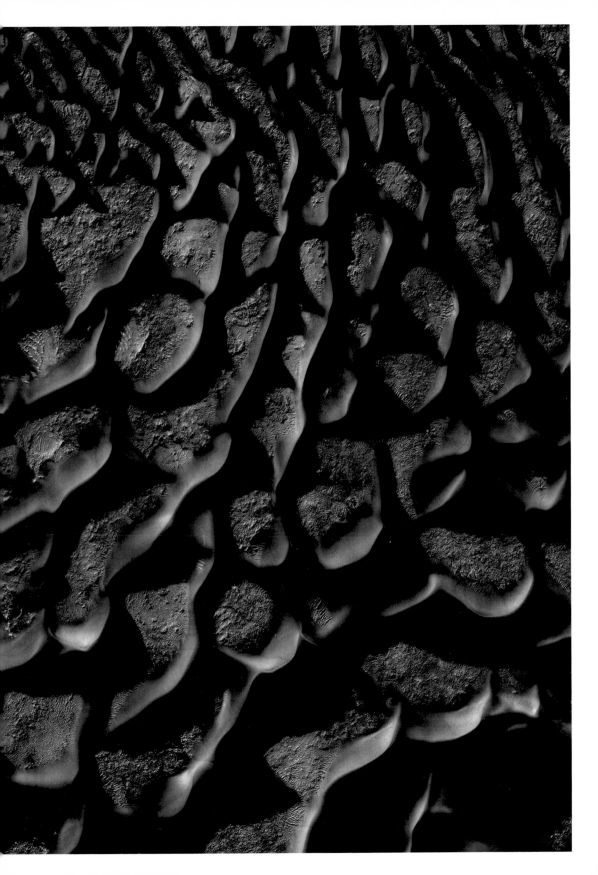

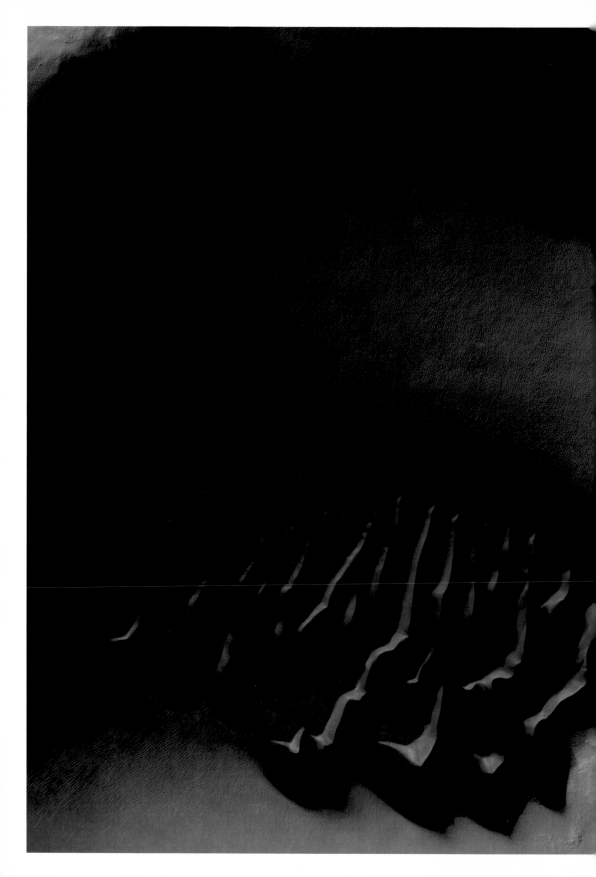

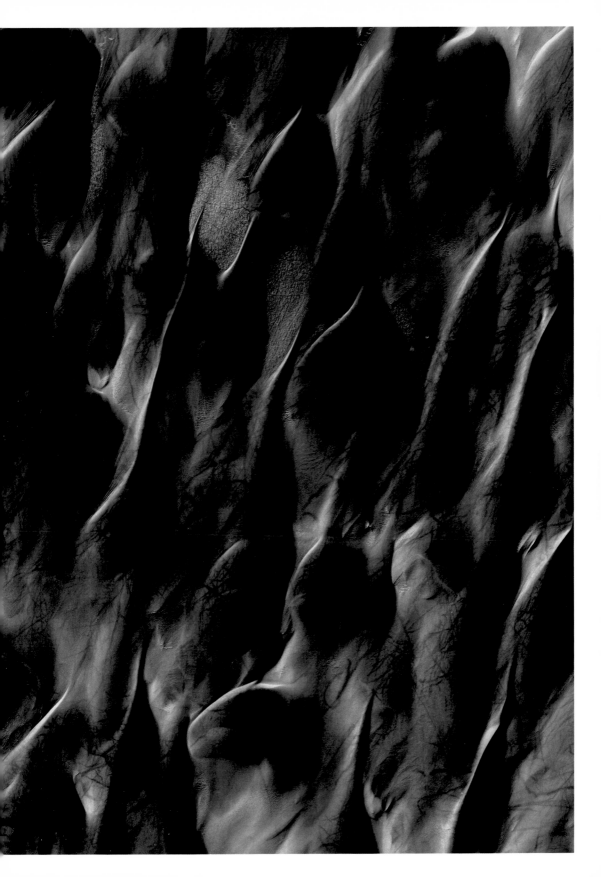

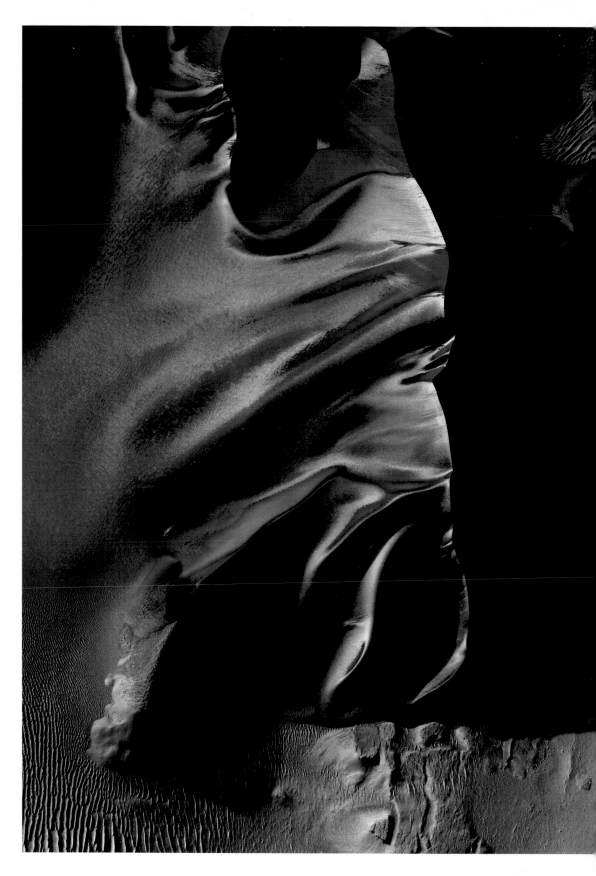

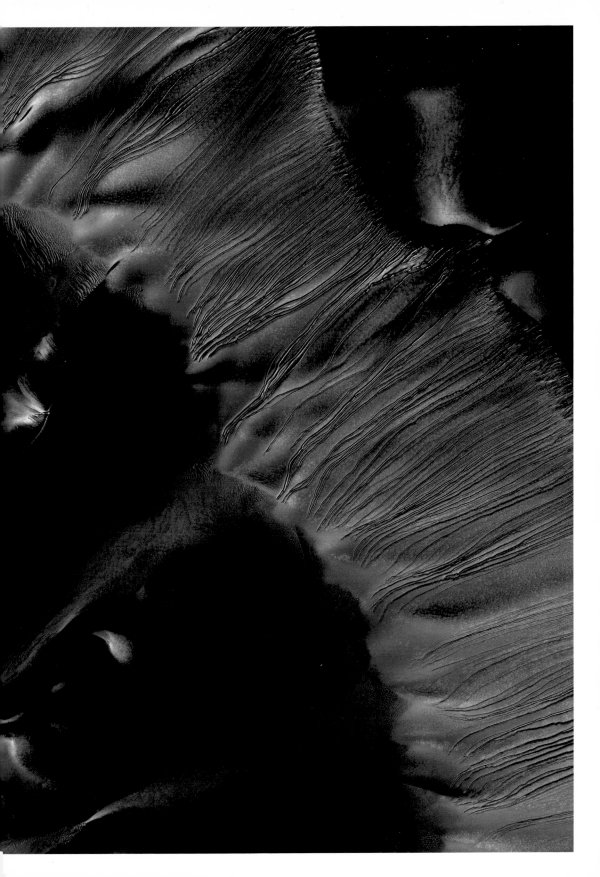

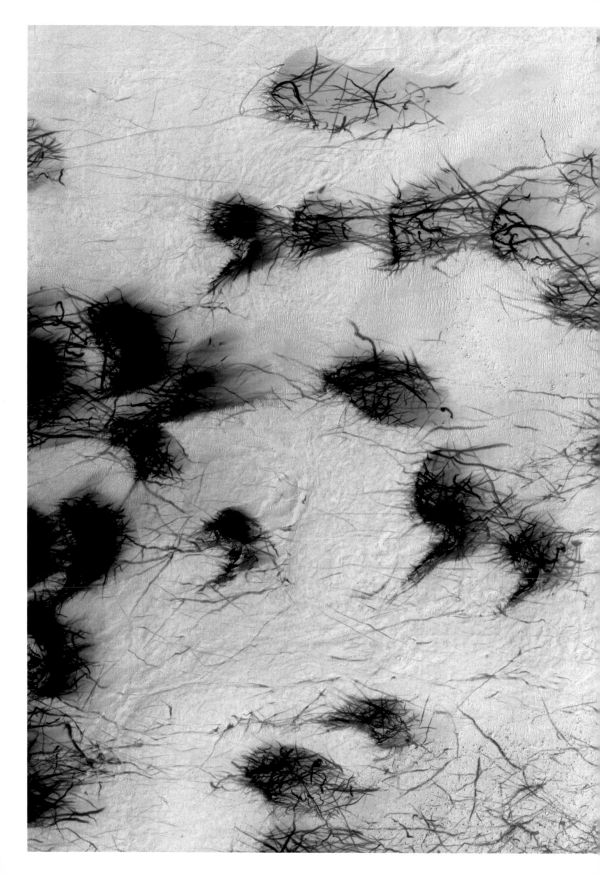

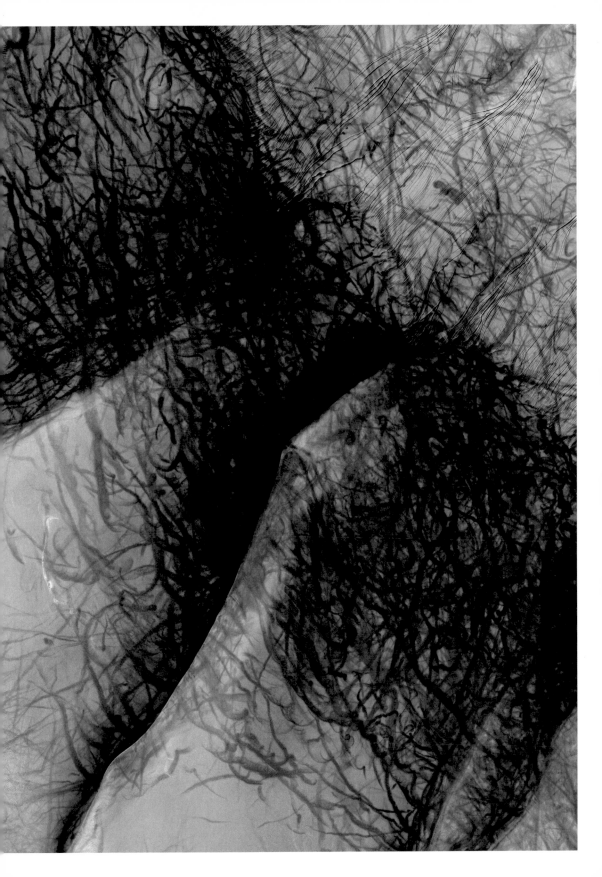

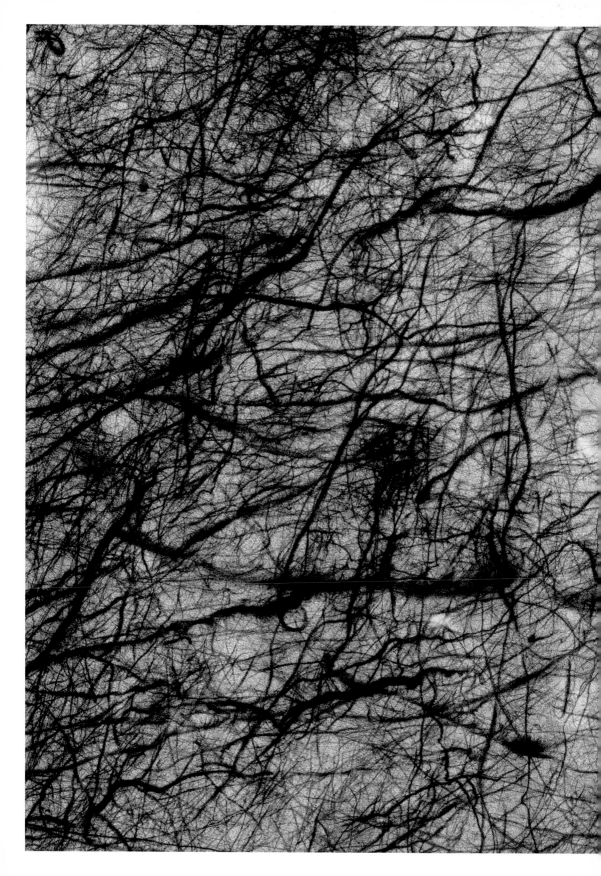

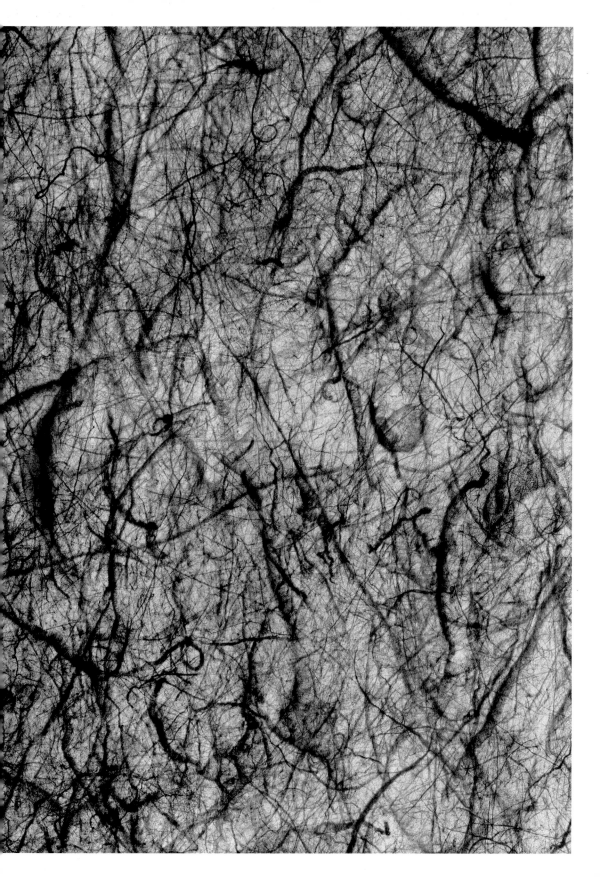

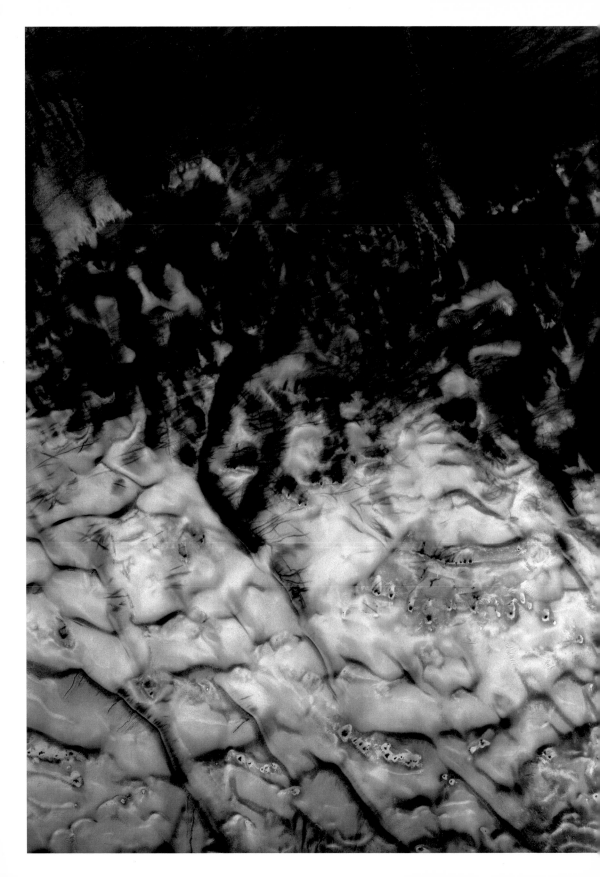

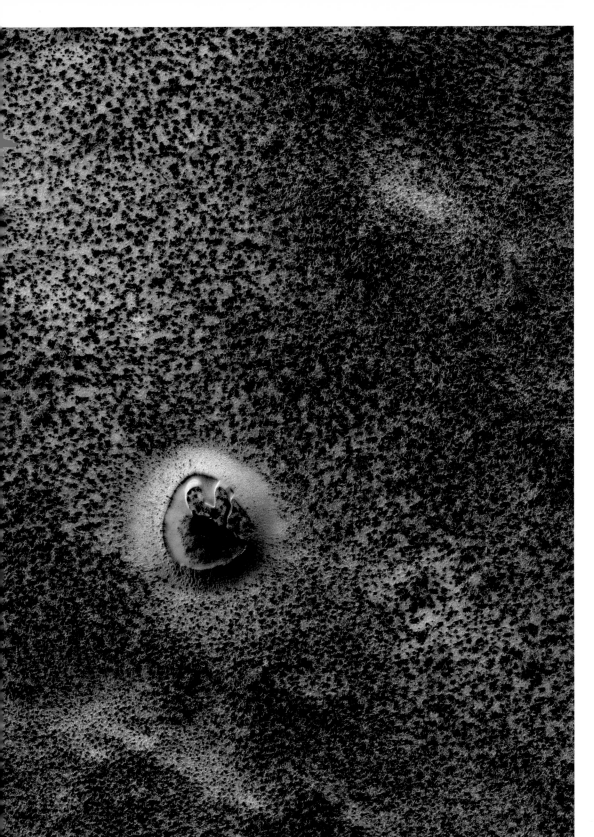

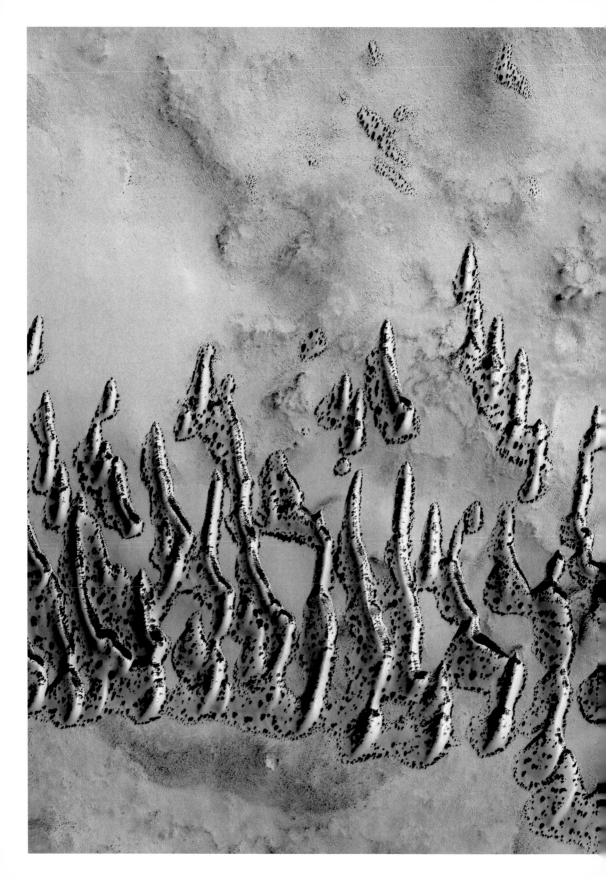

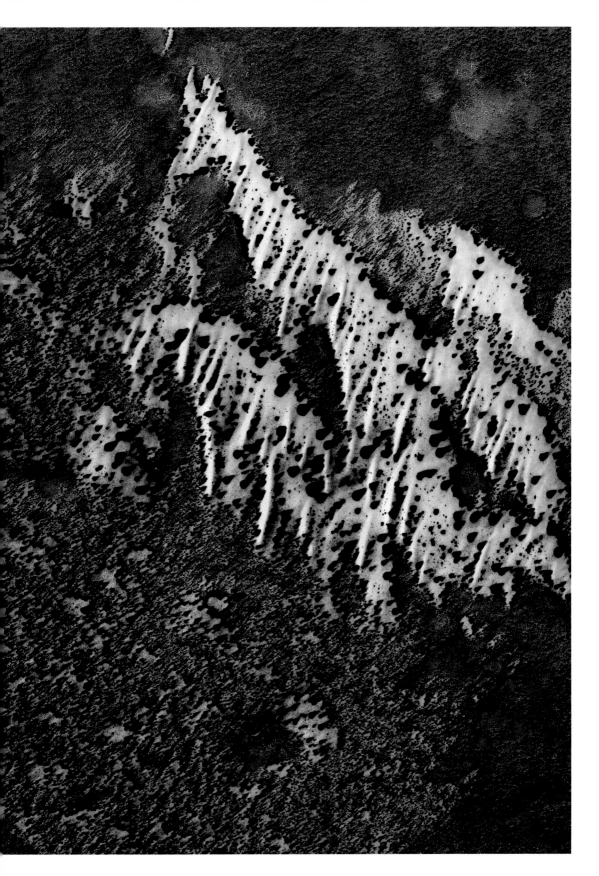

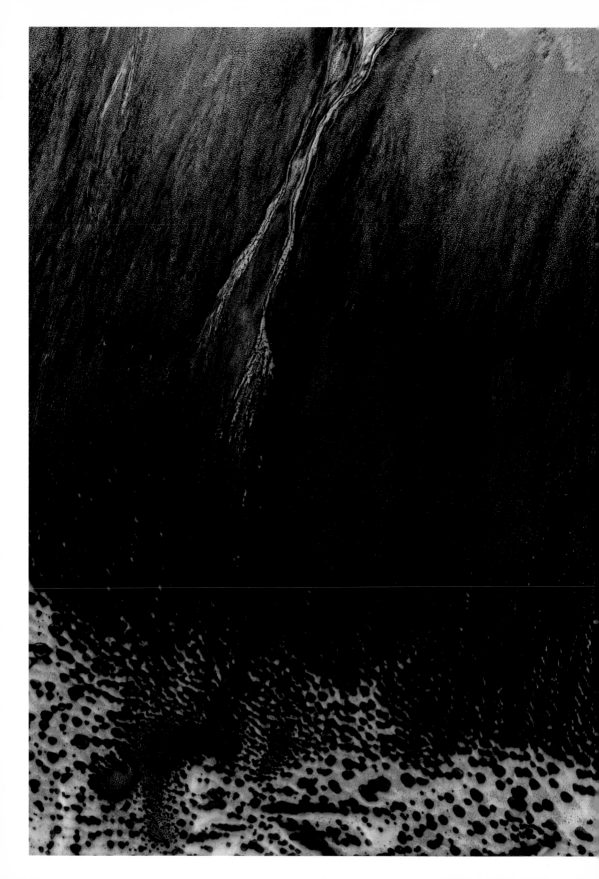

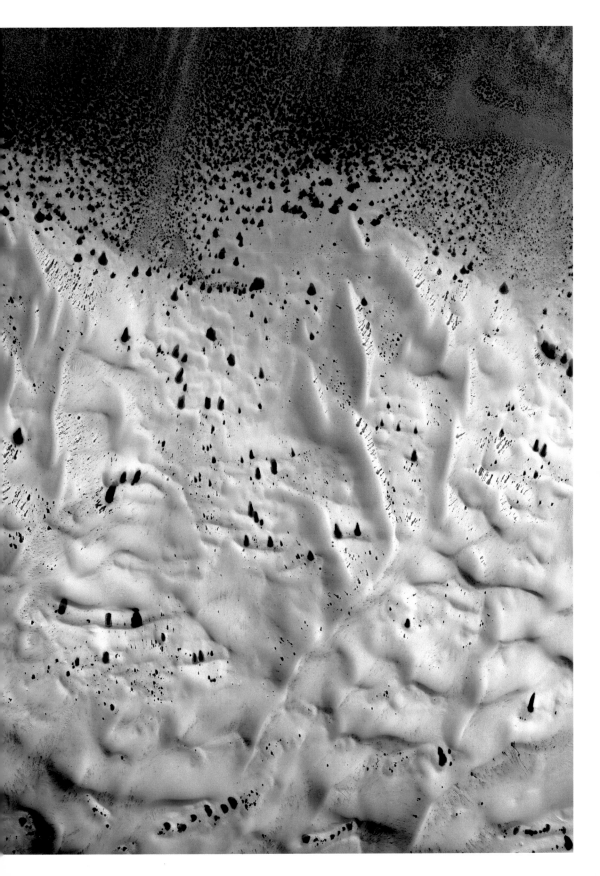

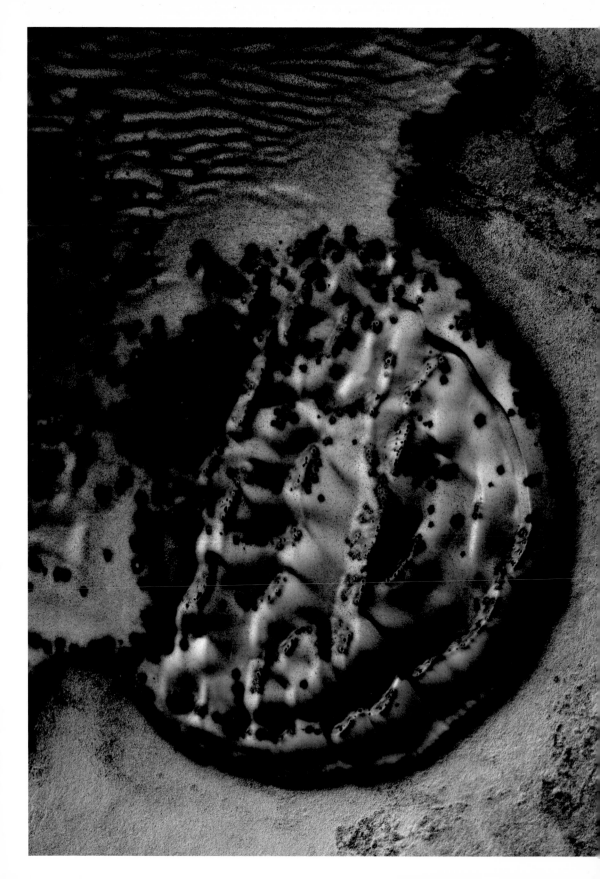

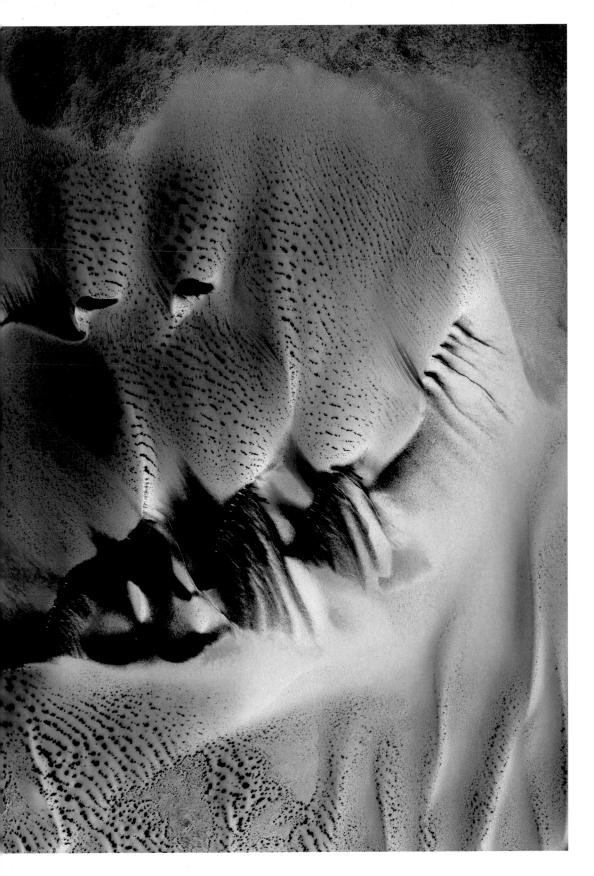

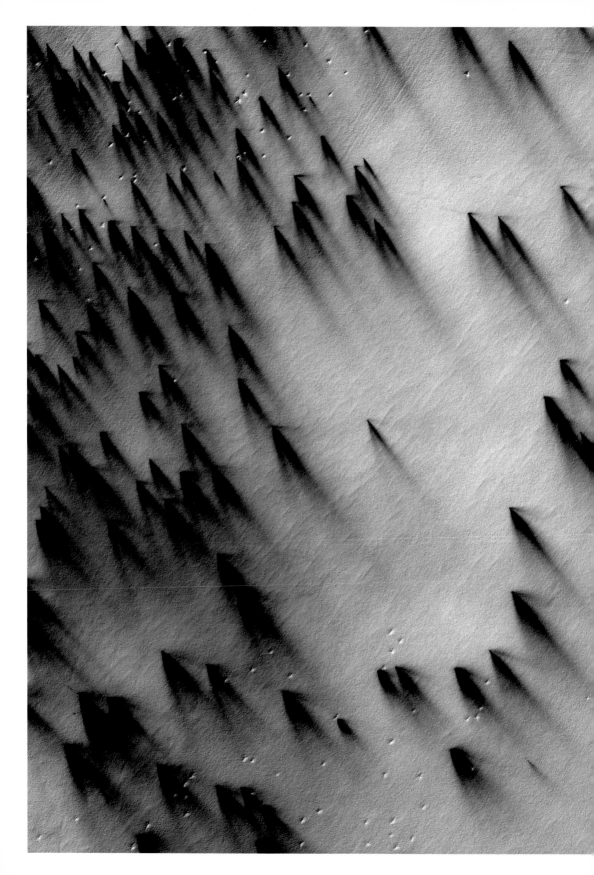

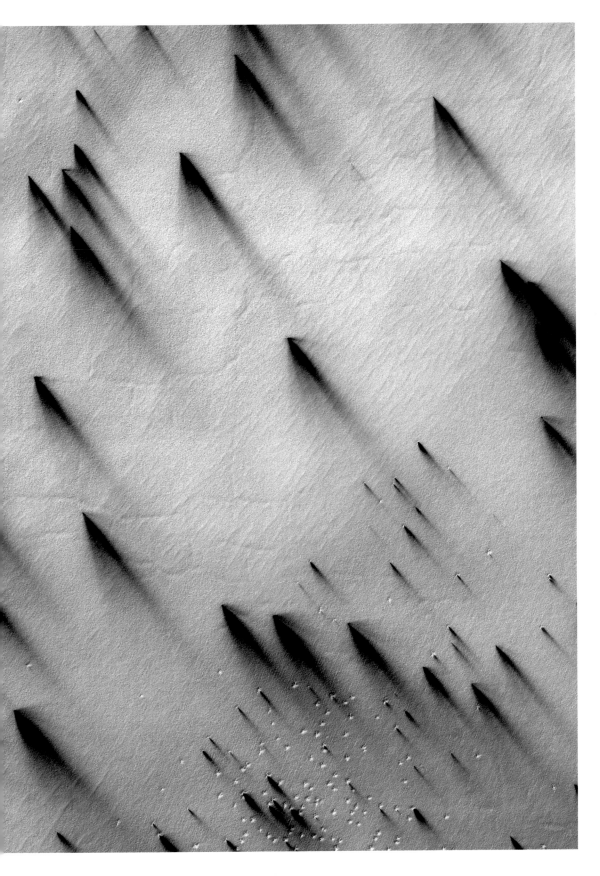

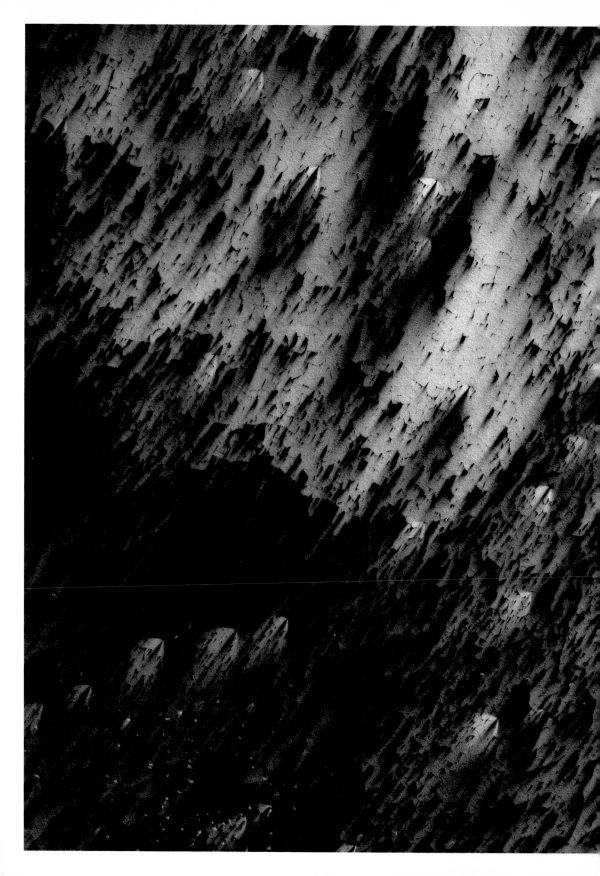

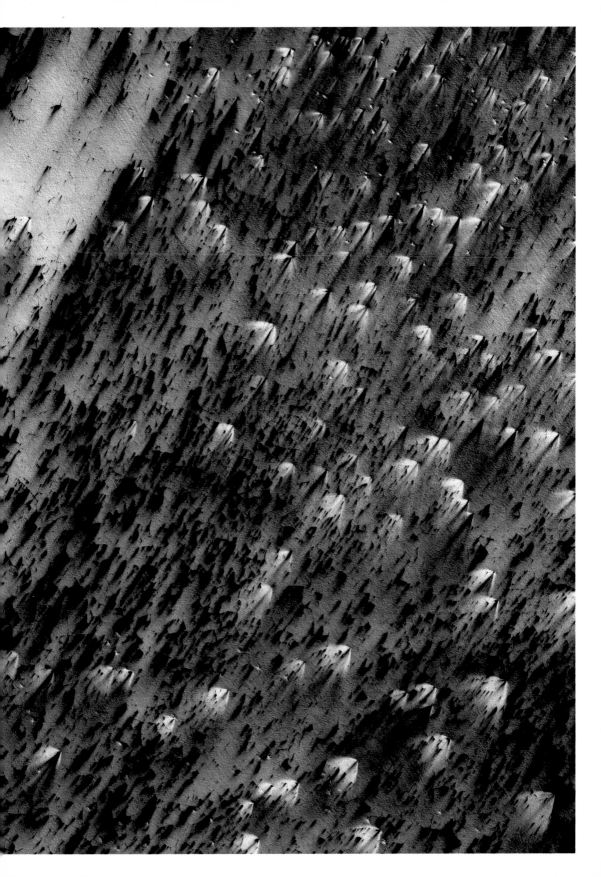

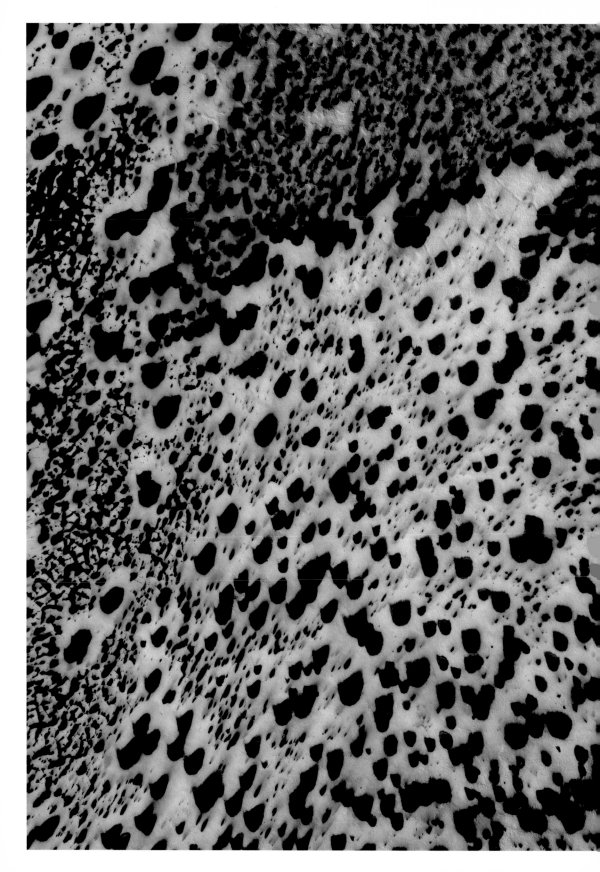

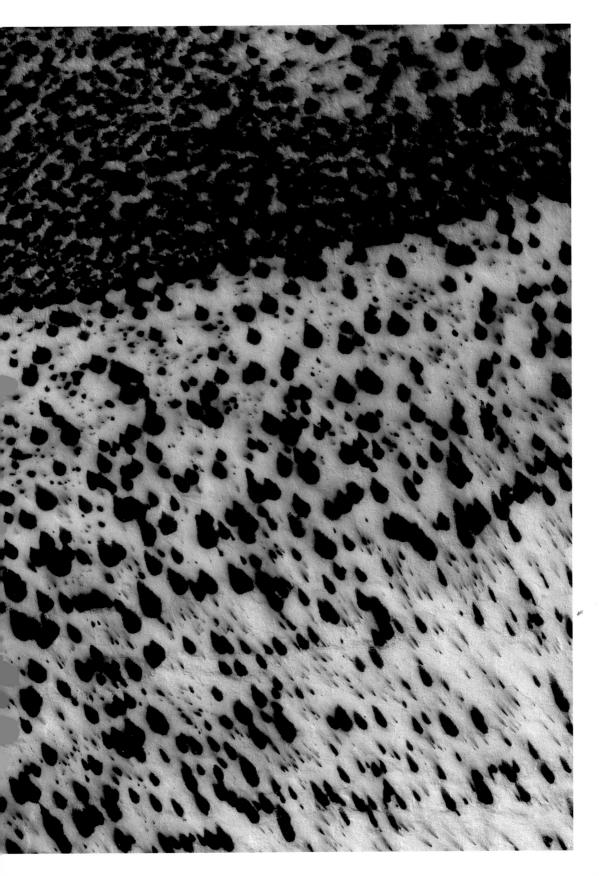

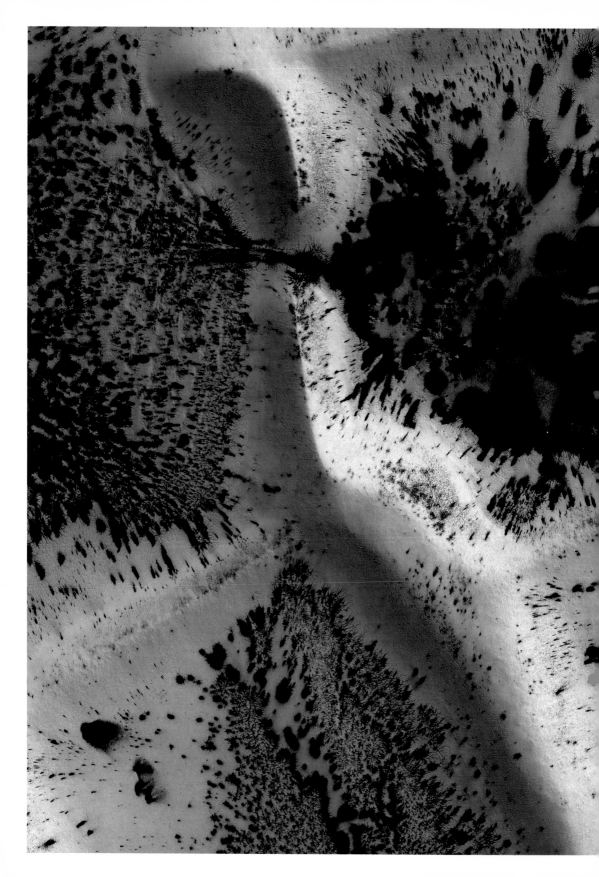

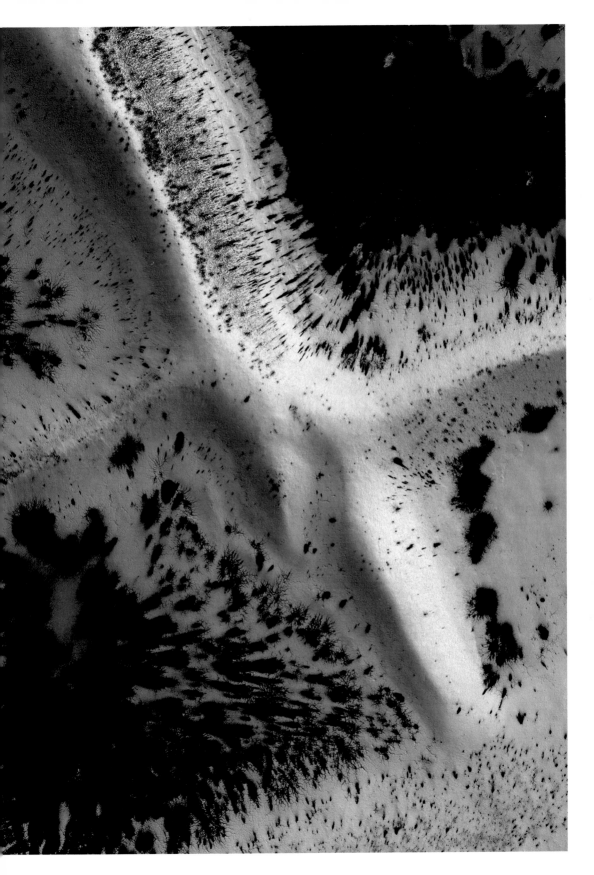

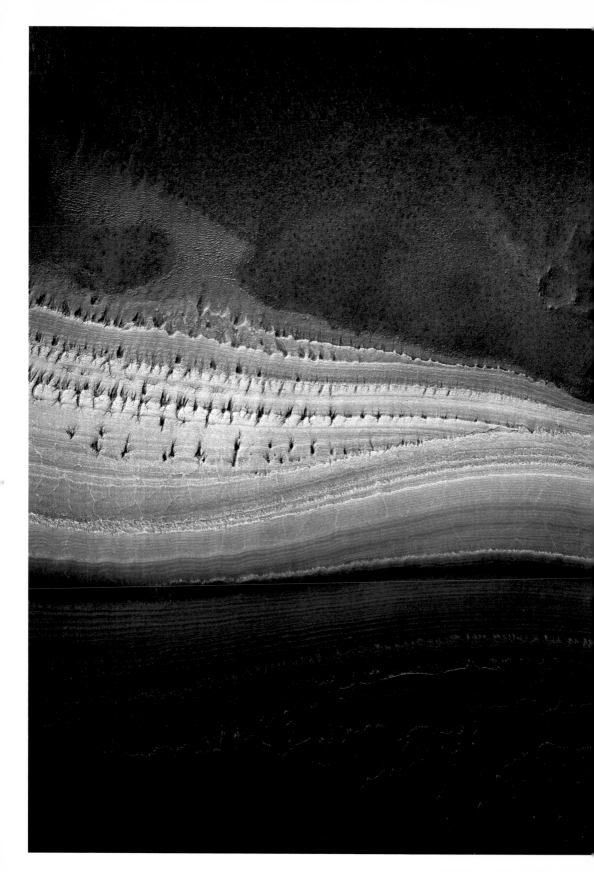

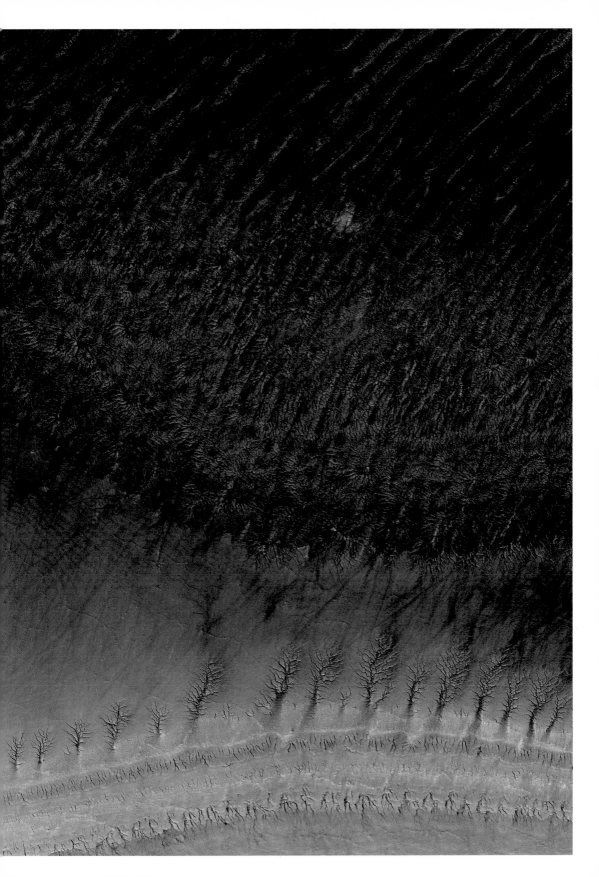

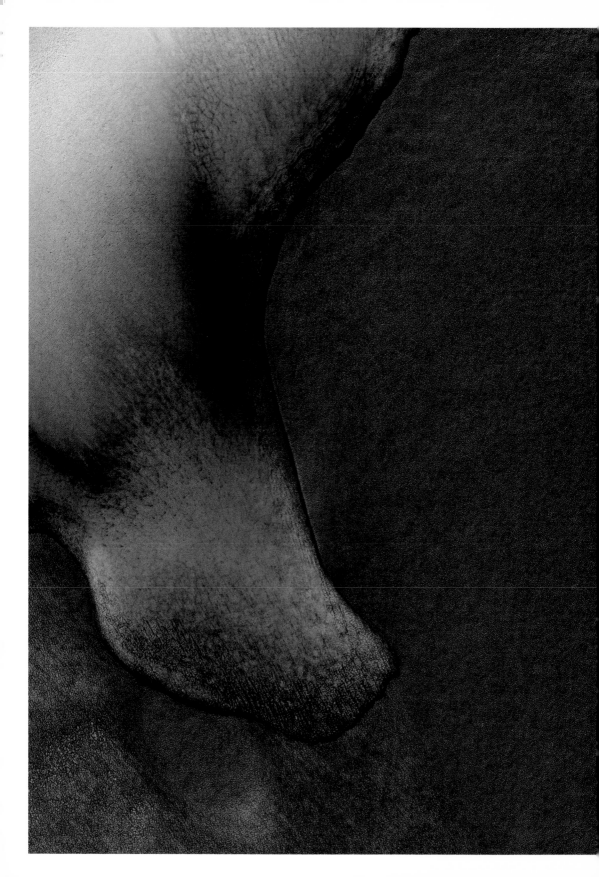

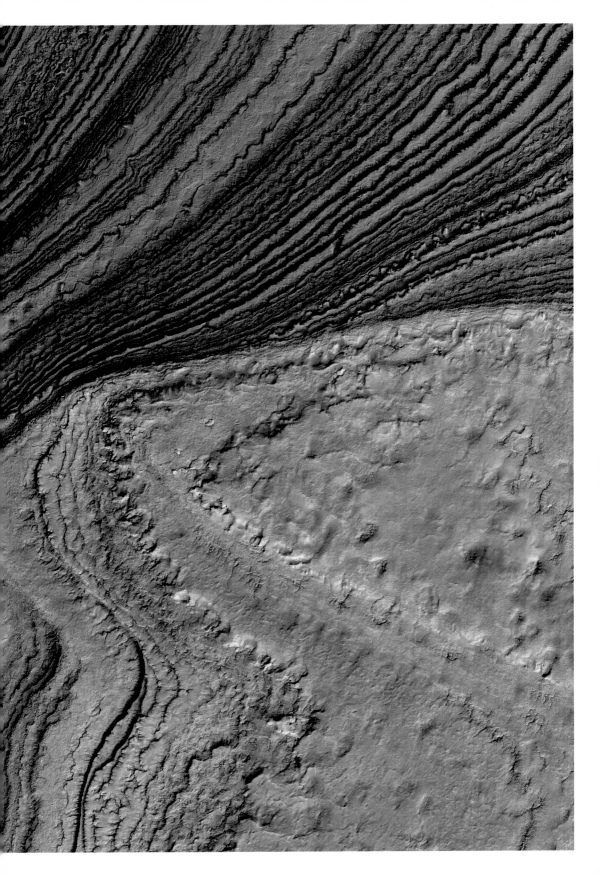

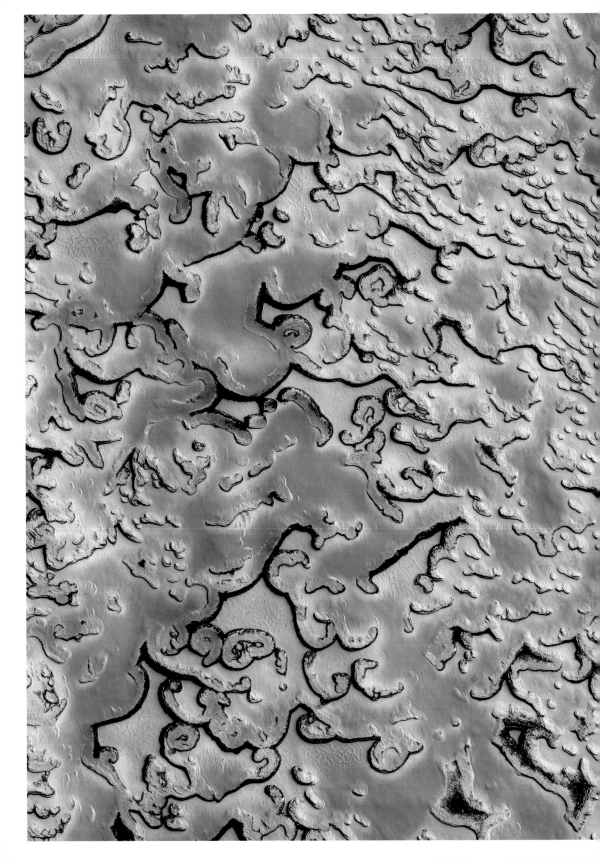

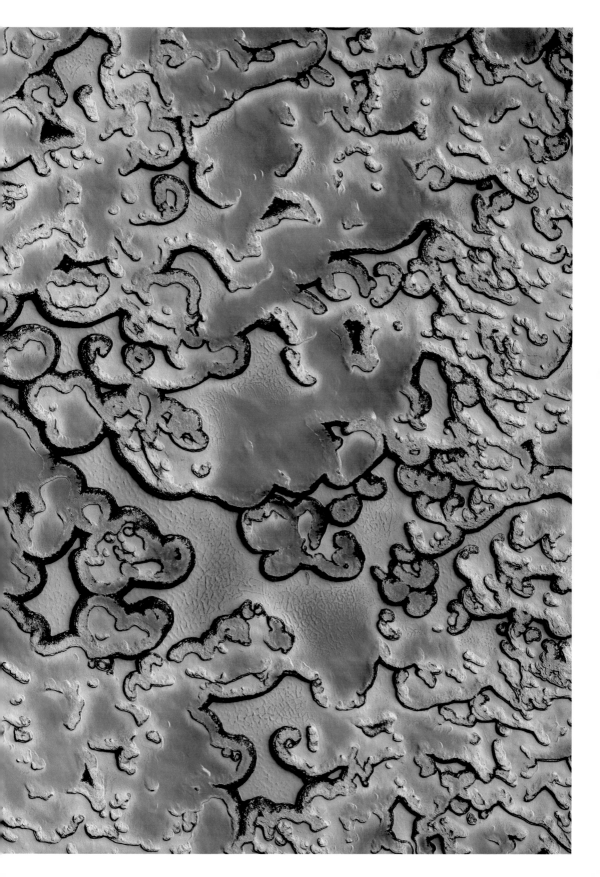

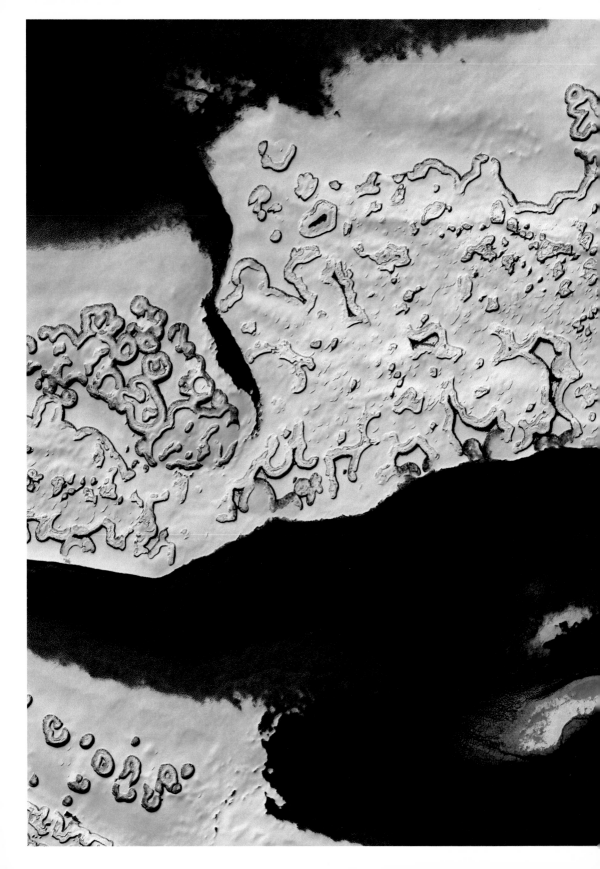

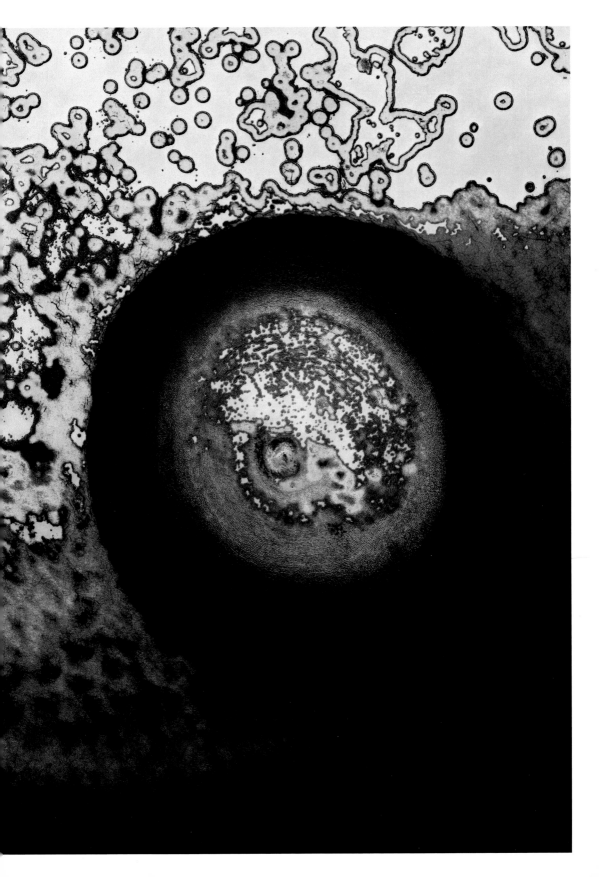

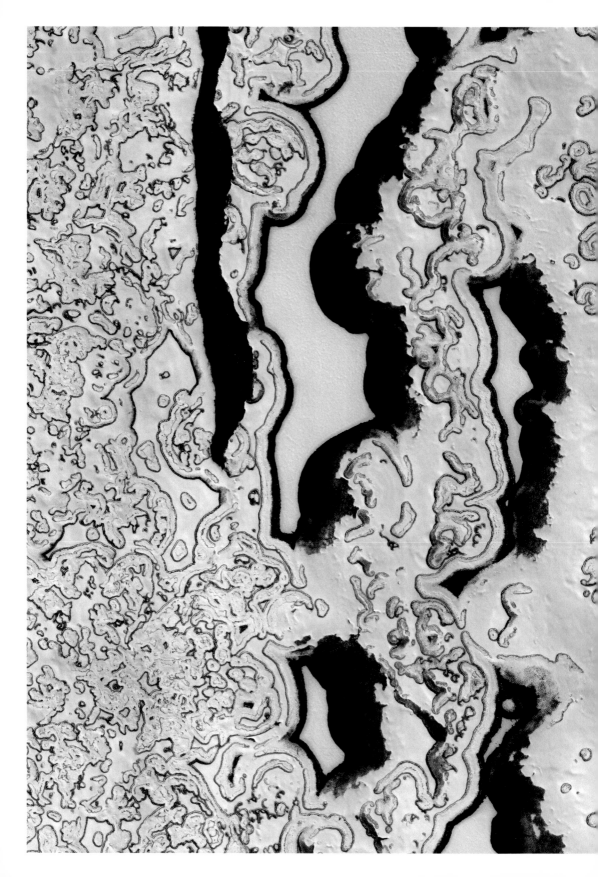

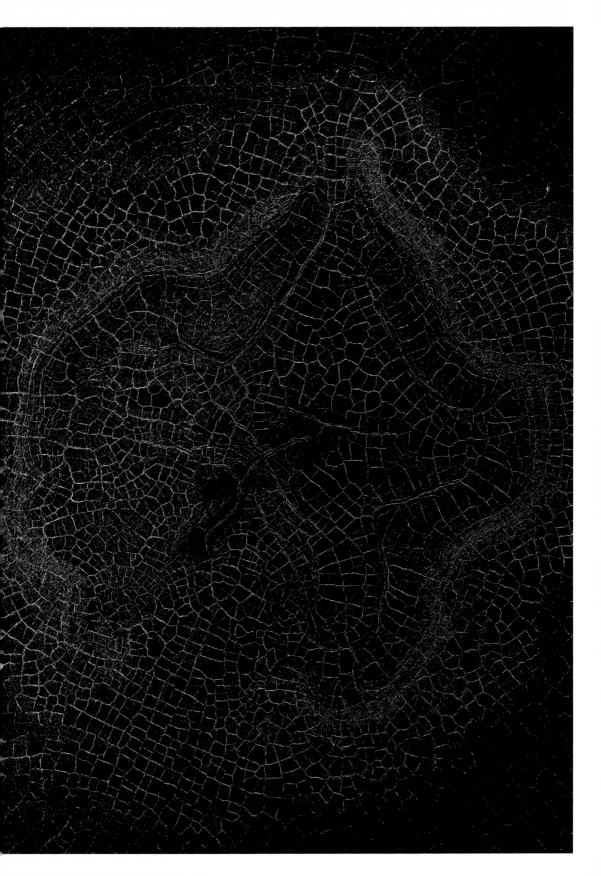

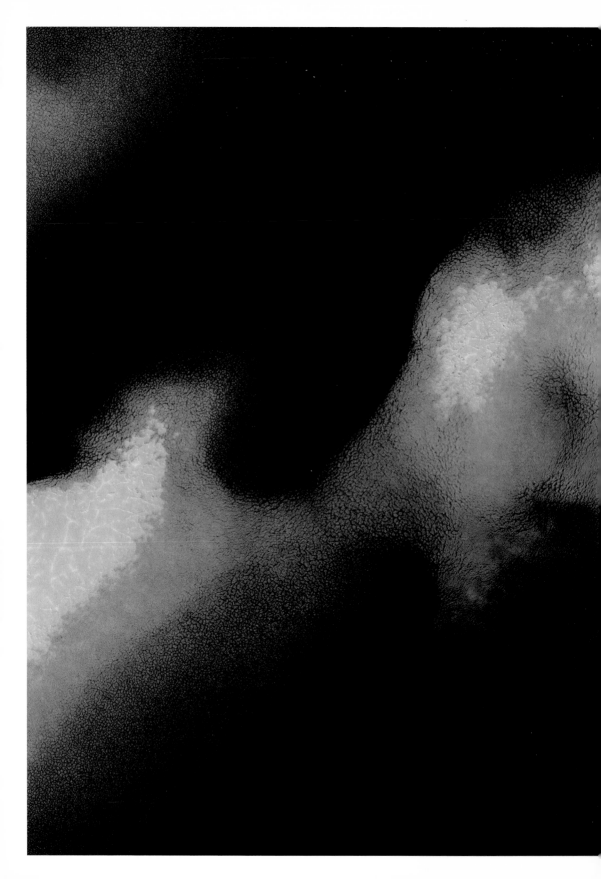

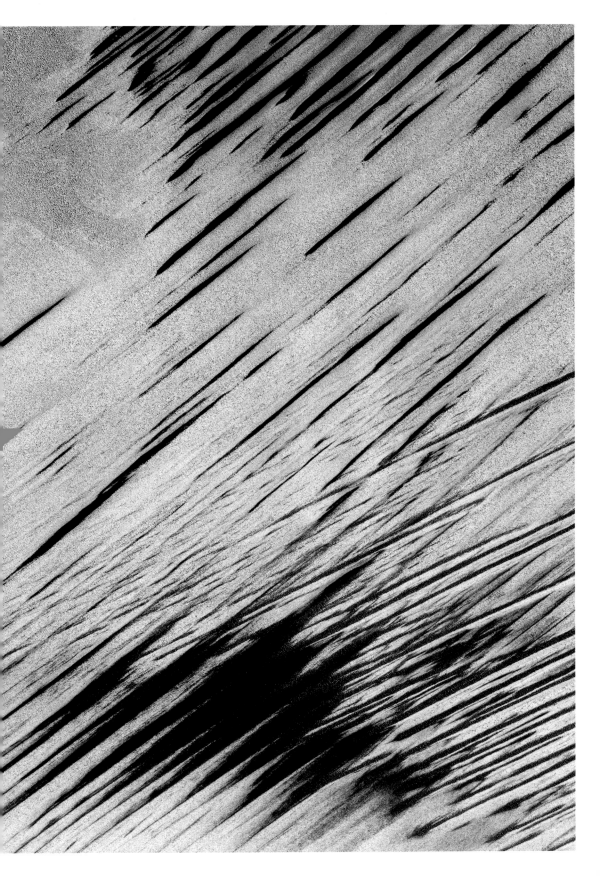

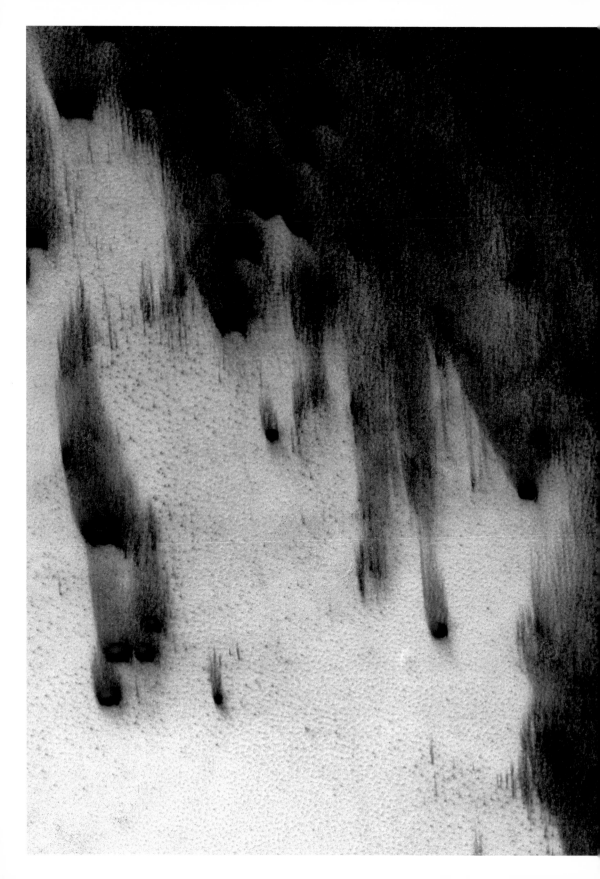

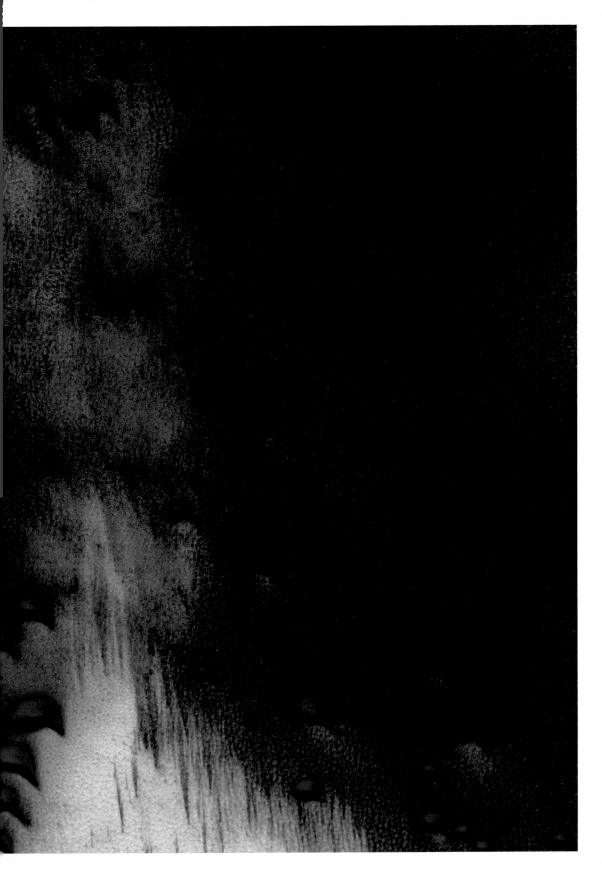

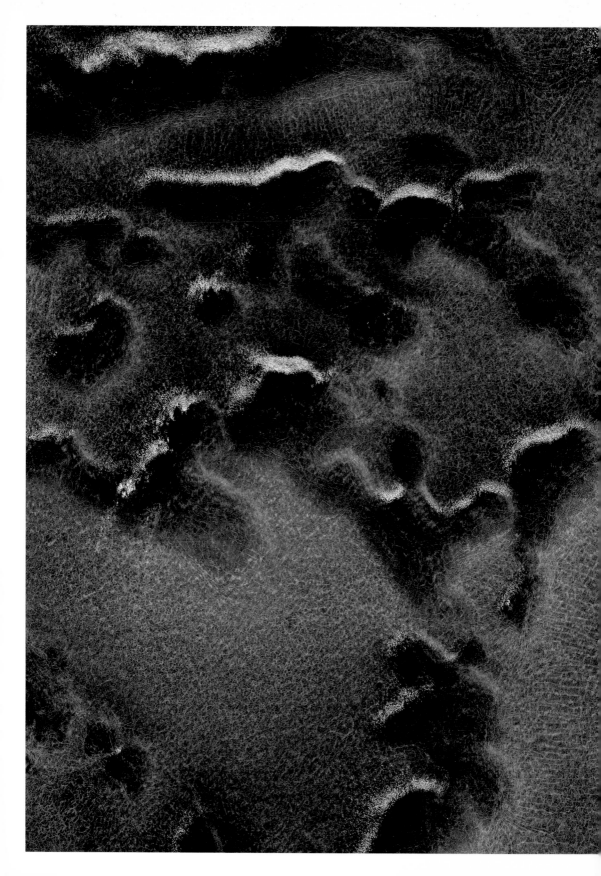

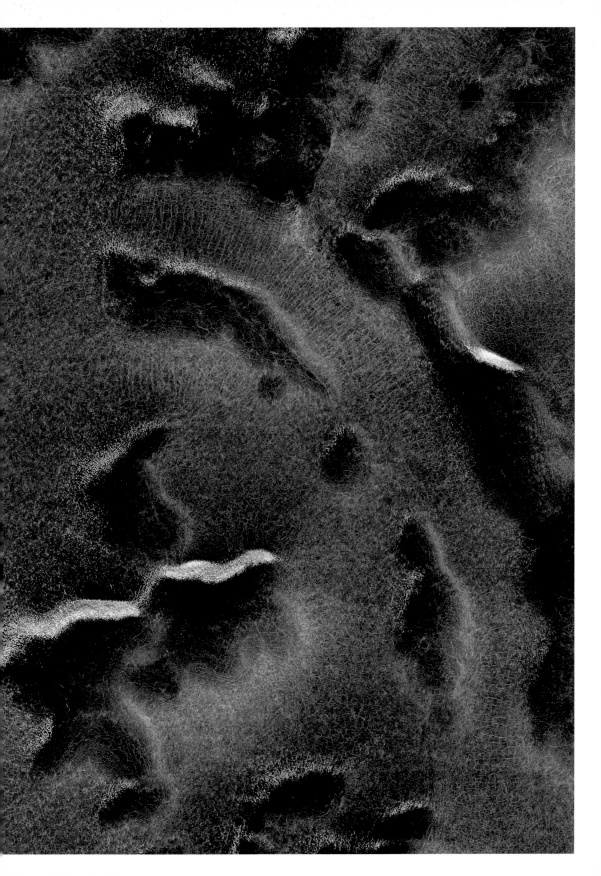

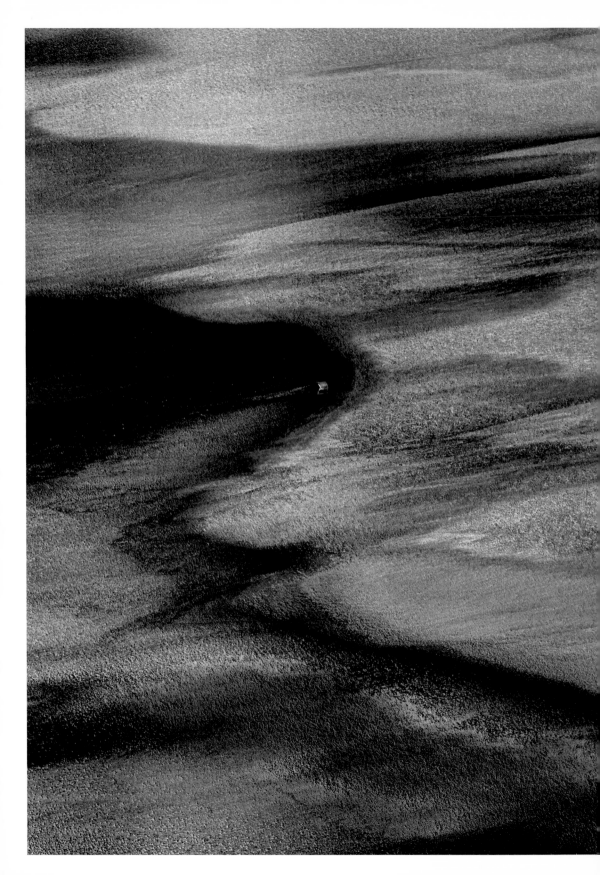

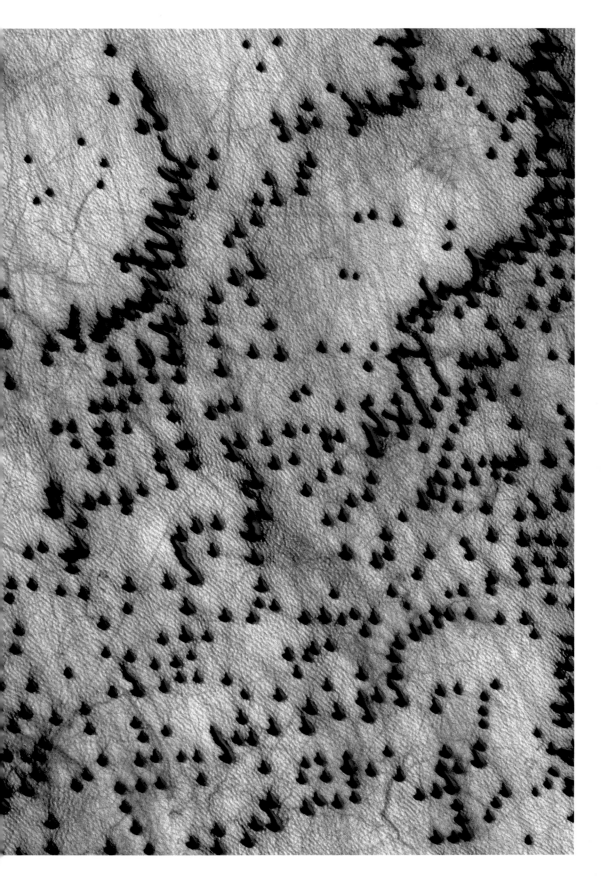

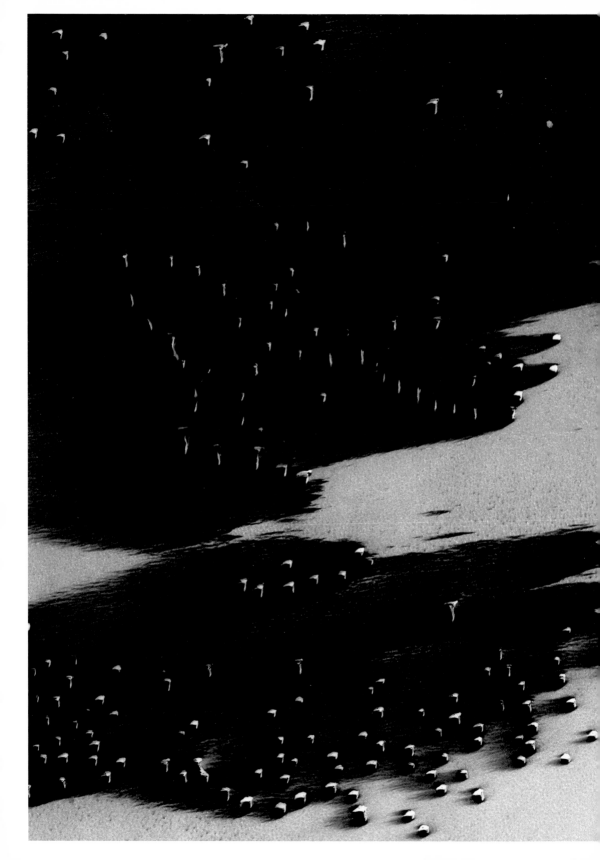

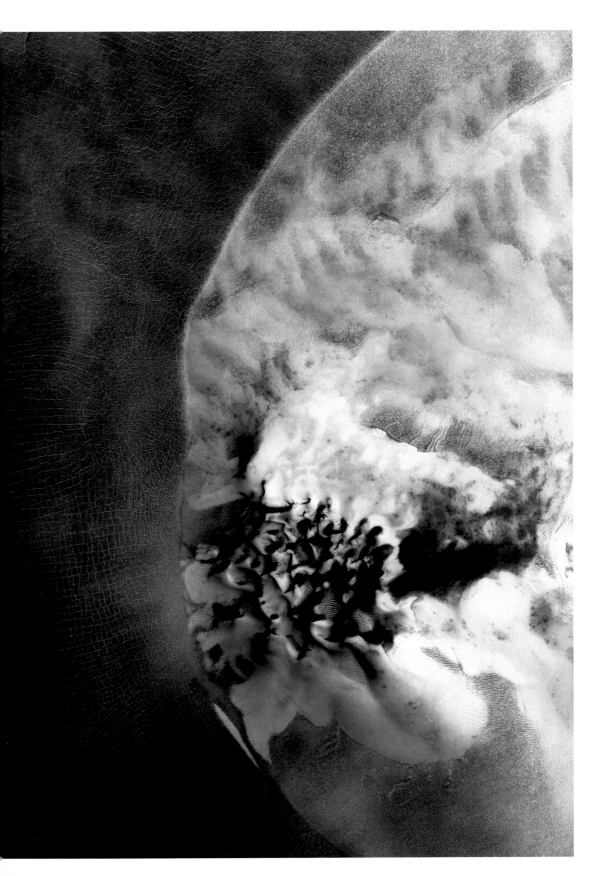

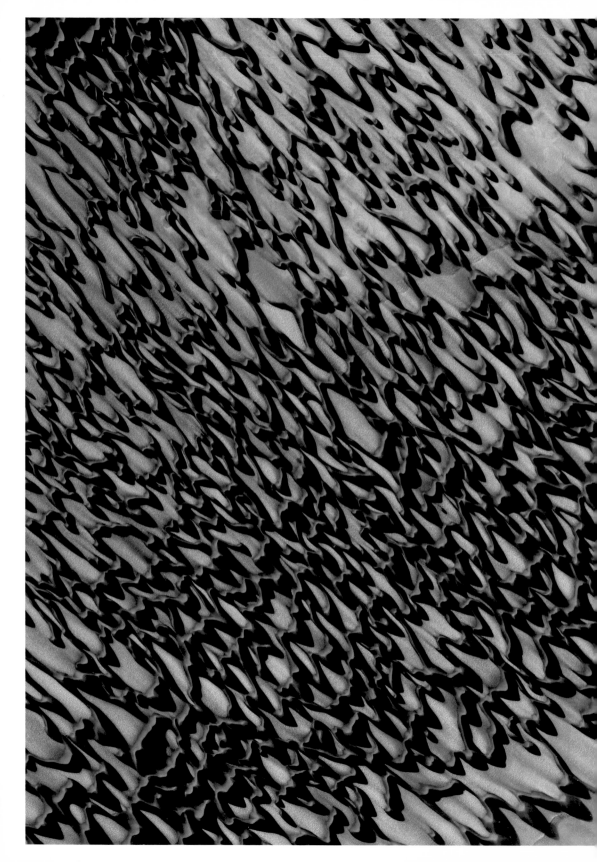

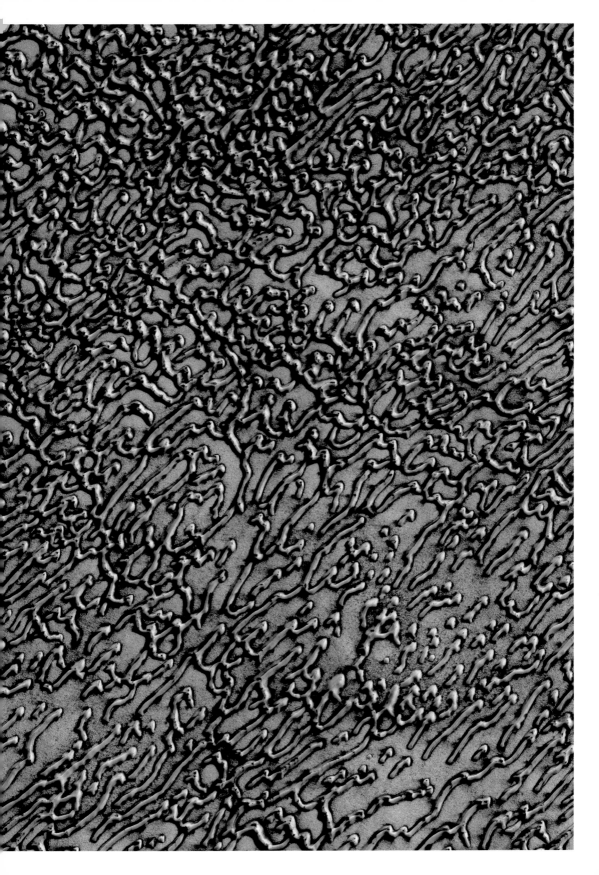

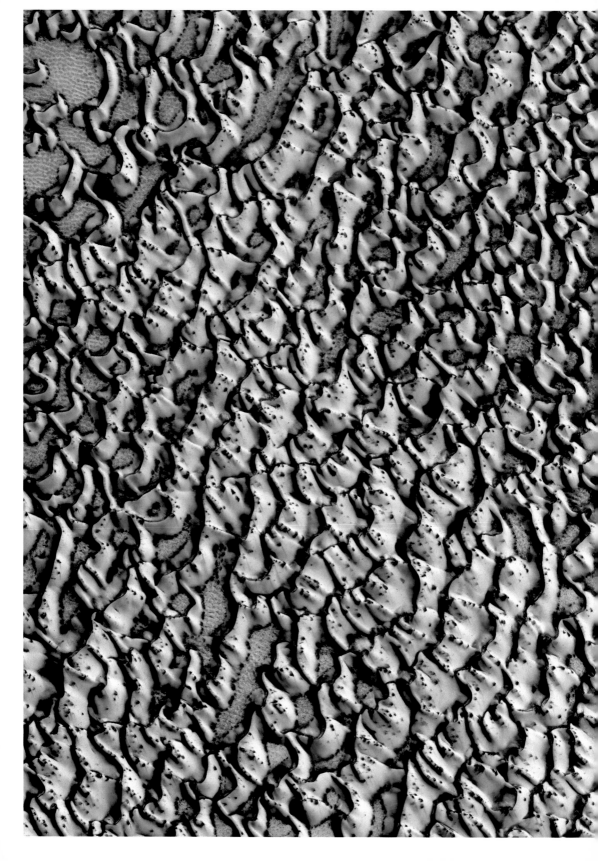

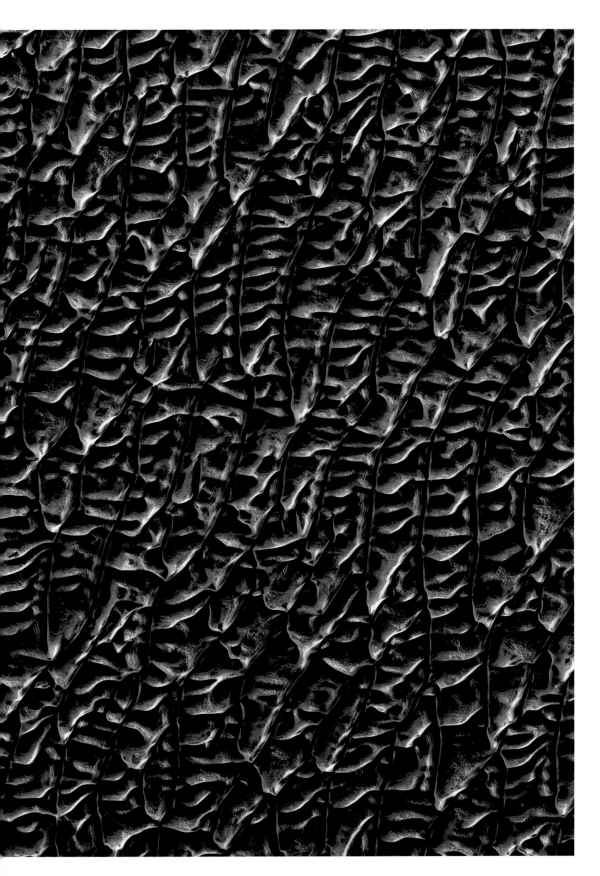

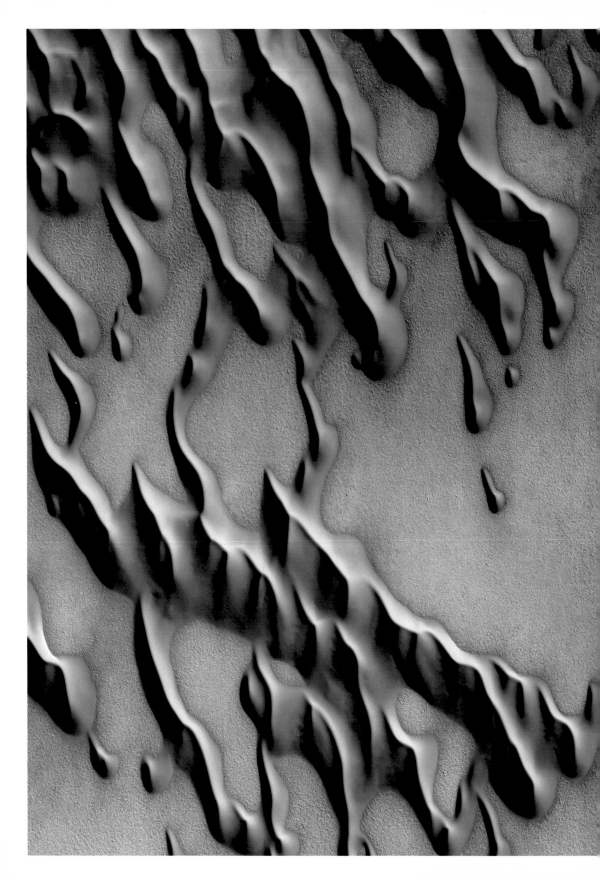

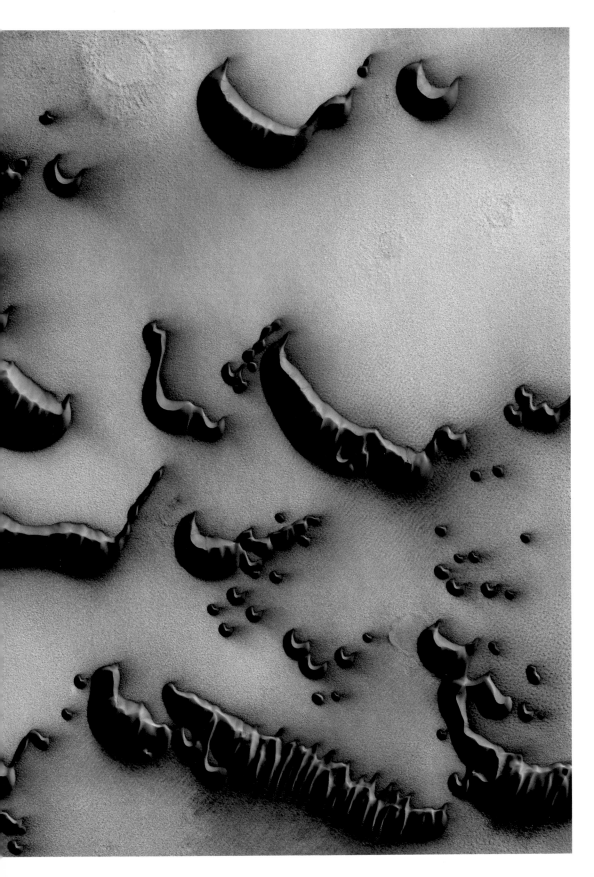

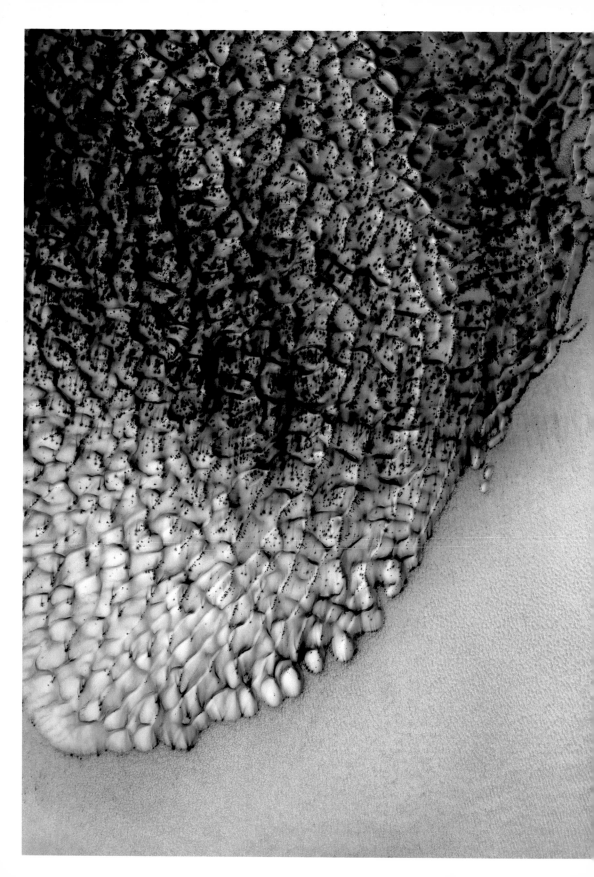

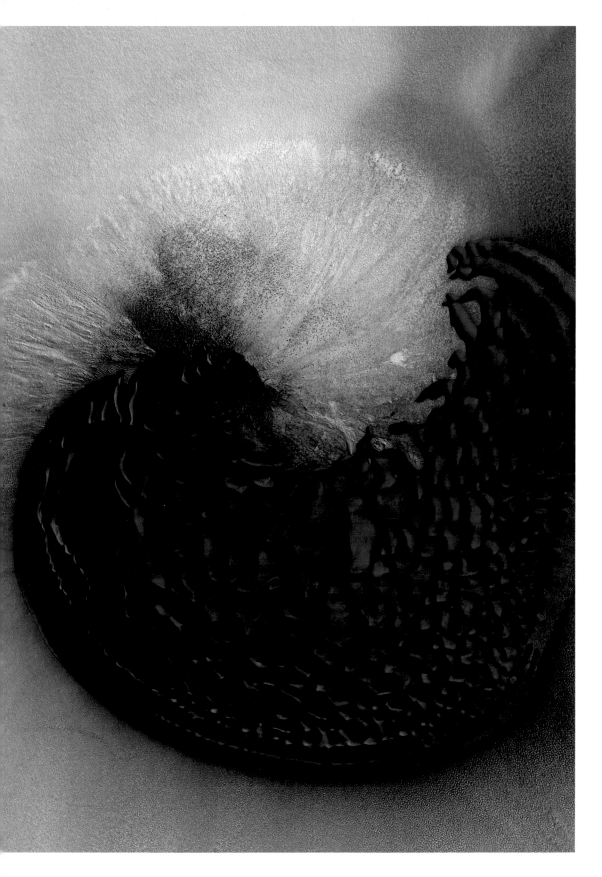

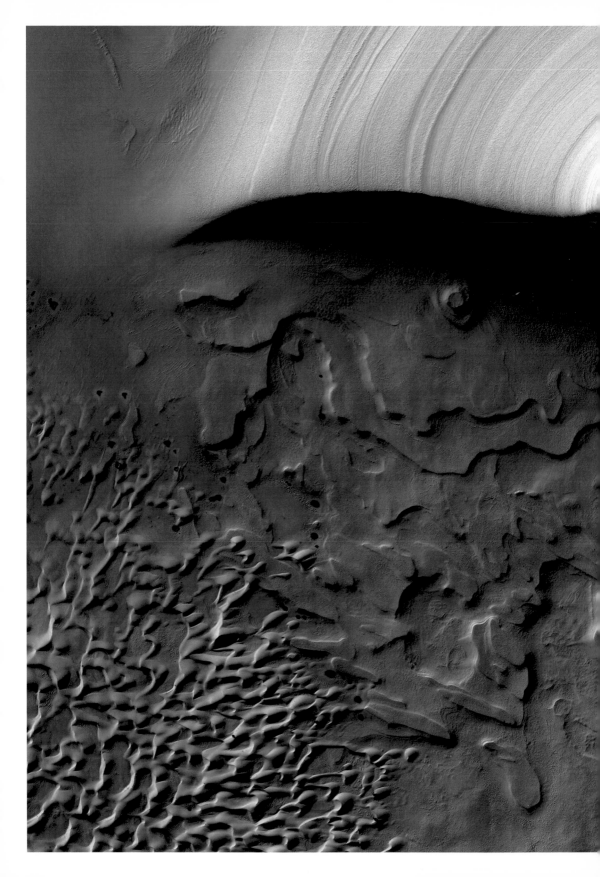

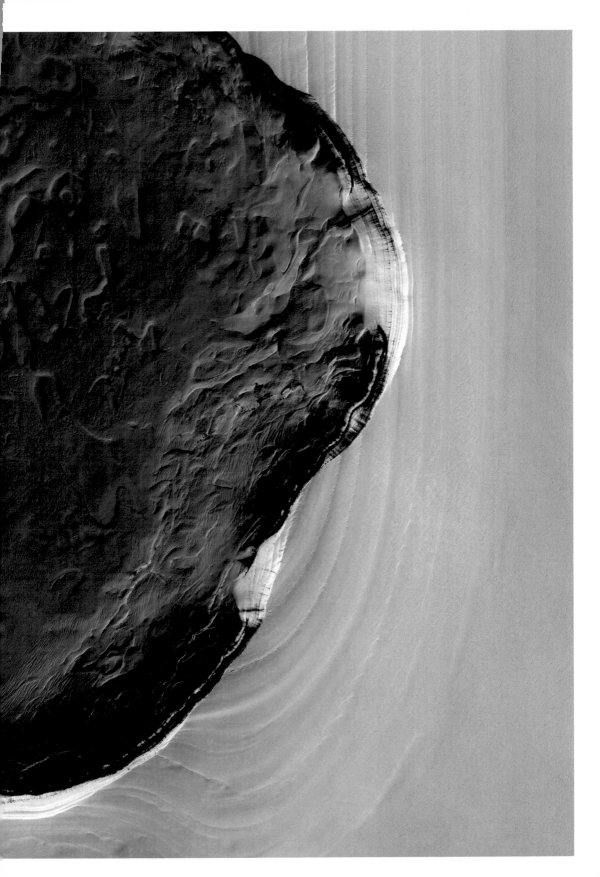

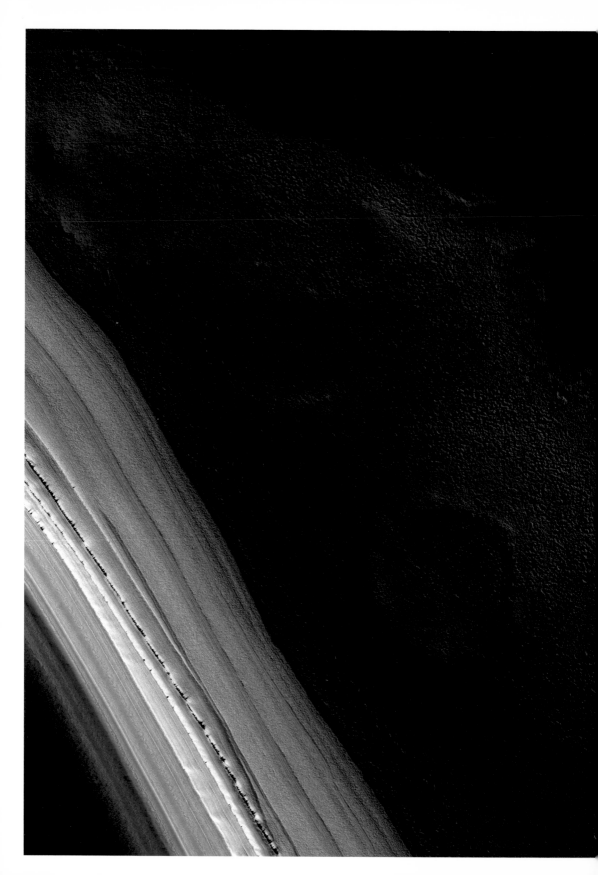

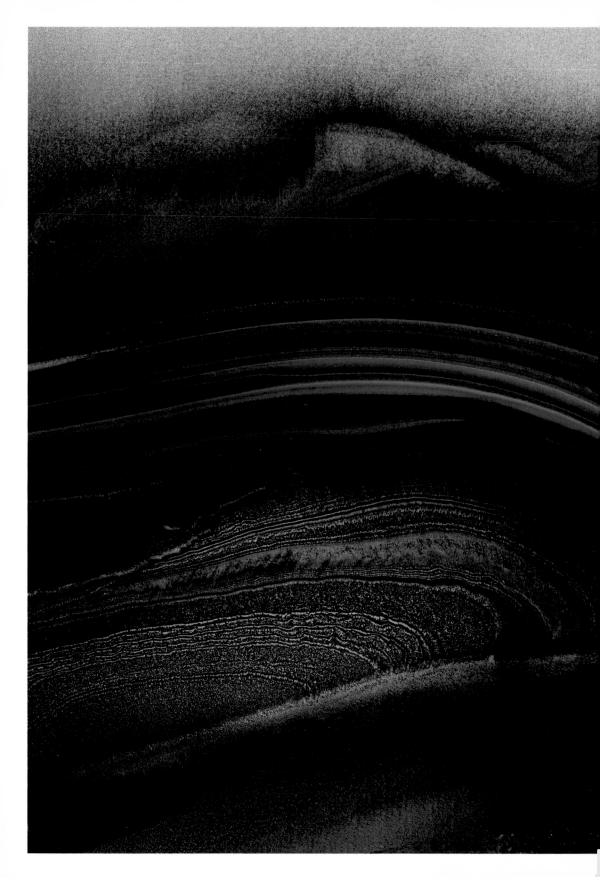

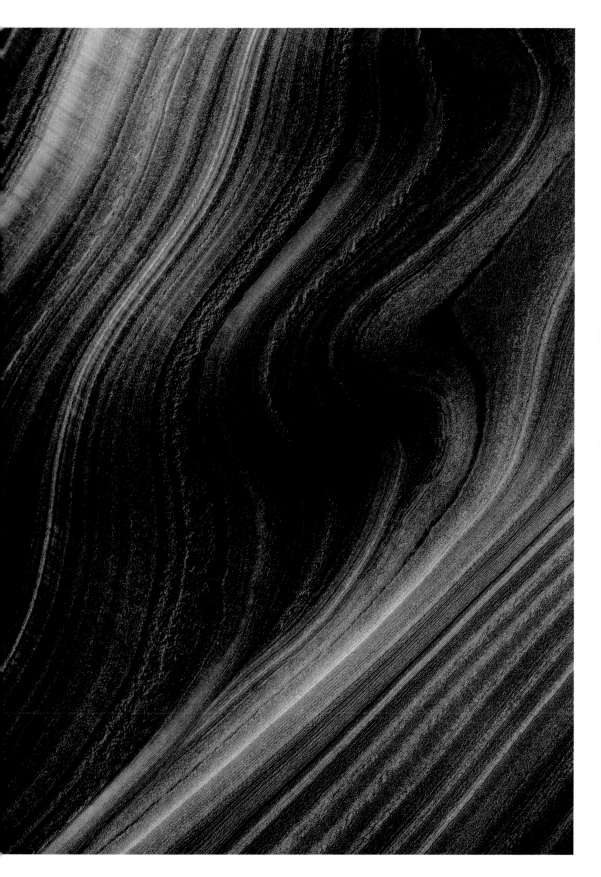

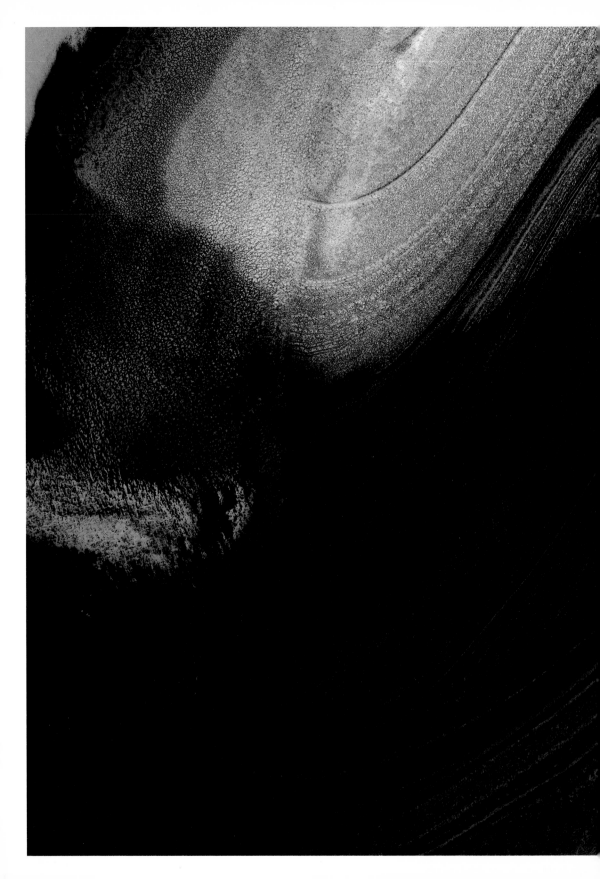

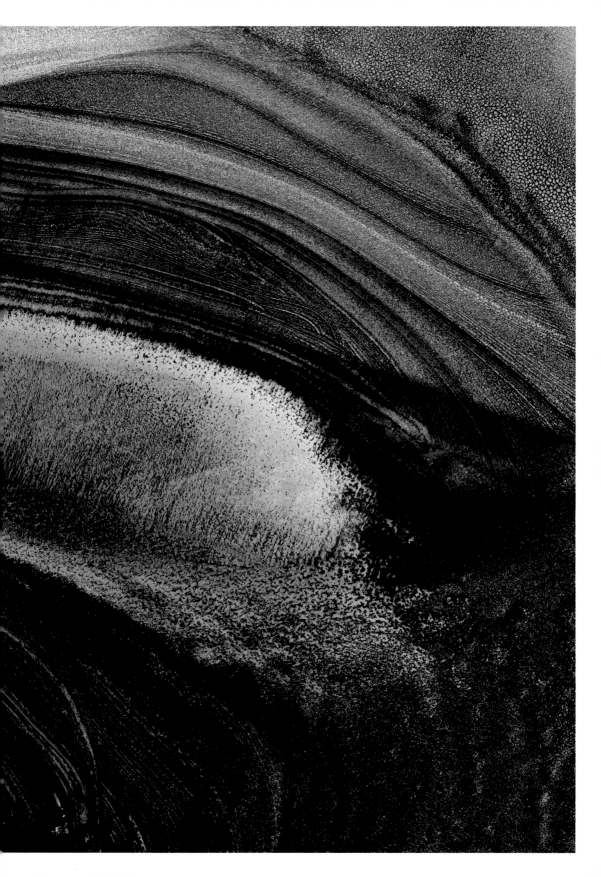

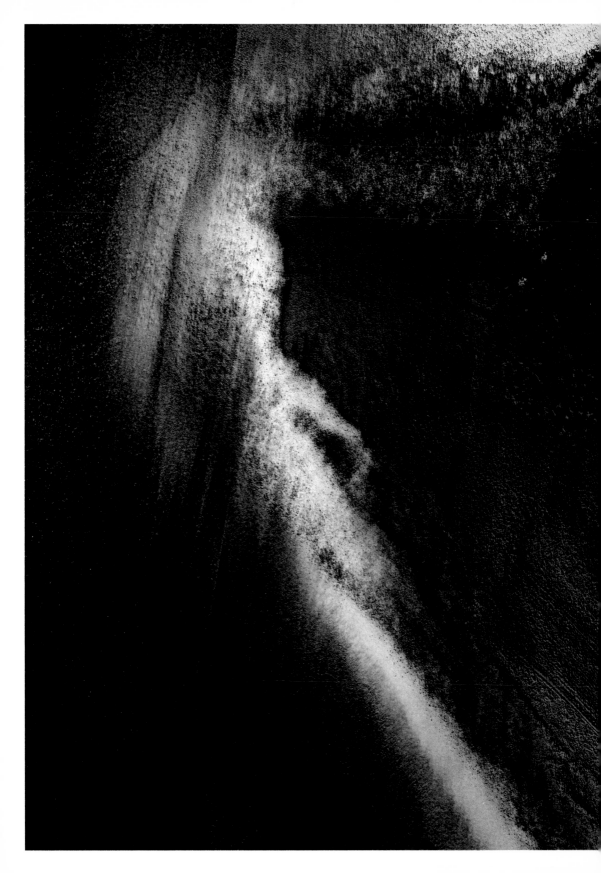

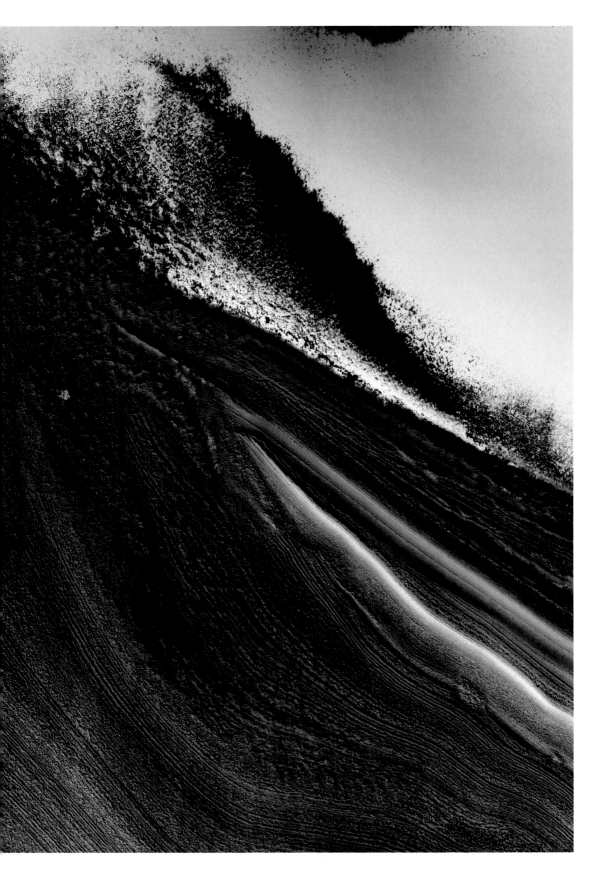

HiRISE:
A NEW VIEW
OF MARS

ALFRED S. McEWEN

Alfred S. McEwen is a professor of planetary science
at the University of Arizona in Tucson.
He is the principal investigator for HiRISE
and he also works on missions to Saturn
and to Earth's Moon.

ON AUGUST 12, 2005, the space probe *Mars Reconnaissance Orbiter* (MRO) left the Cape Canaveral launch base for Mars. Its first objective: to map the planet in order to identify and characterize landing sites for future missions with robots. To this end, NASA equipped the probe with a camera known as HiRISE (High Resolution Imaging Science Experiment), the largest and most powerful camera ever sent to another planet. After reaching orbit on March 10, 2006, MRO entered a phase of aerobraking for several months, using friction from the upper atmosphere to lower and circularize its orbit around the planet. On September 29, 2006, the camera sent out its first high-resolution image from the final orbit.

The camera was designed and built by Ball Aerospace and Technologies Corporation in Boulder, Colorado, and required the participation of a large team of skilled personnel. Since it was sent into orbit, several hundred collaborators have been handling operations, performing the scientific analysis of the data, and processing the images at the University of Arizona in Tucson under my direction.

The HiRISE camera is an exceptional tool, orbiting Mars at a distance of between 250 to 320 kilometers (approximately 150 to two hundred miles). It has fourteen charge-coupled device (CCD) detectors: ten with broadband "red" filters covering the full-swath width (which is six kilometers wide, or 3.7 miles), and four with blue-green and near-infrared color bandpasses to provide a central strip in three colors. The color field is therefore limited to 1.2 kilometers (0.7 miles), while the black-and-white photographs provide a field six kilometers (3.7 miles) wide, thus revealing spectacular views and a new and original overview of the planet. HiRISE images are twenty thousand pixels wide (four thousand in color), and up to one hundred thousand pixels long, so they cover areas of up to six-by-thirty kilometers (180 square kilometers, or 111.8 square miles). Furthermore, its reflective telescope measuring 0.5 meters (1.6 feet) in diameter, the largest ever sent to another planet, provides images of a resolution of twenty-five to thirty-two centimeters (9.8 × 12.6 inches) per pixel. Even when compressed, these images require several gigabits of data, but fortunately the MRO probe is capable of returning large quantities of data. It has transmitted more than forty-six thousand images of the planet Mars since 2006, which is much more data than all previous remote-sensing missions to other planets (not counting the Moon).

Yet these images only cover 2.5 percent of Mars's surface! The choice of very high-resolution shots means that the surface covered remains limited. Also, each photograph aims to provide precise

information about a site or area of terrain in order to answer a specific scientific question. Although members of the HiRISE team target most images, Internet users can also make suggestions using the HiWish website (uahirise.org/hiwish).

Over the past ten years, the HiRISE images have delivered much information about the planet. Firstly, they have allowed us to identify the best landing sites, for the *Phoenix* lander, for instance, and the *Curiosity* rover from the Mars Science Laboratory mission. They have also helped to plan traverses for the *Spirit*, *Opportunity*, and *Curiosity* rovers, avoiding sand traps and other hazards. The HiRISE team also expects to help with the European Space Agency's plans to launch a lander and a rover in the future.

Secondly, these images also contribute essential scientific data pertaining to the past and present state of Mars. With respect to the history of the planet, HiRISE has discovered and measured water-indurated bedrock joints and rhythmic layering of sedimentary rocks, as well as provided stratigraphic context for discoveries of hydrated minerals by orbiting spectrometers. The presence of these hydrated minerals indicates past environments that were habitable—life could have flourished there, if it ever existed on Mars. HiRISE has also contributed to better understanding "middle-age" Mars, a time after the heavy impact bombardment when surface activity was dominated by floods of lava and water. As for the present state of Mars, the images transmitted by the HiRISE camera allow the surface to be carefully observed, including sand dunes, new impact craters (some exposing clean-water ice), avalanches of dust, frost, ice, rocks and ravines, and many other curiosities, such as what may be small active flows of salty water.

But the images taken by HiRISE also reveal all of the beauty of Mars. They generate wonder, awakening our curiosity and inviting us to explore. While their quality and precision are indispensable for the scientific success of the MRO's mission, they also faithfully capture the planet's mysterious splendor. Physical processes have produced pleasing patterns on its surface, such as polygons, stair-stepped layers, flowing sand dunes, meandering river deposits, lava flows with spiraling coils, explosive impact craters with dramatic radial patterns, eroded mesas with vertical cliffs, layered ice deposits over the poles, icy flows over the middle latitudes, dust deposits with strange textures, and sharp-rimmed gullies that look like they formed just yesterday (some of them did). The images also reveal deep collapse pits (perhaps connected to caves), giant canyons and

landslides, jumbled deposits of multicolored bedrock blocks, and bizarre folded structures, like those in *Hellas Planitia* or *Valles Marineris*. They unveil the existence of scalloped terrain from sublimation of shallow ice, the presence of strange linear channels with raised edges that form over sand deposits, and fields of giant boulders that beg the question of how they got there. We also found rectilinear and curving ridges and rifts of all sizes, windblown streaks of many hues, frosted surfaces that glimmer in early spring sunlight, and even "spiders" (radiating channels) produced by the flow of carbon dioxide gas over the south polar layered deposits, which erupt to form cold jets in the spring.

What does the future hold for the HiRISE camera? While the MRO probe has enough fuel to continue orbital operations for another ten years, some instruments are starting to show their age. One of the fourteen CCDs of HiRISE is no longer used because the electronics stopped communicating in August 2011, probably from failure of an electronic part. Fortunately, this CCD is at the edge of the array, so the images are just 10 percent narrower, rather than having a gap in the middle. We can't predict when the next failure may occur. The camera was designed to last for at least four years in Mars's orbit, so all of the images that have been obtained after the end of 2010 have been considered "bonus coverage." Another camera like HiRISE is planned to accompany the NASA orbiter *NeMO* (*Next Mars Orbiter*) by 2022. The Mars program has come to expect this kind of information to select landing sites and rover traverses. If significant Mars exploration is to continue, especially leading to human exploration, global high-resolution capability will be needed. Finally, let's hope that HiRISE-class imaging will one day be available for the observation of many other planets in our solar system, thus guiding Homo sapiens in our fascinating planetary exploration.

A GEOLOGY
OF EXCESS

FRANCIS ROCARD

Francis Rocard, a French planetologist,
has been in charge of the solar system
exploration program at the National
Center for Studies of Space (Centre national
d'études spatiales [CNES]) since 1989.

GLOSSARY

Each entry in this glossary
is marked by an asterisk at
its first appearance in the text.

ORBITER
A satellite in orbit around
another planet.

INTRODUCTION

ALONG WITH EARTH, Mars has a history that is the richest and the most varied in our solar system. Like other telluric planets, Mars has undergone tectonic activity from numerous volcanic eruptions that spread an enormous amount of dusts, significant lava flows, and hilly magma deposits that shape its surface. Mars also went through a warm and wet period during which water flowed abundantly over its surface, a unique case shared with Earth. Finally, the action of the wind throughout the planet's history has also contributed significantly in shaping its contour. In contrast to Earth and Venus, which have an atmosphere, Mars has conserved the memory of very ancient events on its surface, something that is also true of the Moon and Mercury, which have no atmosphere. This relation of ancient surfaces to an atmosphere is unique in the solar system. The variety of Mars's landscapes renders their interpretation very complex. Many geologists are applying themselves to these questions.

The first global map of the planet was created during the 1970s. The resolution barely covered a kilometer (0.6 miles)—in other words, each pixel of the digital image represented an area measuring one square kilometer (0.4 square miles). The large geological entities had already been identified. With the two American *Viking* orbiters* in the 1980s, a new map with a two-hundred-meter (650-foot) resolution was made, and certain images in high resolution (ten meters, or thirty feet) were also taken. Currently, the camera of *Mars Express* accumulates observations in order to get a (nearly) global map with scores of meters in resolution. It was necessary to wait thirty years for a gain of a factor of one hundred in scale. To seek an additional ten factor is not foreseen for practical reasons—the volume of data to be sent back to Earth would be prohibitive, and geologists don't seem to need it. On another hand, obtaining images of a very high resolution locally is of major scientific interest, and that is the prime function of the HiRISE camera, images from which are reproduced here. While mapping only certain percentages of the planet's surface, HiRISE has nevertheless collected a volume of data far superior to the volumes of all previous missions to Mars combined.

This camera equals a naked-eye view of the planet at a flight level of approximately one kilometer. Placed at a similar height, a person could see details as precise as those in HiRISE's images, taken from a height of about three hundred kilometers (190 miles). Each black-and-white image has a six-kilometer-wide (3.7-mile) viewing range, a range that is reduced to 1.2 kilometers (0.75 miles) for images in color. The limited range of color images prompted us to keep

the black-and-white ones for the present volume. All of the images in the book retain their original range, an editorial decision having been made to not present images that have been artificially zoomed.

Thanks to HiRISE's power of resolution, the geologist and the observer have entered a new era in the study of Mars. New subjects of study have multiplied: fine stratifications whose origin is often unknown, as well as new craters and dynamic surface variations, such as the advancement of dunes. A powerful tool, HiRISE provides unique geological data about tectonics, volcanoes, the effects of climate and seasons, crater formation, fluvial and glacial processes, and more.

The level of enlargement and the limited viewing range accentuate the difficulty in interpreting these images. It is necessary to step back, that is to acknowledge, the context for each image, its surrounding area. The following discussions are meant to guide the reader who wishes to understand the evolution of this very singular planet. Its current topography is actually the result of successive, cumulative volcanic, fluvial, glacial, and eolian effects over several billion years. These lasting effects do not have an equivalent on Earth, where erosion by water and continental drift has erased them from the most ancient surfaces.

MAIN BELT
(OR ASTEROID BELT)
The main asteroid belt is the region of the solar system between the orbits of Mars and Jupiter that contains the major number of known asteroids.

FORMATION

The planet Mars is situated between Earth and the main belt* of asteroids. If these asteroids exist and aren't merely the agglomerate of a planet, it means that gigantic Jupiter was formed before the terrestrial planets. Because of its mass, Jupiter disturbed the formation of bodies within its gravitational zone. The stage of these asteroids' evolution has remained at the level of proto-planets, small bodies of less than one thousand kilometers that are unable to agglomerate so as to form a planet. Recent studies have shown that Jupiter's orbit has changed a lot over time. Soon after its formation, while the internal solar system still had quantities of gas, the gigantic gaseous planets migrated toward the internal solar system in the asteroid belt, disturbing this area considerably. This incursion is probably the reason that Mars wasn't able to attain a size similar to Earth or Venus. Jupiter's gravitational pull considerably limited the number of asteroids in Mars's orbit, which, because it accrued only a limited amount of matter, reduced the planet's final mass.

Ultimately, the formation of Saturn produced an inverse migration, causing the distancing of Jupiter to its current position of about five astronomical units* (or five times the distance from the Earth to the Sun). This model presented in 2011 predicts nicely the existence of two populations of asteroids which are observed: the objects of the internal belt, which have been deprived of water, and those of the external belt, which have not.

Jupiter's comings and goings explain why Mars wasn't able to attain a mass equivalent to the Earth or Venus. Its small size was a determining factor in its evolution. Given that its diameter is only some 6,400 kilometers (3,980 miles, or roughly half of the Earth's), its mass represents but a tenth of that of Earth. This parameter of mass, and therefore of volume, is determinant in explaining the cold that reigns on Mars today. In fact, the recently formed planetary bodies are hot inside and cool down progressively through to their surfaces. The smaller a body, the less hot its interior and the more quickly it will cool.

Mars's inner heat comes from two origins. In one, a natural decrease of unstable elements creates heat, which causes a rise in the internal temperature of the planet. In another, energy has accumulated on the surface through impacts. The related heat induces an intense volcanic activity and a progressive de-gassing of volatile compounds, which also make up the primordial atmosphere of the planet, rich in carbon dioxide. This dense atmosphere lasted some five hundred million years, preserving through a greenhouse effect* a temperature and pressure compatible with the presence of liquid water. (What used to be but a hypothesis has now been established by the discovery of clays on Mars that could not have been formed without an abundance of liquid water.) Consequently, the disappearance of Mars's internal magnetic field, due to the deep cooling that freezes tectonic movements in their depths, produced a global climate change. The planet then found itself rapidly losing its protective magnetosphere; solar wind (constituting ions and active electrons moving at great speed) struck the high atmosphere, provoking its gradual erosion. Different mechanisms came together like this to wrest atoms or molecules away from Mars's atmosphere, which are then carried into the interplanetary medium.

Due to an atmosphere dense with carbonic gas, the greenhouse effect spreads progressively through the low pressure. A slight lowering of the temperature causes the condensation of less volatile elements, diminishing again the greenhouse effect, which in turn ushers in a new lowering of the temperature, and so on. In less than

ASTRONOMICAL UNIT
The average distance from Earth to the Sun. One astronomical unit (ua) is equal to about 150 million kilometers (ninety-three million miles).

GREENHOUSE EFFECT
The greenhouse effect principle states that an atmosphere allows solar rays (during the day only) to pass through it so that the ground absorbs and re-emits (during the day and at night) this energy in the form of infrared rays that are this time absorbed by the atmosphere. This heats up the planet and makes it send back toward the ground a part of the energy that escaped it, effecting a reduction in heat loss and therefore raising the ground temperature.

one hundred million years, pressure and temperature were reaching levels that were close to its current situation. Today the atmosphere, composed of 95 percent carbon dioxide gas, produces a surface pressure of only six to ten mbar. (As long as can be remembered, the atmospheric pressure of Earth has been about one thousand mbar.) And the temperature on Mars ranges widely, with temperatures changing from 0° to 100° C (32° to 212° F) between night and day. Before becoming a frozen desert, Mars would go through an intermediary period characterized by a powerful meteoric bombardment* and intense volcanic activity that released great quantities of sulfur in the atmosphere. Its environment was generally dry but was occasionally punctuated by humid periods in an acidic and sulfured milieu propitious for the formation of sulfates. Having brushed over this summary of Mars's primitive history, we will evoke the geology of the planet over the ages in greater detail.

To write the history of Mars's evolution from its formation to our time is one of the fundamental objectives in the study of this planet. Of course, this history is constructed bit by bit as a stream of new results is brought in. To take on this long-term study, one has to go over the ensemble of available technical means for studying a celestial body. The entirety of the accessible electromagnetic spectrum is used, from the largest radio waves (for the study of an ionized environment or for the sounding of depths of the ground) to the shortest wavelengths, such as X or gamma rays that inform us about the elementary composition of surface minerals (silicon, magnesium, iron, oxygen, hydrogen, and so on). These studies require observations both from orbit (in order to access the global covering of the astral body) and also of the ground itself, analyzing samples of the solid or gaseous elements on the surface in order to determine their mineral, molecular, atomic, and isotopic compositions. Finally, we will see, it will be necessary to envisage the ultimate transport of fragments of Mars to Earth in order to study them with the help of immobile instruments on our planet.

In order to understand Mars's evolution, it is necessary to retrace the history of its interior, its surface, its atmosphere, three interlinked components that react to one another. Thus, the de-gassing of the interior of Mars is at the origin of its primordial atmosphere, and the existence of volcanoes has to do with a particular internal activity. Another example, the existence of a fluid core, produces, in a "dynamo" effect*, a bipolar magnetic field that protects against the interplanetary medium and, consequently, the solar wind.

THE EVOLUTION OF MARS

The surface and interior of the recently formed planet Mars are extremely hot. That is due, notably, to the accumulation of heat caused by intensive bombardment that rages through the entire solar system and especially on Mars. The kinetic energy of asteroids that pound the planet is transformed largely into heat that liquefies part of the impacted area. Another source, coming from the decrease of radioactive elements such as uranium, thorium, and potassium, liberates immense quantities of heat that last for a long time. It is estimated that the primordial radioactivity could have elevated the internal temperature up to 2,000° C (3,632° F), the temperature threshold at which iron begins to fuse. The strong density of iron creates its collapse toward the center of the astral body, dragging with it other heavy elements such as nickel. The melting of iron also caused the melting of other, lighter elements that, in turn, moved up toward the surface to form a floating crust on top of what was probably a melted mantle (an ocean of magma). This process comprises differentiation*, the splitting up of the planet into a core of densely rich iron and nickel, an intermediary mantle, and a lighter crust.

During this entire period, the interplanetary medium was subjected to intense meteoritic bombardment, traces of which are visible as impact craters on the Moon, Mars, and other bodies. Nevertheless, in general, the first hundred million years after the collapse of the primitive nebula* did not leave any visible trace on Mars's surface, and the geological study of the planet, notably through the interpretation of images taken by probes in space, only gives researchers access to the last four billion years. This bombardment, while diminishing, has continued until recently and will allow us to construct a chronology of Martian events, however relative and greatly imprecise in determining absolute eras.

DIFFERENTIATION
During the formation of a planet, it can differentiate itself to form the surface crust, the subjacent mantle, and the central core. This differentiation is produced if, through the pull of gravity and sources of internal heat, the matter becomes fluid, provoking the melting of heavy atoms such as iron and nickel, which will accumulate at the core. Inversely, light material will migrate toward the surface and will constitute the crust. This process happens only if the planetary body has a diameter of at least five hundred to one thousand kilometers (three hundred to six hundred miles).

PRIMITIVE (OR SOLAR) NEBULA
The primitive nebula is a cloud of gas and dust from which the solar system was formed. This hypothesis was proposed for the first time in 1734 by Emanuel Swedenborg and in 1755 by Emmanuel Kant, both of whom supposed that the nebula turned slowly on itself, gradually condensing and flattening through the pull of gravity and creating an accretion disc that later formed the Sun and the planets. A similar model was proposed in 1796 by Pierre-Simon Laplace.

AREOGRAPHY

THE ORIGIN OF LONGITUDES

To establish the cartography of a planetary surface, it's necessary to define a system of longitudinal and latitudinal coordinates and to locate the point of origin. The origin of latitudes is easily defined as a great median circle at equal distance from the two poles. For the origin of longitudes, the zero point needs to be defined arbitrarily.

It should be close to the equator and easily observable with a small telescope. In the nineteenth century, observatories had two markedly contrasting, neighboring reference "points" situated on the equator. The origin of longitudes was designated at the intersection of these two points. With the improvement in the quality of observations, it was necessary to be more precise. A small crater (five hundred meters, or 1,600 feet, in diameter) in the *Sinus Meridiani* region, named *Airy* after the British astronomer and optician George Biddell Airy, was finally chosen.

Whoever wishes to understand Mars's history and its complex evolution should have a geographic or areographic spirit. Four great, geological formations characterize its surface: a crustal dichotomy, the large basins of impact,* the dome of *Tharsis*, and the volcanic structures.

THE CRUSTAL DICHOTOMY

IMPACT BASIN
A very large crater of meteoric impact that pierced the crust and provoked an outpouring of lava.

The crustal dichotomy of Mars is the most basic process that affected its morphology quite early in its history. It is characterized by a morphological frontier situated on a large circle inclined about 35° from the equator and separates the young and smooth plains at the north from the ancient high plateaus at the south—which are strongly craterized and where one can detect faults, steep cliffs, and chaotic regions. The difference in altitude of the two regions is at least six thousand meters (twenty thousand feet). This probably happened very early in Mars's history, about four billion years ago. The origin of this dichotomy is imperfectly understood. It has been proposed that it resulted from a variation in thickness of the crust having a tectonic origin, as it is sixty kilometers (thirty-seven miles) thick in the south and only thirty kilometers (nineteen miles) on the level of the plains. Processes of convection and subduction belonging to a tectonic forging of the plates might have caused an accumulation of lava that was greater in the south than in the north. Nevertheless, without excluding this tectonic hypothesis, another origin may be the impact of one or more larger celestial bodies (approximately one hundred kilometers, or sixty-two miles, in diameter) that may have crashed on Mars's northern side, leaving a gigantic crater on impact. The latter—comparable to the immense craters on the Moon (*Aitken* basin: 2,500 kilometers, or 1,500 miles, in diameter) and on Mercury (*Caloris* crater: 1,500 kilometers, or nine hundred miles,

in diameter)—is the largest of the solar system. Recent hypotheses that are particularly seductive associate both endogenous and exogenous causes. One (or several) bodies smaller than the Moon struck the planet during its first hundred million years. The impact brought on considerable heat that diffused itself laterally over more than half of the globe, creating an ocean of magma. As it cooled down, this magma crystalized into a thick crust of silicates. This localized source of heat would also induce an increase in convection on the mantle before evacuating the excessive heat. A large plume of magma developed in depth and then progressively accumulated a significant volume of matter on the surface, creating the gigantic dome of *Tharsis*—which represents 80 percent of Mars's diameter! This model also predicts quite simply the correlation between the intense bombardment producing both an input of heat and surplus tectonic and volcanic activities.

One has to recognize that gravimetric measurements were unable to reveal the presence of any large, ancient crater that may have subsisted these impacts. In fact, the origins of this dichotomy is not for sure known.

IMPACT BASINS

In its southern regions, Mars is essentially covered by craters that resulted from an ancient bombardment—the traces of which were frequently preserved. The biggest are called basins of impact because they pierced the crust and reached the mantle. They date from approximately four billion years ago, that is, they are contemporaneous with the late heavy bombardment.* If five basins have been recently counted, only three are easily visible on the globe and have been recognized as such for several decades. One is *Hellas* [p. 98, 99, 100], the biggest and deepest. Its diameter is 2,200 kilometers (1,400 miles) and it is 9.5 kilometers (5.9 miles) deep in the *Coronae Scopulus*, which makes it the lowest point on Mars. The crater is bordered on the east and west by ramparts that form eroded mountains culminating two thousand meters above the crater's floor. The evolution of the crater after its formation was complex and caused volcanic interventions and outflows of mud. On the east is *Dao Vallis*, a long valley of more than eight hundred kilometers (five hundred miles) that drained out huge quantities of water and mud, resulting in the possible melting of a ground rich with ice* water.

LATE HEAVY BOMBARDMENT OR LHB
About four billion years ago, the slow migrations of Jupiter and Saturn toward the Sun ended resonantly when Saturn's rotations became two times longer than Jupiter's. Gravitational disturbances became more cumulative, which completely destabilized the orbit of asteroids beyond Neptune. These penetrated the internal solar system and intensely bombarded the planets. The LHB was discovered with studies of the lunar craters.

ICE(S)
Volatile molecules—such as ammoniac, molecular nitrogen, carbonic dioxide, water, molecular hydrogen, methane—that are chemical species having a low boiling point. When these species condense at a low temperature, they form ice, of which water ice is one example.

At the southwest, a chain of *caldeiras** was uncovered, and today we know that the southern end of the crater is covered by a huge expanse of lava that came from these aligned volcanoes.

Argyre Planitia [p. 101] is the second crater from the impacts, and has a diameter of eight hundred kilometers (five hundred miles) and a depth of more than five kilometers (3.1 miles). *Agyre* is situated west of *Hellas* at southern latitudes of 50° (compared to 43° for *Hellas*). Further north is *Isidis*, straddling the "dichotomy" of the planet. These three basins are more or less situated at the antipodes of important volcanoes. This singular positioning allows the suggestion that the major impacts, having created these basins, could have also provoked the emergence of volcanic activity at the antipodes. The ages of the volcanoes and the basins, as well as their positioning, make this hypothesis plausible.

After the discovery of these three basins at the beginning of the era of space exploration, it was determined that the plain *Utopia Planitia*, northwest of the *Olympus Mons*, and more modestly *Chryse Planitia*, at the mouth of chaos *Margaritifer,* are also ancient impact basins.

CALDEIRA (OR *CALDERA*)
A *caldeira* is a vast circular or elliptical depression, generally of a kilometric order and often with a flat floor, situated at the heart of certain large, volcanic structures and resulting from an eruption that emptied the subjacent magmatic chamber.

THE CRATERS

Mars's surface is riddled with impact craters [p. 30, 31, 39, 54, 61, 70, 71, 75, 91, 153, 165]. The bombardment that created them was probably similar to the one that affected the Moon and our Earth. Like the Moon, Mars has conserved the scars from this rain of rocks over a large part of its surface, and this abundance of craters is, moreover, a method of dating the surface of a body.

This admittedly relative mode of dating lets us know if one surface is younger or older than another. Obtaining absolute dates when determining ages is more complex, as shown by the fact that these absolute ages have varied considerably over the last few decades of research. The method is based on the idea that the flux of meteoritic bombardments can be used as a means for dating a surface when this flux can be determined independently. Very intense at the beginning of formation of the planets, meteoritic bombardments have, though decreasing progressively, lasted to this day. This slow decrease was interrupted by what has been called the "late heavy bombardment," coincident with a second migration of the giant planets due to their respective interactions and to the presence of the Kuiper belt situated beyond Neptune. This slowing

down set off a slow spiraling of Jupiter toward the Sun. Around 3.8–4.1 billion years ago, its period of revolution around the Sun became half of Saturn's, which provoked a phenomenon of resonance between the two bodies. The small effects of disturbances, which had theretofore habitually cancelled each other out, began instead to accumulate. These tiny, cumulative nothings had devastating consequences, unleashing a veritable chaos in the solar system pushing the ice giants, Uranus and Neptune, outward into the Kuiper belt. Neptune's intrusion throws off the trajectory of asteroids of the main belt. These were then ejected and dispersed, some of them hitting planets throughout the solar system.

Models of these first hundreds of millions of years are meant to determine the flux of impacts through time. But the different teams conducting these studies do not always agree.

For a given surface, the more significant the density of craters, the more it has been subjected to a bombardment of long duration. If one could assess this flux over time, the measurement of the density of craters would give us the age of the surface. This method has been applied to the lunar surface from which the Apollo missions retrieved samples of rock and soil. The analyses of radioactive isotopic elements in the samples brought back from different geological entities on the Moon made it possible to arrive at an absolute and precise dating (within a million-year span). The curve of the crater density as a function of surface's age could thus be "nailed." This method has subsequently been transposed to Mars, with some hypotheses on the flux of meteorites at the level of its orbit in relation to the flux received on Earth (and therefore on the Moon). The result reveals that the method is relatively precise for the primordial, intense flux at the beginning, but is more uncertain when taking into account the flux related to the late heavy bombardment.

To facilitate a description of the planet's evolution, it seemed useful to organize its geological history into three defined periods in a rather arbitrary fashion. The Noachian* period thus corresponds to the oldest surfaces, which represent half of Mars's total surface—as compared to less than 1 percent of the total surface of Earth, proof that erosion and continental drift on Earth have eradicated its oldest surfaces. The intermediary period is called Hesperian,* and the most recent, Amazonian.* The transition between the Noachian and the Hesperian corresponds to the time of geological unity of *Hesperia Planum* at the northwest of *Hellas*, a plateau partially covered by fluid outpourings from the volcano

NOACHIAN
The first of the three Martian geological epochs, extending from about 4.6 to 3.7 billion years ago. The most ancient terrains on Mars, situated on high, cratered plateaus mainly on its southern hemisphere, correspond to this epoch.

HESPERIAN
The second of three geological Martian epochs, this is the intermediary period extending 3.7 to 3.2 billion years, though another estimation situates it between four and 3.5 billion years. It corresponds to the aftermath of a meteoritic bombardment (see Late Heavy Bombardment, p. 98) and strong volcanic activity. The main volcanoes on Mars have ages that correspond to the Hesperian.

AMAZONIAN
On the scale of Martian geological time, the Amazonian is the most recent period, and the one to which the present epoch belongs. The Amazonian period began between 3.5 and 3.2 billion years ago, according to the authors. The climate is cold and dry, and eolian activity dominates.

Tyrrhena Patera. In a similar way, the Hesperian-Amazonian transition corresponds to the *Amazonis Planitia* west of *Olympus Mons*.

After more than twenty years of studying the dating method of the planet's geologic entities, in the 1980s planetologists arrived at the conclusion that the Amazonian period, when frozen deserts were swept by winds and which represents at least half of Mars's history, today covers more than three quarters of its existence. In other words, the volcanic and eventful period on Mars did not last some three billion years, as previously thought, but rather only one billion. All the Martian events thus became suddenly older.

<div align="center">THE DOME OF THARSIS</div>

"Mars is like the Moon plus the dome of *Tharsis*." This way of summarizing the history of Mars is symptomatic of the importance this dome has in the evolution of the planet. The bulge of *Tharsis*—the largest volcanic formation on the planet—is a vast up-thrust of about 5,500 meters (18,045 feet) above the reference level. Centered not far from *Noctis Labyrinthus* [p. 11], it supports three of the most important volcanic structures on Mars: *Olympus Mons* [p. 90, 94, 96]; the three volcanoes of *Tharsis*; and the large *Alba Patera* (1,600 kilometers, or one thousand miles, in diameter), which is surrounded by multiple fissures and situated at the antipodes of *Hellas*. The dome of *Tharsis* also harbors high plateaus of more than five thousand meters (3,100 miles) in altitude, and the multiple canyons of *Valles Marineris* [p. 9, 12, 13, 14, 25].

THE SURFACE ON MARS, HERITAGE OF ITS EVOLUTION

To understand what the surface on Mars reveals, it is necessary to retrace the various phenomena that affected its appearance. This involves waters in both liquid and solid form, but also wind. In fact, the mechanical action of the wind on a surface over a period of billions of years creates considerable macroscopic effects that are visible in the HiRISE images. These long-term effects don't have their equivalent on Earth, whose surface was above all affected by water and the drift of its tectonic plates.

Water ice* is and has been omnipresent on Mars. Except for that at its poles, the ice today is currently unstable and rapidly converts into vapor. Deposits of ice, traces of which can be seen today, have nevertheless accumulated. Let us recall that one of the most important properties of water is that it contracts when melting and dilates when freezing.

These mechanical effects leave visible imprints on the surface when the ice is buried. The terrestrial permafrost is a quasi-permanent frozen ground. If the ice melts temporarily then freezes again, the water's effects of contraction and dilation will be translated by the presence of more or less regular polygonal forms [p. 53, 134, 136]. These polygonal motifs have been observed in multiple regions, often at high altitudes, attesting to the presence of ice in the ground. The site where *Phoenix* landed in 2008 is studded with these polygonal forms in agglomerations of blocks of about three meters (ten feet) that, taken together, measure about twenty meters (sixty feet). These visible features have a sorting effect on the small rocks on the surface, which group themselves in a regular fashion due to the surface's contraction and dilation. However, on Mars it isn't necessary to go through the liquid phase, since the difference between the temperature in winter and summer is 80° C (176° F), which creates a sufficient contraction and dilation of the ice to explain the formation of the polygons. A drying mechanism can explain the observed formations, even if the de-icing of the water contributes to it as well.

Glacial activity had an equally important role on Mars. Ancient glacial valleys in a *U* formation have been identified. The region west and south of *Olympus Mons* has been interpreted as an ancient glacial valley dating to the epoch when ice accumulated at the middle latitudes. The ground there is ravined by glaciers that have disappeared today. The volcano itself is bordered by abrupt cliffs. It is difficult to imagine that the volcano came out of the ground and that cliffs appear due to that movement. Instead, it is very probable that these features were the result of the ravine formations in the terrain surrounding the volcano, and that glaciers that dug the ground to a significant depth are what uncovered the cliffs. Simulations of the climate on Mars have moreover uncovered that ice deposits for an important obliquity* are to the west of the large volcanoes of *Tharsis*, which seems to support the hypothesis that an ancient glacier bordering *Olympus Mons* existed at a very distant epoch.

Other regions reveal the presence of flows that are typically glacial [p. 64]. For example, a crater pours fluid matter into an adjoining crater; it crosses a narrow channel in its passage. This double crater,

WATER ICE
Water in solid form. Due to the weak pressure on Mars, water can't exist on the surface except in solid or gaseous form. Outside of the poles, water ice on the surface sublimates quickly. White frost from water has been observed in early mornings. It sublimates quickly with the rising Sun. Only glaciers covered by a protective layer of sediments exist still today on Mars.

OBLIQUITY
The inclination of an axis or obliquity is a magnitude that gives the angle between the rotational axis of a planet (or a natural satellite of a planet) and a perpendicular to its orbital plan.

named *Hourglass*, is characteristic of the presence of ice having flowed as slowly as a mountain glacier. This glacier is currently covered by a thick layer of solidified dust. Glacial fillers of this type are frequent at middle latitudes, and when the layer of ice is sufficiently thick it can be detected by radar soundings.

THE EFFECTS OF WATER

CHAOS Very common terrains on Mars, the Chaos or chaotic terrains, are specific to the planet. In fact, these terrains are found only very sporadically on Earth—and not at all on other planets. *Margaritifier Terra* is situated at the mouth of *Valles Marineris*. As vast as Europe, this region stretches out over close to three thousand kilometers (1,900 miles) from north to south and from east to west. Chaotic regions also border the frontier between the southern plateaus and the northern plains, and are also present at the depths of the large crater *Hellas*.

Chaotic terrains are regions where the ground has melted locally and sometimes only partially, allowing the hills, called *mensae** ("tables" in Latin), or local plateaus to appear. A chaotic region is often striped like a zebra in two directions; deep valleys delineate the *mensae* [p. 46, 87]. These terrains are often compared to valleys of down-stream collapses*. The chaos has often been interpreted as source of the fluid matters that led to such collapses.

The very presence of the chaotic terrains confirms that the melting of the ground was only partial. Notably, the *mensae*, unmelted zones, and dunes correspond to incomplete meltings. That is why it is likely that these unmelted grounds shelter large amounts of water ice.

By which phenomenon was the melting in the chaotic zones provoked? Their age is very old—more than 3.5 billion years. The first state was the piling up of sediments rich in ice. It's possible that warm periods may have existed, periods during which water must have flowed abundantly. These warm periods must have been succeeded by colder ones during which these sediments were cemented by the ice from the water.

During a second period of time, a warming-up happened again, either coming from the interior due to an upsurge in volcanic activity or provoked by the action of the Sun during a period of large obliquity. This localized melting of the ground brought on gigantic collapses, as testified by the numerous valleys that furrow *Margaritifer Terra*

MENSA, MENSAE OR MESAS
Mensa, "table" in Latin, designates an elevation of surface whose top is flat and the sides are cliffs. The *mensae* on Mars are numerous, notably in the chaotic regions.

DOWN-STREAM COLLAPSES characterizes the melting of a river or ocean. On Mars, down-stream collapses or outflow channels are observed. The source of the debacle is due to the melting of ice on the ground, or the eruption of water or fluid lava underground.

and *Ares Vallis.* Another hypothesis for explaining this immense chaotic region is the presence of *Valles Marineris* above it. It is certain that the giant canyon of tectonic origin saw significant volumes of water circulating from the west, that is, toward *Margaritifer*, which poured into the plain further north in *Chryse Planitia*. It is probable that these diverse mechanisms acted in conjunction. The case of *Aram Chaos* [p. 18] is interesting in this regard.

A crater three hundred kilometers (190 miles) to the west of *Margaritifer Terra, Aram Chaos*, is the largest chaotic region on Mars. The interior of the crater has undergone a chaotic, global melting. Completely filled with ice water, the ground itself melted because of melting ice. The ramparts of the crater are nevertheless still present. With the exception of a narrow valley to the east of the crater, into which all or some of the immense volume of water and debris must have accumulated only to flow out into the big valley of collapse, *Ares Vallis*, two thousand kilometers (1,200 miles) in length, opens out in the plain of *Chryse Planitia*. Moreover, the presence of this important valley of collapse was the main argument for the landing site of *Pathfinder* in 1996, which was at the mouth of the valley. Gray hematite [p. 34], a mineral that is formed with the presence of water, has been detected in the grounds of *Aram Chaos*.

TURBULENT TERRAINS Turbulent terrains (or fretted terrains) are encountered all along the frontier between the plateaus of the south and the plains of the north. One finds them also in the *Hellas* crater. Situated in steeply sloping zones, they correspond to transitional regions between the plateaus and the plains that having been traversed by large quantities of water, and were therefore left abundantly eroded. In them one can find cliffs again at several gradient levels of large fluvial valleys with a flat bottom.

Crater *Gale*, where the rover *MSL* was placed in the summer of 2012, is located precisely in this transitional region.

FLUVIAL VALLEYS AND HYDRATED MINERALS Streaming water on the surface of Mars has essentially left two kinds of traces: the ramified valleys (*Valley Network*) and the valleys of collapse (*Outflow Channel*) [p. 48, 84]. The first, also called fluvial dendritical valleys, are the oldest, and might have been shaped during long episodes of flow at the beginning of Mars's history. The second presents a very different morphology, and would be associated with brutal discharges over short periods of time.

Ramified valleys appeared quite early in the history of Mars, at the end of the Noachian epoch. They are situated exclusively on very old, high, cratered plateaus. These valleys resemble our terrestrial rivers, but their structure is less complex, having a smaller number of ramifications. The valleys' beds have a very pronounced *U* shape. In general, their length doesn't reach beyond two hundred kilometers (120 miles), and their width is rarely more than a few kilometers. Some, nevertheless, are several hundred kilometers in length by tens of kilometers in width.

Ramified valleys are smaller, for the most part, than outflow channels, and they correspond to lesser floods. A priori, they could have been formed by running water that may have come from either precipitations or water released from below ground. But the absence of small-sized branches suggests an origin linked instead to subterranean rather than to rain water. One of the most meaningful examples of ramified valleys is *Nanedi Vallis*, which, having flowed for centuries or millennia, has a structure completely similar to a terrestrial river. Sometimes the valleys were filled with deposits, forming inverted channels.

Certain attenuations of this valley are tapestried by sediments that could contain clays. These minerals, discovered in 2005 by the OMEGA instrument of *Mars Express*, are proof that Mars underwent a period some four billion years ago when water flowed abundantly over its surface. The fluvial valleys and the clays are dated from the same epoch. The link between the valleys and clays has sometimes been established even if clays were found in other ancient terrains not related to this kind of valley as well. The presence of clays is characteristic of the most ancient terrains on Mars.

Other rocks linked with water have been discovered, such as sulfates. Rich in sulfur, these minerals are posterior to the presence of clays. They correspond to the intermediary period of Hesperian, when Mars underwent an intense volcanic activity that released large quantities of sulfur into the atmosphere. The sulfates represent an epoch when water was less abundant and the environment was acidic. One tends to think that the epoch of sulfates was generally a period of dryness interrupted by brief events rich in acidic water.

THE GIGANTIC COLLAPSES OF THE *KASEI VALLES* The outflow channels are posterior to the ramified valleys. They are the result of violent phenomena implying great volumes of water. *Kasei Valles* is the biggest system of valleys carved by water on Mars. *Kasei* ("Mars"

in Japanese) extends over more than 2,400 kilometers (1,500 miles) in length from *Echus Chasma** to the north of *Valles Marineris* to the plain of *Chryse Planitia*. At its mouth, the valley is four hundred kilometers (250 miles) wide. Since 1972, the *Mariner 9* orbiter located this valley and identified that it had been formed after several successive outflows. All along the valleys, the reliefs were sculpted by water. The ground and the shaping of obstacles such as the craters were eroded by torrential floods. The valleys were hollowed out to depths of one thousand to two thousand meters (3,300 to 6,600 feet) in relation to the plateaus (*mensae*) that remain in place. The considerable volume excavated during the collapses could obviously not have been eroded by local rains. The source of the collapse is situated upstream from *Kasei* in *Echus Chasma*.

The valley of *Echus Chasma* is bordered at the north by a cliff of more than five thousand meters (sixteen thousand feet) whose summit is part of the *Tharsis* plateau. Bear in mind that the formation of *Tharsis* comes from the rising of hot lava from underground. The heat brought on during its formation spread close to the surface and melted the ice contained on the ground surrounding *Tharsis*, especially to the north. The meltdown created the collapse that ravined *Echus* and swallowed the region of *Kasei*. Let us note that now *Echus* is a valley with a flat bottom situated more than one thousand meters (3,280 feet) below the plateaus and devoid of reliefs at its center. This shows that the collapses were rich in water and extremely destructive, since no reliefs remain in the valley. One could determine that the valley underwent several successive outflows that varied in intensity, the strongest of which having submerged the *Sacra Mensa* situated between the two main valleys of *Kasei*.

CHASMA, CHASMATA
A very steep valley or canyon.

If one takes into consideration the volumes eroded and the dimensions of its valleys, *Kasei* is the most extreme example that existed on the planet. But other, more modest *Kaseis* have existed in Mars's multiple regions. It's a common phenomenon that occurred throughout the first billion of years of Mars's life.

ATHABASCA VALLES: THE WATER SPRINGING UP FROM THE GROUND FAULTS The case of *Athabasca Valles* is unique and it has been frequently studied because its source is perfectly identified. This outflow channel is situated to the southwest of the massive volcano *Elysium* in *Elysium Planitia*. This large valley with slight outcroppings extends over nearly three hundred kilometers (190 miles), and the images reveal reliefs that are characteristic of an erosion due to a gigantic

outflow of water. Numerous craters forming water ramparts are found today surrounded by a "drop-of-water" type of erosion; the tip pointing downstream. Other craters were submerged by water and today are but small, crescent-shaped hillocks, the rest of their circular form having been completely eroded. But the particular attraction of *Athabasca Valles* is its having been one of the youngest outflows on Mars. It must have been active at the end of the Amazonian period and some studies give it an age of only two million years! This recent resurgence of fluid magma and liquid water is to be corroborated by the numerous analyses attesting that an underground environment, simultaneously warm and wet, could still exist today in Mars's underground. However, to drill to kilometric depths is still inconceivable for at least half a century and there would have to be solidly convincing arguments as to whether this enterprise is worth undertaking.

The source of this breakdown is *Cerberus Fossae,* a series of faults situated upstream from *Athabasca*. One of the faults of *Cerberus* reaches more than 1,500 kilometers (930 miles) in length, while its width in some places is but ten meters (thirty feet) or so. This one seems to be extremely young because it has been little eroded. Its presence is proof that more recent outpourings were made by water devoid of lava. In fact, if the lava had been solidified it would have hidden the fault. Estimations of the violence of floods have been proposed. One rate is estimated from the volume eroded in this valley, the equivalent of a cube with one-hundred-meter sides for every second. This flow corresponds to five times the average flow of the Amazon, the river with the greatest flow on Earth. Elsewhere, the height of the craters's eroded ramparts here and there reaches about one hundred meters (328 feet), which gives an idea of the cataclysmic event that befell this region.

Anywhere that water rushed in with force caused an erosion that is easily visible today. Inversely, stagnant water leaves few traces. Does it remain liquid to form lakes or oceans? Does it freeze quickly to form glaciers? Or else does it sink into the ground to disappear once more? It's possible that these three phenomena could have been found on Mars because of conditions that dominated during the epoch of outflows. The latter stretched over a great period of time, typically between four and one billion years ago. But it is also possible that these conditions could have been found very recently, since the cataclysm that produced the *Athabasca Valles* occurred only several million years ago.

THE YOUNG RAVINES In 2000, Mike Malin and Kenneth Edgett, who were responsible for the camera of the *Mars Global Surveyor*, announced the discovery of flows that caused the gullies that are perfectly visible on about two hundred and fifty sites, mainly concentrated in the southern hemisphere.

The remarkable fact is that these flows seem to be very recent. These little gullies [p. 69, 106, 130] are situated on the flanks of certain craters and face toward the south, that is, on the flank least affected by the Sun, which at first seems paradoxical. Their lengths range from about a hundred meters (three hundred feet) to one kilometer (0.6 miles) and seem to be astonishingly fresh. The arguments affirming the youthful age of these phenomena are triple: the absence of craters of impact in these zones; the debris caused by the gully that has accumulated on the dunes is certainly less than a million years old; and, finally, these manifestations seem very little eroded (and therefore young).

Until now, Mars was considered a planet where liquid water flowed abundantly during epochs going back several billion years, whereas the temperature and conditions now, especially the pressure, make water unstable in liquid form: ice melts and liquid water begins to boil immediately. Hence the surprise caused by the publication of Malin and Edgett's article, and the discussion that ensued is hardly closed. The authors imagined a mechanism through which ice boulders formed at the flanks of the crater could have broken and violently released water highly charged with mineral salts, such as the sulfates discovered earlier. The presence of salts, as in our terrestrial oceans, in effect allows the conservation of water in its liquid form at lower temperatures than pure water. The latter, while evaporating, has time to cause visible effects before disappearing either as vapor. But the idea that liquid water can be found beneath the ground on Mars at a depth of only several hundred meters doesn't seem realistic, and this schema has been judged unsatisfactory. Other authors have recently proposed an analogous mechanism provoked not by water but by CO_2 that, it's true, is much more abundant in the atmosphere.

But the most interesting interpretation was formulated by Philip Christensen of the University of Arizona. According to his model, deposits of snow and dust accumulated on the craters' flanks. The temperature on the surface, for obliquities superior to 45° on the middle latitudes during summer, could, within hours or even months, exceed the point of fusion of ice. In summer, at the south pole, great

amounts of ice water would begin to sublimate and melt. The corresponding increase in temperature and pressure would permit water to flow on the surface. At the middle latitudes, accumulated deposits then begin to melt, producing the observed gullies.

But the origin and age of the gullies remain the subject of intense discussion. Recent studies have shown that they are of different types, implying several mechanisms at work, including the case of dry flows without any liquid elements.

In 2011, then more recently in 2015, the discovery of recurring slope lineae (RSL) came as a surprise. These even and dark linear flows appear in early summer when temperatures are at their hottest and they recur year after year. The seasonal arguments suggest the presence of liquid flows due to water. In 2015, the presence of salts, perchlorates, was confirmed, reinforcing the idea that the phenomenon is provoked by liquid water with high salt content.

VOLCANIC ACTIVITIES

Volcanic and tectonic action [p. 15, 32] on Mars played a determining role in the molding of its surface, in particular through the frequent interaction with the abundant ice beneath its ground. The very beginning of Mars's history seems to have been deprived of volcanic activity, which didn't begin until about four hundred million years after its formation. It is even proposed that volcanic activity started with the late heavy bombardment only four billion years ago. The age of the large impact basins (*Hellas*, *Argyre*, or even the plain of *Utopia*) corresponds to this epoch, and their location not far from the antipodes of the large volcanoes, seem like convincing arguments. The violent impact, having created a large crater, provoked a seismic wave that would traverse the planet on several paths converging upon a region at the antipodes of the point of impact. This focalization of seismic waves would have shaken up a large region and unleashed tectonic movements, creating the opening up of faults that were able to release massive volcanic eruptions. On Earth, the Deccan traps in India are an example of this kind of gushing volcanic activity spreading enormous layers of liquid lava.

ERUPTIVE VOLCANOES This period of transition, about four billion years ago, is decisive because it is also around this epoch that magmatic movements [p. 82] in the mantle near the core would cease,

provoking the disappearance of the bipolar magnetic field of Mars and leaving a thick atmosphere in direct contact with solar wind, which resulted in its progressive waning.

The hot magma will maintain an intense eruptive activity near the surface for another four hundred million years. After that, this activity will decrease significantly but not completely. The last eruptions have been dated to around 1.5 billion years ago and, more recently, in the last four hundred million years, but they are considered of little importance. To be precise, several young flows have been dated at ten million years old, proof that the volcanoes didn't cool off completely and that a residual activity could have subsisted until now. Today, however, no evidence of activity has appeared and no hot spot has been found.

This intense eruptive activity liberated huge quantities of dust and sulfur dioxide (SO_2). These dusts, cemented today and associated with very fluid lava, cover immense regions on Mars. Thus, the great majority of Martian surfaces are linked to a volcanic or magmatic origin. In certain regions, volcanic dusts, dispersed by wind, have regrouped to form dark dunes. Thus the largest field of dark dunes on Mars borders the North pole, a sign that important volcanic activity existed in this region. Consequently, numerous small volcanic structures have been identified in the boreal region. But the link between these cones and the dark dunes is yet to be established.

Elsewhere, the volcanic sulfur [p. 18, 96] interacted with rocks to form sulfates such as gypsum (hydrated calcium sulfate) and kieserite (hydrated magnesium sulfate). These minerals were produced during the Hesperian period, when Mars experienced transitory humid periods in an acid environment.

VOLCANIC EFFUSIONS Though less visible on the surface than a massive volcanic shield, a particularity of Mars is that it has undergone significant volcanic activity of a particular type: effusive eruptions. This phenomenon, less violent than explosions into the air, doesn't produce dust, but rather astonishingly fluid lavas [p. 86] that were certainly saturated with water that flows in practically horizontal waves. Faults (*fossae*) [p. 88], created by a localized tectonic upheaval and causing a fracture on the surface, are often the volcanic sources. At an exceptionally vast scale, the tectonic bulge of *Tharsis*, with its very numerous faults, has provoked a rupture of more than four thousand kilometers (2,500 miles) in length and several hundred kilometers wide, and opened the large canyon *Valles Marineris.* But

this extreme phenomenon is unique: the other faults rarely reach a thousand kilometers (620 miles) in length and generally only several kilometers in width.

These faults [p. 91] can expel a very fluid lava that spreads over tens of thousands of square kilometers. This phenomenon, which has regularly appeared on Earth, is also evident on great expanses of the Moon and Mercury. Another particularity unique to Mars is the presence of a large quantity of water in the form of ice or even liquid underground. The fluid lava comes into contact with the ice, making it melt, which causes enormous and extremely liquid overflows exclusively consisting of water. It's this emergence of a great quantity of water from underground that creates outflows, which are numerous on the planet.

Like on Earth, lava sometimes flows under the surface of an already-solidified ground. This provokes subterranean tunnels [p. 89] that appear on the surface during the ground's meltdown. Then, pits that are more or less circular and often aligned appear.

THE ACTION OF WIND

During the major part of its evolution, Mars went through a long period during which climatic conditions were close to what they are today. There certainly were a few volcanic episodes that have diminished over time, even if one dated the young lava flows at only a few million years. These late eruptions do not measure up to the massive eruptions during the Hesperian epoch. Mars became a desert of ice for more than three billion years. During two-thirds of its existence, its contour has been altered mainly by wind [p. 36, 67, 117, 125, 157].

This is a unique case in the solar system. In fact, Mars is the only planetary body that has an atmosphere and a surface that is very ancient. The high, cratered plateaus that represent close to 60 percent of its total surface have ages of greater than 3.5 billion years—and actually, for some, greater than four billion years. Certain bodies have even more ancient surfaces, such as the Moon and Callisto, a satellite of Jupiter; but they don't have an atmosphere. Those which do have an atmosphere, such as Venus or Earth, have younger surfaces. (Venus's surface is typically less than a billion years old, for example.) The gaseous and icy planets may very well have a thick atmosphere traversed by violent winds, but these planets have no surface except at the level of their core.

CLIMATE

Because of its greater distance from the Sun, Mars receives significantly less solar energy than Earth. Moreover, the weak surface pressure (six to eight mbar) produces a very weak greenhouse effect. Its average annual temperature is -53° C (-63° F), as compared to +14° C (57° F) on Earth. It can vary from about -125° C (-193° F) at the South Pole in winter to 23° C (73° F), the maximum temperature measured by *Viking* lander. The planet has daily thermal variations of close to 100° C (212° F), which could possibly be explained by the absence of oceans, which on Earth create a strong thermal inertia that attenuates extreme variations in temperature. But these wide temperature ranges are equally due to an almost complete absence of clouds. On Earth, clouds block thermal radiation emitted by the surface, which prevents the atmosphere from becoming cold at night. On Mars, the surface radiates and cools off quickly because of the absence of clouds. One consequence is that the temperature varies notably within the first few meters: a man on Mars would experience a difference of about twenty degrees Celsius between his head and his feet.

Nevertheless, clouds are seen occasionally on Mars. The atmosphere contains only traces of water vapor, but its pressure and temperature explain why that vapor is always so close to the saturation point, when water vapor becomes liquid. It's why clouds can appear, as on Earth, through the condensation of water vapor. At very high altitudes, where the temperature is sufficiently low, carbon dioxide (which makes up most of the atmosphere) can also condense. Then one can see clouds that contain crystals of CO_2. Thus, for example, cirrus clouds made up particles of dry ice* have been observed at an altitude of thirty-five kilometers (twenty-two miles).

When air encounters a natural obstacle, it rises and cools down, thus permitting the formation of clouds. These are the high clouds that form near high reliefs such as the volcanoes of *Tharsis*. Giovanni Schiaparelli, the great nineteenth-century observer of the planet, gave *Olympus Mons* the name *Nix Olympica* (The Snows of Olympus) because he thought that he was seeing a snowy mountain. Morning fogs also exist in the depressions, but these disappear soon after sunrise.

We will see that the pressure varies considerably during a seasonal cycle. This is due to the cycle of condensation-sublimation* of CO_2 at the poles. Mars has seasons [p. 180, 182] that come from the inclination (25°) of its rotating axis in relation to the plan of its orbit. But the orbit of Mars is also particularly elliptical in comparison with that of the Earth's. For example, at its perihelion (the point closest to the Sun), Mars receives 44 percent more energy (it is then

CARBONIC ICE OR DRY ICE
Carbon dioxide in its solid phase. At the pressure on Mars, CO_2 condenses at about -120° C (-184° F). It becomes stable in winter at the poles, which are then covered by a gigantic layer of brilliant dry ice one to ten meters (three to thirty feet) thick and extending to latitudes of 50–60°. In the spring, with the arrival of the first light from the Sun, this layer sublimates in the form of gas.

SUBLIMATION
The process by which a solid body, subjected to a heightening of temperature, goes directly from a solid state to a gaseous one (the inverse of the process of condensation, in which a gas transforms into a solid state).

summer at its southern hemisphere) than at its aphelion. The seasons on Mars are therefore very marked and uneven. The southern hemisphere is the hemisphere of extremes: the winters are long and cold, and summers short and fresh. Inversely, on the northern hemisphere, winters are short and warm and the summers long and fresh.

On the northern hemisphere, spring falls on May 6, 2017, summer on November 21, 2017, autumn on May 23, 2018, and winter on October 17, 2018. To calculate the seasons that follow, two years need to be added and forty-three days subtracted from those dates. Therefore the spring of 2019 will fall on March 14, and so forth.

ACTION OF THE WIND IN THE COURSE OF TIME

SALTATION
The process of transport of a sediment by water or wind. Carried by fluid, particles the size of sand or gravel move by hopping.

Mars is a unique case in which the action of the wind has remained the preponderant evolutionary phenomenon of its surface for a very long period of time. During the Amazonian epoch, liquid water practically no longer appeared, except perhaps during rare episodes and in very localized zones. The dryness favors erosive mechanisms, since a humid ground has in effect a cohesion that considerably limits its erosion. Wind is abundant on Mars and storms that are sometimes global—as observed by *Mariner 9* in 1972—produce some violent gusts. The *Viking* landers measured ground winds that surpassed one hundred kilometers (sixty-two miles) per hour. Some researchers propose speeds of more than two hundred kilometers (124 miles) per hour during storm periods. There have been attempts to explain how these winds, when extremely violent, could project the fine dust of Mars into the atmosphere despite very weak pressure at the surface (equivalent to that at an altitude of thirty kilometers, or nineteen miles, above Earth). The process of saltation* implies grains of sand of approximately two hundred micrometers. A frequent mechanism on earthly deserts, saltation occurs when the wind makes the grains of sand roll and hop around the ground, but the mechanism is not strong enough to project them into the atmosphere. This is the principal mechanism acting in the formation and the displacement of sand dunes.

TWO POPULATIONS OF GRAINS A large part of the surface of Mars is covered with dust and sand [p. 9, 20, 78], which constitute two large populations of grains whose dynamic behavior and effects are very different. First, the grains of less than thirty micrometers constitute

a fine, homogenized dust throughout the entire planet. On Earth, this kind of dust comes from the erosion of clays and silt. The atmosphere of Mars permanently contains dust, albeit in variable quantities, and for this reason the sky there is a reddish color. This tint comes from the color of rust in ferric oxides formed during the Noachian epoch. Thus, for example, while dusts of three micrometers in size can remain indefinitely in a calm atmosphere, a moderate wind (of less than ten kilometers, or six miles, per hour) allows dusts of twenty micrometers to stay permanently in the atomosphere.

The second population is the sands whose grains measure between fifty and one thousand micrometers. The pressure being weak on Mars, these grains cannot be injected into the atmosphere, and their displacement remains only local or regional. They will agglomerate to form sand dunes, which are very numerous on Mars, including near the poles. They will also form ripples [p. 24, 40] that are, in a way, miniature dunes. Dunes can also be found at the bottom of certain craters. It needs to be pointed out that the displacement of grains by saltation is more efficient when the wind is strong, but also at locations where the pressure is high. In other words, saltation is more efficient on the plains and in depressions, and less at higher altitude, where pressure is weak. That is why there are numerous dunes in the large crater of *Hellas*, which has the lowest altitude on Mars. At an equal velocity, winds are more effective at setting sands into motion at the bottom of depressions and large craters than at a high altitude.

BEDROCK
A geological term designating the crust of a planetary surface.

The movements of sands and dusts caused by winds have two main effects. On the one hand, the shocks between the particles and the surface release new grains of sand and dusts—what is known as the aeolian mechanism of erosion. The dust creating dust by erosion explains why Mars has become a dusty planet over time. On the other hand, the particles redistribute themselves to form fine layers of dusts, with local accumulations of dust downstream of certain reliefs. On Mars, the local relief and direction of the dominating winds end up forming very dusty regions, in contrast to others where the bedrock* [p. 102] has been uncovered by the dominant erosion process and the dust has been removedremoval of dust. Finally, saltation will form and displace the dunes and ripples but in more localized zones. On Mars, as on Earth, the saltation of the grains of sand will provoke a shock with other, smaller dust particles that will then be projected into the atmosphere. The dust having been evacuated, a triage among the grains according to their size then goes into effect. The dust flies off and globally homogenizes the planet,

while the grains of sand roll around and progressively form dunes; the larger, immobile grains will end up on the surface because of the evacuation of the smallest grains.

This wind erosion mechanism, accumulated over several billion years, has produced significant effects whose importance is unequaled in the solar system, the only place where the surface of solid bodies is known. If erosion is on a microscopic level during one year, the accumulated effect over billions of years can sculpt a relief at a kilometric scale (one micrometer × one billion = one kilometer). The polar caps on Mars are certainly a representative example. The northern polar cap is dented by a large canyon, *Chasma Boreale*, more than five hundred kilometers (310 miles) long and several kilometers deep. This canyon resulted from the action of the wind around the pole, which turns in a vortex*—in fact a double vortex, if one takes into account the dipolar aspect of the cap. At a lesser scale, the two caps are zebra-striped by numerous canyons on the totality of their surfaces. These canyons are created by turbulent winds over geological durations, resulting from a thermal gradient between the colder ice cap and the warmer surrounding areas.

VORTEX
In an outflow, a vortex is a whirlpool with a vertical axis.

Although the eolian erosion is very important on Mars, it is sometimes difficult to interpret certain reliefs. For example, in the regions showing significant stratification—where the layers can be counted by the dozens, as in the valleys of *Chandor Chasma* or *Juventae Chasma*—it hasn't been clearly established that these *mille-feuilles* were formed by eolian deposits, by the accumulation of volcanic deposits, or by accumulations of aqueous deposits.

But the action of the wind on Martian surfaces can produce two opposing effects: the preponderant phenomenon is either an erosion that produces an evacuation of matter, or the deposit of dusts or sand from elsewhere. Following the evolution of the regime of the winds, an alternation between these two phenomena can exist. Numerous images in this book show a gray tint and a rather smooth surface, due to the fine dusts that cover the region, a layer often lighter than the rock beneath. Depressions, like the floors of craters, are often covered by a more-or-less thick layer of dusts as well as sand dunes. Inversely, regions like the crests or summits of reliefs are completely devoid of powders, and the underlying rock is uncovered. In these last cases the erosion mechanism is preponderant.

DUNES Sand dunes exist in abundance on Mars, particularly close to the northern and southern polar caps [p. 108, 112]. The matter

constituting the dunes comes at the same time from volcanic dusts expelled into the high atmosphere during eruptions and wind erosion that produces great quantities of sand. The formation of dunes requires intense wind, but also a dry surface that allows grains to be set into motion and to not stick to the ground. As soon as a milieu becomes damp, grains stick to its surface, their production stops, and the dune no longer evolves. The significant number of dunes on Mars means that a dry climate lasted over long periods, probably during all of the Amazonian—that is, for more than three billion years.

DUNE ACTIVITY The question whether these dunes are still active today [p. 117, 122] has often been posed. We had to wait for the HiRISE camera, with its powers of resolution of less than a meter (3.3 feet), to obtain an answer.

Observing the same area at several intervals (of two and even four years), under the same seasonal conditions and the same illumination from the Sun, necessitated extremely precise adjustments. At first sight, the dunes had not evolved at a scale of a meter, but a precise superposition of images revealed, for the first time, slight evolutions at certain places. It appears that, in spite of the very weak pressure that prevails today, certain dunes are still active.

DUNES TYPES The morphology of the dunes results from the accumulated wind effects over a long period of time. The wind on a given surface will displace grains, inducing their triage according to size. The finest grains fly off into the atmosphere; the medium-sized grains of sand roll around without flying off; and the biggest accumulate locally and move down the slopes created by the wind.

Wherever a small relief exists, such as a rock or a hillock, the wind rebounds from it, causing a wave that will create an accumulation of sands behind the relief. The latter will grow until it becomes a dune. This wave can also create a similar relief on the downwind. From a first relief can be born regular sequences reproducing themselves over considerable distances. Mini-dunes, or small ripples, spaced less than a meter (3.3 feet) apart and only a few centimeters high, appear at a perpendicular direction from the wind. They are frequently found on a dune itself. They are very young and seasonal. What's more, *Curiosity* explored a dark sand dune up close (the *Bagnold* Dunes) and highlighted a second type of ripple, one that does not exist on Earth and measures approximately three meters (about ten feet).

Dunes themselves, on the other hand, are the result of eolian effects [p. 133, 169] over a long term, and particularly of frequent strong winds during the stormy season. It is well known that, at sea, tempestuous winds create waves that can be several hundred meters long. Similarly, intense winds create great oscillations of wind on the surface that induce the formation of large dunes.

But the mechanisms of dune formation are complex. For example, unidirectional winds can create parallel dunes aligned to the axis of the wind, and elsewhere parallel dunes that are oriented perpendicularly to the axis of the wind! The first case can be explained by winds that blow preferentially in two opposite directions according to the time of day or season. Another explanation is that the winds vary slightly in terms of their direction around the dunes' alignment, causing the sand to converge with this axis.

Other parallel alignments that are also linked to dominant winds exist on Mars, but they aren't dunes. Certain surfaces swept by unidirectional winds are progressively hollowed out, creating long, parallel, and regular depressions, known as yardangs [p. 110, 164, 171], that look like an inverted ship's keel. These regions produce dusts that are dispersed far away by the winds, which, when re-deposited downstream, can form new dunes or accumulations of sand in the hollow of these depressions.

But many dunes have more complex forms, such as the *barkhanes* [p. 110, 163, 164] that are crescent-shaped with points oriented downstream of the wind. These are formed when the source of sand is limited and within governing, unidirectional winds. The grains of sand are pushed by the wind; they climb up the dune, but are mostly thrown off by the slope and end up supplying the horn of the *barkhane*. *Barkhanes* are often isolated, separated by a patch of ground without sand. Certain *barkhanes* can climb on a less-mobile *barkhane* situated downstream.

The direction of the wind [p. 166, 173] is an essential parameter in the formation of dunes, and all of the preceding cases correspond to unidirectional or parallel wind of the north-south and south-north types. Frequently the winds can take multiple directions, and one can then observe dunes transitioning from being shaped like a triple-pointed star to not having any particular shape. The interest in studying the morphology of dunes rests in the fact that they reflect the dominant patterns of the wind. They are valuable "recorders" for studying the climate during the last million years or so.

"INVERTED CHANNELS" A unique phenomenon on Mars has been brought into evidence as a result of the cumulative effect of wind erosion. It has to do with "inverted channels." [p. 84] These chains "in relief," which are not hollow, are explained by a radical change in the environment. A channel is hollowed at first by a torrent of fluid muds, or even lavas. Consequently the matter solidifies in the channels through the cementation of mud and cooling of the lava. The wind then enters into action for several hundred thousand, or even millions, of years, thus eroding the surface. If the matter in the channel is more solid than matter surrounding it, the latter will be eroded more quickly than the channel, which then appears in relief. This example is indicative of a very particular phenomenon.

OBLIQUITY AND OSCILLATION OF THE CLIMATE What about the climate during the long Amazonian period? The question is important since wind cycles can be affected by it. Locally, a change in the wind patterns (force and direction) will modify, even invert, the sequences of erosion and deposition of dusts [p. 121] from one region to another. A region already strongly eroded by winds can suddenly begin to accumulate dusts following a modification in climate.

A method that is particularly effective in answering this question consists in simulating, through calculus, the subjection of Mars's rotation around the Sun to the perturbations of other planets, and to that mastodon Jupiter in particular. Thereby one can go back in time some ten million years, which corresponds uniquely to the recent climatic period. Indeed, this latter method becomes unworkable at the scale of the great, geological Martian periods. The results are completely different from those obtained on Earth. For our planet, these simulations reveal that the astronomic parameters of the Earth, in particular the inclination of its rotational axis, its obliquity, is much more stable than for Mars. The terrestrial obliquity effectively varies only about 2° throughout a period of one million years, whereas for a similar period on Mars it oscillates more than 30°. This range, fifteen times greater on Mars than on Earth, is explained by the significant mass of the Moon (1 percent of the mass of the Earth), which stabilizes the rotational axis of our planet, whereas the small satellites of Mars, Phobos and Deimos, produce no stabilizing effect.

With 1 percent of the Earth's mass, the Moon monopolizes the essential moment of inertia (the amount of rotational movement) of the Earth-Moon system and efficiently stabilizes the movement of Earth.

It is easy to understand that a weak obliquity produces a warmer climate at the equator and a colder one at the poles, which are hardly ever warmed by the Sun. Seasonal cycles are attenuated and the winds become less strong. Year after year, an important effect is the inexorable accumulation of carbonic gas and water that will condense on permanently cold surfaces, like the polar caps. The atmosphere on Mars is therefore less charged with dust because of the weak winds. (The effects of erosion and deposition are similarly slowed down.)

Inversely, a large obliquity has more extreme effects. The poles warm up more in summer, ridding their seasonal frost of carbonic ice but also some of their underground glaciers. The variations in temperature throughout the seasons being more pronounced, the winds are reinforced, injecting more dust into the atmosphere and thus reinforcing the effectiveness of erosion and deposition.

In the absence of dust and at a strong obliquity, the sublimation-condensation cycle of the ice [p. 177, 178, 179, 182] would have accrued, but without a cumulative effect on the caps. These latter would be very young since they would sublimate almost entirely each summer. But the presence of dusts modifies this simplified schema. In fact, when an atmosphere rich in dust condenses at the poles during winter, the icy layer they form is more-or-less darkened and reveals the quantity of dust trapped in the ice. During the following summer, the cap sublimates progressively when it is warmed by the Sun. But the top layer of dust without ice creates a thermal isolation that interrupts the sublimating of the ice below this layer. Year after year, one attends a slow, yet nevertheless varied, accumulation of fine layers of dust mixed with the ice from the poles. The latter are called North Polar Layered Deposits (NPLD) and South Polar Layered Deposits (SPLD). Each layer thus retains the memory of a seasonal cycle. A dark and thick layer would reflect a particularly dusty year. Studies are now being conducted to decipher these "PLDs" in order to reconstitute the recent climate of Mars. In an analogous manner on Earth, the analysis of Antarctic ice cap has confirmed the model that Milutin Milanković developed between the two wars, which concludes that the recent climate on Earth was regulated by the parameters of the terrestrial orbit (its eccentricity and obliquity).

It is nevertheless less easy to understand what becomes of this sublimate ice at the poles when they are greatly heated during the period of strong obliquity in summer. The Laboratoire de meteorology dynamique de Paris (Meteorological Dynamics Laboratory of Paris) has conducted simulations of the climate on Mars in order to

reproduce this phenomenon. In this way it has found evidence that the gas issued by the caps condensed at middle latitudes, notably to the west of the very large volcano *Tharsis* and *Olympus Mons* (but also to the east of the crater *Hellas*). This prediction has been confirmed by the presence of viscous flows that is attributable to old glaciers in the regions. Today, these glaciers are not thermodynamically stable and numerous examples among them have disappeared over a very long period of time. But, again, if a glacier is covered by several meters of accumulated dusts, the underground ice, thermodynamically isolated, could still remain today. Radar soundings have moreover confirmed their presence at different places.

DUST DEVILS In certain regions on Mars and during certain seasons, dust tornadoes (or "dust devils") [p. 119, 125] are produced relatively frequently. Spotted by the first orbiters in the 1970s, they were recorded in 1996 by the *Pathfinder* lander, whose animated images revealed these spectacular events occurring within the camera's range. The Mars Exploration Rovers, *Spirit* and *Opportunity*, arrived in 2004, and the passage of a tornado over *Spirit* cleaned the dust off of its solar panels and brought about one of the most interesting results of the mission. The rover was not damaged, in spite of gusts of more than one hundred kilometers (62 miles) per hour; the pressure was such that the mechanical turbulence on the rover was minimal. The operators realized that during this storm the available energy of the solar panels was brusquely raised to its maximum level. This kind of natural drenching had been foreseen and studied, but the possibility that the dust would be electrically charged and that it would adhere to the panels could not be predicted. Storms, moreover, had been the reason given by the Jet Propulsion Laboratory for guaranteeing a lifespan of only ninety Martian days for the two rovers. The passage of the first tornado over the solar panel completely dissipated this concern. Afterward, the drenching phenomenon was reproduced on multiple occasions on both *Spirit* and *Opportunity*. Today, thanks to cleaning rags applied after each tornado, *Opportunity* pursues its exploration for more than a decade—but it could also be stopped suddenly due to an electronic failure.

Even if only a few of these tornadoes have been observed in action, in reality they are frequent. Their passage lifts the dust from the ground in their path, leaving a dustless, rocky, and sandy floor. Often the subjacent ground is darker than the dust and the arabesque trace is dark against a bright ground.

BRIGHT AND DARK STREAKS The eolian processes also create dark and bright streaks [p. 78] on the slopes of cliffs, dunes, or the flanks of craters. The bright streaks correspond to deposit zones at the end of stormy periods. These streaks can be stable for the duration of a year. The dark streaks are due to the disappearance of dust in the form of an avalanche, exposing the dark subjacent strata.

After more than a century of observations from Earth, and more recently from orbiters, it seems that the eolian processes unfold mainly during summer in the southern hemisphere (the stormy period), even if certain activities have been observed during other seasons.

THE POLAR REGIONS, MEMORY OF THE CLIMATE ON MARS

Because of their bright appearance, the polar regions [p. 134–182] on Mars are the areas most easily detectable from Earth. They have been spotted since the end of the nineteenth century by numerous observatories. Their presence has contributed much to the myth of "Martians," because their caps were thought to be made of ice water.

In winter, the bright polar caps extend to latitudes of 50–60°, the latitude equivalent to Canada's. Being the coldest regions, they play a central role in the annual cycle of seasons. The winter temperatures allow carbon dioxide (CO and water vapor to condense into carbonic snow and ice, respectively. Even though CO_2 is much more volatile than water (it condenses at -125° C, or -184° F, whereas water freezes at 0° C, or 32° F), its abundance in the atmosphere (95 percent) makes it in fact the preponderant element in the polar cycle.

The variations of pressure on Mars throughout the year are instructive in this respect. They were measured on the ground by the *Viking* landers between 1977 and 1982. Throughout the course of a seasonal cycle, it varies considerably from seven to ten mbar, and presents two maxima. The most important one culminates at ten mbar during summer at the southern hemisphere, and corresponds with the sublimation of the austral cap. The second, less important one corresponds to the sublimation of the boreal cap. The difference of 10 percent between the two maxima comes from the difference in altitude, and therefore the temperature, of the two caps. The southern cap is more elevated (by almost 6.5 kilometers, or four miles) and, because of this, is clearly much colder than the

northern one. The lowest temperature measured on Mars, -143° C (-225° F, a temperature well below the condensation point of CO_2), was recorded in the south. A colder cap will condense more CO_2 in winter, which, when fully released in summer, will cause the observed pressure peak.

For a century it has been observed that each winter, at the north as well as at the south, a white frost [p. 128, 131, 134] alternately covers the poles. We know today that it isn't ice but carbonic snow, and that this layer reaches several meters in thickness over thousands of square kilometers. Nevertheless, whereas this bright frost totally disappears in the north in summer, the southern cap conserves a layer of carbonic snow that makes it bright.

Recent observations allow three distinct regions to be identified at the polar caps. Four-fifths of the bright and fine surface layer is made up of carbonic snow, the rest of ice water. Beneath this layer there is an actual glacier of ice water mixed with dust and called Polar Layered Deposit (PLD) or stratified polar deposit. PLDs reach two to three kilometers (1.86 miles) in thickness in both the north and the south. The poles, finally, are surrounded by fields of dunes made of sands that are sometimes dark.

"NORTH AND SOUTH POLAR LAYERED DEPOSITS" The PLDs [p. 181] were discovered by the *Mariner 9* mission in 1970. They record the evolution of the recent climate as successive strata, and have been abundantly studied. The PLDs are barely visible in images because their shade is only slightly distinguishable from the surrounding environments and their reliefs are barely evident. It is thanks to altimetric measurements on which an artificial texture has been applied that the PLDs become clearly evident.

THE NORTHERN CAP The PLDs in the north measure about one thousand kilometers (620 miles), and are twice as large in the south. The northern cap [p. 157–183] is characterized by numerous valleys ranging outward in a spiral formation from the pole. These valleys, called *Chasma*, are the result of violent winds that emanate from the pole and descend the slope toward the surrounding plains. The cold and more dense air of the pole follows the slopes of the cap, creating density winds, called katabatic winds,* due to the difference of temperatures in spring between the cold cap and the warmer surrounding regions. As on Earth, winds undergo the force of Coriolis that provokes, according to the planet's rotation, a force

KATABATIC WIND
From the Greek *katbatikos*, which means descending a slope, this is a gravitational wind produced by the weight of a cold-air mass descending a geographic relief.

that deviates them toward the left in the northern hemisphere and to the right in the other hemisphere—hence the spiral form of the valleys. These are excavated by winds transporting both ice and dusts toward the downward plains. During the spring in the southern hemisphere, the katabatic winds are so violent that they can create a dust storm over the entire planet. Since 1950, a global storm has been unleashed every three Martian years—that is, once every six years. But numerous local or regional storms happen more frequently—they are actually annual occurrences. One of these valleys, *Chasma Boreale* [p. 157], cuts the northern PLD into two distinct regions. This *chasma* has the same dimensions as the Grand Canyon in Arizona, with a depth of two kilometers (1.2 miles). A whirlwind phenomenon is developed on either side of *Chasma Boreale*, creating a double vortex. All along the length of the flanks of these valleys successive layers of NPLD have been observed. These valley flanks have been abundantly scrutinized by the HiRISE camera in order to understand the climate on Mars during the last several million years.

The first three hundred meters (one thousand feet) of thickness of the northern PLD are constituted of fine, more-or-less dark layers that are sometimes only a few meters thick. These layers are composed essentially of water ice and about 15 percent of dusts. The dark matter comes from the dusts projected into the atmosphere during global tempests or volcanic eruptions, or are the ejecta* from nearby impacts. These different layers are the result of a complex cycle of condensation and sublimation of the polar ice during the alternation of seasons. During the years in which a global dust storm took place, the quantity of dust deposited on the northern PLD would be significant. A periodicity for these layers has been found with a cycle of thirty meters (one hundred feet). This period corresponds to a duration of about fifty thousand years. The first three hundred meters (one thousand feet) are equal, then, to the last five hundred thousand years of the Martian climate. During this period, obliquity on Mars, or the planet's axis of rotation in relation to its orbital course, which today is 25.2°, varied from 27–28° to 22–23°. Later, between 0.5 and 2.1 million years ago, the obliquity varied considerably, going from 15° to almost 35° every 110,000 years. As seen previously, at a weak obliquity (less than 20°), the seasonal effects diminish and the mechanism of transport between the north and south is nearly at a stop. Inversely, beyond 30°, the poles progressively lose their volatile gasses, water vapor, and carbonic gas

because they are heated substantially by the Sun and ice is deposited at lesser latitudes; this is the glacial period. It is only at the intermediate values of obliquity that the PLDs of the north accumulated. One can very well understand that the deciphering of these *millefeuilles* on a temporal scale is not an easy thing, and that the work isn't yet finished.

THE SOUTHERN CAP The particularity of the southern cap [p. 127–156] is that it is situated at a higher altitude than the northern one, and therefore the climate is much colder at the south than at the north. An important difference is that the frost of carbonic snow does not sublimate completely in the summer and a layer dry ice averaging about 20 meters (65 feet) remains.

Culminating at a thickness of 3,700 meters (twelve thousand feet), the SPLD contains a quantity of ice equivalent to the northern cap.

This cap with perennial CO_2 isn't centered on the geographic pole but shifts about 2–3°. This phenomenon is due to the proximity of the large crater of *Hellas*, the depth of which promotes the circulation of winds and provokes an accumulation of condensation at a staggered point of 150 kilometers (ninety miles) from the pole.

AVALANCHES The term *avalanche* [p. 174] is applied on Earth to the sudden downward rush of snow on a mountain. On Mars, dust plumes have been observed on the flanks of the polar *Chasmas*. The high-resolution images created by HiRISE are particularly well adapted for studying their occurrence, although one of them has yet to happen at the moment a picture is taken by the camera, since the duration of the event is only about one minute. Finally, after numerous attempts, some have been caught. The first one was fortuitously discovered in February 2008. The observations consisted in marking the evolution of the carbonic ice frost in spring on the northern pole. A plume of dust revealed that an avalanche had just occurred on a seven-hundred-meter-high (2,300-foot) cliff.

The causes of an avalanche are multiple and not well known. They could be the sublimation of carbonic ice, the mechanical effects of freezing water ice, an earthquake on Mars, or the nearby impact of a meteorite*. This last phenomenon in particular has been studied with HiRISE. The procedure has involved comparing new images with old to look for the appearance of new craters. About twenty new craters have been found every year using this method. New craters are then correlated with a large number of slides in the surrounding

METEORITE
A fragment of rock of extraterrestrial origin that has fallen on the surface of Earth. Of the more than sixty thousand meteorites that have been tracked in collections, more than one hundred have a confirmed Martian origin. These were expelled from Mars during the impact of a large meteorite and traveled in the solar system for millions of years before falling on Earth. Moreover, today scientists have identified some meteorites on Mars's surface. Its atmosphere being more tenuous, objects penetrating it are less broken up than those falling on Earth.

terrain. This phenomenon does not apply only to the poles, but is observed everywhere on the planet. As the term *avalanche* is reserved for the downpour of water and carbonic ice crystals, the term *landslide* is more appropriate to the descent of matters very rich in dust and sand. What surprised the observers was that the landslides of bright dust on a dark surface, or "dark streaks," could appear by the thousands in the vicinity of a recent crater. It seems that the shockwave created by the entry into the atmosphere of a meteorite at high velocity, more than the wave from the impact itself, could have been the main trigger of these landslides. To be exact, whereas on Earth a meteorite has to reach a size of thirty meters (one hundred feet) in order to create an impact crater, on Mars, where the atmosphere is more tenuous, an object of only one meter (three feet) can create a crater detectable by HiRISE. It is little surprise that the unleashing of a landslide caused by meteorites would be a phenomenon rarely occurring on Earth.

GEYSERS A very particular phenomenon [p. 127, 134, 136, 143, 148] is observed during the seasonal sublimation of the southern cap. Dark cones (or sometimes bright ones) appear on the surface, all of them oriented in the same direction. In a matter of a few weeks the cones grow considerably, darkening almost the totality of the surface. The interpretation of this phenomenon is tied to the appearance of the Sun in spring. It brightens the surface and photons penetrate the layer of carbonic snow until they reach the subjacent layer that is darkened by dust. This dark layer accumulates heat and warms the dry ice on contact from below. The ice then sublimates in depth, provoking an overpressure of carbonic gas that pierces the surface and escapes in the form of violent geysers. The dynamic gush escaping the surface carries with it dust that is deposited on the ground downstream from its point of exit according to the wind's direction. Even if no geyser has been filmed in action, this phenomenon has been compared to the nitrogen geysers observed by *Voyager 2* spacecraft during its flyby of Triton, Neptune's satellite.

This explanation is but an attempt; more questions remain. Why do geysers appear preferentially below the SPLD, whereas the layers of frost from carbonic ice in winter are much more widespread? Why are geysers more frequent in the south than in the north?

"SPIDERS" Another phenomenon characteristic of the southern cap has been observed: the appearance of "spiders," [p. 146] small cracks,

in the form of spiders, that appear on the frozen surface. An inter-pretation has been proposed. When a geyser has been active, a cavity appears underneath the ice that can fissure the area around the mouth of the geyser. These fissures cause the ice to collapse around that point, and the fissures and falling-in take this peculiar form.

POLAR DUNES *Olympia Undae* [p. 164] is found opposite *Chasma Boreale* in relation to the northern pole. It's the largest field of dunes on the planet. Infrared spectral imagery by the *Mars Express* space-craft has revealed that these dunes are made of sulfates. Sedimentary rocks rich in sulfur, sulfates are obtained through alteration in the presence of water. The sulfur from these rocks most certainly comes from particularly intense volcanic activity during the Hesperian epoch.

The presence of this field of sulfurous dunes near the northern pole indicates that strong volcanic activity must have existed in this region. The paradox is that there aren't any important volcanic massifs, but only small cones that are attributed to volcanoes. On the perennial cap in summer, very dark regions, certainly con-taining volcanic dust, can be observed. But the presence of these small volcanoes, even if they are numerous, poorly explains the formation of this immense, dark dune.

These dunes surely resulted from the interaction of sulfurous matter of volcanic origin with silicate sediments. Otherwise, it seems that dunes were formed in place without the help dust and sand transported from other regions. Finally, their age is greater than the cap itself.

THE PROMISES OF MARS

The quality of the HiRISE images allows a new approach to Mars. Metric details at a, let us say, "human" scale are henceforth identifi-able. The images literally give us a new vision of this planet. The main objective of HiRISE is to identify the sites on which future missions will land. The site of the rover *Curiosity*, which landed in the crater *Gale* on August 6, 2012, had been scrutinized with exacting details—both to determine the most interesting place to explore and to assure a secure landing. The images transmitted since allow for the viewing of the landers on the ground. *Spirit, Opportunity, Phoenix*, and now

Curiosity have thus been localized with a precision of some dozen centimeters (five inches), which is unprecedented. The arrivals of *Phoenix* in 2008 and of *Curiosity* in 2012 have even been photographed "live," while they are descending.

On a scientific level, these images reveal evolutions on a scale of a meter (three feet). Thus it has been proved that certain dunes are still active today. New craters, whose ages are no more than a few years, have been brought to light. Avalanches have been observed at the poles, as well as dust devils. But the volume of these images is so considerable that it excludes mapping the planet in its entirety. Barely 10 percent of the surface is likely to be studied, even with the exceptional lifetime of the MRO.

What will be the future of HiRISE? We will exploit it for the longest time possible, until a technical failure occurs or it exhausts its fuel. Moreover, it seems improbable to send an even more advanced camera. The identification of objects the size of a centimeter isn't of major scientific interest, as such images would need to be contextualized by a separate camera with a wide field of view. On the other hand, in terms of future missions, it might be necessary to send a new camera of the same type around Mars. HiRISE has proven to be useful in mapping the landing sites in preparation of the missions, and this necessity will continue to exist.

After the two *Viking* landers failed to detect signs of life on Mars, the strategy adopted henceforth has been both prudent and methodical: first "Follow the water," then "Follow the carbon," and ultimately "Follow the life."

The first campaign, centered around water, has practically been achieved. The most important discovery of the decade is certainly that of clays that are proof that Mars went through a warm and wet period at the beginning of its history. The second stage is on course with the recent landing of *Curiosity* on Mars. This rover is placed on a site rich in clays and has instruments of analysis capable of detecting complex organic molecules. It's necessary to state that, currently, the only carbon detected on Mars is in oxide form (especially CO_2 and a bit of CO) and that it is very stable; the detection of methane (CH_4) has yet to be confirmed. The absence of organic molecules is a great difficulty, as it is inconceivable to think of living organisms without the diversified chemistry of carbon. If *Curiosity* does not find any molecule made up of carbon chains, the search for life will come to a dead-end. But if these molecules are identified, it will be time to go on to the third, and by far the most ambitious, phase of

our exploration and research. But first it is useful to recall a discovery that shook scientific circles a few years ago.

It has to do with the "affair" of the meteorite ALH84001, subject of an intense scientific and media debate that took place over many years. At the beginning of summer 1996, NASA announced that David McKay had, through electronic microscopy, detected fossils of nano-bacteria, incontestably of Martian origin, on ALH84001. Such a finding had never been obtained on Mars due to the extremely small size (less than one hundred nanometers) of these bacteria. The publication caused a lot of ink to flow, and provoked lively controversies. Had McKay discovered life on Mars in a new type of bacteria unknown on Earth and too small, according to some, to even be considered bacteria? Then, the same type of nano-bacteria was found on another meteorite, this one not Martian. This fallen meteorite* had remained in the desert for sixty years. Other fragments that were collected soon after its fall did not contain a trace of these nano-bacteria. This result aided supporters of the thesis that a contamination of ALH84001 occurred during its stay in the Antarctic. In 1998, several American teams also came to the conclusion that the contamination was of terrestrial origin. In other words, McKay's pretend discovery, using the most advanced analytical technology at the limits of its functional capacity (both in spatial resolution and sensitivity), revealed at once immense possibilities and intrinsic limitations. The detection of bacteria on Martian samples promises to be difficult, and such samples can't be studied exhaustively on Mars itself because of the lack of sufficiently advanced instruments.

The affair of the ALH84001 meteorite supports the argument that researching life on Mars should be undertaken with Martian samples brought back to Earth. In fact, imagine that a scientist announces having found proof of biological activity through an analysis undertaken on the Martian surface. It is very likely that other scientists would come up with other conceivable interpretations. A polemic would ensue and it would be impossible to arrive at a conclusion. To discriminate between the two contradictory ideas, it would be necessary to undertake a new experiment, one that would need a dozen years before a new mission with the experiment on board could arrive on Mars. However, with samples brought back to Earth, a new analysis can be conceived immediately and the scientific debate can move forward. The discovery of life beyond Earth represents a considerable undertaking, one that couldn't possibly be

FALLEN METEORITE
A meteorite is said to be "fallen" if its fall was observed by witnesses. These meteorites are particularly interesting because they are picked up quickly, before having spent a long time on Earth's surface.

the act of a lone individual. It needs to convince the scientific community to be taken up by a wider public.

The "Martians" obstinately demand a round-trip mission to bring back valuable rocks to our laboratories. The launching of such a venture is extremely complex. First, a mobile robot should be capable of intelligently collecting samples; second, it must secure the sample container and return it to a rocket that sends it orbiting around Mars; then, a final spacecraft would be in charge of recuperating the container, bringing it back to Earth. This plan must be followed without a hitch, or else the mission would fail. . . .

First foreseen in the 1980s, then again in the 2000s, the recovery of samples from Mars is once again in the news. In fact, the next American rover, which will be similar to *Curiosity*, is scheduled for 2020. However, it is expected that this rover will be able to carry out the step of collecting samples and putting them in a sealed container on Mars, a process usually called "caching." Later, if NASA decides to do so, a new mission will be charged with retrieving the container and propelling it into Martian orbit using a small rocket so that it can be captured and sent back to Earth. Given the difficulty, it could be a joint enterprise between Europe and the United States.

If traces of life are discovered, the event would be considerable, and would finally answer the question that humanity has asked itself over fifty centuries: are we alone in the universe? The event would be even more decisive if it managed to identify the DNA (or its equivalent) of Martian bacteria. Whether this DNA would be analogous to ours or not would make us see-saw between two very distinct universes. If it is identical, it would follow that our life isn't unique in the universe and, by extrapolation, that it is universal. This would mean that wherever favorable conditions exist, life will inexorably appear in the form that we know. But this rapid conclusion would also be contested: how to ensure that discovered life isn't a contamination deriving from terrestrial DNA? Of course, the scientists would retort that they had taken precautions to render impossible any such contamination. One can imagine that it would be technically possible to be assured by this. But another, more serious polemic would arise. It is in fact possible that Earth and Mars mutually contaminated each other through the exchange of meteorites containing bacteria, a process called panspermia.* Ultimately, the discovery of traces of life on Mars would barely allow a conclusion—making it necessary to look for traces of life even further, on Enceladus around Saturn, for example, or even further than that. It goes without saying

that we would have to wait decades to know the answer. If, then, the discovered life were different than ours—if it is confirmed that this life is not based on DNA, the universal element of all life on Earth—the discovery would have a greater impact, implying that different forms of life could exist according to locally governing conditions. That would make our presence on Earth more ordinary. Earth is already recognized as but a large grain of dust in the immensity of the universe, and in such a discovery we would lose our uniqueness. There is no doubt that such a discovery would completely overthrow human thought.

But if nothing were to be discovered from samples collected at different sites in the future, a last hope would yet remain. It could be, in fact, that life still exists today on Mars, at least where water can remain in its liquid state: in its interior. It would be necessary to excavate deeply, perhaps ten, one hundred, or even one thousand meters (thirty, three hundred, or three thousand feet). To this end, it would be necessary to call on oil-drilling technologies, which probably necessitates sending men to carry out the drilling at such exigent depths. The sending of humans to Mars would provide a motive for science. But we must counsel patience, as such an enterprise is not imaginable for several decades.

Finally, even if we were able to conclude that life never occurred on Mars, the quest for extraterrestrial life would nevertheless continue. There exist two places in the solar system where it might exist: in the deep oceans of Europa, one of Jupiter's moons, and on Enceladus or Titan, which orbit Saturn. But to attain such subterranean immensities is even more complex than going to Mars, and. . . .

THE MAPS
OF MARS

ESTABLISHED
ACCORDING TO THE
U.S. GEOLOGICAL SURVEY

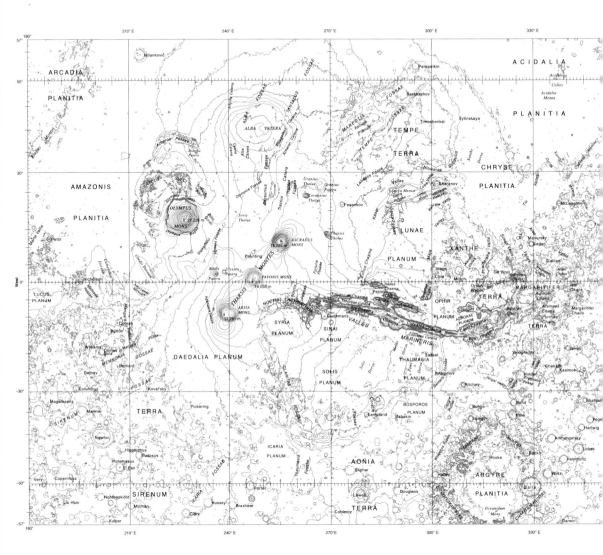

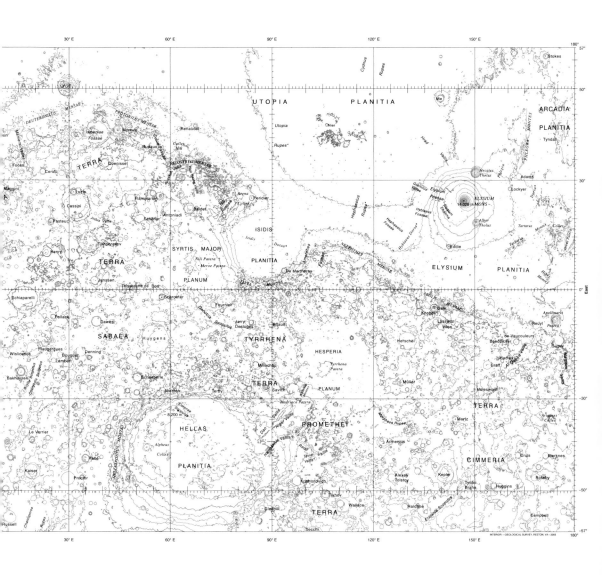

1,000 meters altitude between contour lines

THE PLANET MARS

Scale 1:39 235 294 (1 mm = 39 km) at 0° latitude

Mercator Projection

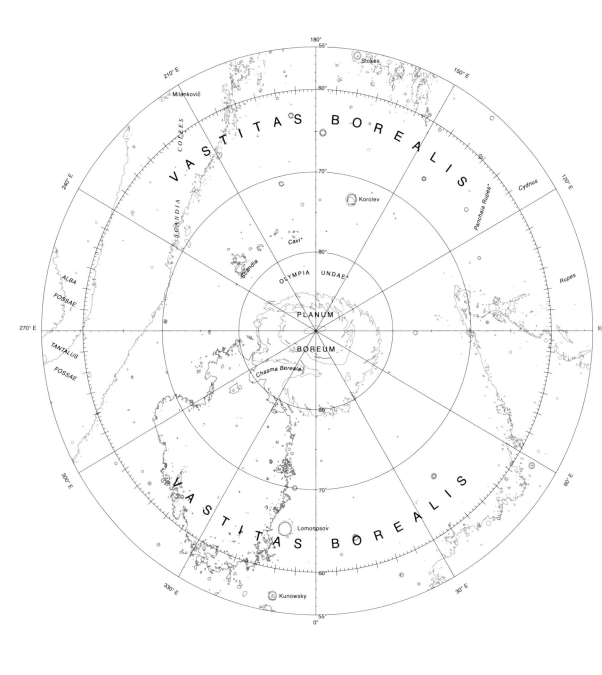

1,000 meters altitude between contour lines

NORTH POLAR REGION

Scale 1 : 23 904 937 (1 mm = 24 km) at 90° latitude
Polar Stereographic Projection

2

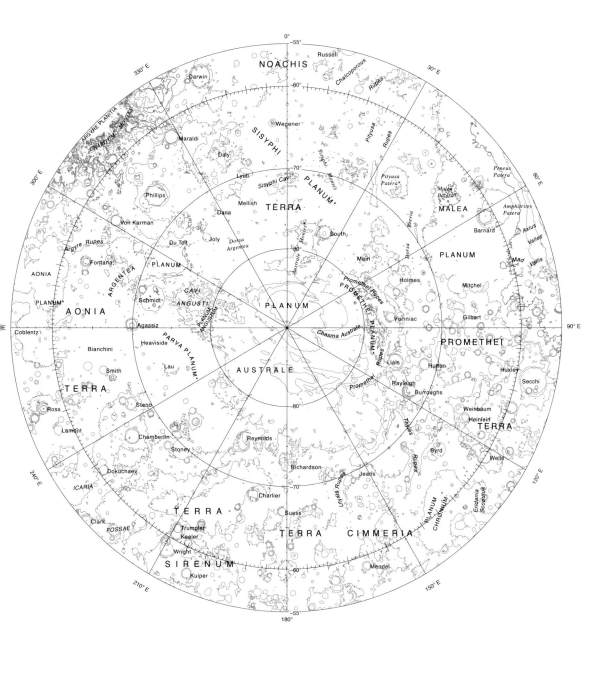

1,000 meters altitude between contour lines

SOUTH POLAR REGION

Scale 1 : 23 904 937 (1 mm = 24 km) at 90° latitude
Polar Stereographic Projection

A SHORT HISTORY OF OBSERVATIONS OF THE PLANET MARS

COMPILED BY
FRANCIS ROCARD AND
NATHALIE CHAPUIS

ANTIQUITY

The planet Mars has been known since antiquity, in particular by the Babylonians and Egyptians: visible to the naked eye, it is the reddest star in the sky. Like all the planets, Mars orbits around the Sun, moving across constellations from east to west in relation to fixed stars. But in ancient times, the movements of Mars and other visible planets were not understood.

In ancient Greek, the word *planet* means "errant star," and, in fact, the Greeks of antiquity observed the irregular movement of Mars, which during certain months slows down, then stops, then goes off in the opposite direction, before continuing on its previous course. They associated this planet with disorder and with Ares, the god of war. With the Romans, this god took the name of Mars.

SECOND CENTURY AD

Ptolemy, the Greek astronomer and geographer, drew up a system in which he placed the Earth at the center of the universe, with the Sun and the five planets observable by the naked eye—Mercury, Venus, Mars, Jupiter, and Saturn—turning around it. Each star executes a small circle (called an epicycle) whose center also describes a circle (called a deferent) centered on the Earth. This theory permitted Ptolemy to determine the position of moving stars. His theory would last for fifteen centuries.

1543

In his work *De rovlutionibus orbium coelestium* (Of celestial orbital revolutions), the Canon Nicolas Copernic declares that the Earth turns around the Sun just as the other planets do, with the exception of the Moon, which turns around the Earth.

1576

The Danish astronomer Tycho Brahe installs his observatory on the island of Hveen, in the waters near Copenhagen. With the aid of revolutionary instruments, he establishes the most precise possible position of a thousand stars and steadily measures the position of the Sun, the Moon, and the planets. Between 1599 and 1601, Johannes Kepler was his assistant. The steadfastness and precision of Brahe's observations, notably of the planet Mars, would permit Kepler to establish his famous laws.

1609

Kepler publishes *Astronomia Nova*, in which he pursues the study of the orbit of Mars more pointedly. His first law (of which there are three) involves the orbits: they are not circles, but ellipses for which the Sun is a center of focus. These ellipses that the planets describe are almost circular, with the exception of Mercury's and Mars's, the latter having the most elliptical orbit of all. His second stipulation is that the closer a planet is to the Sun, the faster it moves, and the farther it is, the slower it moves.

1610

Galileo observes Mars, thanks to the first astronomical telescope. He writes to Father Castelli: "I don't dare affirm that I might be watching the phases of Mars; even so, if I am not mistaken, I believe to have already seen that it isn't perfectly round."

1636

The astronomical telescope is perfected; the Italian astronomer Francesco Fontana perfects his own version. He observes Mars from the city of Naples and draws the first representation of the planet: at the middle of a circle, there is a thick, black point.

1659

The first systematic observation of Mars by the Dutch mathematician and astronomer Christiaan Huyghens, who identifies the region *Syrtis Major* and determines, for the first time, the period of the planet's rotation—estimated at about twenty-four hours—and the diameter of the planet, which he estimates to be 60 percent of the terrestrial diameter. He makes four drawings of the planet: on each one there is a spot that changes place.

1666

Jean-Dominique Cassini, the first director of the Observatory of Paris, determines the duration of the period of rotation of Mars: twenty-four hours, forty minutes.

1672

The Academy of Sciences of Paris sends the astronomer Jean Richer to Cayenne, French Guiana, to observe Mars during an opposition called a "perihelion," the moment when the planet passes the closest to Earth. Mars, the Earth, and the Sun are aligned in this order. At the same time, Jean Picard and Cassini do the same in Paris. Their measurements, using two distinct points on the globe, allowed the distance between Mars and the Earth, as well as that of the Earth and the Sun, to be calculated. The results overturn the givens: the solar system is revealed to be twenty times more extensive than had been thought before.

1683

Huyghens notices a white spot at the South pole of Mars: he thinks that it could be Martian ice. Several of his drawings show a sandy form.

1780

The English astronomer William Herschel conceives a more advanced telescope that allows for more precise observations. He can then measure the inclination of the rotational axis (the obliquity) of Mars, and notices the formation and the recesses of the polar vaults, confirming their existence, which was suspected by Huyghens a century earlier. According to him, their seasonal variations are due to the inclination of the planet's rotational axis and they consist of snow and ice. The refinements of new observational instruments allow astronomers to make even more precise drawings. Thus, several years later, Herschel's son, the astronomer John Herschel, identifies some spots that he likens to "oceans."

BEGINNING OF THE NINETEENTH CENTURY

The German astronomers Wilhelm Beer and Johann Heinrich von Mädler, the Italian Angelo Secchi, and the English Norman Lockyer allow new details to appear on their drawings: yellow and red stretches, observed thanks to the improvement of instruments, are likened to vast continents, and dark blue and green areas are considered oceans. They also noticed that these "continents" are traversed by trails, which could be rivers.

1869

In England, Richard Proctor creates the first precise map of Mars that depicts oceans and rivers.

1877

Mars passes closest to Earth during the opposition of the 1877 perihelion. The use of a telescope measuring twenty-six thumbs, recently installed at the U.S. Naval Observatory in Washington, D.C., allows the astronomer Asaph Hall to discover two satellites of Mars, Phobos and Deimos.

The same year, the director of the observatory of Brera, Italy, Giovanni Schiaparelli, observes Mars thanks to a telescope 21.8 centimeters (8.6 inches) in diameter, and makes a map rich in detail. To name these places, he applies Latin terminology, using names from mythology and the Bible. Thus, the brilliant point on the northern hemisphere became *Nix Olympica*, the snows of Olympus. This is the biggest volcano on Mars, later renamed *Olympus Mons*. The dark zones are defined as seas (*mare*) and the brighter ones as terrains (*terrae*). He also indicated the presence of lakes (*lacus*), bays (*sinus*), and channels (*cannale*). The latter would become "canals," and this semantic slur would have profound consequences: the "canals of Mars" imply that water had been abundant on Mars, and that "Martians" had constructed the canals in order to irrigate the plains.

THE 1880S

Thanks to the development of spectroscopy, observations on Mars reveal the presence of water vapor in scarce quantities in its atmosphere.

1890

William Henry Pickering takes the first photographs of Mars from the observatory on Mount Wilson in California.

1905

From the observatory that he built near Flagstaff, Arizona, in the United States, Percival Lowell draws the first detailed maps of Mars, on which he distinguishes about forty canals. He is convinced of the presence of Martians, who would be victims of a terrible aridity. Therefore, he believes they built gigantic canals in order to guide water from the poles toward the equatorial regions, about five thousand kilometers (3,107 miles). In his work, *Mars*, he enumerates more than four hundred canals.

1920

At the observatory of Meudon, in Paris, thanks to an exceptional telescope with an aperture of eighty-three centimeters (32.67 inches), Eugène Antoniadi arrives at a theory of the canals. Mars is a planet of a reddish hue, on whose surface both light and dark zones can be distinguished. It has an atmosphere that is active with clouds and tempests, and two polar vaults, constituted of ice from water, whose dimensions vary according to seasons. This interpretation comes from the observation that in spring the periphery of the vault becomes darker, which is attributed to the melting of ice and the dampening of the surrounding terrains.

1924

In the United States, the astronomers William Coblentz and Carl Lampland measure significant variations in temperature during both day and night: they estimate the variations to go from -70° to 10° C (-94° to 50° F). These appraisals support the idea that there is liquid water on the planet, and therefore life.

1956

Detection of the first global sand storm on Mars.

1962

The USSR sends its first satellite to Mars, but *Mars 1* breaks all communication with Earth at more than one hundred thousand kilometers (62,137 miles). The probe, nevertheless, establishes a record of spatial communication.

JULY 14, 1965

The first flight to Mars by the American probe *Mariner 4*, and the first images of the surface. Launched on November 28, 1964, the probe weighs 260 kilograms (573.2 pounds). It has solar panels for energy, a computer, gyroscopes, an altitude- and orientation-control system, and a parabolic antenna to communicate with Earth. It flies around the planet at an altitude of 9,850 kilometers (6,120.5 miles). The camera with which it is equipped takes twenty-two photos of the southern hemisphere. These images show numerous craters and reveal a planet as "dead" as the Moon. For the first time, the atmospheric pressure is measured in situ: the results, between 4.1 to seven mbar, exclude all presence of liquid water on the surface of Mars.

1969

Mariner 6 and *Mariner 7* make their first observations through infrared and ultraviolet wavelengths of the surface and atmosphere, and on the terrains of Mars. They send 201 images that reveal landscapes different from those of the snapshots taken by *Mariner 4*. It is discovered that the South pole is essentially covered by carbonic snow.

NOVEMBER 1971

The Soviet probes *Mars 2* and *Mars 3* send sixty images of Mars that show the presence

of mountains twenty-two kilometers (13.7 miles) in height. The probes also measure temperatures varying from -110° to 13° C (-166° to 55.4° F). But at that moment the planet underwent a big sand storm and remained completely veiled. The photos therefore do not reveal much when compared to those brought back by the American probe *Mariner 9*, launched in May 1971, which remained in orbit around Mars after the storm. This is the first probe to remain as a satellite around a planet other than Earth. In a series of seven hundred orbits, the probe sends more than 7,300 photos that cover 98 percent of the planet. The resolution of these images allows the discovery of a variety of topographical features on Mars: volcanoes, river beds, lava flows, glaciers, and canyons like *Valles Marineris*, which was measured at four thousand kilometers (2,485.5 miles) in length, two hundred kilometers (124.3 miles) in width, and seven kilometers (4.3 miles) in depth.

1973

The Soviet Union intends to launch four probes to Mars: the orbiters *Mars 4* and *Mars 5* are to study the planet and its atmospheres; the landers *Mars 6* and *Mars 7* are equipped with meteorological collectors and a mass spectrometer to measure the chemical composition of the atmosphere. But *Mars 4* and *Mars 7* don't head in the right direction and get lost in space; *Mars 6* lands successfully, but breaks contact with Earth, and *Mars 5* becomes silent after about twenty orbits.

1975

The American satellites *Viking 1* and *Viking 2* are launched by rockets with the objective of finding proof of the existence of life on Mars. Each satellite is composed of an orbiter and a landing gear. The orbiters are equipped with cameras, an infrared mapping system, and a detector of water vapor in the atmosphere. After ten months, *Viking 1*, launched on August 20, goes into orbit around Mars. Its instruments search for an ideal site on which to land, and on July 20, 1976, the lander places itself on the plain of *Chryse Planitia*. It is joined by *Viking 2*, which lands on September 3 on the plain of *Utopia*.

Equipped with numerous instruments, the *Viking* mission intends to carry out three actions, which are to gather and analyse samples of Martian soil aided by a robotic arm. The results reveal that Martian soil is very oxidized because

of the presence of iron, which isn't conducive to the existence of organic molecules. No biological activity is detected.

Conceived to conduct analyses for sixty days, *Viking 1* and *Viking 2* furnish information for six years and more than three years, respectively.

The *Viking* orbiters gather fifty thousand images of the surface, and 90 percent of the planet is mapped at a resolution of one hundred to 150 meters (328.1 to 492.1 feet). As to the vapor catcher, it detects vapor on top of the northern vault during the receding of ice in spring, revealing that both vaults are made of ice from water.

1988–1989

The Soviets finalize the mission *Phobos*, and two satellites are launched in July 1988. *Phobos 1* and *Phobos 2* are to study the atmosphere of Mars and the surface of its satellite *Phobos*. But an error in command, sent from Earth during the cruise, causes the loss of *Phobos 1*. *Phobos 2* successfully goes into orbit and observes the planet Mars for two months. The first maps of hydration on the ground are obtained.

1993

The American satellite *Mars Observer* is put into orbit in August, but no communication with Earth was possible, undoubtedly because of a hypergolic fuel leak.

1996

After the failure of *Mars Observer*, NASA decides to finalize more frequent missions under the slogan "Faster, Better, Cheaper." On November 7 and December 4, respectively, the probes *Global Surveyor* and *Mars Pathfinder* are launched. The first is equipped with six observation instruments for the planet, and weighs only 1,100 kilograms (2,425.1 pounds).

After three hundred days of flight, *Mars Global Surveyor* is put into orbit. In spite of an aeronautic braking incident that damages one of the solar panels, the scientific mission is a success. The camera produces more that 240,000 images at a very high resolution, which reveal existing gullies; the magnetron detects, for the first time, a magnetic crustal field; the infrared spectrometer

reveals the presence of crystalized grains of oxide; and the readings of the altimeter allow the mapping of the topography of the entire surface of Mars. The probe would remain active for ten years and would be the first to take images of other satellites in orbit: in November 2005, it transmitted photos of *Mars Odyssey* and *Mars Express.*

As for the probe *Mars Pathfinder*, it sits on Mars after seven months. It is equipped with a small, six- wheeled vehicle (rover), baptized *Sojourner*, that can explore the terrain a few meters around the lander. This robot has a camera as well as a spectrometer with X-rays permitting it to analyze the basic composition of rocks. The lander is equipped with a panoramic camera and a robotic arm; analyzed rocks have proven to be volcanic rocks that never interacted with liquid water.

1998–1999

Following the success of *Mars Global Surveyor* and *Pathfinder*, NASA decides to launch two new probes to Mars: *Mars Climate Orbiter* and *Mars Polar Lander* are to study the climate history of Mars. In order to do that, *Mars Polar Lander*, launched on January 3, 1999, was to be placed near the South pole, its polar vault covered with strata born from climatic variations. But the two missions failed: due to a navigational error, *Mars Climate Orbiter* disintegrates in Mars's atmosphere in September 1999 and *Mars Polar Lander*, which was to land on December 3, crashes into the ground due to a technical failure.

2001

Launched on April 7, *Mars Odyssey* arrives in orbit around Mars on October 23. The probe is equipped with three main instruments: the gamma ray spectrometer (GRS) will analyze the composition of the ground from orbit; the thermic camera *Themis*; and the instrument *Marie*, which permits the measurement of radiation from the solar and galactic rays in preparation for future manned missions to Mars. The GRS detects the presence of hydrogen, attributed to the ice from water in the ground on Mars, for the first time. The infrared camera *Themis* allows study of the evolution of the polar vaults through the seasons. In December 2010, *Mars Odyssey* became the longest-lasting satellite in orbit around Mars, overtaking *Mars Global Surveyor*. It was still active at the end of 2016 and remained highly useful for relaying the findings of the rover *Curiosity*.

2003–2004

On June 2, the European Space Agency launches the probe *Mars Express*. It's the first European mission to another telluric planet. Launched by the Russian firing rocket *Soyouz* from Baïkonour, Kazakhstan, the probe is equipped with multiple instruments made by different European countries: a German color and stereoscopic camera; a French spectro-imager, *OMEGA*, for the study of surface minerals; a French ultraviolet and infrared spectrometer, *SPICAM*, to study the atmosphere; and an Italian radar for probing underground and searching for water. (It is the first radar that penetrates the Martian ground.)

On December 19, *Mars Express* releases the British probe, *Beagle 2*, that will settle on Mars, but it never communicates with Earth and is declared lost. In January 2015, after an extensive search, HiRISE images locate *Beagle 2* on Mars's surface. These reveal that the lander had failed to deploy its four solar panels and therefore did not have enough power to function. The British team responsible for the lander considers itself to be the first among Europeans to have set down on Mars.

Having entered into orbit on December 25, 2003, *Mars Express* begins its first scientific observations on January 15, 2004. The mission accomplishes numerous scientific discoveries, the most important of which is the detection of clay (by the instrument *OMEGA*) at several different places on Mars. The presence of sedimentary rocks could be interpreted as proof that Mars went through a period during which liquid water was present in abundance on Mars in the first five hundred million to seven hundred million years of its existence. The mission continues and will be ongoing until its ergs are depleted.

In the United States, NASA launches two probes toward Mars on June 10 and July 17, 2003, in order to increase the chances for success. Each is equipped with a robot (rover): the *Mars Exploration Rovers* (MER) will have a lively media profile and are a scientific success. Their object is to study the geology and history of water on Mars, and for that they are equipped with, among other things, a panoramic camera; an infrared, thermic spectrometer to study rocks and the atmosphere; an X spectrometer to analyze the composition of rocks; a Mössbauer spectrometer to study iron in the rocks; a microscope to observe minerals; and little magnets to analyze the magnetic properties of Martian dust.

The two rovers, baptized *Spirit* and *Opportunity*, situate themselves, respectively, on January 3 and January 25, 2004, on two sites at antipodes from each other: the *Gusev* crater, which was probably filled by a lake at some other period, and *Meridiani Planum*, a site rich in ferric oxide (proof of an ancient presence of liquid water). Having a mass

of about 180 kilograms (396.8 pounds), the rovers move at a speed of 108 miles per hour on flat terrain and are fueled by solar panels. They are activated for two hours in the morning and two hours in the early afternoon in order to get the greatest advantage from insolation. Each day, they communicate with Earth through the intermediaries of probes in orbit (*Mars Global Surveyor, Mars Odyssey,* and later *Mars Reconnaissance Orbiter*).

Made to last for ninety days, the mission is a success. The two rovers explore the craters, climb the dunes, and uncover the geology of very different sites. *Spirit* will remain active until 2010; *Opportunity* was still sending information at the end of 2016. *Opportunity* discovered, for the first time, the presence of sulfur hydrates on the ground, proof that during an intermediary period Mars was episodically plunged into a milieu that was somewhat humid and acidic.

2005

On August 12, 2005, *Mars Reconnaissance Orbiter* (MRO) is launched from Cape Canaveral. The probe arrives in orbit around Mars on March 10, 2006. The main objective of this mission is to map the planet at a very high resolution in order to mark future landing sites precisely for future landers, which include *Phoenix* and *Curiosity*. The probe has six instruments on board: a radar, a radiometer, a spectrometer, and three cameras, of which one, named *HiRISE*, took color images of a very high resolution (twenty-five to thirty-two centimeters, or 9.8 to 12.6 inches, per pixel), and black-and-white images with an exceptional range of six kilometers (3.7 miles) in width. The radar is able to probe beneath the first layers of the Martian surface in order to detect the presence of ice in the ground, and to probe the polar vaults. Finally, an atmospheric probe (MCS) has as its objective to study the climate by measuring the temperature, pressure, presence of sand, and vapor from water in the atmosphere of the planet.

The different MRO instruments, among other things, quantified the volume of ice of the polar vaults, observed avalanches, identified clays and sulfates, and detected various types of minerals. The mission has been extended many times and continue to operate today.

2008

On May 25, the lander *Phoenix*, sent by NASA, places itself near the North pole of Mars, in the region of *Vastitas Borealis*, because of the large amount of water spotted in the area. Its first mission is to look for iced water in the ground, thus completing the work of *Spirit* and *Opportunity*. It is meant to also study the climate on the planet and prepare for future manned missions by observing the planet's environment and meteorological conditions. Thanks to a robotic arm, it identifies the presence of ice from water in the ground of the North pole. *Phoenix* also reports on the formation and movement of clouds, as well as those of storms and sand. The mission lasts five months instead of the predicted three and is interrupted on November 2 with the arrival of winter in the Northern hemisphere.

2011

Mars Science Laboratory is launched on November 26: NASA sends a third-generation rover to Mars, *Curiosity*, weighing nine hundred kilograms (1,984.2 pounds), of which seventy-five are attributed to scientific instruments. It is able to move over a dozen kilometers (7.5 miles) or so, thanks to a nuclear battery charging its six, power-driven wheels. It carries two mini-laboratories (*SAM* and *CheMin*), as well as a laser *ChemCam* that can analyze rocks at a distance. The mission of *Curiosity* is to study the geology of the landing site, the *Gale* crater, exemplary for its representation of different geological periods in the history of the planet, as well as collect information about the climate on Mars and radiation on the ground. *Curiosity* should detect the presence of organic molecules in the clay strata at the foot of *Mount Sharp*, a mountain overlooking the center of the *Gale* crater.

2012

Suspended on three cables, the rover *Curiosity* is placed on Martian ground on August 6. On August 22, it begins its first trip. *Curiosity* explored different sites, beginning with *Yellowknife Bay,* four hundred meters (1,312.3 feet) from its landing site, and realized numerous analyses with the help of various instruments.

At the end of 2013, the scientific team behind *Curiosity* publishes an article proving the habitability of Mars. *Yellowknife Bay* is therefore determined to be the floor of an ancient lake where past conditions could have allowed for life, with a neutral environment, neither acidic nor basic, low salinity, and a variable oxidation/reduction potential that could be used by certain living species.

In the years that follow, *Curiosity* travels for some dozen kilometers alongside a dark sand dune it is unable to cross and arrives at a pass without sand allowing it to head toward Mount Sharp. At the foot of this mountain are strata of hydrated clays and sulfates, the rover's principle objective. Somewhat later than scheduled, *Curiosity* is expected to reach this objective between now and the spring of 2018. The goal will be to analyze these hydrated minerals in hopes of finding ancient organic molecules that synthesized when Mars was hot and humid more than 3.5 billion years ago.

2014

In September 2014, two space probes, *Maven* and *Mangalyaan*, are successfully launched into orbit. The goal of NASA's *Maven* orbiter is to study the "atmospheric loss" occurring around Mars, a complex process resulting in molecules escaping into interplanetary space through interactions with solar wind. This process explains the atmospheric loss that has been occurring for four billion years following the extinction of the internal shielding effect of the magnetic field. *Maven* thus determines that Mars loses its atmosphere at a rate of 100 grams per second and that this rate increases considerably during solar storms. The preponderant escape process is described: extreme ultraviolet radiation ionizes molecules in Mars's upper atmosphere, which are then transported by the magnetic field of solar wind.

Mangalyaan, the first Indian probe, is equipped with a methane sensor, but to date, no detection of gas has been confirmed.

2016

The *ExoMars 2016* mission arrives on Mars in October. The *Trace Gas Orbiter* (TGO) is charged with studying atmospheric gases, including methane, in small amounts. These gases result from chemical and physical processes like dust storms, interactions with solar wind, and interchanges between surface and atmosphere. The TGO successfully enters orbit on October 19 and is expected to start making observations in late 2017. It had transported the EDM lander *Schiaparelli* that failed to land on Mars due to a malfunction during descent.

2018

In late 2018, the lander *InSight* is expected to land on Mars using technology similar to that of the Phoenix. The lander's goal is the study of the planet's interior structure. It carries an extremely sensitive seismometer built in France.

2020

ExoMars's second mission is scheduled to include the launching of the *Pasteur* rover in 2020. This European rover is equipped with numerous instruments that enable research into traces of past life. It is equipped with a drill that can acquire samples shielded from radiation up to two meters (about six and a half feet) down. NASA's *Mars 2020* rover is set to launch in 2020. The offspring of *Curiosity*, this rover will notably be charged with collecting samples and placing them in a container. Later, if the decision is made, another mission will go retrieve the container on the ground so as to send it back to Earth.

2022 AND BEYOND

A high-performance American orbiter is scheduled for 2022. It will be able to retrieve a samples container sent from ground into orbit. The first Martian samples could therefore arrive on Earth around 2025 to 2030. Their analysis will be decisive in the research on past life on the Red Planet.

GEOMORPHOLOGY
OF THE PLATES

NICOLAS MANGOLD

Nicolas Mangold is director of research
at the CNRS, French National Center for Scientific
Research, in the planetology and geodynamics
laboratory at Nantes, France. After studies
in geology, he joined the CNRS at Orsay in 2000,
where he participated, notably, in the discoveries
of the European probe *Mars Express*.
He is currently on the team of scientists
of *Curiosity*, the rover that landed on Mars
in August 2012.

9

13

10

14

11

15

12

16

9 *VALLES MARINERIS,*
 STRATIFIED, SEDIMENTARY TERRAINS
 LAT: -5.4° LONG: 286.4°

The elongated, thin reliefs on the left correspond
to the veins or seams formed by resistant minerals
crystallized during the circulation of fluids in
fractures. Erosion uncovered these veins, which
were formed deep below the surface. The fine,
parallel dark ridges oriented from top to bottom
are basaltic dunes that almost totally cover
the rock outcroppings in a peculiar manner,
explaining the uniform dark shade of the image.

10 *TITHONIUM CHASMA,*
 BRIGHT TERRAINS
 LAT: -4.9° LONG: 269.9°

These (light) sedimentary terrains, situated on
the flanks of the 810-kilometer-long (503-mile-long)
canyon *Tithonium Chasma*, are covered by thick
dunes of black sand. The bright terrains in this
image are among the first to have been identified
as containing sulfates of magnesium by the
spectro-imager *Omega* on the European probe
Mars Express, in February 2004.

11 *NOCTIS LABYRINTHUS,*
 TERRAIN COVERED BY DARK DUNES
 LAT: -7.2° LONG: 267.9°

The grains of sand in these dunes notably contain
pyroxene minerals that give the basaltic sand
its dark shade. The arrangement of dunes depends
on the topographical locale. The light zones are
windows of erosion, that is to say, zones where
the substrata are visible. The zones in this case
contain iron and aluminum sulfates characteristic
of interactions between volcanic matter and liquid
water in the presence of sulfur.

12 *VALLES MARINERIS,*
 SEDIMENTARY TERRAINS
 LAT: -6.5° LONG: 283.1°

The visible strata in this image are sediments
rich in sulfur salts (sulfates). They were formed
during climatic periods that were most favorable
for liquid water to appear on the surface or in
depths (of several hundred meters). The strata
are deformed—they show pleats and curvatures—
by gravitational movements linked to the feeble
resistance of sulfates, an element that is easily
deformed under its own weight, like a glacier.

13 *VALLES MARINERIS,*
 SEDIMENTAL BUTTES AND DEBRIS APRONS
 LAT: -6.1° LONG: 285.2°

This butte overhangs, by about a hundred meters
(328.1 feet), terrain largely covered by eolian
forms, in particular the dunes on the right-hand
side of the image. The slopes of the butte are
covered by aprons of debris formed by the falling
of blocks. In this case, the aprons of debris have
typically characteristic dry, gravitational forms
in the absence of volatiles (water, carbonic gas).

14 DETAIL OF THE FLANKS
 OF THE CANYON *VALLES MARINERIS*
 LAT: -13.3° LONG: 294°

The canyon of *Valles Marineris* is about
3,770 kilometers (2,343 miles) long, with an
average depth of ten thousand meters (32,808 feet).
One can distinguish volcanic accumulations here;
they are recognizable as the dark, very resistant,
and numerous strata that are several kilometers
thick. The smooth terrains correspond to the
debris coming from the dismantlement of these
strata by erosion that, on Mars, is strongly linked
with significant thermic variations—up to 100° C
(212° F) of difference between day and night—that
fracture the rock.

15 STOPPAGES ON THE FLANKS
 OF *COPRATES CHASMA*
 LAT: -12.8° LONG: 299.9°

See caption for page 14.

16 DETAIL OF THE SLOPES
 OF THE CANYON *TITHONIUM CHASMA*
 LAT: -5.3° LONG: 270.8°

Some sediments appear bright, the image
primarily shows cliffs that are several kilometers
high and made of volcanic rock. The base of the
flanks is covered by blocks detached from the cliffs.

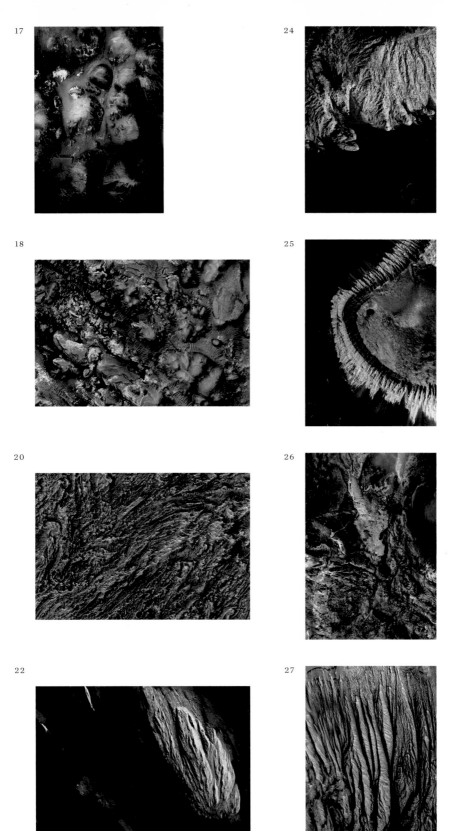

17

18

20

22

24

25

26

27

17 *IANI CHAOS*, LIGHT-COLORED
OUTCROPPING ON A HUMMOCK
LAT: -1.1° LONG: 342.6°

In the regions of *Iani*, the chaos consist of high
buttes of a few hundred meters that strew
the terrain. Sometimes one can distinguish
the residues of light sediments often composed
of sulfate minerals, as at the upper-left of
this image.

18 *ARAM CHAOS*, CENTRAL ZONE
AT THE LARGE DEPRESSION
LAT: 3.1° LONG: 340.2°

The scattering of dark buttes in the image
were formed by destabilization, probably implying
volcanic, tectonic, or glacial processes, the
combination of which remains poorly understood.
The beautiful, very bright terrains are sediments
known to be outcroppings of magnesium sulfates
(the mineral known as kieserite) coupled in places
with iron hydroxides like goethite. These minerals
are testimonials to the importance of water
in this region.

20 INTERIOR SEDIMENTS
OF THE CRATER *COIMBRA*
LAT: 33.6° LONG: 328°

This image shows an ensemble of sediments,
partially preserved by erosion, in the form
of numerous intact buttes. They are locally
covered by volcanic sands. A crater of impact
linked to a falling meteor in the recent past
has punctuated these terrains. The right-hand
side of the image is brighter because it is
homogeneously covered by bright sands,
whereas the zones at the left-hand side
of the image are not.

22 *GANGES CHASMA*,
TERRAINS WITH STRONG ALBEDO
LAT: -8.6° LONG: 313.9°

Terrains with sediments containing sulfates
are surrounded by plains of black sand
(in the lower zones) and punctuated by dunes
(the dark and smooth zones). The lengthening of
the bright outcroppings is typical of eolian erosion,
indicating transversal winds; in the image,
these winds would have blown in a vertical
direction. This direction is coherent with
the dunes that reveal a predominant wind
at the bottom of the image.

24 *EOS CHASMA*, LIGHT-COLORED ROCKY BASE
AND EROSION CHANNELS
LAT: -12.6° LONG: 312.8°

This superb outcropping of sediments rich in
sulfates (bright terrains) and covered by a thick
coat of eolian sands has created small dunes
(or wrinkles) visible at the right of the image,
opposite a cliff of sediments. Small channels
coming from alcoves (rounded hollows) at
the summit suggest an outflow through which
some brackish water may have run a very
long time ago.

25 *VALLES MARINERIS*,
HILL OF BRIGHT DEPOSITS
LAT: -12.7° LONG: 313.9°

The border of this hill of bright, stratified deposits
juts out over a plain of dark sand. The slopes of the
butte are scattered with dry gravitational outflows
that leave gray deposits at their bases. The
possibility that a liquid, brackish water might have
once sculpted these sediment deposits has not
been excluded, but remains debatable.

26 LIGHT-COLORED TERRAINS
ON THE FLANKS AND THE FLOOR
OF THE CANYON *MELAS CHASMA*
LAT: -9.1° LONG: 282.5°

Sediments identifiable by their light tones are
often deformed in this zone. Dark matters
correspond to former volcanic terrains or,
locally, to accumulations of sand covering
the outcroppings of sediments.

27 *HEBES CHASMA*, OUTCROPPINGS
OF THICK, SEDIMENTARY STRATA
LAT: -0.8° LONG: 283.6°

These bright sedimentary strata contain salts
of sulfur (sulfates). The stratification here is
almost invisible because a strong, eolian erosion
sculpted the strata parallel to the slope (top and
bottom of the image). These sculptures are called
yardangs, a term of Türkmen, an origin used
to describe formations in Asia, notably in
the Taklamakan Desert in China. The dark
terrains at the foot of the slope, at the bottom
of the image, are dunes pushed by the wind.

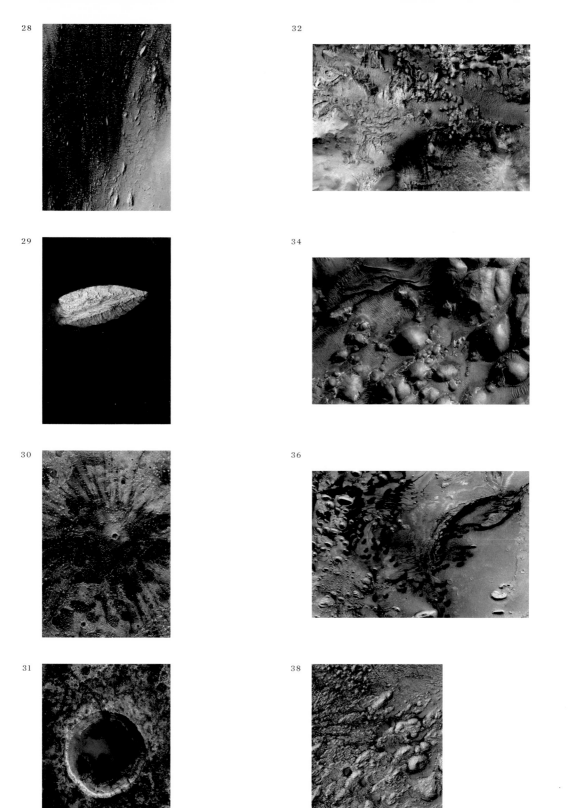

28

32

29

34

30

36

31

38

28 CRATER *HENRY*, ZONE OF FINELY STRATIFIED SEDIMENTS LAT: 10.2° LONG: 24°

Not visible here because it's larger than the range of this image, the crater *Henry* is almost four million years old and is 170 kilometers (105.6 miles) in diameter. The butte of sediment at the center of the crater is several kilometers high, and testifies to the efficaciousness of sedimentary processes in the past. The difference in tone between the right and left sides of the image has to do not only with the presence of black sand on the left side, but also with a layer of bright dust on the right that blends the tone of the subjacent terrains. The crater was named in honor of two astronomers, natives of Nancy, France, the brothers Paul-Pierre and Mathieu-Prosper Henry, who discovered several asteroids at the Observatory of Paris.

29 *GANGES CHASMA*, TERRAINS WITH STRONG ALBEDO LAT: -8.6° LONG: 313.9°

See caption for page 22.

30 *MERIDIANI PLANUM*, IMPACT CRATER AND ITS RADIATING RAYS, LAT: 1.2° LONG: 6.1°

This Martian "sun" was caused by a very recent crater, probably several thousands of years old. In spite of the small size of this impact, the shock created a blast capable of blowing up the surroundings of the crater, creating zones washed over by (dark) dust in comparison with other less-affected and better-preserved zones (bright). The alternations of these rays create an appearance that is absolutely particular to this crater. These rays would fade progressively with time due to the active eolian processes on the surface.

31 CRATER HAVING IMPACTED THE STRATA OF THE PLATEAU *MAWRTH VALLIS* LAT: 24.3° LONG: 340.7°

Contrary to the sediments containing sulfates, the European infrared spectrometer Omega has shown that in this case the strata at the edge of the crater are composed of phyllosilicates (from the Greek *phyllos*, meaning "sheet"), which are also called clay minerals. These minerals are formed by the transformation of the liquid water in primary minerals (silicates) into silicate sheets containing water molecules, more commonly known as clay. These are among the most interesting mineralogical testimonies of the ancient, humid past of the planet Mars.

32 CANYON OF *IUS CHASMA* LAT: -7.9° LONG: 276.7°

This view plunges into the canyon of *Ius Chasma*. Raised terrains are on the left; the canyon floor, situated about four kilometers (2.5 miles) below, is toward the right. The left terrains correspond to the volcanic substrata of the region, whereas the terrains on the right show fine stratifications, often of a light tint. Dunes oriented from the top to bottom of the image cover the depressed zones.

34 *ARAM CHAOS*, TERRAIN SCATTERED WITH BUTTES LAT: 2.6° LONG: 340.5°

This complex terrain is scattered with high, rounded buttes measuring about one hundred meters (328.1 feet) and surrounded mainly by fields of parallel dunes that fill the depression. Very white terrains emerge here and there, corresponding to the residues of sedimentary deposits containing sulfates, as observed in the numerous zones of *Aram Chaos*.

36 CRATER IN WESTERN ZONE OF THE *ARABIA TERRA* LAT: 8.8° LONG: 358.9°

At the left of the image, one can detect intact buttes from the eolian erosion of the sedimentary terrains (bright hills). The preferential lengthening of the buttes is determined by the preferential direction of the winds. The dark buttes, on the other hand, are dunes that punctuate the landscape. A careful look at the dunes situated at the center of the image can help one detect the direction of these winds, which blow from the bottom-right to the top-left.

38 *MERIDIANI PLANUM*, FAULTS IN THE SEDIMENTARY STRATA OF AN IMPACT CRATER LAT: 7.7° LONG: 353.2°

This complex assemblage shows sedimentary strata at various degrees of erosion in the interior of an impact crater (not visible in the image). The strata are particularly visible when the black sand has just slid over the topographical ladder of steps between two strata, emphasizing the effects of erosion.

39

40

41

42

43

44

45

46

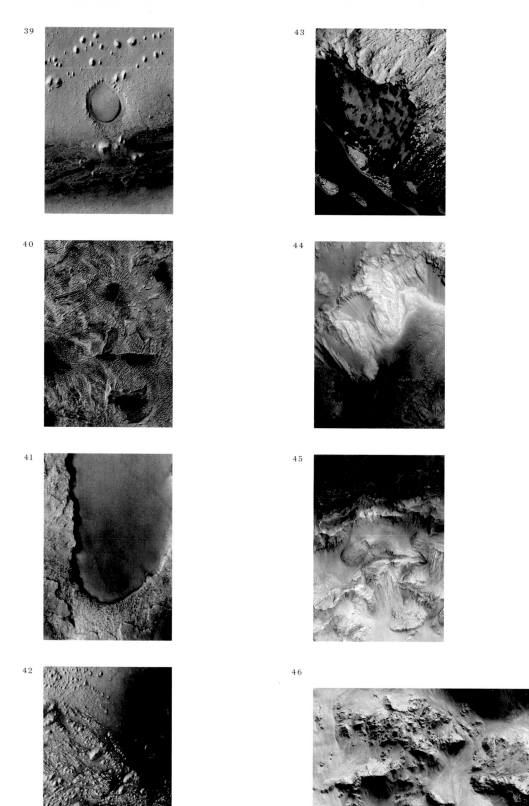

39 *GEMINA LINGULA,*
IMPACT CRATER
LAT: 5.6° LONG: 355.5°

At the center, one can distinguish an impact crater that became a heap of sediments before being partially eroded. The fine strata of hardened sediments are visible here and there on the crater, as well as at the lower part of the image, where they are slightly deformed. The linear forms in the interior of the crater are, in contrast, connected to small, movable sand dunes trapped in a topographical hole. The small buttes, notably at the top part of the image, are intact buttes of an eolian erosion, but their preferential alignments could equally be explained by the circulation of fluids that hardened the sediments locally all along hydrothermal sources.

40 *MELAS CHASMA,*
SEDIMENTARY DEPOSITS IN A CANYON
LAT: -11.1° LONG: 286.3°

The sedimentary deposits in the canyon *Valles Marineris* are covered by small eolian dunes, or wrinkles, undulating on the surface and have a decametric scale.

41 *AONIA TERRA,*
DUNES OF VOLCANIC SAND
LAT: -41.4° LONG: 297.6°

At the bottom are dark cords of volcanic sand that have accumulated transversally according to the dominant winds. At the top-right are bright sediments containing sulfates deposited in strata. These sediments could have been formed by deposits in a lake or through the alteration of liquid, sulfurous water from preexisting sediments, undoubtedly volcanic ash.

42 *ARABIA TERRA,*
INTERIOR STRATA OF A CRATER
LAT: 8.1° LONG: 352.6°

At the bottom-left, one can distinguish finely stratified terrains filling a crater of the *Arabia Terra* region. To the right, sediments are covered by dark and smooth sand that has gathered into some local dunes. At the top-right, the sand is covered by a fine layer of dust that has been swept by tornadoes, leaving criss-crossed, rounded traces on the surface.

43 *DANIELSON* CRATER,
SEDIMENTS AT THE INTERIOR OF A CRATER
LAT: 7.9° LONG: 353°

This crater, whose origin is unknown and which has been strongly dismantled by wind, has an accumulation of sediments (at top right) that allow only a few residual buttes to appear at a given place.

44 *MOJAVE* CRATER,
COLLAPSED AND FRACTURED SURFACES
LAT: 7.1° LONG: 327.1°

This image shows the slopes and the floor of the impact crater *Mojave*, whose diameter measures about sixty kilometers (37.3 miles). At bottom right, the terrains are fundamentally fractured and pitted. These are rocks that melted due to the impact energy of a meteor (of several hundred meters in diameter) having struck the surface of Mars several dozen million years ago. The pits suggest a volatile degassing process. The sloped cliffs lacking in small impact craters are characteristic of freshly formed inclines of a relatively recent epoch.

45 *ACIDALIA PLANITIA,*
NOT-YET-NAMED CRATER
LAT: 36.7° LONG: 329.6°

A fresh crater measuring twenty-five kilometers (15.5 miles) in diameter. In this image one can see only one slope and one section of its floor. The texture of the slope evinces gravitational processes of the landslide type. At bottom, the floor of the crater shows fractured forms in varying directions that could correspond to materials having been ejected from the crater itself, which fell back and filled its cavity.

46 THE WEST BORDER AND EJECTA
OF THE *MOJAVE* CRATER
LAT: 7.4° LONG: 326.6°

These views of the ramparts of the *Mojave* crater show thin, bright, and sinuous forms covering the hills' slopes: they are fluvial valleys formed by liquid, flowing water. The origin of this liquid water is probably tied to sporadic snowmelts, perhaps connected to the formation of the impact crater itself. Unexpected in such a young terrain, these valleys are smaller and more localized than the ancient fluvial valleys, but they show that the existence of liquid water is possible episodically, even in the recent past.

48

53

50

54

51

55

52

56

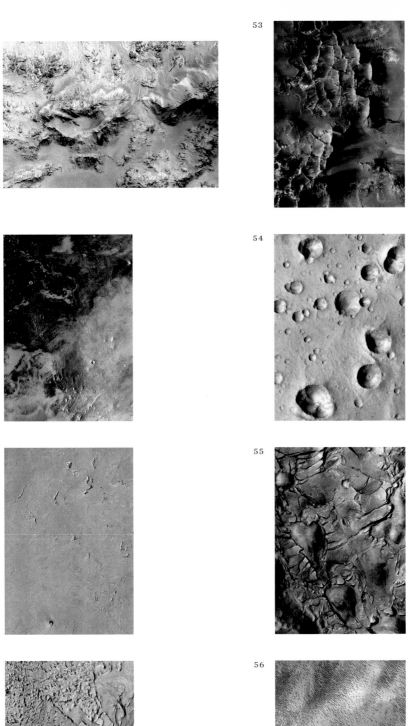

48 CLEAR FLUVIAL VALLEYS ON THE SLOPE
OF THE *MOJAVE* CRATER
LAT: 7.6° LONG: 327.4°

See caption for page 46.

50 ELONGATED RELIEFS
LAT: 5° LONG: 12.9°

Dark and finely stratified terrains where the layers
are difficult to detect, whether as deposits or zones
of deformation tied to terrain movements. These
terrains are covered, at bottom left, by delicate,
bright dunes, and, on the right, by a fine,
homogeneous layer of eolian dust.

51 *ATHABASCA VALLES,*
LAVA PLAINS
LAT: 8.7° LONG: 154.7°

A detailed observation of this group of very recent
and flat lava plains reveals sinuous lines in relief
of a few meters and several dozen meters long.
They are pressure ridges tied to the internal
constrictions of more or less viscous lava.

52 SEDIMENTS AND STRATA OF HYDRATED
MINERALS IN THE *BECQUEREL* CRATER
LAT: 21.3° LONG: 351.8°

At the right of the image, one can see long cliffs
with very visible sedimentary deposits and regular
strata. On the left, eolian erosion has rendered
the terrains more furrowed and the strata less
perceptible. The cyclical nature of strata, that is,
the regularity of their pilings, has been studied in
detail because of their connection to climatic cycles.

53 *NILI FOSSAE,* POLYGONAL CRESTS
AND LIGHT-COLORED TERRAINS
LAT: 17.5° LONG: 76.4°

These terrains are situated in the region of the
Nili Fossae, one of the most ancient on Mars, on
the border of *Syrtis Major.* The polygonal images
visible in the image are demarcated by more or
less linear fractures that suggest either the role of
mineralization, whether through fluids or cooled
lavas. The presence of clay minerals in these
terrains pleads in favor of circulations of fluids
having created veins resistant to erosion.

54 ZONE OF CLUSTER CRATER.
SWARM OF HECTOMETRIC IMPACT CRATERS
LAT: 30.1° LONG: 346.4°

In general, swarms of craters tied to the
fragmentation of asteroids or comets are elongated
in the direction of a meteor's entry into the
atmosphere, which isn't the case here. Swarms
tied to the fragmentation of a single meteor in
the atmosphere generally form only with craters
much smaller than one hundred meters (328.1 feet)
in diameter. In the present case, the numeric
models have shown that it could have something
to do with the ejection into space of a large crust
of Mars, following a very large meteoric impact
(creating, moreover, a crater of more than
ten kilometers, or 6.2 miles, in diameter) that
would have then fragmented in the atmosphere
before falling back on Martian ground.

55 *ISMENIUS LACUS,*
CRATER WITHOUT A NAME
LAT: 38.8° LONG: 2.1°

The floor of this crater presents a complex geology.
Round buttes emerge from a landscape where they
are partially covered by a material that broke up
into hectometer-size pieces. It's probable that this
material may have contained some ice that had not
escaped by melting, destabilizing the terrains,
surmounting them and provoking their bursting
into multiple pieces.

56 FIELD OF EOLIAN TRANSVERSAL CRESTS
AND SUPERPOSED IMPACT CRATERS
LAT: -3.3° LONG: 12.9°

Taken together, the field of small, parallel eolian
dunes covers a bright and smooth terrain.
Most of the impact craters, having been buried
beneath the dunes, are barely visible.

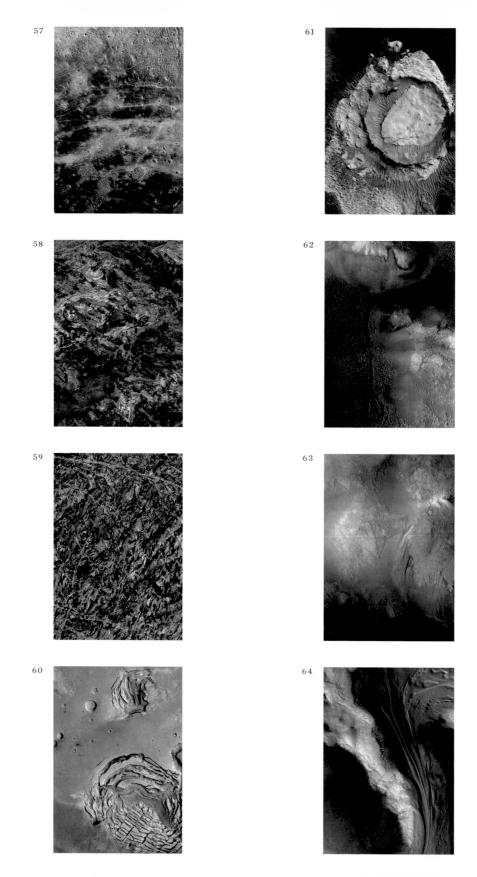

57

58

59

60

61

62

63

64

57 *CAPEN* CRATER, TERRAINS COMPOSED
OF ERODED, OR MORE-OR-LESS ERODED,
SEDIMENTS
LAT: 6.7° LONG: 14°

In the top part of this image, residual buttes show
sedimentary residues. The bottom part of
the image is heavily cratered, revealing a recent,
less important erosion. Certain craters are filled
with small, elongated structures parallel to each
other, which are dunes of bright sand.

58 SEDIMENTS OF OPAL
NEAR *VALLES MARINERIS*
LAT: -10.7° LONG: 281.6°

These bright, finely stratified sedimentary
deposits enclose deposits of hydrated silica
referred to as opal. The deposits are partially
covered by small, decametric dunes.

59 *OPHIR CHASMA*,
SEDIMENTARY TERRAINS
LAT: -4.6° LONG: 288.4°

Sediments containing sulfates (or sulfur salts) are
tied to precipitation in the presence of liquid water.
The sediments are strongly eroded by the wind
and partially covered by sand, making the texture
of the terrains very complex.

60 THE SETTLING OF ROCK SEDIMENTS
LAT: 39.5° LONG: 6.7°

This circular zone of collapse, or caving, is
probably the result of a volcanic-glacial episode.
This type of structure has been observed on
Iceland when a volcano pierces a layer of ice,
thereby causing it to melt and the caving in
of the glacier parallel to the volcanic chute.

61 SMALL CRATERS MADE UP OF SEDIMENTARY
STRATA IN THE *SCHIAPARELLI* CRATER
LAT: -0.8° LONG: 14.4°

This crater, four kilometers (2.5 miles) in diameter,
recognizable by its circular form, was almost
effaced by eolian erosion on the surface of Mars.
Its interior is formed by easily erodible sedimentary
strata of little resistance, seen at the bottom right
of the image, and topographically present beneath
the circular form. At the center of the crater,
one can see other, somewhat brighter, sediments,
evidence of a flooding having taken place after
the formation of the crater. These strata present
a different aspect—a notably smoother texture—
than the older strata they cover.

62 BUTTES AND CHANNEL
IN THE MIDDLE OF A RUGGED PLAIN
LAT: 49.9° LONG: 31.1°

This rugged plain scattered with buttes is traversed
by a channel of unknown origin. At these lesser
latitudes, ice from water is often present on the
ground near the surface.

63 RAVINES ON THE CENTRAL MONTICULE
OF THE *LYOT* CRATER
LAT: 50.4° LONG: 29.4°

In this view of the central peak of the *Lyot* crater,
the slopes (at left in the image) present small valleys
(notably the two at the bottom of the image) that
were formed by liquid outflows. The most common
interpretation of them implies liquid water during
short periods, liquid water created liquid outflows,
designated as flows of debris.

64 CRESTS AND HOLLOWS IN THE VALLEY
AT THE BORDERS OF THE *MOREUX* CRATER
LAT: 40.8° LONG: 44.1°

The image (bright terrains) shows the ramparts
of the large impact crater *Moreux*. The elongated
structures are moraines left behind by passing
glaciers. Ice is no longer on the surface, but
it remains a few meters below the ground. The
sublimation process has permitted ice to
transform directly into water vapor because
of weak atmospheric pressure.

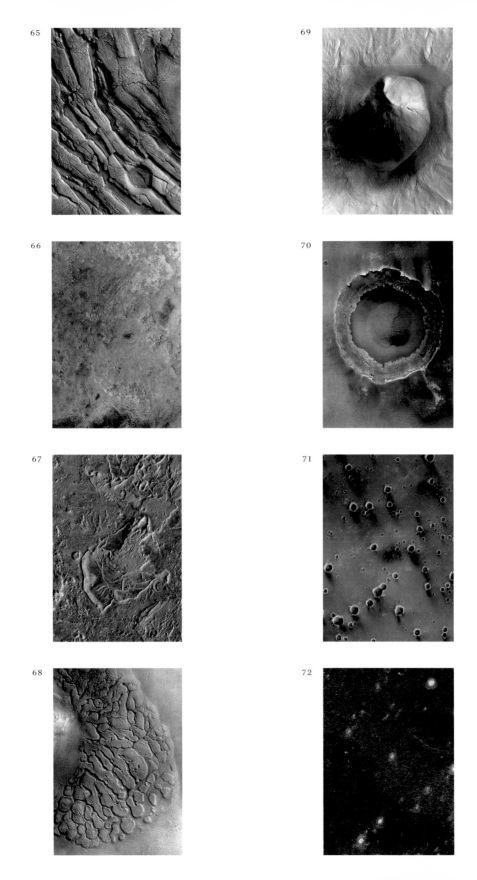

65

69

66

70

67

71

68

72

65 *MOREUX* CRATER
LAT: 41.2° LONG: 44.1°

This crater, of which only an infinitesimal part is visible in this image, was named in honor of Théophile Moreux, a priest and astronomer during the first half of the twentieth century who was also called Abbot Moreux. The image shows, more precisely, a region with deposits of ice near the surface. This ice in the ground generated vast movements of the terrain by flooding, and induced the fracturing of the surface.

66 *NILI FOSSAE*,
SMALL DUNES OF BRIGHT SAND
LAT: 21.7° LONG: 79°

This terrain of the region *Nili Fossae* is covered for the most part by small decametric dunes of bright sand. The sand is bright here because of the significant proportion of olivine, a yellow, olive-green mineral, as it name indicates. At the bottom of the image, and on the top right, are outcrops of bright terrains, not covered by dunes, that contain magnesium carbonates (or magnesite), a type of rock that is not very abundant on the surface of Mars.

67 DEFORMATIONS IN THE NORTHEAST
OF THE *ARABIA* REGION
LAT: 28.9° LONG: 64.6°

Depicted are terrains whose thin, elongated, and sometimes rounded ridges appear in relief because of a differential, erosional phenomenon. In fact, these elongated filaments are probably more resistant to wind erosion than the terrains on which they were formed, or by which they were covered over, and so are not completely eroded, as opposed to the terrains that surround them. This type of structure could exist because of volcanic veins or fluvial channels.

68 *DEUTERONILUS MENSAE*,
FRACTURED TERRAINS
LAT: 44.1° LONG: 26.8°

This "brain," several kilometers wide, is a structure that contains a lot of ice from water. The image is at the lower latitudes (40°-50° North, equivalent to the latitude of France), a zone in which the ground conserves ice at several meters in depth. These terrains were fractured by the movement of this ice, in part by its weight, like that of a glacier, and in part by the process of sublimation that makes ice escape directly into the atmosphere in the form of water vapor.

69 CENTRAL PEAK OF A CRATER
LAT: 52.4° LONG: 39.9°

A zoomed-in of the central peak of a crater: the center of the image depicts a topographic elevation. Thin, linear, and slightly sinuous forms extend to the bottom right of this peak; they are recent ravines whose origin is tied to volatiles, probably ice melting locally. The presence of ice from water is confirmed by the structures of sublimation that are around the central peak and, from the top left, by rounded tongues, testimonials to the flow of viscous ice. Ravines can't be formed except on steep inclines, which is the only explanation for their presence on the peak.

70 *MERIDIANI PLANUM*,
A LARGE AND YOUNG CRATER
LAT: -2.5° LONG: 357.6°

The region of *Meridiani Planum* was explored by the NASA rover *Opportunity*. The sedimentary strata studied by instruments in this region confirm them to be a series of alternating eolian sediments from the circulation of subterranean waters rich in sulfur, and hardened by this process in a distant past of about 3.5 million years. The geometric forms in the interior of the crater are linked to active dunes, that is, dunes still mobile through the effects of winds but trapped by the topography of the crater's floor.

71 *MERIDIANI PLANUM*,
SMALL IMPACT CRATERS
LAT: -2.3° LONG: 356.5°

This field is scattered with small impact craters of a few dozen meters in diameter. The smallest among them are covered by black sand, which makes them even more difficult to see. That also explains the difference in tone between the terrains and the very bright edges of the craters.

72 TERRAINS "IN MOUNDS"
ON THE NORTHERN PLAINS
LAT: 37.6° LONG: 202.8°

In these regions, the wintry accumulation of frost on the ground and its subsequent sublimation create terrains with particularly embossed textures.

73

78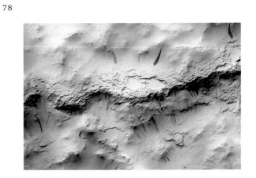

74

75

76

80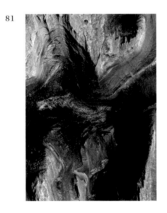

81

82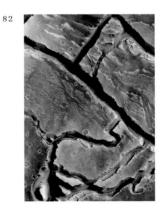

73 REGION OF *THEMIS*,
STRIATED PLAINS OF THE NORTH
LAT: 72° LONG: 125°

The striations are chains of buttes that probably
come from the combination of periglacial
(linked to ground ice) and eolian processes.
Some meteoric impact craters are present,
but they are completely blunted through
re-coverings and the activities of the ice,
which condenses and sublimates each winter.

74 AGGLOMERATIONS OF SEDIMENTS
ON THE FLOOR OF THE
MELAS CHASMA CANYON
LAT: -8.8° LONG: 282.9°

These blocks were probably deposited during
a mass sliding of sedimentary strata. These
terrains remain among the most enigmatic
on Mars's surface.

75 THE CENTRAL HILLOCK
OF THE *OUDEMANS* CRATER
LAT: -9.9° LONG: 267.9°

Oudemans is an impact crater more than one
hundred kilometers (62.1 miles) in diameter.
Like all craters this size, it has a central peak
linked to the crust, having rebounded in a manner
similar to how a drop of water falls into liquid.
This central peak cropped up from the
surface of strata that were hidden several
kilometers below.

76 NORTHERN ZONE OF THE *MERIDIANI
PLANUM*, LINEAR CRESTS
LAT: 11.9° LONG: 0.7°

These sedimentary terrains show parallel
alignments whose interpretation remains
uncertain. They could have been caused by
the hardening of longitudinal dunes, which are
also very linear, or by the processes of fracturing
and hardening occasioned by the circulation
of fluids. In any case, these terrains have been
heavily eroded and the linear forms convey
a preferential hardening in relation to this
sedimentary heap.

78 *ARABIA TERRA*,
CRATER EDGE
LAT: 11.3° LONG: 32.4°

These terrains, heavily covered by sand, were
subject to landslides, hence the dark traces one can
detect. It has been shown that the slides were
unleashed by dominant winds all along the steepest
slopes or at the base of topographical reliefs.

80 CANYON OF THE *GALE* CRATER
LAT: -5.2° LONG: 137.4°

The *Gale* crater, named in honor of Walter Gale,
an amateur Australian astronomer, consists
of a canyon with central deposits. This crater,
170 kilometers (105.6 miles) in diameter, was
selected for the landing of the rover *Curiosity* in
order to analyze the strata visible in this image.
The presence of clay minerals and hydrated
sulfates at the lower part of these strata, needing
the action of water in their formation, was a
decisive argument in favor of this site. *Curiosity*
is a 900-kilogram (1,984-pound) machine that
includes a dozen instruments geared to the
detailed analysis of the mineral and organic
chemistry of these sedimentary rocks.

81 SULFATE LAYERS INSIDE
THE *GALE* CRATER
LAT: -5.3° LONG: 137.2°

See caption for page 80.

82 *GRANICUS VALLES*
LAT: 27.3° LONG: 135.5°

A labyrinth of canyons hollowed out by outflows
on a volcanic plateau near the *Elysium Mons*
volcano. During a volcanic action that traverses
a region containing ice, albeit subterraneously,
a chain of processes is set off from explosions
called phréatogmatiques or lahars, those muddy
or doughy outpours that, on Earth, flow down
snow-covered volcanoes. The nature of these
outflows, at the same time muddy, rocky, and fluid,
is not precisely known, but these have probably
been brief and are not directly connected to
climatic conditions. The volcanism on Mars is
a source of heat that can explain the local presence
of liquid water in a climate that remains very cold.

83

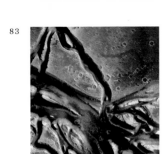

84

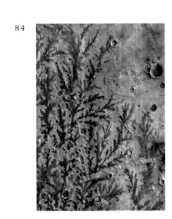

85

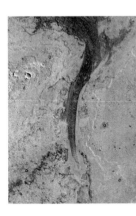

86

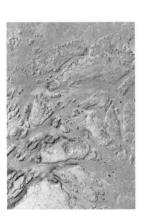

87

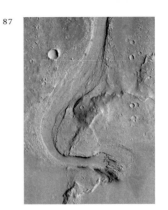

88

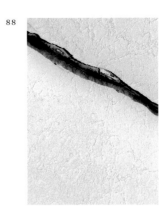

89

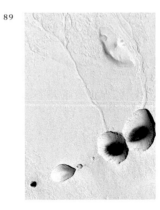

90

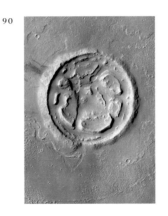

83 *TINJAR VALLES*
LAT: 27.3° LONG: 135.5°

See caption for page 82.

84 BRANCH-LIKE FORMS ON THE FLOOR
OF THE *ANTONIADI* CRATER
LAT: 21.4° LONG: 61.3°

The terrain inside the *Antoniadi* crater evokes
tree branches. These are fluvial channels whose
topography is inverted. In fact, the channels have
shingled sediments of rough sands that harden
preferentially, notably with the presence of water.
Outside the channels, the sediments are finer
and less resistant. When a humid period ends,
the eolian erosion, dry this time, begins, and
the deposits of the channels become more difficult
to erode than the fine deposits of the surrounds.
It is what one calls differential erosion: the deposits
of the channels will become perpendicular,
as they were initially, when inside the topographic
depressions.

85 POSSIBLE LAVA FLOWS CANALIZED
IN THE SOUTH-CENTRAL PART
OF THE *ELYSIUM PLANITIA*
LAT: 2.8° LONG: 157.1°

The channel at the center of the image doesn't show
any particular erosion. This is because some
of the lava fluids have channelized. At the bottom
of the image, the end of the channels shows some
polygonal structures linked to the cooling of the
lava flows. These flows are part of the most recent
lavas on the surface, only several thousand years old.

86 *LETHE VALLIS*, VOLCANIC TERRAINS
ERODED BY CHANNELS
LAT: 4.5° LONG: 156.1°

The blocks of terrain in the middle of the image
are "islands" preserved by the erosion that ate up
all the surrounding terrains when the liquid did
not leave as quickly as it appeared. This channel,
like many others of the same type that traverse
flows of fresh lava, is at the center of a debate to
determine if the outflow was due to muddy or very
fluid volcanic flows.

87 *ATHABASCA VALLES*, CASCADES OF PROXIMAL
EXTREMITY OF THE DEVIANT OUTFLOWS
LAT: 8.2° LONG: 154.9°

The channel that traverses the volcanic plains
depicted here had a heavy output, perhaps close
to that of the Amazon, but it probably lasted only
several days. At the bottom right of the image,
the apparent source of the channel does not
correspond to the reality that at the first traces
of erosion, it generated the rupturing of a slope

in its passage. It was probably present higher up,
but did not leave any traces on the surface.
In the present case, a channel linked to liquid
water is the preferred explanation. The force
of the erosion leads one to suspect a massive
melting of subterraneous ice directly linked
to the volcanic activity present in the region.
These are hypotheses that continue to be debated.

88 *CERBERUS FOSSAE*, CREVASSES
LAT: 8.8° LONG: 163.4°

The fissure at the middle of the *Cerberus Fossae*
is very recent (a few thousand years) on the scale
of the planet's age (4.5 billion years). It is at
the origin of an important volcanic eruption that
was probably the last big eruption that took place
on the surface of Mars. The volcanic region is
dormant, but that does not exclude the possibility
of volcanic eruptions in the future.

89 *AMAZONIS PLANITIA*, CHANNELS AND CAVITIES
LAT: 22.2° LONG: 202.8°

The rounded cavities with depths of several
hundred meters, at the bottom right of the image,
are holes linked to meltdowns. In fact, the
volcanoes are furrowed by tubes inside of which
lava circulates more than it does on the surface,
eroding its foundations. These subterranean tubes
of lava sometimes melt, creating round, elliptical
holes. Two channels come out of these cavities
as if serving up water. The lava channels here
are phenomena that exist when lava is very fluid
and mimes the flow of liquid water. That doesn't
raise doubt about the existence of liquid water
on Mars. Fluvial valleys have been observed at
quite a distance from volcanoes and with multiple
sources, whereas the lava channels have always
had immediate sources, as in the present case.

90 *OLYMPUS MONS*, DARK MATTER AND AUREOLE
LAT: 17.6° LONG: 216.3°

This image was taken close to *Olympus Mons*,
the biggest volcano in the solar system, more
than twenty-five kilometers (15.5 miles) tall
and 650 kilometers (403.9 miles) in diameter.
It's a volcanic shield formed by the accumulation
of liquid lava. The most comparable terrestrial
volcano is the Hawaiian Mauna Loa, which rises
nine kilometers (5.6 miles) above the ocean floor.
Three reasons explain why the volcanoes on Mars
are bigger than those on Earth: the more rigid crust
on Mars allows greater pressures to be sustained;
gravity is less strong on Mars, reducing the
pressure on falling rocks; and tectonic plates are
absent, permitting volcanic activity to continue
in the same place.

91

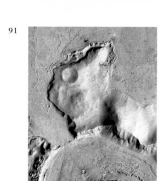

98

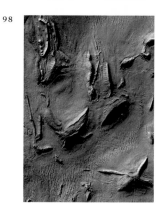

92

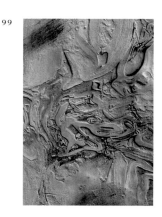

99

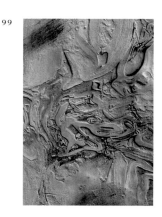

94

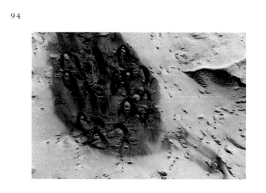

100

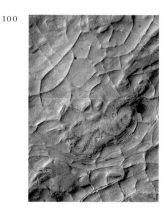

96

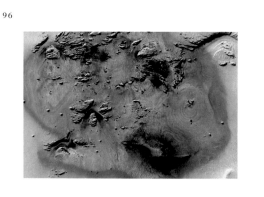

101

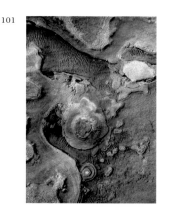

91 *ELYSIUM PLANITIA*, VOLCANIC FISSURE
IN AN IMPACT CRATER
LAT: -1° LONG: 159.8°

The relief of the smooth surface corresponds to
ancient terrains in which large impact craters were
once formed. These terrains have subsequently
been filled by volcanic eruptions. These are visible
on the image as flat terrains in the topographical
hollows that are more or less crumpled on the
surface, resulting in the cooling of lavas.

92 *ELYSIUM PLANITIA,*
FRACTURED BLOCKS
LAT: -3.3° LONG: 167.9°

Volcanic terrains aren't always dull plains.
This assemblage of fractured blocks, whose origin
isn't completely understood, attests to that.
The lava was pushed upward then broken while
cooling off, and became fixed. The terrains are bright,
with the exception of some rare, dark cliffs, because
a cover of dust hides the true shade of the lavas.

94 DARK MATTERS AND AUREOLES
ON THE APPROACH TO *OLYMPUS MONS*
LAT: 17.6° LONG: 216.3°

The big difference in tone between the center of
the image and the surrounding areas isn't because
they are geologically different, but because of a fine
layer of dust. It is absent at the center of the image,
revealing the true tone of Martian rocks, which
is in general darker and is due in this case to their
basaltic origin.

96 DARK MATTERS AND AUREOLES
ON THE APPROACH TO *OLYMPUS MONS*
LAT: 17.3° LONG: 217.5°

At the center of this image there is a dark spot
that actually reflects the true tone of this volcano.
The terrains are bright when they are covered with
dust, whereas the dark tone is the more natural
one for volcanic materials. At the interior of these
dustless openings there are aureoles, that is, strata
that coil around themselves. Volcanic ashes were
deposited during the explosive phases of the volcano,
probably at the end of its life, when the summit
crater was formed by the collapse of a magmatic
chamber.

98 ELONGATED RELIEFS
IN THE REGION OF *HELLAS*
LAT: -43.9° LONG: 78.1°

A row of hills comes out of a zone filled with
glaciers in all its topographical hollows. The
surface looks homogenously bright, not because
of ice, but because of a coat of dust on the terrain.
By masking the ice, the dust contributes to its
preservation, as it isolates it from the atmosphere
and prevents it from transforming into water vapor.

99 STRATA IN THE REGION OF *HELLAS*
LAT: -42.7° LONG: 52.8°

This zoomed-in view shows the terrains situated
on the floor of the gigantic impact basin *Hellas*.
The geological strata show folds linked to ductile
deformations, a name used in geology; they
are without any rupturing or breakage of rocks.
The origin of the deformation remains poorly
known and might eventually implicate the saline
sediments of ice layers.

100 POLYGONS BORDERED BY CRESTS
IN THE *HELLAS* BASIN
LAT: -37.4° LONG: 54.4°

Another example of exotic reliefs on the floor
of the *Hellas* basin, where an inversion of relief
is created following the preferential preservation
of topographical wrinkles, or webs of veins,
of an unknown origin. These demarcate polygons
in various forms.

101 STRATIFIED, SEDIMENTARY BUTTES
IN THE REGION OF *ARGYRE*
LAT: -49.8° LONG: 302.9°

Argyre is the second-largest impact basin on Mars.
More than 1,500 kilometers (932 miles) in diameter,
it resulted from a collision with an asteroid about
four billion years ago. This zoomed-in view inside
the basin resembles the much more recent terrains
that filled the cavity. The bright terrains are
regrouped into stratified buttes of a clearly
sedimentary origin. In the context of *Argyre*,
beyond the lesser latitudes propitious for ice, it is
possible that these sediments may have had, or still
have, ice from water. The low plains are filled with
dunes detectable by their wrinkled terrain,
generally in the vertical direction of the image.

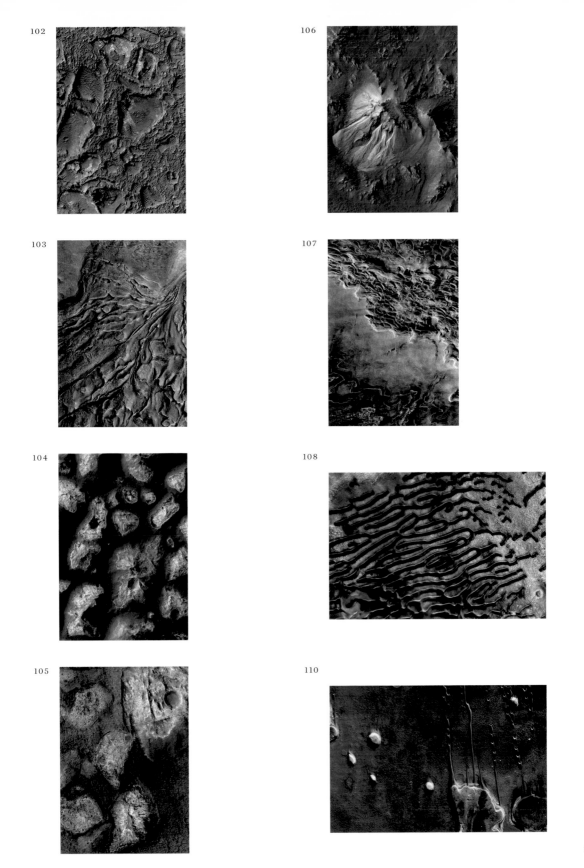

102

106

103

107

104

108

105

110

102 ROCKY BASE ON THE FLOOR OF A CRATER
LAT: -19.5° LONG: 66.3°

These complex terrains show a differential erosion, that is, the preferential erosion of the most mobile terrains and the preservation of the most resistant ones, creating an inversion of the reliefs. The visible veins are of an unknown nature, volcanic or sedimentary.

103 *HARMAKHIS VALLIS*, PART OF WHICH IS FROM A GLACIER FLOW
LAT: -37.7° LONG: 95.6°

The zones at lower latitudes (between 40° and 60°) contain very large proportions of ice, notably in the form of glaciers. In the present case, the glacier flows toward the lower-left part of the image—as the nearly parallel lines, all running in the same direction, indicate. A detailed viewing allows even smaller lines perpendicular to this direction to be perceived. These are fractures or crevasses similar to the crevasses that are formed on the glaciers of the Alps, notably when the glacier rolls down the sides of the reliefs.

104 *ARIADNES COLLES*, HILLS
LAT: -34.8° LONG: 171.5°

In these two images, the bright zones are hills belonging to the same geological type. Around the hills, the dark matter probably corresponds to eolian deposits that tapestried the region and are found situated essentially among the bright hills. It is probable that these dark terrains covered the entire region homogeneously, but recent erosion caused the removal of the buttes' summit. This is fortuitous for the comprehension of the site, because the bright material contains clay minerals, proof of the presence of water during the formation of these terrains, well before their having been covered by black sand.

105 *TERRA CIMMERIA*, HILLS
LAT: -36.2° LONG: 162.6°

See caption for page 104.

106 CHANNELS STRONGLY REFLECTING LIGHT FROM THE SUN IN THE *HALE* CRATER
LAT: -36.5° LONG: 322.7°

With its dimensions of 150 by 125 kilometers (93.2 by 77.7 miles), the *Hale* crater is among the most vast of the craters formed during the last three million years. It carries the name of an American astronomer, who specialized in the Sun and worked at the beginning of the twentieth century. The center of the image shows a peak that is part of the central ring formed by the rebound of the crust just after a meteoric impact. On this peak there are small channels and ravines that have eroded the debris apron at the foot of the cliffs. These ravines are probably not linked to the melting of local snows.

107 SEDIMENTARY, BRIGHT STRATA ON THE SOUTHERN PART OF THE *GALLE* CRATER
LAT: -51.8° LONG: 329.5°

The *Galle* crater (not to be confused with the *Gale* crater, target of the rover *Curiosity*) is characterized by a heap of sediments of unknown nature. They are distinguished by strata that are several meters high, and stand out, one by one, in this image like irregularly formed steps.

108 DUNES IN THE REGION OF *HELLESPONTUS*
LAT: -44.9° LONG: 38.7°

These dark dunes, of basaltic composition, are situated to the west of the *Hellas* basin, known for hiding one of the most beautiful Martian dune complexes. These parallel dunes are called longitudinal dunes. In general, they are the product of predominant winds from two directions at about 30° to 60° of the dunes' axes, an infrequent situation. One of the particularities of longitudinal dunes is the presence of bifurcation of some of them into two branches, which makes them resemble large-scale digital prints.

110 *BARKHANES* IN THE CRATER ZONE
LAT: -41.5° LONG: 44.6°

The bright and rounded zones are buttes in relief (the light from the Sun comes from the right in the image). Two large buttes with a plateau can be detected on the left side of the image. On the right side, cordons of black dunes stretch out across the plains. Some of the dunes are *barkhanes*, a word of Arabic origin meaning crescent. These dunes indicate a wind that comes from the left and goes toward the right of the image, while the interior facets of a crescent-shaped dune are turned toward the right, as in the present image.

112

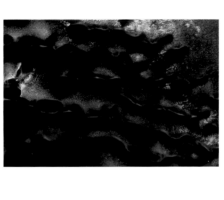

117

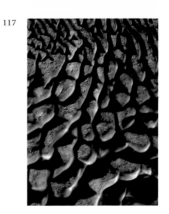

114

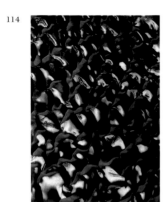

118

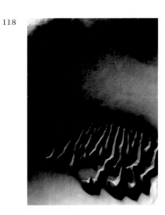

115

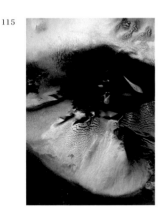

119

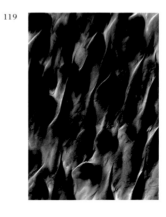

116

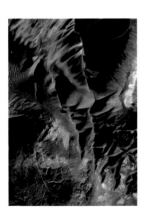

120

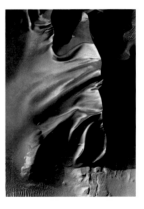

112 DUNES IN THE REGION OF *HELLESPONTUS*
LAT: -45.1° LONG: 28.9°

These dark dunes, which have a basaltic composition and are situated west of the *Hellas Planitia*, are separated by bands of rough earth. More irregular than those shown on page 108, they are the result of winds that vary seasonally. On Earth, the cordons of dunes separated by earth are often called seif, a word of Arabic origin.

114 FIELD OF DUNES IN THE *PROCTOR* CRATER
LAT: -47.2° LONG: 33.9°

Hundreds of black-sand dunes of basaltic composition have accumulated on the floor of the *Proctor* crater. In winter, because of the relatively high latitude (47° south), these dunes are covered by frost and carbonic ice, in particular on the polar flanks deprived of sunlight, thus creating a sharp contrast in tone.

115 CRATER IN THE SOUTHERN HEMISPHERE
LAT: -54.6° LONG: 17.5°

In this image, taken at a latitude of 55° south, one can distinguish a dune of dark sand even darker than in all the other images thanks to the strong contrast of albedo (the capacity of rocks to reflect light) with the surrounding terrains that are covered in winter frost. This frost is, at most, two meters (6.6 feet) thick and, in regions of 50° to 60° latitude, can occupy the totality of the surface for several months.

116 LARGE DUNES AND RAVINES
IN THE REGION WEST OF THE *ARGYRE*
LAT: -48° LONG: 303.7°

The tops of these large dunes of black sand are partially covered by frost. The light from the Sun comes from the top, accentuating the difference in tone between each slope of the dunes. The topography isn't flat. As on Earth, the largest dunes are frequently observed in hilly regions; the dunes are stabilized on the slopes of hills to the point of engulfing them completely.

117 SEQUENCE OF TRACES LEFT BY DUST
WHIRLWINDS ON THE FIELD OF DARK
DUNES IN THE *BUNGE* CRATER
LAT: -33.5° LONG: 311.2°

These triangular dunes where created by winds probably coming from three main directions. On Earth, such dunes are called star dunes and are among the tallest. On Mars, the tallest dunes rise to five hundred meters (1640.4 feet), and in that they are comparable to the tallest dunes on our planet, found in China, in the Gobi and Badain Jaran Deserts.

118 GROUP OF DUNES
LAT: -56.1° LONG: 2.1°

This group of dunes accumulated on the floor of a depression in the high austral latitudes.

119 TRACES OF DUST WHIRLWINDS
AND DARK DUNES IN THE *HOOKE* CRATER
LAT: -44.6° LONG: 315.2°

This field of dark dunes is thinly covered by bright dust. This dust is locally swept by dust tornadoes (dust devils), thus creating fine, dark traces.

120 DUNES ON THE FLOOR
OF AN IMPACT CRATER
LAT: -49.1° LONG: 27.2°

The top of the image shows a group of dunes on the floor of an impact crater. In winter, because of the relatively high latitude (49° south), thin, dark dunes become covered by frost from carbonic ice. Such ice very thin here, identifiable by subtle differences in tone.

121

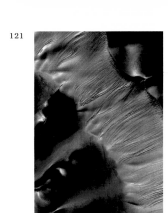

122

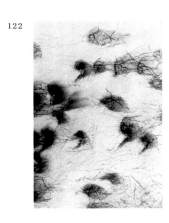

123

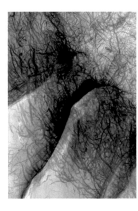

124

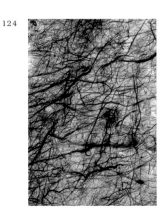

125

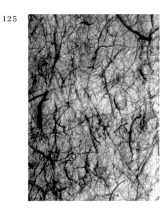

126

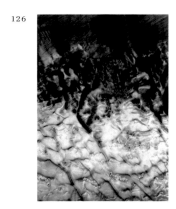

127

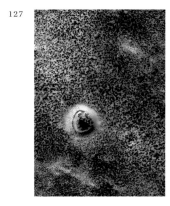

128

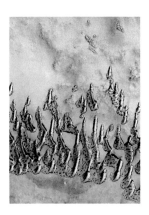

121 DUNES OF THE *RUSSELL* CRATER IN WINTER
LAT: -54.3° LONG: 13°

The *Russell* crater contains the largest dune on Mars, close to five hundred meters (1,640.4 feet) high. Along the flanks pictured here, inclined at 10° toward the west, flow dozens of small parallel channels (or ravines). These traces of outflows appear locally in spring and summer due to the destabilization of frost, actually liquid water formed during the seasonal reheating.

122 SAND DUNES
LAT: -52.7° LONG: 351.5°

Black-sand dunes are shown in the plains of the southern hemisphere. Here they are partially covered by dust that was lifted by tornadoes. Traces of tornadoes are modified from one year to the next, showing that there still is activity now.

123 DUNES IN THE *RUSSELL* CRATER
LAT: -54.3° LONG: 13°

During the less windy seasons in the *Russell* crater, on the highest dune on Mars, the black sand is completely covered with traces marking where tornadoes have lifted the accumulated sand.

124 TRACES OF SAND WHIRLWINDS
LAT: -62.9° LONG: 162°

In these two images, the terrains are completely covered with traces of sand whirlwinds. One can notice, notably in the second image, a large number of circular and helicoid traces. In fact, the whirlwinds are sometimes fast and linear, but often they spiral in less-direct trajectories. These whirlwinds have been feared by the operators of the Martian rovers *Opportunity* and *Spirit*, but in reality they present only a weak, immediate danger, because the extremely fine dust doesn't damage the rovers' shells. On the contrary, they have even cleaned off existing dust on the solar panels, renewing the rover's energy. Over the long term, however, this fine dust could end up jamming the mechanisms.

125 TRACES OF SAND WHIRLWINDS
LAT: -59.5° LONG: 116.8°

See caption for page 124.

126 SEASONAL HALOS IN THE ZONES
NEAR THE REGIONS OF THE SOUTH POLE
LAT: -69.5° LONG: 153.4°

These terrains, neighboring the regions of the South pole, are partially covered by seasonal frost, at the bottom of the image, and without frost, at the top. This geographic zone is made up of dark dunes, which explains the sharp contrast in tone. In the dark part, on the top of the image, we can see two kinds of traces one results from tornadoes, and other from winds blowing sideways.

127 POLAR REGION OF THE SOUTH,
SPRINGTIME PHASE OF DEFROSTING
LAT: -78.8° LONG: 68.8°

The hundreds of dark traces correspond to fractures created by mini geysers that uncover the dark matter beneath the frost.

128 DEFROSTING OF DUNES
LAT: -60.2° LONG: 7.9°

The seasonal frost that covers this terrain is made of some ice from water, but is mostly carbonic ice, the CO_2 that condenses at -125° C (-193° F). The polar terrains at latitudes of more than 60° on the north hemisphere, as in the south hemisphere, have winters that reach this temperature. The carbonic gas of the atmosphere condenses directly on the ground and creates atmospheric fluctuations specific to this process. The terrains are uncovered in spring, when the daytime temperature exceeds 125° C (257° F) and the frost volatilizes into the atmosphere. This phenomenon takes several days, even weeks, depending on the thickness of the frost and the physical properties of the subjacent terrains. When the terrains are very dark, like the dunes, or inclined toward the Sun, they warm up more rapidly, creating dark, defrosted patches in the middle of a plain that is still white.

129

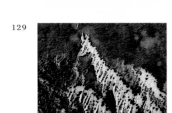

133

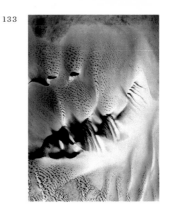

130

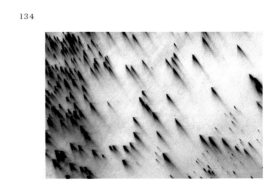

134

131

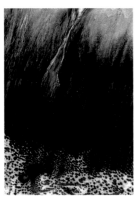

136

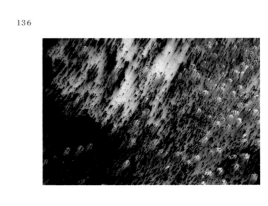

132

138

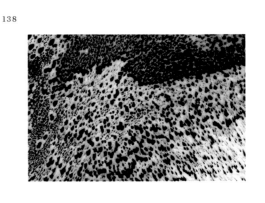

129 *AONIA TERRA*, DUNES
LAT: -63.8° LONG: 251.7°

See caption for page 128.

130 THE DEFROSTING OF A CHANNEL
AND DUNES
LAT: -58.5° LONG: 305.3°

In the spring, the frost-covered terrains
progressively lose their icy layer. (The bright zones
on the image are those that remain covered with
frost.) A recent channel cuts the slope of this hill.
The dotted texture of these slopes suggests
the presence of water underground, as is frequent
at similar latitudes.

131 SEASONAL HALOS AND FRACTALS
LAT: -69.5° LONG: 153.4°

See caption for page 128.

132 SOUTHERN HEMISPHERE,
DEFROSTING OF DUNES
LAT: -62.8° LONG: 128.6°

These dark dunes are heavily covered with seasonal
frost; nevertheless, one can see dark traces at
the foot of the dunes, which are already defrosted,
at the right of the image. The sharp contrast between
the two tones, the black sand and the frost that
covers them, makes it difficult to read the image.

133 DUNES COVERED BY SEASONAL FROST
LAT: -58.6° LONG: 8.8°

The dark points forming parallel lines, visible
at the center of the image, mark the first traces
of seasonal defrosting at the beginning of spring.
On the other slope, small ravines are incised into
the dunes.

134 POLAR REGION OF THE SOUTH,
FANS AND POLYGONS
LAT: -87.3° LONG: 168°

The dark triangles are fans that come from
the geysers formed during the defrosting of the
southern polar regions. In this image, subjacent
material is dark and covers the bright ice that
is still quite present in the first days of spring
in the hemisphere of the South.

136 POLAR REGION OF THE SOUTH,
DEBRIS FANS AND POLYGONS
LAT: -87.3° LONG: 168.1°

The sublimation of carbonic gas near the South
pole creates very particular phenomena similar
to those of geysers, allowing fans to rise to the
surface. The carbonic gas is relatively transparent
in some places, allowing the warmth of the Sun
to penetrate. Underneath the frost, the gas begins
to accumulate at the bottom of the layer because
of the higher temperature; then, with the pressure
created underneath, these pockets of gas break
the cover of frost and explode like geysers, creating
fans of debris.

138 SEASONAL DEFROSTING
IN THE POLAR REGION
LAT: -84.3° LONG: 242.1°

This Martian Dalmatian is a view of the polar
region in the process of seasonal defrosting.
Defrosting begins with the dark points that enlarge
progressively until they meet and completely
uncover the once-frosted surface; in this image,
a few dozen centimeters of carbonic ice and a bit
of frost from water remain.

140

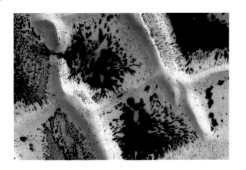

145

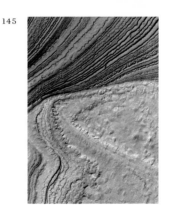

142

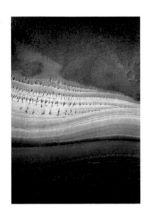

146

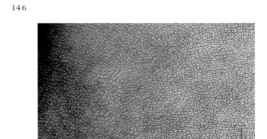

143

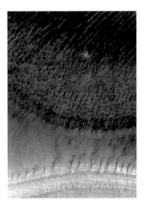

148

144

150

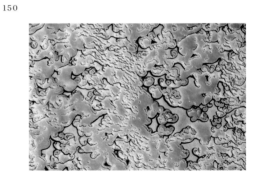

140 DEFROSTING OF THE CRESTS OF *INCA CITY*
LAT: -81.5° LONG: 296.3°

Audaciously called *Inca City* because of its rectangular, geometric shapes evoking vestiges of habitats, these terrains have nothing reminiscent of a city or of the Inca. Their size—several kilometers—is the best proof of that. The nature of this polygonal network, unique on Mars, remains poorly understood, but seems to be linked to volcanic dykes covered by eolian sand. These terrains are close to the South pole and undergo springtime defrosting in dark patches that become progressively larger as temperatures climb.

142 REGION OF THE POLAR SOUTH,
STRATIFIED, POLAR DEPOSITS
LAT: -75.8° LONG: 201.6°

These polar deposits of the southern vault contain at least 90 percent ice from water that is more or less rich in dust. The more dust there is, the darker the strata in the image. In general, the dust has a brightening effect on the terrains on Mars, but in this case, the iced water is brighter than the dust, and is therefore darkened by the latter.

143 REGION OF THE POLAR SOUTH,
SEDIMENTARY STRATA FORMED IN SPRING
AND AT THE END OF SUMMER
LAT: -78.2° LONG: 203.2°

The dark traces that converge come from a multitude of fractures are linked to the sublimation of a layer of carbonic ice. This forms geysers because the evaporation of ice proceeds more rapidly beneath the thin layer of ice.

144 REGION OF THE POLAR SOUTH,
CLIFFS DISCLOSING WHAT ARE PROBABLY
SEDIMENTARY POLAR STRATA
LAT: -88.2° LONG: 212.1°

These terrains of the polar vault in the South have been little observed, and show a cliff (black edge), more than several dozen meters high, at the limits of a low zone (at the top left) and a plateau (at right and bottom). Poorly known, the origin of the cliff probably implies processes linked to the ice contained in these terrains.

145 REGION OF THE POLAR SOUTH,
DEEP INCISION IN THE POLAR,
SEDIMENTARY STRATA
LAT: -86.1° LONG: 172.1°

The sedimentary strata are mostly composed here of ice from water and not carbonic ice. The fractures that traverse these strata come from strong, seasonal thermal variations that can reach close to 100° C (212° F).

146 REGION OF THE POLAR SOUTH,
WEB OF NOTCHED FRACTURES
LAT: -85° LONG: 259.1°

Integrally covered by carbonic ice, this terrain shows fractures that form a more-or-less polygonal web. These polygons are very irregular and notched. Their structure has to do with a very large number of old geysers having cracked the layer of ice. Here there are no longer any fan-shaped plumes showing a difference in tone. Having been taken in summer, the image shows that the vault of ice has disappeared. It follows that the terrains are of a more homogeneous tone, and that they have preserved the passage of winter frost through the presence of small cracks—which shows that geysers affect not only the layer of ice, but also the subjacent layer of sand.

148 REGION OF THE POLAR SOUTH, GEYSERS
LAT: -87° LONG: 99.5°

This zone of the southern vault presents many geysers, ranging in size from decameters to hectometers, that result from the defrosting of carbonic ice. These geysers are called "spiders" because of the spider-web fractures surrounding their sources.

150 REGION OF THE POLAR SOUTH
LAT: -86.7° LONG: 297.6°

The terrains of carbonic ice of the southern vault have been eroded, leaving circular depression, by sublimation—except when the terrains are heterogeneous and inclined, in which case arabesques of small cliffs are formed. The orientation of the terrains, had they been moderately inclined in relation to the pale Sun, low on the horizon at the poles, is in fact fundamental to this process.

152

156

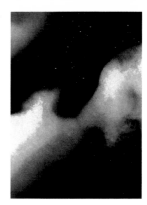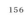

153

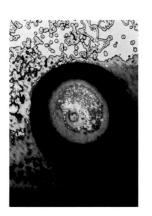

157

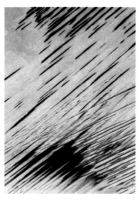

154

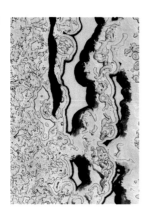

158

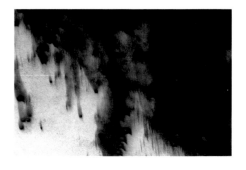

155

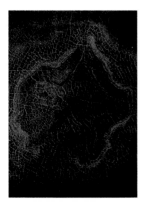

160

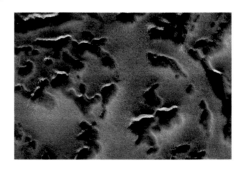

152 POLAR REGION OF THE SOUTH,
DARK LINES IN THE LAYER OF RESIDUAL ICE
LAT: -89.4° LONG: 310.8°

The bright terrains correspond to carbonic ice,
which is several meters thick and locally eroded
by sublimation. Underneath this layer there are
darker terrains that correspond to the ice from
water mixed with a little bit of dust. The ice from
water appears dark in this image against the strong
white of the carbonic ice, but it would be brighter
than the rest of the Martian surface if it was seen
juxtaposed with rocky terrains.

153 REGION OF THE POLAR SOUTH,
"SWISS-CHEESE" TERRAINS
LAT: -86.7° LONG: 248.9°

In this image, the bright terrains correspond
to winter frost. The ice appears dark because
it is engorged with dust. In reality, it looks almost
white to the human eye. The depression in the middle
is a crater with a peak at its center. Inside the crater,
especially on the northern side, these terrains show
circular forms having to do with carbonic ice during
volatilization through the process of sublimation.
There, carbonic ice that is only a few meters thick
will completely disappear in a few years. American
scientists have named these concentric forms
"Swiss-cheese terrains," undoubtedly without
knowing that a true Gruyère doesn't have holes!

154 REGION OF THE POLAR SOUTH
LAT: -86.8° LONG: 15.7°

See caption for page 150.

155 POLAR CRATER AND SUMMER ICE
LAT: -69.1° LONG: 123.4°

These terrains present polygonal webs in relatively
regular, geometric shapes. These webs are composed
of fractures resulting from frost preserved for long
periods in the crater's cavity. This type of polygonal
terrain has been observed, at high altitudes
(60° to 70°) on either hemisphere, and comes from
the fracturing of the ground due to the presence of
ice from water. Temperatures go from -30 to -40° C
(-22 to -40° F) on a summer day to 125° C (-193° F)
on a winter day, creating a range of more than
80° C (176° F) from one season to the other. This
difference in temperature creates a tightening
in the ground due to the contraction of ice with the
lowering of temperatures and its dilation at higher
temperatures, setting off a progressive fracturing
of these terrains to a depth of several meters.

156 REGION OF THE POLAR SOUTH,
DEFROSTING OF SEDIMENTARY STRATA
LAT: -87.7° LONG: 273.2°

The strong contrast between bright and dark zones
evinces a progressive diminution of the proportion
of carbonic gas on the surface; the same for passages
of bright, almost pure, zones of ice in the dark,
defrosted zones.

157 *CHASMA BOREALE*,
EOLIAN FIGURES
LAT: 83.2° LONG: 314°

In this image, the vault at the North is partially
covered in seasonal frost. The ice, which looks
fairly dark, is cut into "flutes" by strong winds.
This type of geological configuration is
the equivalent of the yardangs observed in
sedimentary terrains. The direction of the wind
is indicated by the lengthening of the flutes.

158 NORTH POLAR REGION,
ZONE PARTIALLY COVERED BY FROST
LAT: 73.5° LONG: 353.7°

Terrains partially covered by seasonal frost are
at the bottom of the image, and defrosted ones
at the top and at right. This sector is notably
composed of dark dunes, which explains the sharp
contrast in tones. At the juncture of the two zones,
parallel traces and the form of crescent dunes
indicate the direction of the wind from top
to bottom of the image.

160 PLAINS OF THE NORTH, HETEROGENEOUS
TERRAINS OF HIGH LATITUDE
LAT: 73.5° LONG: 74.4°

The white traces underscore the seasonal frost
present in zones that remained in the shade.
The flat terrains are constellated with small,
polygonal fractures linked to the presence of ice
from water underground.

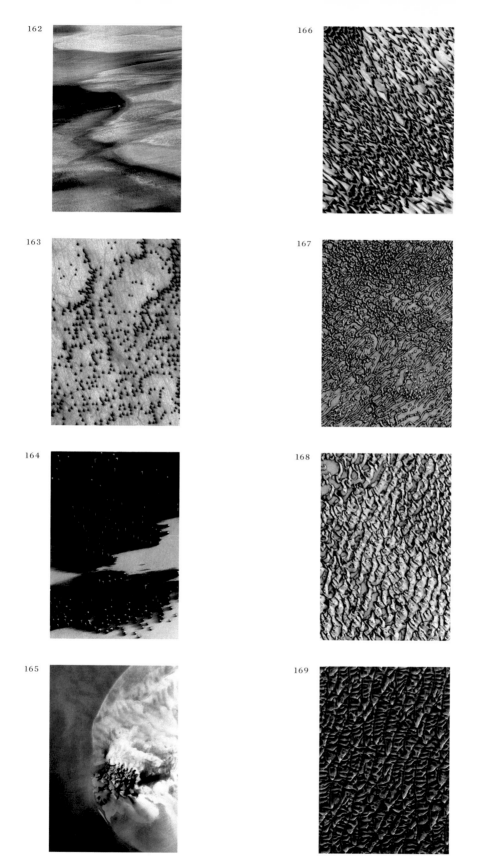

162

163

164

165

166

167

168

169

162 POLAR REGION OF THE NORTH,
CRATER TOPPED BY SEDIMENTS
LAT: 81.3° LONG: 91.5°

Extremely flat polar terrains where the wind,
transversal in the image, has created elongated
traces, leaving terrains more or less covered
by dust and variable in tone.

163 POLAR TERRAINS COVERED BY DUNES
LAT: 70.8° LONG: 305.3°

These polar terrains are scattered with crescent-
shaped dunes (*barkhanes*). This image was taken
while the dunes were free of frost. The subjacent
terrains show an embossed texture indicative of
the presence of ice from water at a shallow depth.

164 POLAR REGION OF THE NORTH,
ERG BORDER
LAT: 73.3° LONG: 355.1°

These are not cuneiform texts, but rather are dunes
of the *barkhane* type, that is, crescent-shaped;
one of the slopes is still partially covered by
seasonal frost because it hasn't yet benefited from
the warming light of the Sun. The terrains between
the dunes are defrosted, with the exception of
a thin, bright band still covered with frost.

165 CHANGING FROSTS IN THE *LOUTH* CRATER
LAT: 70.2° LONG: 103.5°

At the edge of this small polar vault, there extends
a landscape of dark dunes within the *Louth* crater:
at the center of the image, these appear partially
covered by frost; at left are polygonal terrains
evincing the presence of ice from water a few
centimeters beneath the ground surface.

166 POLAR REGION OF THE NORTH, ERG
LAT: 70.8° LONG: 305.3°

Thick system of dark, connected dunes in the form
of arabesques in the middle of high-latitude plains.

167 REGION OF THE POLAR NORTH, ERG
LAT: 77.6° LONG: 84.1°

When one sees undulating figures in geometric
forms resembling digital prints on Mars, they are
usually sand dunes. Their curves are emphasized
by the presence of frost, or rather the absence of
frost at the foot of the dunes, which creates a dark
boundary. The extremely variable form of the dunes
is the result of variable winds that here come from
the top right of the image, as is proven locally
by the *barkhanes* and elongations of the dunes.

168 SERIES OF DARK DUNES IN PLAINS
OF THE NORTH
LAT: 72.3° LONG: 311.8°

As during all winters, the dunes are 90 percent
covered by seasonal frost, which renders their real
tone almost invisible. Nonetheless, the conditions
of seasonal defrosting can be divined by the dark,
dotted traces visible notably on the flanks of
the dunes.

169 DUNES
LAT: 80.2° LONG: 217.1°

Networks of dark dunes near the North pole.

170

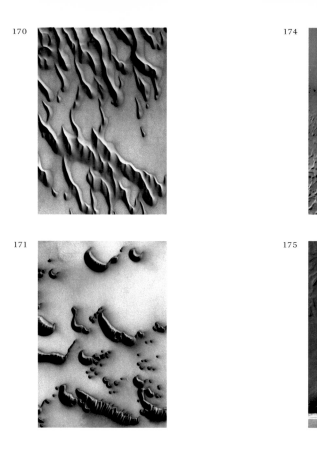

171

172

173

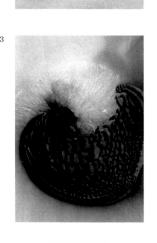

174

175

176

177

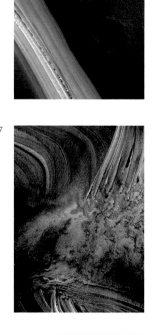

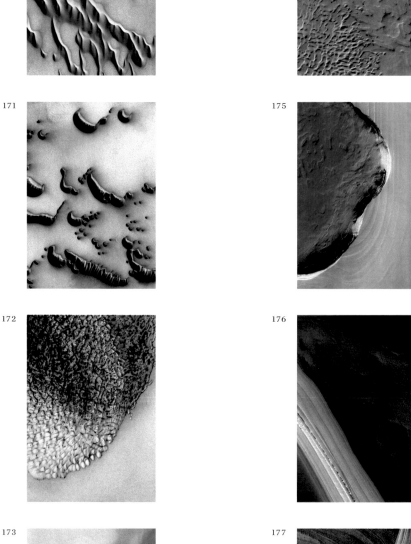

170 PLAINS OF THE NORTH, DUNES
LAT: 80.2° LONG: 130.4°

The plains of the North are extremely flat terrains
on which dunes are moved at the mercy of the
winds. These form elongated and sometimes
complex reliefs. Recent studies have shown that,
as on Earth, some dunes on the surface of Mars
migrate a few meters each year.

171 POLAR REGION OF THE NORTH,
BARKHANES
LAT: 76.1° LONG: 98°

This group of more-or-less large *barkhanes* is lit
by the Sun, the light of which comes from the summit
at the right in this image. On Earth, in periods of
violent winds, dunes move at rates of a few meters
each year. Small dunes move more quickly than
larger ones, but, when they head toward the large
ones, they are agglomerated. An identical process
exists on Mars, even if the polar dunes are actually
not very mobile, probably because of ice from
water that still remains in their porosities.

172 LARGE CRATER,
NORTHWEST OF THE *LOMONOSOV* CRATER
LAT: 75.1° LONG: 340.1°

This Martian "brain" is in reality a network
of dunes in complex formation due to their
accumulation on the floor of a depression. These
dunes are of a rather dark tone, but seasonal frost
has almost completely covered them. This image
was taken in spring, which explains the dark
patches characteristic of a defrosting period.

173 AGGLOMERATION OF DUNES IN A CRATER
LAT: 71.9° LONG: 344.8°

Black sand incorporated in dark dunes has
wrapped around a relief inside the impact crater
(not visible in the image).

174 POLAR REGION OF THE NORTH,
STRATA RESULTING FROM FROST
AVALANCHES ON PRONOUNCED CLIFFS
LAT: 83.8° LONG: 237.3°

The North vault was formed by accumulations
of ice from water and from fine atmospheric dust.
Because of the quantity of dust, these strata appear
more or less dark—that is to say, more or less
orange in color, the dust containing orange-colored
iron. The wind—and eventually other agents such
as landslides and avalanches—erodes certain
regions of the vault, creating cliffs and allowing
strata to appear. Without this erosion one would
perceive the vault as a smooth expanse of ice from
water on the surface.

175 POLAR REGION OF THE NORTH,
STRATIFIED TERRAINS
LAT: 83.8° LONG: 237.3°

In this image of the stratified terrains of the
Northern vault, one can observe small strata that
are more granular and less smooth than most
others. They are created by layers rich in dust that
render the process of erosion more heterogeneous;
ablations by the wind leave a level that is less smooth.

176 POLAR REGION OF THE NORTH,
OUTCROPPINGS OF SEDIMENTARY STRATA
LAT: 81.1° LONG: 66.1°

The parallel terrains at the left of the image
are borders of the polar vault at the North. They
are perpendicular to the dark plains, which feature
an impact crater that is completely filled and
remodeled by glacial phenomena.

177 REGION OF THE POLAR NORTH,
OUTCROPPINGS OF UNCOMFORMANT
SEDIMENTARY STRATA
LAT: 80° LONG: 23.3°

Each strata represents a cycle of several hundred
to several thousand years of ice condensing from
water. The deposit cycles sometimes stop due to
a period of erosion. Certain more recent deposits
are truncated, and the following cycle of deposits
begins on top of strata that can be much older, at
least to the extent that the erosion has been strong.
The border between these two cycles of deposits
is called an unconformity—a discordance in
French—one of which traverses this image.

178

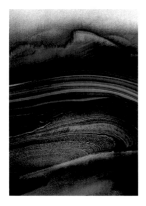

182

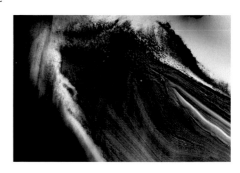

179

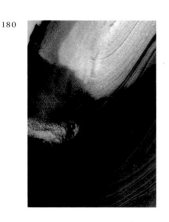

180

180

181

178 REGION OF THE POLAR NORTH,
UNCONFORMITY IN THE SEDIMENTS
LAT: 81.5° LONG: 64.4°

At the edge of the vault at the North, whose plains
are visible at the top of this image, one can
distinguish strata that come from the superposition
of several cycles of deposits/condensation and
erosion/sublimation, with quantities of dust that
vary among the strata.

179 REGION OF THE POLAR NORTH, CURVED
OUTCROPPING OF SEDIMENTARY STRATA
LAT: 82.5° LONG: 58.7°

The polar vault of the North is thick: it measures
close to three kilometers (1.9 miles), and each
strata is visible because of dust mixed into the ice
in proportions ranging from 10 to 20 percent.

180 REGION OF THE POLAR NORTH, CLIFF
LAT: 81.5° LONG: 61.2°

Strata of the polar vault (at right), partially
covered by seasonal frost (of carbonic ice)
at the top of the image.

181 HIGH REGION OF THE POLAR NORTH,
MULTIPLE UNCONFORMITIES OF
SEDIMENTARY STRATA
LAT: 79.7° LONG: 23.4°

Near the base of the polar vault at the North,
accumulations of ice are testimony to very ancient
deposits, about one thousand years or older.
Following the sequence of multiple ice-deposit
episodes, then the partial erosion of these deposits,
new ice accumulated on top of the older vault
zones, sometimes in a discontinuous manner. Thus
the cross sections of strata, called unconformant
in geology, are witnesses to these episodes
of deposits and erosion of the vault, revealing
an accumulative process much more complex than
the simple, progressive deposits of an ice mass.

182 POLAR REGION OF THE NORTH,
SEDIMENTARY STRATA
LAT: 81.8° LONG: 241.4°

Terrains of the plains in the North, in proximity
to the polar vault, are covered by seasonal frost
in the lower-left side of the image. The subtle
variations in tone are the result of a complex play
of dust deposits present in the atmosphere, the
condensation of seasonal frost, and wind erosion,
which leave traces going from the bottom to the
top of this image.

PHOBOS

Mars is endowed with two satellites: Phobos and
Deimos. Both orbit around the planet at a distance
of a few kilometers, and were discovered in 1877
by the American astronomer, Asaph Hall. These
irregularly-formed and heavily craterized bodies
could be more than 3 billion years old. Their
composition of rocks rich in carbon and ice from
water leads one to think that they could have been
asteroids captured during the final stages of
formation of the planet Mars. The large *Stickney*
crater (10 kilometers in diameter, a little over
6 miles) could have been the origin of the small
cracks one can see on its surface.

DEIMOS

In Greek mythologie, Phobos and Deimos are
the sons of the war god, Ares. Their names, which
can be translated as "fear" and "terror," make
reference to their function as satellites: they
are the guard corps of the planet. . . Like Phobos,
Deimos is studded with craters, but of a different
composition. Here, they are partially covered
by a light-toned dust. This dust, which makes
it look smoother than Phobos, could be the result
of constant bombardments by micro meteorites.

ACKNOWLEDGMENTS

For their generous contributions, the editor wishes to thank Alfred S. McEwen, Francis Rocard, and Nicolas Mangold, as well as Kenneth L. Tanaka of the USGS Astrogeology Science Center in Arizona and Ari Espinoza of HiRISE Media and Public Outreach.

For their close assistance, he also thanks Sébastien Girard, Sylvestre Maurice, Coline Aguettaz, Nathalie Chapuis, Yseult Chehata, Charlotte Debiolles, Aminatou Diallo, Emmanuelle Kouchner, Annette Lucas, Céline Moulard, Richard Oliver, Daniel Regard, and Perrine Somma.

THIS IS MARS

Front cover:
BARKHANES IN THE CRATER ZONE
LAT: -41.5° LONG: 44.6°
(see p. 110)

Back cover:
DUNES COVERED BY SEASONAL FROST
LAT: -58.6° LONG: 8.8°
(see p. 133)

CREATIVE DIRECTION AND EDITING
Xavier Barral with the collaboration of
Sébastien Girard

EDITORIAL COORDINATION
Nathalie Chapuis and Céline Moulard

ARTISTIC DIRECTION
Xavier Barral, Coline Aguettaz
assisted by Alix Barral

PRODUCTION
Charlotte Debiolles

SEPARATIONS
Les Artisans du Regard, Paris

The staff for the Aperture edition of *This Is Mars* includes:
Chris Boot, Executive Director; Sarah McNear, Deputy Director;
Lesley A. Martin, Creative Director; Amelia Lang, Executive Managing
Editor; Kellie McLaughlin, Director of Sales and Marketing;
Richard Gregg, Sales Director, Books; Susan Ciccotti, Senior Text Editor;
Taia Kwinter, Associate Managing Editor; Sally Knapp, Proofreader;
Giada De Agostinis, Work Scholar

Second Aperture edition copyright © 2017

Published by arrangement with Éditions Xavier Barral, Paris,
copyright © Éditions Xavier Barral, 2013 and 2017
Photographs copyright and courtesy
© Nasa/JPL/The University of Arizona
Maps p. 234–37 courtesy and copyright
© U.S. Geological Survey

Printed by Daniel Grammlich in Germany
January 2017
10 9 8 7 6 5 4 3 2 1

Library of Congress Control Number: 2013937118
ISBN 978-1-59711-415-8

To order Aperture books, contact: +1 212.946.7154
orders@aperture.org

For information about Aperture trade distribution worldwide,
visit: www.aperture.org/distribution

aperture

Aperture Foundation
547 West 27th Street, 4th Floor
New York, N.Y. 10001
www.aperture.org

Aperture, a not-for-profit foundation,
connects the photo community and its audiences
with the most inspiring work, the sharpest ideas,
and with each other—in print, in person,
and online.